P9-AET-707

NEW CENTURY BIBLE COMMENTARY

General Editors

RONALD E. CLEMENTS
(Old Testament)

MATTHEW BLACK
(New Testament)

Leviticus

THE NEW CENTURY BIBLE COMMENTARIES

Other titles are in preparation

NEW CENTURY BIBLE COMMENTARY

Based on the New Revised Standard Version

LEVITICUS

PHILIP J. BUDD

Marshall Pickering
An Imprint of HarperCollinsPublishers

WILLIAM B. EERDMANS PUBLISHING COMPANY
GRAND RAPIDS

Marshall Pickering is an Imprint of
HarperCollins*Religious*
Part of HarperCollins*Publishers*
77–85 Fulham Palace Road, London W6 8JB

First published in 1996 in Great Britain by Marshall Pickering
and in the United States by Wm. B. Eerdmans Publishing Co.,
255 Jefferson Ave. S.E., Grand Rapids, Michigan 49503

1 3 5 7 9 10 8 6 4 2

Copyright © 1996 Philip J. Budd

Philip J. Budd asserts the moral right
to be identified as the author of this work

British Library Cataloguing in Publication Data

A catalogue record for this book is
available from the British Library

Marshall Pickering ISBN 0-551-02834-3

Eerdmans ISBN 0-8028-4197-X

Printed in the United States of America
for Marshall Pickering and Wm. B. Eerdmans

CONTENTS

PREFACE

The problems posed by Leviticus for the modern reader are all too obvious. It is not simply that many of its laws and procedures are out of date; it is rather that its underlying pervasive presuppositions about purity and holiness seem inappropriate and uncongenial. Much of the book apparently stands in tension with more attractive texts among the narratives, in the psalms, or in the prophets, and biblical theologians generally have found it difficult to assign it a significant place in their systems. Distinctions between "moral" and "ceremonial" law exacerbate the problem. They come from outside as impositions upon the text, and they confirm the impression that Leviticus has much to do with ancient ceremony, and next to nothing with modern morality.

An historical approach can be of assistance here. In seeking to locate texts within the situations from which they emerged, and in sketching the pressures and circumstances behind the texts, a broad sympathy for the faith that gave rise to them can sometimes be generated. Here too, however, there are tensions and ambiguity. Viewed from one perspective it is possible to see Leviticus as a crucial means by which priests in Israel secured and extended their power within the community, including their revenues. From another perspective it can be seen as the literature of a colonized and oppressed people, who find meaning in an emphasis on their distinctive rites and beliefs, and which in turn enables them to resist and endure.

The recognition that purity systems are themselves ambiguous is also important if Leviticus is to be understood and appreciated. On the one hand they are exclusive and therefore divisive; they can readily become oppressive

insofar as they are the means by which power is secured and sustained. On the other hand it can reasonably be maintained that their roots lie in a profound reverence for life, in all its forms, which modernity might do well to recover.

Ambiguities such as these are intrinsic, and are not necessarily a barrier to the discovery of meaning. This commentary is offered in the conviction that they clarify the complexities of human experience, and provide some insight into what is necessary if the human condition is to be understood.

In short, it is precisely because of its ambiguities, and the ways in which they accurately reflect the enigmatic character of human motivation and experience, that Leviticus deserves to be taken seriously theologically. A theology which fails to grasp such "nettles" will ultimately fail in its endeavour.

Philip J. Budd
April 1995

ABBREVIATIONS

BIBLICAL
OLD TESTAMENT (OT)

Gen.	Jdg.	1 Chr.	Ps(s).	Lam.	Obad.	Hag.
Exod.	Ruth	2 Chr.	Prov	Ezek.	Jon.	Zech.
Lev.	1 Sam.	Ezr.	Eccles.	Dan.	Mic.	Mal.
Num.	2 Sam.	Neh.	Song	Hos.	Nah.	
Deut.	1 Kgs.	Est.	Isa.	Joel	Hab.	
Josh.	2 Kgs.	Job	Jer.	Amos	Zeph.	

GENERAL

AES Archives européennes de sociologie
BASOR *Bulletin of the American Schools of Oriental Research*
BDB F. Brown, S. R. Driver and C. A. Briggs (eds.), *A Hebrew and English Lexicon of the Old Testament*, Oxford, 1957 (3rd edition)
BHS *Biblia Hebraica Stuttgartensia* (ed. K. Elliger and W. Rudolph), Stuttgart, 1967/1977
BJRL *Bulletin of the John Rylands Library*
BWANT *Beiträge zur Wissenschaft vom Alten und Neuen Testament*
BZAW Beihefte zur *Zeitschrift für die Alttestamentliche Wissenschaft*
CBQ *Catholic Biblical Quarterly*
ET English translation
EvT *Evangelische Theologie*
ExpT *Expository Times*
GNB *Good News Bible*
HUCA *Hebrew Union College Annual*
IDB *The Interpreter's Dictionary of the Bible in Four Volumes* (ed. G. A. Buttrick *et al.*), Nashville/New York, 1962, and the *Supplementary Volume* (ed. K. Crim *et al.*), 1976
IEJ *Israel Exploration Journal*
JB *Jerusalem Bible*
JBL *Journal of Biblical Literature*
JPS *The Jewish Publication Society*
JQR *Jewish Quarterly Review*
JSOT *Journal for the Study of the Old Testament*
JSOTSS *Journal for the Study of the Old Testament Supplement Series*

JSQ	*Jewish Studies Quarterly*
JSS	*Journal of Semitic Studies*
JTS	*Journal of Theological Studies*
NEB	*New English Bible*
NIV	*New International Version*
NJB	*New Jerusalem Bible*
NRSV	*New Revised Standard Version*
OTS	*Oudtestamentische Studiën*
PEQ	*Palestine Exploration Quarterly*
RB	*Revue Biblique*
REB	*Revised English Bible*
RSV	*Revised Standard Version*
RV	*Revised Version*
SCTT	*Studies in Cultic Theology and Terminology*, J. Milgrom, Leiden, 1983
SJT	*Scottish Journal of Theology*
SVT	*Supplement to Vetus Testamentum*
VT	*Vetus Testamentum*
WMANT	*Wissenschaftliche Monographien zum Alten und Neuen Testament*
ZAW	*Zeitschrift für die Alttestamentliche Wissenschaft*
ZLThK	*Zeitschrift für die gesamte Lutherische Theologie und Kirche*

BIBLIOGRAPHY

COMMENTARIES

Chapman, A. T. and Streane, A. W., *The Book of Leviticus*, (*Cambridge Bible*), Cambridge, 1913.

Elliger, K., *Leviticus* (*Handbuch zum Alten Testament 4*), Tübingen, 1966.

Hartley, J. E., *Leviticus* (*Word Biblical Commentary*), Dallas, 1992.

Levine, B. A., *Leviticus* (*The JPS Torah Commentary*), Philadelphia, 1989.

Milgrom, J., *Leviticus 1-16* (*The Anchor Bible*), New York, 1991.

Noth, M., *Leviticus* (*Old Testament Library*), (ET by J. E. Anderson), London, 1962/1965.

Porter, J. R., *Leviticus* (*Cambridge Commentary on the New English Bible*), Cambridge, 1976.

Rendtorff, R., *Leviticus* (*Biblischer Kommentar – Altes Testament*), Neukirchen-Vluyn, 1985.

Snaith, N. H., *Leviticus and Numbers* (*New Century Bible*), London, 1967.

Wenham, G. J., *The Book of Leviticus* (*The New International Commentary on the Old Testament*), Grand Rapids, 1979.

Items on Leviticus by J. Milgrom and J. R. Wegner in one-volume commentaries on the whole Bible are indicated below.

OTHER WORKS

Aberbach, M. and Smolar, L., "Aaron, Jeroboam and the Golden Calves", *JBL* 86 (1967), pp. 129–140.

Alt, A., "The Origins of Israelite Law", *Essays on Old Testament History and Religion*, (ET by R. A. Wilson), Sheffield, 1934/1989, pp. 79-132.

Alter, R., "A New Theory of Kashrut", *Commentary* 68 (1979), pp. 46-52.

Anderson, G. A., *Sacrifices and Offerings in Ancient Israel: Studies in their Social and Political Importance*, Atlanta, 1987.

Auerbach, E., "Die Feste im alten Israel", *VT* 8 (1958), pp. 1-18.

—, "Das Aharon Problem", *Congress Volume Rome 1968*, *SVT 17*, Leiden, 1969, pp. 37-64.

Baker, D. W., "Leviticus 1-7 and the Punic Tariffs: A Form Critical Comparison", *ZAW* 99 (1987), pp. 188-197.

Baltzer, K., "Liberation from Debt Slavery after the Exile in Second Isaiah and Nehemiah", *Ancient Israelite Religion: Essays in Honour of Frank Moore Cross* (ed. P. D. Miller, P. D. Hanson, S. D. McBride), Philadelphia, 1987, pp. 477-484.

Baring, A. and Cashford, J., *The Myth of the Goddess: Evolution of an Image*, London, 1991.

Baudissin, W. W. G. von, *Die Geschichte des Alttestamentlichen Priesterthums*, Leipzig, 1889.

Beattie, J. H. M., "On Understanding Sacrifice", *Sacrifice*, (ed. M. F. C. Bourdillon and M. Fortes), London, 1980, pp. 1-27.

Begrich, J., "Die Priesterliche Tora", *Werden und Wesen des Alten Testaments* (ed. J. Hempel *et al.*), *BZAW* 66, Berlin, 1936, pp. 63-88.

Bettenzoli, G., "Deuteronomium und Heiligkeitsgesetz", *VT* 34 (1984), pp. 385-398.

Bigger, S. F., "The Family Laws of Leviticus 18 in Their Setting", *JBL* 98 (1979), pp. 187-203.

Blenkinsopp, J., "The Structure of P", *CBQ* 38 (1976), pp. 275-292.

—, "Temple and Society in Achaemenid Judah", *Second Temple Studies 1. Persian Period*, (ed. P. R. Davies), *JSOTSS* 117, Sheffield, 1991, pp. 22-53.

Boer, P. A. H. de, "An Aspect of Sacrifice", *Studies in the Religion of Ancient Israel*, *SVT* 23, Leiden, 1972, pp. 27-47.

Brichto, H. C., "On Slaughter and Sacrifice, Blood and Atonement", *HUCA* 47 (ed. S. H. Blank), 1976, pp. 19-55.

Brown, F., Driver, S. R., and Briggs, C. A. (ed), *A Hebrew and English Lexicon of the Old Testament*, Oxford, 1957 (3rd edition).

Brueggemann, W., "The Kerygma of the Priestly Writers",

ZAW 84 (1972), pp. 397-439.

Budd, P. J., "Holiness and Cult", *The World of Ancient Israel*, (ed. R. E. Clements), Cambridge, 1989, pp. 275-298.

Carpenter, J. E. and Harford, G., *The Composition of the Hexateuch*, London, 1902.

Cartledge, T. W., *Vows in the Hebrew Bible and the Ancient Near East*, *JSOTSS* 147, Sheffield, 1992.

Carroll, M. P., "One More Time: Leviticus Revisited", *AES* 99 (1978), pp. 339-346. Reprinted in B. Lang (ed), *Anthropological Approaches to the Old Testament*, London, 1985, pp. 117-126.

Chirichigno, G. C., "Debt Slavery in Israel and the Ancient Near East", *JSOTSS* 141, Sheffield, 1993.

Cholewinski, A., *Heiligkeitsgesetz und Deuteronomium*, Rome, 1976.

Clifford, R. J., "The Tent of El and the Israelite Tent of Meeting", *CBQ* 33 (1971), pp. 221-227.

Cody, A., *A History of Old Testament Priesthood*, Rome, 1969.

Coote, R .B. and Coote, M. P., *Power, Politics, and the Making of the Bible*, Minneapolis, 1990.

Coote, R. B. and Ord, D. R., *In the Beginning: Creation and the Priestly History*, Minneapolis, 1991.

Couturier, G., "Le Sacrifice d' 'action de grâces'", *Eglise et Théologie*, 13 (1982), pp. 5-34.

Cross, F. M., "The Priestly Houses of Early Israel" and "The Priestly Work", *Canaanite Myth and Hebrew Epic*, Cambridge, MA, 1973, pp. 195-215, 293-325.

Daiches, S., "The Meaning of 'rp in Lev. 5:8", *ExpT* 39 (1927-28), pp. 426-427.

Davies, D., "An Interpretation of Sacrifice in Leviticus", *ZAW* 89 (1977), pp. 388-398. [reprinted in B. Lang (ed.) *Anthropological Approaches to the Old Testament*, London, 1985, pp. 151-162].

Day, J., *Molech: A God of Human Sacrifice in the Old Testament*, Cambridge, 1989.

Douglas, M., *Purity and Danger: An Analysis of Concepts of Pollution and Taboo*, London, 1966.

—, *Natural Symbols. Explorations in Cosmology*, London, 1970.

—, *Implicit Meanings*, London, 1975.

—, "The Forbidden Animals in Leviticus", *JSOT* 59 (1993), pp. 3-23.

—, "Atonement in Leviticus", *JSQ* 1 (1993/94), pp. 109-130.

Driver, G. R., "Birds in the Old Testament", *PEQ* 87 (1955), pp. 5-20.

—, "Three Technical Terms in the Pentateuch", *JSS* 1 (1956), pp. 97-105.

Driver, S. R., *Introduction to the Literature of the Old Testament*, London, 1891/1913 (9th ed.).

Durkheim, E., *The Elementary Forms of the Religious Life*, (ET by J. W. Swain), London, 1912/1971 (2nd edition).

Eissfeldt, O., *The Old Testament: An Introduction*, (ET by P. R. Ackroyd), Oxford, 1964/1965.

Elliott Binns, L., "Some Problems of the Holiness Code", *ZAW* 67 (1955), pp. 26-40.

Emerton, J.A., "The Priestly Writer in Genesis", *JTS* 39 (1980), pp. 381-400.

Fager, J. A., *Land Tenure and the Biblical Jubilee*, *JSOTSS* 155, Sheffield, 1993.

Firmage, E., "The Biblical Dietary Laws and the Concept of Holiness", *Studies in the Pentateuch*, (ed. J. A. Emerton), *SVT* 41, Leiden, 1990, pp. 177-208.

Fohrer, G., *Introduction to the Old Testament*, (ET by D. Green), London (1965/1970).

Frazer, J. G., *The Golden Bough: A Study in Magic and Religion*, London, 1922.

Freedman, D. N., "Variant Readings in the Leviticus Scroll from Qumran Cave 11", *CBQ* 36 (1974), pp. 525-534.

—, and Matthews, K. A., *The Paleo-Hebrew Leviticus Scroll (11QpaleoLev)*, Winona Lake, IN, 1985.

Friedman, R. E., *The Exile and Biblical Narrative: The Formation of the Deuteronomistic and Priestly Works*, Chico, CA, 1981.

—, *Who Wrote the Bible?*, London, 1988.

Gabel, J. B. and Wheeler, C. B., "The Redactor's Hand in the Blasphemy Pericope of Leviticus xxiv", *VT*, 30 (1980), pp. 227-229.

Gane, R., " 'Bread of the Presence' and Creator-in-Residence", *VT* 42 (1992), pp. 179-203.

Geller, M., "The Šurpu Incantations and Lev 5:1-6", *JSS* 25

(1980), pp. 181-192.

Gevirtz, S., "West-Semitic Curses and the Problem of the Origins of Hebrew Law", *VT* 11 (1961), pp. 137-169.

Görg, M., "Eine neue Deutung für kapporet", *ZAW* 89 (1977), pp. 115-118.

Gorman, F. H., *The Ideology of Ritual: Space, Time and Status in the Priestly Theology*, *JSOTSS* 91, Sheffield, 1990.

Gottwald, N., *The Tribes of Yahweh: A Sociology of the Religion of Liberated Israel 1250-1050 BCE*, Maryknoll/London, 1979/1980.

—, *The Hebrew Bible: A Socio-Literary Introduction*, Philadelphia, 1985.

Grabbe, L. L., *Leviticus*, (Old Testament Guides), Sheffield, 1993.

Gradwohl, R., "Das 'fremde Feuer' von Nadab und Abihu", *ZAW* 75 (1963), pp. 288-296.

Gray, G. B., *Sacrifice in the Old Testament*, Oxford, 1925.

Gray, J., "The Religion of Canaan", *The Legacy of Canaan*, Leiden, 1965, pp. 152-217.

Gugliemo, A. de, "Sacrifice in the Ugaritic Texts", *CBQ* 17 (1955), pp. 76-96.

Gunneweg, A. H. J., *Leviten und Priester*, Göttingen, 1965.

Halbe, J., "Erwägungen zu Ursprung und Wesen des Massotfestes", *ZAW* 87 (1975), pp. 324-346.

Hallo, W. W., "The Origins of the Sacrificial Cult: New Evidence from Mesopotamia and Israel", *Ancient Israelite Religion: Essays in Honor of Frank Moore Cross* (ed. P. D. Miller, P. D. Hanson, S. D. McBride), Philadelphia, 1987, pp. 3-13.

Haran, M., "The Uses of Incense in the Ancient Israelite Ritual", *VT* 10 (1960), pp. 113-129.

—, "Shiloh and Jerusalem: The Origin of the Priestly Tradition in the Pentateuch", *JBL* 81 (1962), pp. 14-24.

—, "The Passover Sacrifice", *Studies in the Religion of Ancient Israel*, *SVT* 23, Leiden, 1972, pp. 86-116.

—, *Temples and Temple Service in Ancient Israel: An Inquiry into the Character of Cult Phenomena and the Historical Setting of the Priestly School*, Oxford, 1978.

—, "Behind the Scenes of History: Determining the Date of

the Priestly Source", *JBL* 100 (1981), pp. 321-333.

Heider, G. C., *The Cult of Molek: A Reassessment, JSOTSS* 43, Sheffield, 1986.

Heller, J., "Die Symbolik des Fettes im A.T.", *VT* 20 (1970), pp. 106-108.

Herrmann, B. W., "Götterspeise und Göttertrank in Ugarit und Israel", *ZAW* 72 (1960), pp. 205-216.

Hillers, D. R., "Ugaritic šnpt 'Wave Offering'", *BASOR* 198 (1970), p.42: *BASOR* 200 (1970), p.18.

Hoftijzer, J., "Das sogenannte Feueropfer", *Hebräische Wortforschung. Festschrift zum 80. Geburtstag von Walter Baumgartner SVT* 16, Leiden 1967, pp. 114-134.

Hogland, K., "The Achaemenid Context", *Second Temple Studies: 1. Persian Period* (ed. P.R.Davies) *JSOTSS* 117, Sheffield, 1991, pp. 54-72.

Horbury, W., "Extirpation and Excommunication", *VT* 35 (1985), pp. 13-38.

Houston, W., *Purity and Monotheism, JSOTSS* 140, Sheffield, 1993.

Houtman, C., "Another Look at Forbidden Mixtures", *VT* 34 (1984), pp. 226-228.

Hubert, H. and Mauss, M., *Sacrifice: its Nature and Function*, London, 1898/1964.

Hubner, U., "Schweine, Schweineknochen und ein Speisverbot im alten Israel", *VT* 39 (1989), pp. 225-236.

Hunn, E., "The Abominations of Leviticus Revisited", *Classifications in their Social Context* (ed. R. F. Ellen and D. Reason), London, 1979, pp. 103-116.

Hurvitz, A., "The Evidence of Language in Dating the Priestly Code", *RB* 81 (1974), pp. 24-57.

—, *A Linguistic Study of the Relationship between the Priestly Source and the Book of Ezekiel: A New Approach to an Old Problem*, Paris, 1982.

James, E. O., *Origins of Sacrifice*, London, 1933.

Janowski, B., *Sühne als Heilsgeschehen, WMANT* 55, Neukirchen-Vluyn, 1982.

Jay, N., "Sacrifice, Descent and the Patriarchs", *VT* 38 (1988), pp. 52-70.

—, *Throughout Your Generations Forever: Sacrifice, Religion and*

Paternity, Chicago, 1992.

Jensen, P. P., *Graded Holiness: A Key to the Priestly Conception of the World*, *JSOTSS* 106, Sheffield, 1992.

Jirku, A., "Lev 11:29-33 im Lichte der Ugarit-Forschung", *ZAW* 84 (1972), p. 348.

Judge, H. G., "Aaron, Zadok and Abiathar", *JTS* 7 (1956), pp. 70-74.

Kaufmann, Y., *The Religion of Israel*, (ET by M. Greenberg), London, 1961.

Keel, O., "Erwägungen zum Sitz im Leben des Pascha", *ZAW* 84 (1972), pp. 414-434.

Kellermann, D., " 'Asham in Ugarit?", *ZAW* 76 (1964), pp. 319-322.

Kennett, R. H., "The Origin of the Aaronite Priesthood", *JTS* 6 (1905), pp. 161-186.

Kilian, R., *Literarkritische und formgeschichtliche Untersuchung des Heiligkeitsgesetzes*, Bonn, 1963.

Kiuchi, N., *The Purification Offering in the Priestly Literature*, *JSOT* 56, Sheffield, 1987.

Klostermann, A., "Beiträge zur Entstehungsgeschichte des Pentateuchs", *ZLThK*, 38 (1877), pp. 401-445.

Knierim, R. P., *Text and Concept in Leviticus 1:1-9*, Tübingen, 1992.

Knohl, I., "The Sin Offering Law in the 'Holiness School' " (Numbers 15:22-31), *Priesthood and Cult in Ancient Israel* (ed. G. A. Anderson and S. M. Olyan), *JSOTSS* 125, Sheffield, 1991, pp. 192-203.

Koch, K., *Die Priesterschrift von Exodus 25 bis Leviticus 16*, Göttingen, 1959.

Kraus, H. J., "Zur Geschichte des Passah-Massot-Festes im Alten Testament", *EvT* 18 (1958), pp. 47-67.

Laughlin, J. C. H., "The 'Strange Fire' of Nadab and Abihu", *JBL* 95 (1976), pp. 559-565.

Leach, E., "The Logic of Sacrifice", *Anthropological Approaches to the Old Testament*, (ed. B. Lang), London, 1985, pp. 136-150.

Leeuwen, J. H. van, "The Meaning of tup'îin in Lev 6:14", *ZAW* 100 (1988), p. 268.

Levine, B. A., *In the Presence of the Lord – a Study of Cult and*

some Cultic Terms, Leiden, 1974.

Levine, B. A. and Hallo, W. W., "Offerings to the Temple Gates at Ur", *HUCA* 38 (1967), pp. 17-58.

Lindblom, J., "Lot Casting in the Old Testament", *VT* 12 (1962), pp. 164-178.

Livingston, D. H., "The Crime of Lev. 24:11", *VT* 36 (1986), pp. 352-354.

Loewenstamm, S. E., "M/Tarbit and Neshek", *JBL* 88 (1969), pp. 78-80.

Macht, D. I., "A Scientific Appreciation of Lev. 12:1-5", *JBL* 52 (1933), pp. 253-260.

MacRae, G. W., "The Meaning and Evolution of the Feast of Tabernacles", *CBQ* 22 (1960), pp. 251-276.

Malina, B. J., *The New Testament World: Insights from Cultural Anthropology*, London, 1983.

Maloney, R. P., "Usury and Restrictions on Interest-Taking in the Ancient Near East", *CBQ* 36 (1974), pp. 1-20.

Marx, A., "Sacrifice de Réparation et Rites de Levée Sanction", *ZAW* 100 (1988), pp. 183-198.

Matthews, K. A., "The Leviticus Scroll (11QpaleoLev) and the Text of the Hebrew Bible", *CBQ* 48 (1986), pp. 171-207.

May, H. G., "The Relation of the Passover to the Festival of Unleavened Cakes", *JBL* 55 (1936), pp. 65-82.

McCarthy, D. J., "The Symbolism of Blood and Sacrifice", *JBL* 88 (1969), pp. 166-176.

—, "Further Notes on the Symbolism of Blood and Sacrifice", *JBL* 92 (1973), pp. 205-210.

McEvenue, S. E., *The Narrative Style of the Priestly Writer*, Rome, 1971.

McKay, J. W., "The Date of Passover and its Significance", *ZAW* 84 (1972), pp. 435-447.

Milgrom, J., "The Biblical Diet Laws as an Ethical System", *Interpretation* 17 (1963), pp. 288-301.

—, "The Cultic Śegāgāh and its Influence in Psalms and Job", *JQR* 58 (1967), pp. 73-79 [reprinted in *SCTT*, pp. 122-132].

—, "Sin-Offering or Purification Offering", *VT* 21 (1971), pp. 237-239 [reprinted in *SCTT*, pp. 67-69].

—, "A Prolegomenon to Lev. 17:11", *JBL* 90 (1971), pp. 149-

156 [reprinted in *SCTT*, pp. 96-103].

—, "The Book of Leviticus", *The Interpreter's One Volume Commentary on the Bible*, (ed. C. M. Laymon), Nashville, 1971, pp. 68-84.

—, "The Alleged Wave-Offering in Israel and in the Ancient Near East", *IEJ* 22 (1972), pp. 33-38 [reprinted in *SCTT*, pp. 139-158].

—, "shôq hatt^e rumāh: A Chapter in Cultic History" (Heb), *Tarbiz* 42 (1972/1973), pp. 1-11. [ET in *SCTT*, pp. 159-170].

—, "The Priestly Doctrine of Repentance", *RB* 82 (1975), pp. 186-205 [reprinted in *SCTT*, pp. 47-66].

—, *Cult and Conscience: The "Asham" and the Priestly Doctrine of Repentance*, Leiden, 1976.

—, "Two Kinds of ḥaṭṭa't", *VT* 26 (1976), pp. 333-337 [reprinted in *SCTT*, pp. 70-74]

—, "Israel's Sanctuary: The Priestly 'Picture of Dorian Gray'", *RB* 83 (1976), pp. 390-399 [reprinted in *SCTT*, pp. 75-84].

—, "Profane Slaughter and a Formulaic Key to the Composition of Deuteronomy", *HUCA* 47 (1976), pp. 1-17.

—, "The Betrothed Slave Girl: Lev. 19.20-22", *ZAW* 89 (1977), pp. 43-50.

—, "Priestly Terminology and the Political and Social Structure of Pre-Monarchic Israel", *JQR* 69 (1978), pp. 65-81 [reprinted in *SCTT*, pp. 1-17].

—, "Religious Conversion and the Revolt Model for the Formation of Israel", *JBL* 101 (1982), pp. 169-176.

—, "The Two Pericopes on the Purification Offering", *The Word of the Lord Shall Go Forth: Essays in Honor of David Noel Freedman in Celebration of his Sixtieth Birthday* (ed. C. L. Meyers and M. O'Connor), Winona Lake, IA, 1983, pp. 211-215.

—, "Review of B. Janowski's *Sühne als Heilsgeschehen*", *JBL* 104 (1985), pp. 302-304.

Mittwoch, H., "The Story of the Blasphemer Seen in a Wider Context", *VT* 15 (1965), pp. 386-389.

Moran, W. L., "The Literary Connection between Lev. 11:13-19 and Deut. 14:12-18", *CBQ* 28 (1966), pp. 271-277.

Morgenstern, J., "The Decalogue of the Holiness Code",

HUCA 26 (1955), pp. 1-27.

Mowinckel, S., *Tetrateuch-Pentateuch-Hexateuch: Die Berichte über die Landnahme in den drei altisraelitischen Geschitswerken,* *BZAW* 90, Berlin, 1964.

Nielsen, E., "Moses and the Law", *VT* 32 (1982), pp. 87-98.

Nielsen, K., *Incense in Ancient Israel,* Leiden, 1986.

North, F., "Aaron's Rise in Prestige", *ZAW* 66 (1954), pp. 191-199.

Noth, M., *A History of Pentateuchal Traditions,* ET by B. W. Anderson, Chico, CA, 1948/1981.

Olyan, S., "Zadok's Origins and the Tribal Politics of David", *JBL* 101 (1982), pp. 177-193.

Péter, R., "L'imposition des mains dans l'Ancien Testament", *VT* 27 (1977), pp. 48-55.

Pfeiffer, R. H., *Introduction to the Old Testament,* London, 1952.

Phillips, A. C. J., "Uncovering the Father's Skirt", *VT* 30 (1980), pp. 38-43.

—, "The Undetectable Offender and the Priestly Legislators", *JTS* 36 (1985), pp. 146-150.

Rabast, K. H., *Das apodiktische Recht im Deuteronomium und im Heiligkeitsgesetz,* Hermsdorf, 1949.

Rad, G. von, *Studies in Deuteronomy,* (ET by D.Stalker), London, 1948/1953.

—, "Faith Reckoned as Righteousness", *The Problem of the Hexateuch and Other Essays,* (ET by E. W. Trueman Dicken), London, 1966, pp. 125-130.

Rainey, A. F., "The Order of Sacrifice in Old Testament Ritual Texts", *Biblica* 51 (1970), pp. 485-498.

Rapaport, I., "The Origins of Hebrew Law", *PEQ* 73 (1941), pp. 158-167.

Rendtorff, R., *Die Gesetze in der Priesterschrift,* Göttingen, 1963 (2nd edition).

—, *Studien zur Geschichte des Opfers im alten Israel,* Neukirchen, 1967.

—, *Der Überlieferungsgeschichtliche Problem des Pentateuch,* BZAW 147, Berlin, 1977.

—, *The Old Testament: An Introduction,* (ET by J. Bowden), London, 1983/1985.

Reventlow, H. G., *Das Heiligkeitsgesetz formgeschichtlich*

untersucht, WMANT 6, Neukirchen, 1961.

Robinson, G., "The Prohibition of Strange Fire in Ancient Israel", *VT* 28 (1978), pp. 301-317.

Rogerson, J. W., "Sacrifice in the Old Testament", *Sacrifice* (ed. M. F. C. Bourdillon and M. Fortes). London, 1980, pp. 45-59.

Rogerson, J. and Davies, P., *The Old Testament World*, Cambridge, 1989.

Rost, L., "Der Leberlappen", *ZAW* 79 (1967), pp. 35-41.

—, *Studien zum Opfer im Alten Israel* (*BWANT* 13), Stuttgart, 1981.

Rüger, H. P., "'Dann entfernt er seinen Kropf samt dessen Federn': Zur Auslegungsgeschichte von Lev 1.16" (*Wort und Geschichte: Festschrift für Karl Elliger zum 70. Geburtstag* (ed. H. Gese and H. P. Rüger), Neukirchen-Vluyn, 1973, pp. 163-172.

Saydon, P. P., "Sin-Offering and Trespass-Offering", *CBQ* 8 (1946), pp. 393-398.

Schenker, A., "kōper et expiation", *Biblica* 63 (1982), pp. 32-46.

Schmid, R., *Das Bundesopfer in Israel*, Munich, 1964.

Schmidt, W., "Mishkan als Ausdruck Jerusalemer Kultsprache", *ZAW* 75 (1963), pp. 91-92.

Schwartz, B. J., "The Prohibitions Concerning the 'Eating' of Blood in Leviticus 17", *Priesthood and Cult in Ancient Israel* (ed. G. A. Anderson and S. M. Olyan), *JSOTSS* 125, Sheffield, 1991, pp. 34-66.

Segal, P., "The Divine Verdict of Leviticus X 3", *VT* 39 (1989), pp. 91-95.

Smith, D. L., "The Politics of Ezra: Sociological Indicators of Post Exilic Judaean Society", *Second Temple Studies: 1. Persian Period* (ed. P. R. Davies), *JSOTSS* 117, Sheffield, 1991, pp. 73-97.

Smith, H. P., "Animal Sources of Pollution", *JBL* 30 (1911), pp. 55-60.

Smith, W. Robertson, *Lectures on the Religion of the Semites*, London, 1907 (2nd edition).

Snaith, N. H., "The Wave Offering", *ExpT* 74 (1963), p.127.

—, "The Sin Offering and the Guilt Offering", *VT* 15 (1965), pp. 73-80.

—, "The Cult of Molech", *VT* 16 (1966), pp. 123-124.

—, "The Sprinkling of Blood", *ExpT* 82 (1970/1971), pp. 23-24.

Snijders, L. A., "The Meaning of 'zār' in the Old Testament", *OTS* 10 (1954), pp. 1-154.

Stevenson, W. B., "Hebrew Olah and Zebach Sacrifices", *Festschrift A. Bertholet* (ed. W. Baumgartner, O. Eissfeldt, K. Elliger, L. Rost), Tübingen, 1950, pp. 488-497.

Thiel, W., "Erwägungen zum Alter des Heiligkeitsgesetzes", *ZAW* 81 (1969), pp. 40-73.

Thompson, R. J., *Penitence and Sacrifice in Early Israel outside the Levitical Law*, Leiden, 1963.

—, *Moses and the Law in a Century of Criticism since Graf*, Leiden, 1970.

Tosato, A., "The Law of Leviticus 18:18: A Reexamination", *CBQ* 46 (1984), pp. 199-214.

Tylor, E. B., *Primitive Culture: Researches into the Development of Mythology, Philosophy, Religion, Art and Custom*, London, 1871.

Vincent, A., "Les rites du balancement (tenoûphâh) et du prélèvement (teroûmah) dans le sacrifice de communion de l'Ancien Testament", *Mélanges Syriens offerts à R. Dussaud I*, (ed. various), Paris, 1939, pp. 267-272.

Vink, J. G., "The Date and Origin of the Priestly Code in the Old Testament", *OTS* 15 (1969), pp. 1-144.

Wagner, V., "Zur Existenz des sogenannten Heiligkeitsgesetzes", *ZAW* 86 (1974), pp. 307-316.

Wambaq, B. N., "Les Massôt", *Biblica* 61 (1980), pp. 31-54.

Wegner, J. R., "Leviticus", *The Women's Bible Commentary* (ed. C. A. Newsom and S. H. Ringe), London/Louisville, 1992, pp. 36-44.

Weimar, P., "Sinai und Schöpfung: Komposition und Theologie der Priesterschriftlichen Sinaigeschichte", *RB* 95 (1988), pp. 337-385.

Weinfeld, M., *Deuteronomy and the Deuteronomic School*, Oxford, 1972.

Weingreen, J., "The Case of the Blasphemer", *VT* 22 (1972), pp. 118-123.

Wellhausen, J., *Prolegomena to the History of Ancient Israel*, (ET by Black & Menzies), Cleveland/New York, 1878/1957.

Wenham, G. J., "Leviticus 27:2-8 and the Price of Slaves", *ZAW* 90 (1978), pp. 264-265.

—, "Why does Sexual Intercourse Defile (Lev. 15:18)?", *ZAW* 95 (1983), pp. 432-434.

Westbrook, R., "Jubilee Laws", "Redemption of Land", *Property and the Family in Biblical Law, JSOTSS* 113, Sheffield, 1991, pp. 36-57, 58-68. [first printed in *Israel Law Review* 6 (1971), pp. 209-226, 367-375].

—, "The Price Factor in the Redemption of Land", *Property and the Family in Biblical Law, JSOTSS* 113, Sheffield, 1991, pp. 90-117. [first printed in *Revue internationale des droits de l'antiquité*, 32 (1985), pp. 97-127].

White, M., "The Elohistic Depiction of Aaron: a Study in the Levite-Zadokite Controversy", *Studies in the Pentateuch* (ed. J. A. Emerton), *SVT* 41, Leiden, 1990, pp. 149-159.

Whitekettle, R., "Leviticus 15:18 Reconsidered: Chiasm, Spatial Structure and the Body", *JSOT* 49 (1991), pp. 31-45.

Wilkinson, J., "Leprosy and Leviticus: The Problem of Identification", *SJT* 30 (1977) pp. 153-169.

—, "Leprosy and Leviticus: A Problem of Semantics and Translation", *SJT* 31 (1978), pp. 153-166.

Williams, J. G., "Concerning one of the Apodictic Formulas", *VT* 14 (1964), pp. 484-494.

Wright, D. P., *The Disposal of Impurity: Elimination Rites in the Bible and in Hittite and Mesopotamian Literature*, Atlanta, 1987.

—, "The Spectrum of Priestly Impurity", *Priesthood and Cult in Ancient Israel*, (ed. G. A. Anderson and S. M. Olyan), *JSOTSS* 125, Sheffield, 1991, pp. 150-181.

Zimmerli, W., "'Heiligkeit' nach dem sogenannten Heiligkeitsgesetz", *VT* 30 (1980), pp. 493-512.

Zipor, M., "Restrictions on Marriage for Priests", *Biblica* 68 (1987), pp. 259-267.

Zohar, N., "Repentance and Purification: the Significance and Semantics of *ht't* in the Pentateuch", *JBL* 107 (1988), pp. 609-618.

Zwickel, W., *Räucherkult und Räuchergeräte: Exegetische und Archäologische Studien zum Räucheropfer im Alten Testament*, Göttingen, 1990.

Acknowledgements

I would like to thank Professor Ronald Clements for the invitation to write this commentary, and for his continuing patience and support. I am grateful too for the support of colleagues at Westminster College, and for the help of staff at the publishers. My wife Janet has been wholly sympathetic to the demands of writing, and a constant source of encouragement.

GENERAL
INTRODUCTION

A. THE TITLE

The English title of the book Leviticus is derived from the Vulgate (the Latin Bible), which is in turn offering a latinized version of the Septuagint's Greek title *Leveitikon*. As with the other five books of Moses (the Pentateuch), this represents an attempt by the Greek translators to do some justice to the content – here described as the Levitical book. Since the Levites were above all Israel's priestly tribe, and since, as soon becomes clear, the book is overwhelmingly interested in priestly matters, the title is appropriate enough. On the other hand it should be noted that Leviticus prefers to depict the priests as *sons of Aaron*, a particular family within the priestly tribe. Allusions to the Levites as such are rare (Lev. 25:32, 33).

The Jewish procedure is to use the first Hebrew word as a title. In this case the word is *wayyiqra'* – "and he called" (or summoned). Such titles may have been little more than a means of identification, but insofar as Leviticus is the outcome of Yahweh's summons to Moses, the laws he is to pass on to the priests and to Israel as a whole, this title also has its point and relevance.

B. TEXT

Despite its antiquity the Hebrew text of Leviticus appears to have been well preserved. A major witness is the Masoretic Text (MT), the standardized form used in the synagogue. It is found in most Hebrew manuscripts dating from about the tenth century CE onwards, but represents the work of Jewish scholars from at least the second century CE. The book's status as part of the Torah (the five books of Moses), and its

general homogeneity, may have protected it from the kinds of error and the dislocations that sometimes affect the textual tradition of other books. Nevertheless, there are various occasions when reference must be made to other witnesses, notably the Greek of the Septuagint (Gk in *NRSV*), whose earliest manuscripts date to the fourth century CE and the Hebrew of the Samaritan Pentateuch (Sam. in *NRSV*), available primarily in thirteenth century CE manuscripts and representing the text as preserved in the Samaritan community.

Arguments for the priority of a particular reading are essentially a matter of text-critical judgement. As a general methodological principle it seems wise to try to treat each problem on its merits, without reference to *a priori* assumptions about the superiority of a particular witness. In practice, in the case of Leviticus, it is often easy to argue in favour of the MT. At the same time it is fair to say that overall there is a large measure of textual uniformity in Leviticus between the three major textual traditions (MT, Gk, Sam.).

Text-critical study of the book has been stimulated by the recent publication of texts from among the Dead Sea Scrolls (11QpaleoLev) (D. N. Freedman and K. A. Matthews, *The Paleo-Hebrew Leviticus Scroll*, 1985). Freedman (*Variant Readings*, 1974) had previously offered an analysis of the divergencies represented in these texts, and a more recent and comprehensive assessment of the finds is made by Matthews (*The Leviticus Scroll*, 1986). These texts from Cave 11 consist of a scroll containing substantial sections from chapters 22–27, and seventeen small fragments from chapters 4–22. The script is well preserved, and the texts can be dated to about 100 BCE, making them the earliest witness to the Hebrew that we have.

Initial evaluation (Matthews, *The Leviticus Scroll*, 1986) suggests no clear relationship to any *one* textual tradition, and the likelihood that the unique readings reflect in the main mechanical error. It suggests that the scroll and its associated fragments do not represent a superior witness to Leviticus, a conclusion which tends to confirm impressions from earlier published fragments from other caves. In short,

it indicates that the texts from Cave 11 will do little to help with major exegetical problems; their main value would appear to consist in evidence they offer for the reconstruction of the history of the main textual traditions.

For our purposes the variant readings discussed will be drawn overwhelmingly from those recorded in *Biblia Hebraica Stuttgartensia* (*BHS*). The English text upon which the commentary is based is that of the *NRSV* except that Yahweh is used as the divine name. This poses problems in *Leviticus* because there continue to be uncertainties about how some of the technical terminology should be best translated (in relation, for example, to sacrifice). The terminology used in this commentary will be that adopted by the *NRSV* translators, but where appropriate reference will be made to other readily available translations.

At one point there is a divergence between the verse numberings in most English translations and those in the Hebrew, with the effect that 6:1–30 (Eng.) = 5:20–6:23 (Heb.). The numbering adopted by the *NRSV*, and English translations generally, will be employed in the body of the commentary.

C. CONTENT

Viewed as a whole the book of Leviticus is distinctly uniform and consistent in content and general point of view. It consists of divine directives to Moses covering matters of particular interest to priests. Dominant concerns are the conduct of sacrificial procedures and the maintenance of ritual purity. Occasionally a narrative interest emerges, but this too is put to use in the service of directives which are intended to shape the life of Israel as a cultic community. It would be a grave mistake, however, to suppose that the book sees itself as narrowly based, with an interest limited to exclusively "religious" concerns. It becomes very clear, particularly in chapters 18–26, that the principles which regulate the community's cultic life are precisely those that determine proper personal and social relationships. These principles, expressed in the book's theological perceptions, give to it a basic cohesion and clarity of purpose.

The following is a preliminary overview of the content of Leviticus.

D. AUTHORSHIP AND REDACTION

While Leviticus has a certain individuality and cohesion of its own it clearly cannot be fully understood and appreciated apart from its wider context. Though the storyline within Leviticus is thinly developed, and the narrative content slight, the book must be seen as integral to the story of Israel which begins in Exodus (including its prelude in Genesis), and which continues in the book of Numbers. The opening references to Moses and the Tent of Meeting (1:1) presuppose the book of Exodus, the account of the ordination of the priests and the inauguration of the cult (8:1–9:24) are events foreshadowed and prepared for in Exod. 28:1–29:46, the identity of Aaron and his sons (10:1–20) is already well established in Exod. 6:23, while various references to "the camp" (e.g. 4:12) indicate the wilderness setting (and Sinai the holy mountain in particular) as depicted in Exodus. Similarly the book envisages a continuing story. Various laws look forward to occupation of the land of Canaan (e.g. 14:34; 17:5; 18:4; 19:9–10, 23; 20:22; 25:2, 38), which also figures prominently in the climactic discourse (26:27–45). Clearly Leviticus encourages us to "read on", at least as far as the book of Joshua, with its account of the occupation.

It is widely held that the first six books of the Bible, *as we now have them*, are the work of priestly authors and/or editors (P) who lived in the sixth and/or fifth centuries BCE, in effect during the Judaean exile or shortly thereafter. In some of these books (e.g. Deuteronomy) the explicit priestly influence is minimal, in others (e.g. Exodus and Numbers) substantial, and in Leviticus total. Earlier substantial texts in the Pentateuch at large are often identified as Yahwistic (J), Elohistic (E), and Deuteronomistic (D), but these are not represented in Leviticus. The reasons for identifying a distinctively priestly influence are stylistic, linguistic, conceptual and ideological, and are well set out in older critical

works such as J. E. Carpenter and G. Harford (*Composition*, 1902) or S. R. Driver (*Introduction to the Literature of the OT*, 1913). More recent studies of the priestly literature include those of M. Noth (*History of Pentateuchal Traditions*, 1948/1981), J. G. Vink (*Date and Origin*, 1969), S. E. McEvenue (*Narrative Style*, 1971), W. Brueggemann ("Kerygma", 1972) and R. B. Coote and D. R. Ord (*In the Beginning*, 1991).

Reasons for associating the priestly writing with the exilic period can also be found in such works. There is a sense in which the whole of the Old Testament, as we have it, is the product of post-exilic Judaism. The re-establishment of cult and community in the land, under Persian auspices, gave to Judaism its distinctive character, and while the continuities are real and should not be minimized, the new social and political realities of what N. Gottwald (*Hebrew Bible*, 1985) calls "colonial Israel" must be given full weight. Within Leviticus itself there are strong indications that loss of land and of independence are not theoretically foreseen, but experienced as harsh reality (26:27–45). In what is arguably the climax of the book worship in the land has ceased (v. 31), enemies are settled in it (v. 32), and Yahweh's people are scattered (v. 33), albeit still functioning as the nucleus of a better future (vv. 44–45). Meanwhile the land experiences its sabbath rest (vv. 34, 43). Many such allusions make good sense as an interpretation of experience, rather than as disembodied prediction.

It should not be assumed, however, that critical thinking about the priestly writing, its extent, its composition, or its date, has remained static or undeveloped. Even the older criticism, strongly influenced by J. Wellhausen's perceptive research (*Prolegomena*, 1889), was alert to unevenness and a lack of uniformity within the priestly writing. It tended to offer three basic conclusions about composition and extent:

1) That the priestly writing is fundamentally a *narrative* work
 – the extensive sections of cultic law are expansions of
 the basic narrative original.
2) That it can be traced as far as the book of Joshua – from

the perspective of literary history (as opposed to canonical history) it is therefore appropriate to speak of the Hexateuch.

3) That it was originally composed *independently* of the other earlier sources, and was subsequently edited into these texts (already existing as an edited whole) by redactors.

The first of these conclusions is still widely accepted. G. von Rad's attempt (*Studies*, 1934) to disentangle parallel threads of law and narrative within the priestly writing has met with little support, and while "narrative only" theories about the original are sometimes queried (e.g. by K. Koch (*Die Priesterschift*, 1959), G. Fohrer (*Introduction to the OT*, 1970)), the basic view of a groundwork (largely narrative) and supplementary material (largely legal) is commonly held. The essentially *narrative* character of the priestly writing is strongly pressed in M. Noth's influential study of Pentateuchal traditions (*History*,1948/1981), and the basic distinction between a narrative groundwork and supplementation of various kinds is maintained by K. Elliger (*Leviticus*, 1966) in his substantial commentary.

Largely as a result of Noth's influence the second conclusion has been subject to modification. His theory that Joshua through to 2 Kings is best characterized as a *Deuteronomic history* with Deuteronomy itself as a prologue has encouraged a tendency to reduce or eliminate altogether the notion of priestly influence in Joshua. One effect is to have done with the idea of a Hexateuch, and to make Leviticus, in terms of its literary history, part of a Tetrateuch. On this view only the account of Moses' death in Deut. 34:1–12 exhibits priestly narrative beyond the book of Numbers. Furthermore, while maintaining the view that the priestly writing is a narrative work in its essential structure, Noth argued that its orientation is towards, not the occupation of the land, but Sinai. This view has the effect of suggesting that much of the supplementary material might be a supplement, not simply to the priestly writing, but to a completed form of the Pentateuch. Thus, where narrative breaks occur, between for example Exod. 40:38 and Lev. 8:1 or Lev. 10:20 and Lev. 16:1,

the intervening material (in these instances Lev. 1:1–7:38 and Lev. 11:1–15:33) may be supplementary, either to the priestly narrative, or to some recognizable form of the Pentateuch itself. Such matters are often hard to decide.

Noth's rethinking did not extend to the third basic conclusion. He remained convinced of the essential *independence* of the priestly writing as a narrative, considering it to be the literary framework used by the redactors to create the Pentateuch as a whole. A more recent study continues to make a case for the independence of the priestly writing in Genesis (J. A. Emerton, *The Priestly Writer*, 1988). There have been various scholars who have queried the notion of original independence, preferring to think of it as "commentary" on earlier traditions, (R. H. Pfeiffer, *Introduction to the OT*, 1952) or as a systematizing expansion of them (F. M. Cross, *The Priestly Work*, 1973). To the extent that this approach suggests that the earlier traditions survive complete and intact it is problematic – as Noth argued such a view is hard to sustain – but if we propose rather that the priestly writing represents the new content in a substantial revision and supplementation of earlier tradition then the need to argue for the original independence of the priestly writing and for the activity of subsequent redactors diminishes. The priestly work is thus both an expansion of and an edited revision of the existing tradition. This is essentially the perspective represented recently, among others, by R. Rendtorff (*Der Überlieferungsgeschichtliche*, 1977, *The OT: An Introduction*, 1985). If the priestly writing is thus seen, not as an independent text, but as an editorial stratum, then some of the questions about original texts and supplementation cease to be applicable. All are in a real sense part of a new unity forged out of elements from various stages in the development of the tradition. Rendtorff in this respect represents a strong modern tendency to be cautious about speculative reconstructions of the history of the various parts of the text.

Discussion about the date of the priestly writing has persisted and remains a live issue. Among those who hold the conventional view there is not in general any great concern to be narrowly specific about the period to which it belongs.

Whether it is sixth or fifth century BCE, exilic or post-exilic, it belongs to "colonial Israel", and in particular to the late Babylonian and early Persian periods. The most sustained challenge to this viewpoint has come from a succession of scholars (among them Y. Kaufmann (*The Religion of Israel*, 1961), M. Weinfeld (*Deuteronomy*, 1972), M. Haran (*Shiloh*, 1962, *Temples*, 1978), A. Hurvitz, (*Evidence*, 1974, *A Linguistic Study*, 1982)) who argue for the priority of the priestly writing over Deuteronomy, and for its pre-exilic origins in association with the Solomonic Temple, or even Shiloh. The standpoint is well represented by R. E. Friedman (*Who Wrote the Bible?*, 1988) and by J. Milgrom in his recent commentary (*Leviticus 1–16*, 1991). Many who retain the conventional perspective readily recognize, in parts of the priestly writing, some significant codification of pre-exilic practice, while doubting whether it attained its final definitive status in Israel's life until at least the time of Ezra (perhaps the second half of the fifth century BCE).

It is impossible here to develop at length and in detail a sustained enquiry into these difficult issues. A dialogue on some aspects of the question has been initiated by Rendtorff and Milgrom (*JSOT* 60 (1993) pp. 75-85). Some indication of the standpoint adopted in the commentary would nevertheless be useful, with hints as to the underlying reasoning.

The priestly writing, as we know it, has its origins in the crucial period between 539–516 BCE when the exiles in Babylon faced the prospect of return to Palestine, the rebuilding of their Temple, and the restoration of their cult. The work involved created a foundation document for the new Temple state (the role of biblical texts as foundation documents is clearly and persuasively discussed by R. B. Coote and M. P. Coote (*Power*, 1990)). It entailed the revision and expansion of existing traditions.

1) Leviticus was part of this process. To this extent the overall perspectives offered by F. M. Cross (*The Priestly Work*, 1973), seeing the narrative in particular as an expansion of previous tradition, seem plausible and acceptable. It is doubtful whether priestly writers would have wished to

construct a narrative that was wholly independent. Nor is it likely that existing written tradition would have been unavailable to them. Their method (the chronicler's treatment of the Deuteronomic history in 1/2 Chronicles may be comparable) is to develop the narrative, and to insert (probably subsequently) substantial legal and cultic material from priestly sources. The result is a new text for new times. From this perspective the theory of an independent priestly narrative (with or without some degree of legal supplementation), and which is *subsequently* edited into the earlier traditions, ceases to be applicable.

2) Despite Noth's generally persuasive arguments for a Deuteronomic history there is good reason to see at least some evidence of this revisionary priestly influence in the book of Joshua. Older critics had some good reasons for seeing the priestly writing there, and the position has been maintained more recently by such as S. Mowinckel (*Tetrateuch*, 1964), J. G. Vink (*Date and Origin*, 1969) and J. Blenkinsopp (*The Structure of P*, 1976). Recent suggestions that the priestly writers or the Deuteronomists actually created the shape of the Pentateuchal story are more questionable – a case can still be made for an earlier narrative tradition embodying a recognizable storyline and incorporating "J", "E", and other materials – but this issue has no direct bearing on Leviticus, and can be left aside.

3) To see the priestly writers as the final influence on the shape and content of the Pentateuchal books leads clearly enough to a later post-Deuteronomic date for their work. To maintain a sixth to fifth century BCE date for the priestly writing is not to deny certain differences between it and the chronicler(s), whose work may reasonably be traced to the fourth or even third century. Nor does it deny that the materials used by these writers are of varied, and in some cases ancient, vintage. That much of the technical terminology and associated practice in the priestly writing is pre-exilic, not least in Leviticus itself, is not in serious doubt. Whole sections may in essence be earlier than the late Babylonian and Persian periods.

On the other hand, some of the older arguments for substantial late elements still carry weight (set out for example by S. R. Driver (*Introduction to the Literature of the OT*, 1913), R. J. Thompson (*Moses*, 1970)). It remains likely that a number of priestly laws are post-Deuteronomic, and an exclusively Aaronite priesthood, such as the priestly writing requires, is hard to find in pre-exilic and other texts. The attempt by priestly writers to present a picture of what N. Gottwald (*Hebrew Bible*, 1985) calls "a stable cult in a stable cosmos" is readily intelligible amid the dislocations and disruptions of the colonial period. The Persians for their part were sympathetic to the re-establishment of local cults, because temples served, or could be made to serve, the interests of the existing order. J. Blenkinsopp calls them "catalysts of economic exchange and promoters of social cohesion..." ("Temple and Society", 1991, p. 26). Persian imperial control mechanisms in other aspects were also firm and effective (K. Hogland, "The Achaemenid Context", 1991).

Nevertheless, the distinctiveness of local cults provided a sense of identity and dignity for controlled peoples, and the new foundation document the priestly writers created for the community served that end. Blenkinsopp (*op. cit.*) makes the further point that as "emblems of collective identity" temples could mitigate "the inevitable resentment generated by subjection to a foreign power". D. L. Smith ("The Politics of Ezra", 1991) draws attention to a "culture of resistance" at this period, embodying a close relationship between ritual purity and social solidarity; the priestly writing in its own way contributes to this.

That priestly writers should concentrate their attention on the pre- and early settlement periods makes good sense if we associate them with the Babylonian Jews of the period. Their work is part of a much wider tendency in exilic/post-exilic literature which is anxious to affirm the authenticity of these Jews and the system they ultimately establish in and around Jerusalem under Persian auspices. To be able to affirm an identity and a cult for Israel which is prior to and independent of the Temple and possession of the land is important to their claims to authenticity. To be outside the land is no

handicap; on the contrary it follows true Mosaic precedent. While the priestly writing doubtless preserves significant elements from earlier priestly practice the absence of a Davidic theology (arguably fundamental to the pre-exilic cult at Jerusalem), and signs that this royal ideology now attaches in some measure to the person of the high priest, suggest quite strongly that the essential habitat of the priestly work *as we know it* is subsequent to the monarchy.

There remains the question as to whether Leviticus (and the other books affected by the priestly revision) has an independent identity. Are the book divisions essentially arbitrary, determined by space on scrolls, or is there some editorial purpose in the creation of the entity we know as Leviticus? It is obviously impossible to give a definitive answer to this, but it is worth establishing an overview of the priestly achievement with respect to the Sinaitic phase in the storyline. Broadly speaking, three distinct accomplishments are evident:

1) Establishing the sanctuary (Exod. 25:1–31:18; 35:1–40:38)
2) Regulating the cult (Lev. 1:1-27:34)
3) Constituting the community (Num. 1:1-10:28).

Such an overview gives to Leviticus a discrete place within the work overall, as it does also of course to Exodus and Numbers, and it may conceivably be the case that the construction of the books we recognize was not arbitrary, but a planned part of the priestly work itself.

E. SOURCES AND COMPONENT PARTS

There are signs that the first phase of the priestly writing was the narrative, a major revision and supplementation of the existing tradition. Legal materials of a cultic and ritual nature appear to have been inserted subsequently, though much of this material is probably a good deal older than the narrative itself.

The component parts of Leviticus may therefore be set out as follows:

A) The narrative thread of the priestly work can be traced in Lev. 8:1-10:20. In telling the story of the ordination of the priests, the inauguration of the cult, and the deaths of Nadab and Abihu it carries forward the storyline begun in Exodus and temporarily discontinued in Exod. 40:38. In the process the narrators evidently made substantial use of ritual material from ordination and purification rites.

B) The procedures for the Day of Atonement (Lev. 16:1-34) are difficult to assess in this respect. In vv. 1–2 evident connections are established with the narrative in chapter 10, and it is quite feasible that the priestly narrative recorded the institution of this important occasion. The literary history of the chapter is complex, however, and subsequent supplementation seems probable.

C) A large section on offerings (Lev. 1:1-7:38), to be designated the Manual of Offerings, appears to be the first major insertion into the priestly narrative. It has connectors with the storyline (e.g. Lev. 1:1; 7:38), but breaks the narrative flow between Exod. 40:38 and Lev. 8:1. Its inclusion here is prompted by the erection of the tabernacle in Exod. 40:1–38. The Manual of Offerings indicates the main rites that will take place within the tabernacle.

The Manual itself seems to consist of an amalgamation of two distinct textual entities, one containing general information for priests and people alike, covering five basic types of offering (Lev. 1:1-6:7), and the other (Lev. 6:8-7:38) containing specific information for the priests on these same offerings. The original independence of these two collections of cultic materials is suggested by the fact that material on the same sacrifices remains scattered and unintegrated (e.g. Lev. 1:1–17 and 6:8–13 on burnt offerings), by the different position that the well-being offering has in the two parts (after the grain offering in 3:1–17 and the guilt offering in 7:1–10), and by the fact that the concluding statement in 7:37 seems to have only 6:8–7:36 in its view.

It is highly probable that these two texts represent the practice of the pre-exilic Temple, and quite possible that they

already existed in written form in priestly archives prior to their incorporation into the priestly narrative.

D) Another section of text which is easily isolated on the basis of its subject matter is Lev. 11:1-15:33, to be designated the Manual of Purity. A consistent interest in uncleanness, and the processes of contamination and purification suggests that this body of material may also have had an earlier independent existence. Furthermore, there are a number of concluding statements indicating that it consists of several smaller collections of rules and guidelines (Lev. 11:46–47; 13:59; 14:54–56; 15:32–33).

Once again, the practice of the pre-exilic Temple is probably embedded in this material, and some, if not all, of the collections are probably drawn by priestly writers from priestly archives.

We may therefore suggest a process of growth involving:

1) the gathering together of smaller collections of laws and ritual material
2) the incorporation of this legal material into the priestly storyline which revises and supplements that of the earlier narrative tradition.

 The book of Leviticus is a product of this growth, albeit only part of what was an immense undertaking.

E) It has been customary in scholarship to identify Lev. 17:1–26:46 as an independent body of legal material, collected together and published somewhat earlier than the main body of the priestly work, incorporated subsequently by the priests, and designated by scholars since Klostermann ("Beiträge", 1877) as the Holiness Code (H). The process by which the Code was incorporated into the priestly writing is therefore very similar to what we have proposed for the two Manuals.

The main reasons for positing a Holiness Code can be summarized as follows:

1) It seems clear that the last verse (26:46) is the end of a

significant body of the law, despite the fact that more Sinaitic law is to follow in chapter 27 and in the book of Numbers. Moreover, Lev. 26:3–45, a sustained exhortation, with warnings and promises, to obey the law is analogous in form and content to concluding material in the Book of the Covenant (Exod. 23:20–33) and in the Deuteronomic Code (Deut. 28:1–68). In short, Lev. 26:1-46 is the conclusion to a distinct and discrete body of law.

2) The style, form, and themes of Lev. 26:3-45 are also evident in briefer passages in the preceding laws, passages which seem to function as connectors between larger sections of text. Good examples are Lev. 18:1–5; 24–30; 19:1–4; 19:36b–37; 20:22–26; 22:31–33. In all of these passages, including 26:3–45, there is a distinct editorial interest which depicts Yahweh's laws as "statutes" and "ordinances", which lays stress on the exodus as Yahweh's great act of separation, and which calls for holiness and an avoidance of all Canaanite defilements. The self-designation "I am Yahweh" is also common (18:4, 30; 19:3, 37; 20:24; 22:33). These editorial interests can also be detected in shorter phrases throughout these chapters.

The long exhortation in Lev. 26:3–46, with its promises of well-being and warnings of disaster, extends the range of stylistic, literary and conceptual phenomena. The laws can also be described as "commandments" (vv. 3, 14, 15), obedience can be defined as "walking" with Yahweh (vv. 12–13, 21, 23, 27), confession of sin is crucial (vv. 40–41), and the "covenant" with the ancestors is recollected (vv. 9, 15, 42, 44, 45). In v. 13 the exodus is presented as an act of liberation (not separation). On the other hand, the law as "statutes" or "ordinances" is common enough (vv. 3, 15, 43, 46), and also Yahweh's self-designation (vv. 13, 44, 45); though some prefer to see it as separate there seem to be no weighty reasons for detaching chapter 26 from the chapters that precede it.

3) Though some of the distinctive stylistic features are absent there are various reasons for associating chapter 17

with the Code. It is noteworthy that other codes begin with
stipulations about the place of sacrifice (Exod. 20:24–26;
Deut. 12:1–31); hence Lev. 17:1–7 seems to be following an
established pattern. It is arguable that this section is in any
case somewhat superfluous after the lengthy descriptions of
the tabernacle and the inauguration of the cult in earlier
parts of Leviticus. Similarly, the prohibitions about the
consumption of blood (Lev. 17:10–14), and the eating of
carcasses (Lev. 17:15–16) have already been explicitly
affirmed (Lev. 7:22–27; 11:39–40). For these reasons chapter
17 seems rather to belong with what follows than with what
precedes it.

4) There are various other literary and legislative features
that give to these chapters a certain distinctiveness and iden-
tity of their own. They have, for example, their own calendar
of sacred feasts in Lev. 23:1–44 (compare Num. 28:1–29:40).
There is also a marked concern to integrate social and ethical
legislation with cultic principles (notably chapters 19 and
25), in a way which is generally untypical of the priestly
writing. Special affinities with the book of Ezekiel, which the
priestly writing in general does not share, have long been
recognized (e.g. J. E. Carpenter and G. R. Harford,
Composition, 1902, pp. 269–284). Equally striking in a similar
way are the connections with Deuteronomy (probed at
length by A. Cholewinski (*Heiligkeitsgesetz*, 1976)).
If this line of argument is accepted, along with the
customary view of the origins of the priestly writing, it
becomes reasonably easy to date the Holiness Code to the late
seventh or sixth century BCE, perhaps specifically to the early
exilic period. The precise relationship with Ezekiel on the
one hand and Deuteronomy on the other remains difficult to
determine. The discussion conducted by L. E. Elliott Binns
("Some Problems", 1955) sees many parallels with
Deuteronomy but no direct dependence, and a text related
to, but somewhat earlier than Ezekiel. E. Nielsen ("Moses and
the Law", 1982) sees Deuteronomy and the Holiness Code as
virtually contemporary. That all three share, in some respects,
a common outlook is reasonably clear.

It should not be supposed that the widely accepted approach is the only available view of the material in question. It has been argued by V. Wagner ("Zur Existenz", 1974) that there was no such thing as the Holiness Code. The suggestion here is that chapters 17–26 are part of a legislative whole which begins with Exodus 25, and which is unintelligible apart from this larger context. Thus, for example, Leviticus 11–15 is to do with reparable impurity and 17–20 with irreparable. The problem with broad thematic arguments of this kind is that they may just as well be drawing attention to subsequent editorial processes as to original compositional intentions. They do not help us understand why there is a concentration of very distinct literary phenomena in chapters 17–26. Nor do they account for the differences of outlook and practice between these chapters and the larger priestly context, as identified, for example, by Elliott Binns ("Some Problems", ZAW 67, 1955).

A more recent and perhaps more challenging approach, pressed strongly in the introduction to J. Milgrom's commentary (*Leviticus 1–16*, 1991), is to see the Holiness Code as the *latest* stage in the development of the priestly writings as a whole. Those responsible for its distinctive and characteristic features are the *editors* of the earlier priestly laws.

It is certainly feasible that Lev. 26:46, and the preceding exhortation, is the conclusion to a larger body of priestly and other laws. While it is true that the stylistic and conceptual features which identify the Holiness Code are overwhelmingly concentrated in Lev. 18:1–26:46 it is not the case that they are found exclusively there. A good example of this editorial style elsewhere is Lev. 11:44-45, where there is Yahweh's customary self-designation, the insistence on holiness, and a reference to the exodus as a ground for Israel's separation (cf. Lev. 20:24b–26). Older critics sometimes found traces in other parts of the priestly writing (Exod. 6:6–8; 12:12; 31:13–14a; Lev. 5:1–4; 10:9a,10; Num. 15:37-41 – see the discussion in S. R. Driver (*Introduction to the Literature of the OT*, 1891, p. 59) and Carpenter and Harford (*Composition*, 1902, pp. 272–273)), and while there was little general agreement on the matter it seemed clear that themes

and motifs common in Lev. 17:1–26:46 were not confined absolutely to these chapters. The more recent researches of Milgrom (which include his discussions with I. Knohl) seek to demonstrate more evidence of "Holiness" editing in texts previously regarded as uniformly priestly.

It needs to be stressed, however, that even if we accept that there is evidence for a Holiness "school" of editors, who are responsible, not only for compiling the Code, but also for editing a much wider body of priestly material, it cannot be decisively shown that this is the latest and final phase in the editing process. The perspective we have suggested is in no way undermined. Having proposed that the Manuals of Offerings and Purity are feasibly pre-exilic there is no difficulty in supposing that they were subject to editing by the same scribes who produced the Holiness Code, and that in this form they were subsequently incorporated into the priestly writing. To the extent that priestly narrative exhibits these editorial characteristics, and it is hardly extensive, it may simply be the case that the priestly writing, in its turn, was influenced by the work of the Holiness "school".

It seems best to assume that the main body of chapters 17–26 (the Holiness Code), like the Manuals of Offerings and Purity, was an earlier compilation incorporated by the priestly writers into the larger body of their work. This seems to be the best explanation for the duplications (e.g. Lev. 17:10–14/7:26–27; 19:6–8/7:15–18; 20:25/chapter 11 – the examples cited by Driver (*Introduction to the Literature of the OT*, 1913, p. 48). As Driver also pointed out there are likely signs that the priestly compiler has sought to bring the laws of the Holiness Code into greater conformity with the priestly material at large. In short, there are a number of important intrusions of a systematizing kind, and characteristic of the priestly writing, within the laws of chapters 17–26 (e.g. 24:1–4).

We may conclude that Lev. 17:1–26:46 contains a miscellany of legal requirements drawn from a variety of different sources, and which we may term the Holiness Code. Exhortations calling above all for holiness, and expressing a theology of separation, serve to connect the component

parts. The enterprise has connections with Deuteronomy and Ezekiel which are extremely difficult to explain in terms of directions of dependence. Suffice it to say that, given the experience of deportation which chapter 26 seems to reflect, the Holiness Code, in its final form, probably represents work undertaken in priestly circles during the exile in the first half of the sixth century BCE. Here too the date denotes very largely the process of editing and compilation; much of the content will be older. The distinctions drawn by W. Thiel ("Erwägungen", 1969) between the priestly editing, the preaching (i.e. the "holiness" material which gives the Code its distinctive character), and the original legal material are carefully drawn, and form the basis for the approach adopted in the main body of the commentary.

F) The final chapter (Lev. 27:1–34), looks very much like a further insertion into the priestly narrative, or perhaps an appendix to Leviticus as we know it. Like most of the main sections in the book it may well be made up from different elements, but in its present form it constitutes a reasonably coherent whole on the subject of redemption and vows.

Sources and Redaction – a Working Hypothesis

There are clearly two main tendencies within the priestly work.

A) The first is *narrative*, providing a new framework for the existing narrative tradition (JE with D elements). The particular concern here, as it affects Leviticus, is to establish that not only were the priestly laws given at Sinai, but that the cult itself was inaugurated there under the control of Moses and Aaron. A sanctuary was constructed (Exod. 25:1–40:38), and the cult begun (Lev. 8:1–10:20). A particular preoccupation within this tendency is the supremacy of Aaron and his sons as priests and the subordination (albeit honourably) of the Levites as their assistants. It should not be assumed that legislative interest was totally absent, but the main concern was to locate key cultic institutions within the Mosaic period.

B) The other main tendency is *legislative*, seeking not only to locate institutions within the wilderness period, but to specify, often in detail, what was then prescribed, and what continued to be required. Material of this kind was inserted within the larger narrative tradition, possibly in three main phases:

1) Archival material from priestly sources (the Manuals of Offerings and Purity) and the Holiness Code were identified as Mosaic, and incorporated, concluding with Lev. 26:46.

2) Supplementary material which subsequent legislators wished to identify as Sinaitic were added, and incorporated between Lev. 27:1 and Num. 10:11 (the point at which the journey from Sinai begins).

3) Later additional legislative material was included (at a point perhaps when the Sinaitic material was deemed complete), but which editors felt able to associate with the subsequent wilderness wanderings, the plains of Moab prior to the settlement, or with the land itself. Deuteronomy had of course established the borders of the land as a place of law-giving.

Precision regarding the dating of the various phases is also speculative. Work on the pre-exilic archives, and the emergence of the Holiness "school", with its distinctive code of laws, is probably traceable to the exile. Work on the narrative probably belongs to the period 539–516 BCE as priestly scribes strove to create a new foundation document for the restored community, and establish the authority of the sons of Aaron. The incorporation of the first phase of legislative material was probably close to the dedication of the second Temple in 516 BCE. The remaining legislative phases followed in sequence, at points which it is hard to establish, so that the whole was complete by the time of Ezra (late fifth–early fourth century BCE).

F. FORMS AND STYLE

In general Leviticus can be characterized as legal material, but further formal distinctions can easily be made. The emergence of priestly narrative in Lev. 8:1–10:20 has already been

noted. The use of narrative for legal ends, in a way that is sometimes described as "midrashic", is also apparent in the story of the blasphemer (Lev. 24:10–23).

Among the serious form-critical enquiries into the cultic and ritual material of the book is G. von Rad's ("Faith Reckoned as Righteousness", *The Problem of the Hexateuch*, 1966) discussion of the *declaratory formulae*. These short statements, covering a wide range of situations, and in essence passing a priestly judgement upon them, are well represented in the book. Thus, for example, the declaration in Lev. 1:13 – "it is a burnt offering" – both identifies and declares acceptable the sacrifice in question. Similarly, the diagnostic statement (Lev. 13:8) – "it is leprosy" – and the subsequent pronouncement (Lev. 13:17) – "he is clean" – make essentially the same type of judgement. Sometimes the point about acceptability and effectiveness is made explicit (e.g. Lev. 1:4, 13; 19:7). Determining what should be done next might also take the form of a declaratory statement – for example, the garment is to be burned in the fire (Lev. 13:52) or the man is to be cut off from among his people (Lev. 17:4). A social context for such statements is not hard to suggest. Priestly supervision of the offerings brought by worshippers and priestly responsibility for access to the sanctuary (n.b. the way in which admission is an issue in Pss. 15, 24) are two such contexts. Furthermore, as Hagg. 2:10–13 and Zech. 7:3 suggest, questions about holiness or cultic observance could be properly addressed to priests at any time, and would presumably draw forth some form of declaratory statement.

Another approach is suggested by J. Begrich's ("Die Priesterliche", *Werden und Wesen*, 1936) distinction between priestly *teaching* and priestly *knowledge*. The perception that in a book like Leviticus there are some texts which embody matters for the priests alone and others containing material which the priests were obliged to teach the people generally is at least as old as Wellhausen (*Prolegomena*, 1885, p. 395). Begrich's work builds on this perception, identifying *teaching* with the latter and *knowledge* with the former. His interpretation of *teaching* is fairly narrow, being confined essentially to distinctions the laity would need to know between clean and

unclean conditions. Support for this sharp distinction between the two realms of priestly expertise was found in such prophetic texts as Hos. 4:6 and Mal. 2:7.

Some aspects of Begrich's thesis are dubious. Texts such as Hos. 4:1–2; 6:6; Isa. 5:13; Jer. 22:16 seem to rule out the likelihood that when the prophets spoke of *knowledge* they were thinking of information preserved privately among the priests. Nor is it necessary to confine priestly *teaching* to directives about clean/unclean conditions. Moreover, in Leviticus itself, it is remarkable that it is precisely those passages which are of special interest to the priests that are designated *teaching* (*torah* – "law" embodies the root "to teach") (e.g. Lev. 6:14, 25; 7:1, 11, 37 – rendered *ritual* by *NRSV*).

R. Rendtorff's earlier work (*Die Gesetze*, 1963) shows how it is possible to conduct a useful analysis of Leviticus, based on some of Begrich's ideas, and developing and modifying the distinction between impersonally formulated texts for the use of the priests, and those in the second person which seem to be answers to the laity in response to cultic questions. In particular, Rendtorff identified a distinct impersonal form which he described as *ritual*, and which consisted of a series of brief indications of how a particular rite was to be performed. Since its form suggests it is intended for public proclamation, and since the laity would need to know its content, Rendtorff preferred to break with the supposition that impersonal formulations necessarily denote a private body of knowledge, preserved only in priestly circles.

K. Koch (*Die Priesterschift*, 1959) readily accepted the presence of *ritual* as a distinct form, and traced it through a wider body of priestly literature. He also recognizes texts formulated in the second person as *torah* or *teaching*, much as Begrich and Rendtorff do. On the other hand he queries the appropriateness of *knowledge* as a description of the material in chapters 6–7, finding there only *teaching* and *ritual*.

Various form-critical studies have been undertaken in relation to Lev. 17:1–26:46 (e.g. K. H. Rabast (*Das apodiktische*, 1949), G. von Rad (*Studies In Deuteronomy*, 1948/1953), J. Morgenstern (*The Decalogue*, 1955), H. G. Reventlow (*Das Heiligkeitsgesetz*, 1961), R. Kilian (*Literarkritische*, 1963).

Apodictic and *casuistic* laws are well represented there, and *decalogues* may also be present. Since A. Alt's pioneering study on laws ("The Origins of Israelite Law", *Essays on OT History and Religion*, 1934/1989) it has been customary to associate apodictic law (framed in the second person) and the Decalogue form with the cult, and casuistic law (with its essentially impersonal formulations) with the administration of justice at the city gate. Some have envisaged a specific covenant festival as the social setting for apodictic law; others have spoken more generally of such law as cultic proclamation. A cultic context would also seem to be applicable to *ritual*, and those laws which embody priestly expertise in one form or another.

There remains the possibility that the search for pre-literary forms and their social settings is mistaken. What evidence is there for oral forms? Is it not likely that the texts were literary from the outset? These questions are raised, among others, in R. P. Knierim's recent study (*Text and Concept*, 1992), where he observes that stylistic criteria do not of themselves create a form or genre. The texts often characterized as ritual are not "instruction", either for priests or people, but case law about the procedures for sacrifice. This has affinities with D. W. Baker's ("Leviticus 1–7", 1987) conclusion that the laws of Leviticus 1–7 are "prescriptive ritual texts" or "reference documents". The purpose of such texts, according to Knierim, is to systematize, standardize and regularize the cult, and to integrate the sacrificial tradition at large. They are intended for future use. They may subsequently be studied and taught, but such social contexts are secondary.

It is easy to envisage major situations that would call for the literary systematization envisaged here, among them the consecration of Solomon's temple, the centralization of the cult under Josiah, and the inauguration of the cult of the second Temple in 516 BCE. There may have been others, both earlier and later. It is easy to see in a text such as Deut. 33:8–11, with its varied historical layers, how priestly responsibility was extended from oracular activity to a closer involvement with incense and the procedures of sacrifice. Such

extended responsibility would naturally call for a clear delineation of duties (priestly and lay) of the kind Leviticus offers. If the Manual of Offerings is indeed an earlier compilation than the priestly narrative (see Sources and Redaction), then the Josianic centralization of the cult might conceivably have given rise to it.

There is much to be said for this overall approach. Its effect is to generate still more caution about the specific social and cultic settings sometimes proposed for cultic literature (e.g. entrance liturgies, covenant festivals). Earlier form-critical work may continue to be useful in terms of the literary and stylistic features to which it draws attention, and in its broad suggestions about situations in life.

The commentary draws attention to three major distinctions:

1) The *ritual* and other cultic material, framed in the third person, which has its roots in priestly expertise, and which, as Knierim suggests, is a product of systematizing and regularizing concerns.
2) Short pieces of material in the second person singular, to be understood as *instruction*, and which may have as their background the teaching passed on by priests to the laity.
3) Material framed in the second person plural, the *statutes* and *judgements*, reflecting the tendency to turn laws into the law, and making rulings for specific situations into national foundation documents (law as canon).

Some of the material can be appropriately categorized as *case law*, and there are occasionally short categorical or *apodictic* collections.

G. HOLINESS

An understanding of the nature of holiness is crucial to an understanding of Leviticus. The sacrificial material in the Manual of Offerings (chapters 1–7) presupposes such an understanding, as of course do the Manual of Purity and the Holiness Code.

The basic distinctions essential to such an understanding

are set out in Lev. 10:10 where two realms, the *holy* and the *common*, are recognized. The former embodies the divine presence in a uniquely intense way; only certain persons and objects can be admitted, and they must be suitably qualified by virtue of their consecration and/or their membership of the community. In terms of priestly topography the Tent of Meeting (1:1), and all it contains, belongs to the realm of the holy. That part of the sanctuary "inside the curtain before the mercy seat" (16:2) exhibits a still greater degree of holiness. By contrast, the camp, and all that lies outside it, belongs to the common. Here, too, there are degrees of what for clarity's sake we shall call purity, primarily between the camp and what lies outside. Hence there are unclean conditions that cannot be admitted to the camp, in particular a "leprous disease" (13:46).

There is a further distinction in Lev. 10:10 between the *unclean* and the *clean*. To be admitted to the *holy* requires that the person, animal or object be *clean*. Any that are *unclean* may be tolerated within the realm of the common, but must be strictly ordered and controlled. Uncleanness therefore does not necessarily entail exclusion from the camp (12:2–5), but it does involve restriction and purification. The two main categories of impurity are considered in detail by D. P. Wright (*The Disposal of Impurity*, 1991), who calls them tolerated and prohibited. He shows, among other things, how the latter are dangerous to society, while the former are often inescapable aspects of life. The tolerated are taken seriously, Wright suggests, because they are a symbolic counterpart of the prohibited; in creating and resolving conflict or anxiety they help guard against the more dangerous evils.

There is the further topographical point that outside the camp there are specified locations, for purposes of disposal, which are *clean* (4:12) or *unclean* (14:41). The nature of the material to be dispensed with clearly determines its destination.

A detailed study by P. P. Jensen (*Graded Holiness*, 1992) shows how the various gradations can be placed within a total spectrum, in terms of their spatial, personal, ritual and temporal content. His inclination is to see the two pairs of opposites in Lev. 10:10 as akin to one another (holy/clean

against common/unclean), though not identical. The wider importance of distinction and differentiation in priestly thought is also stressed by R. B. Coote and D. R. Ord (*In the Beginning*, 1991), who note that this is precisely what the priestly view of creation entails in Genesis 1.

Scholars have worked hard to understand the origins and significance of such ideas in ancient forms of religion, and it is unlikely that any single simple historical solution can be offered (for further discussion see P. J. Budd ("Holiness and Cult", *The World of Ancient Israel*, 1989)). Cultic practice readily takes on new meanings and functions, and the processes by which this occurs are hard to unravel.

W. Robertson Smith (*Lectures*, 1889) saw, in the meticulous detail of sanctuary rules, "survivals" from very primitive religious perceptions. These perceptions attribute to sacred things a life and energy of their own, which is potentially dangerous, and which must be guarded against. Attempts to identify "primitive mentalities" in ancient religion are often deemed inherently dubious, primarily because of the presuppositional framework about "progress" and the "primitive" which tends to guide and control them. The warning is salutary, but should not inhibit an interest in the way religious perceptions change and develop.

E. Durkheim (*The Elementary Forms*, 1912) continues to be influential because of his suggestion that, as the essence of religion, ideas about holiness have a social origin; they give expression to the cohesion that societies express and require.

An influential theory about holiness has been built around the idea that we have a natural tendency to organize our experiences into opposites (the so-called binary principle), and that this helps to account for the distinctions we make between those things we affirm and those we abhor. Such systems of classification are bound to entail borderline decisions, and to generate anomalies.

M. Douglas (*Purity and Danger*, 1966) offered a pioneering interpretation of laws in Leviticus in terms of the binary principle. Convictions about "wholeness" underlie the book's understanding of "holiness", and deviation from that notion of wholeness takes us into the realm of the "unclean". She

also stressed the social function of beliefs about pollution or contamination, suggesting that they protect social systems from unpalatable or threatening realities, and strengthen confidence in the prevailing culture and its norms (*Implicit Meanings*, 1975). For Israel, notions of physical perfection are a major factor in Leviticus 11–15. Such notions obviously imply decisive boundaries, and Douglas maintains that they reflect social anxieties, which are also mirrored in concerns about a perfectly demarcated Temple and bounded land. Biological needs such as eating or procreation generate change, reprocessing and transformations. Perfection and social stability are therefore at risk, and further systems of structural avoidance and/or affirmation are necessary. She also suggested that Israel had a special abhorrence of anomaly, which might be related to the political insecurities that were a continuing feature of her historical experience.

It is possible to see also a wider social function, applicable to human experience generally, in terms of the anthropological distinction between *nature* and *culture* (M. P. Carroll, "One More Time", 1978). Culture is that which human beings create, organize and control. Nature, by contrast, is chaotic and disordered, and therefore inherently dangerous. The pollution systems, and the rites which accompany them, offer protection, and therefore a form of security. It is certainly possible to understand aspects of Leviticus 11–15 in this light, and since the processes under discussion evidently have a long and complex history it is probably wise to take account of a variety of functional models, of which these are but two. P. P. Jensen (*Graded Holiness*, 1992) categorizes them as idealist (order against anomaly) and realist (order against death).

Mary Douglas was clearly aware that social functions have political dimensions, and it is this aspect of the question that deserves further consideration. While it may well be the case that human societies need systems that help them understand and control experience, it is a matter of further interest to consider how and why such systems are exploited by power in the construction of legitimizing myths, and how, with the passage of time, alternative systems and myths, along with

redistributions of power, sometimes replace them. There is little doubt that in post-exilic times the pollution system helped to sustain the position and privileges of the priestly families within the theocratic order. It is clear too that the system developed in the pre-exilic period, thereby enabling the priests to secure their position within the community. That it helped to create in post-exilic times, by means of its distinctiveness, what D. L. Smith ("The Politics of Ezra", 1991) calls the "culture of resistance" is also very probable. Harder to assess is the extent to which pollution systems assisted people at large in their struggles for resources, recognition and influence.

Pollution systems are evidently far older than the beginnings of Israel, and the distinctive shape which the priestly writers gave to them will need to be considered in due course. In general it may be suggested that their essential background lies in the ambivalent relationship which human beings have with their environment. On the one hand there is the need to control and take advantage of the environment, on the other the need to respect and nurture it. It is precisely this ambivalence which pollution systems express, and within which, it may be suggested, they belong. The struggle for resources in difficult and hostile circumstances engenders an abhorrence of what threatens, and an anxiety to regulate and control, tendencies which seem implicit in the concept of uncleanness. At the same time profound feelings of reverence for life, and all that sustains it, may do much to engender an idea and sense of holiness, the recognition that life is God's, and that the divine domain must not be infringed and exploited. Attempts will be made in the body of the commentary to show how often holiness, and the pollution system it entails, exhibits, and seeks to foster, in its own way, a respect for the life principle.

H. SACRIFICE

It is necessary to be cautious about the history and anthropology of sacrifice, as it is about that of purity/pollution systems. Leviticus does not offer a theory of offering, whether of animals or cereal produce; it simply presupposes the practice, and prescribes for it.

With regard to the history of sacrifice in Israel it was customary to accept J. Wellhausen's view (*Prolegomena*, 1878, pp. 69–72) that the burnt and well-being offerings were the oldest sacrifices known and practised by the Israelites. It was also common to draw rather sharp distinctions between the offerings of nomadic and sedentary cultures. Central to Wellhausen's overall theory is the notion that, under priestly influence, the older "gift" and "meal" elements become metamorphosed into rites where slaughter, blood manipulation and atonement are the dominant motifs. These developments took place, in his view, in the context of a major shift from an earlier spontaneity in sacrificial worship, in which quantity and quality are the chief considerations, to the later priestly system, where conformity to statute and ordinance was the essential commitment.

There are likely to be elements of truth in this reconstruction, though as an overall explanatory theory many today would consider it oversimple (see e.g. R. J. Thompson, *Penitence*, 1963, pp. 21–47). It should certainly not be supposed, and Wellhausen did not intend that it should, that blood rites were a relatively late element in sacrificial procedures. Moreover, tendencies towards statute and ordinance are likely at the earliest periods wherever a resident priesthood in need of support is to be found. Nor should it be supposed that the spontaneous free-will offering is precluded in later laws.

Early scholarly theories about sacrifice often sought to identify the essential original element, as, for example E. B. Tylor's emphasis on *gift* or *tribute* (*Primitive Culture*, 1871) and W. Robertson Smith's focus on the *communion meal* in which clan deity and worshippers participate (*Lectures*, 1907). Robertson Smith's approach was based on an attempt to identify "survivals" in later cultic literature, and was couched in what now appears a somewhat simplistic evolutionary framework. This latter point is true also of J. G. Frazer's interesting, copious, and generalizing comparative studies (*The Golden Bough*, 1922), which often presuppose progress from magic, to religion, to science.

Robertson Smith was also well aware of the socially

cohesive function of religion (he associates the emergence of
the gift theory with the development of property relations
within Israel), an awareness which in turn provided a vantage
point from which his own theory could be criticized. H.
Hubert and M. Mauss (*Sacrifice*, 1898/1964), standing within
the tradition of Durkheim, see the unifying element in sacri-
fice, not as an idea (gift or communion), but as a *mechanism*
which establishes contact between a society's sacred and
profane worlds. The death of the victim, which makes it
sacred, is the means by which this contact is effected. A
similar stress on the liberating vitality of sacrificial death is
apparent in the investigations of E. O. James ("Origins of
Sacrifice", 1933).

Modern anthropological study has been concerned very
much with the social *function* of sacrifice, and proceeds on
the assumption that meaning can only be usefully discussed
in such a context. Since Leviticus is interested primarily in
the *practice* of sacrifice, and not with its meaning in any
abstract sense, the book lends itself to this kind of study,
though it has to be admitted, with J. W. Rogerson ("Sacrifice
in the OT", *Sacrifice*, 1980), that problems are created by the
absence of the liturgical material that presumably accompa-
nied sacrifice in Israel. According to E. Leach ("The Logic of
Sacrifice", 1985), sacrifice, and religious performance in
general, constitutes a bridge, or intermediate zone, through
which the power of the other world becomes available to
human beings. It also marks the transitions between time as
we generally experience it, and sacred time, the time of the
other world, which we experience in the cult as a whole. The
death of the victim is the crucial event. By separating the
victim's essence from its material body the bridge with the
other world is built; at the same time death is the supreme
transitional process, and as such appropriately marks the
transitions between the "times" of the two worlds.

A broader approach of a similar type is represented by D.
Davies ("An Interpretation of Sacrifice", 1977). He considers
the social role of sacrifice in the life of Israel at large. An
important emphasis here is the identification of the
sacred/profane polarity with the order/chaos polarity.

Sacredness, order and life are represented by God and Temple; the profane, chaos and death are represented by the Gentiles and the wilderness. Between these two poles, and open to the influence of both, is Israel, its camp and priests, and the world of transient existence as Israel experienced it. Sacrifice has a crucial role in keeping chaos at bay, and dealing with those things that threaten to disrupt the social life of the nation. J. H. M. Beattie ("On Understanding Sacrifice", *Sacrifice*, 1980) sees in sacrifice something similar – a manipulation of and release from different kinds of power.

Other recent studies emphasize aspects of this process in a similar way. B. J. Malina (*The New Testament World*, 1983) links the difference between sacred and profane, and the model of three zones, with the process by which objects, experiences, states and conditions are appropriated and become ours. Sacrifice takes place in the zone of transition between Israel's world and God's, and functions as the mechanism through which interaction between these worlds takes place. Malina, as does Leach, finds room here for the gift theory of sacrifice, and sees offerings as analogous to the gifts given by clients to patrons. For further information on scholarly opinion in these matters see P. J. Budd ("Holiness and Cult", *The World of Ancient Israel*, 1989).

There seems no reason why gift theory and the idea of keeping chaos and disruption at bay should not have coexisted within Israel. Whether there is real inconsistency here is debatable, and even if there is it seems probable, as R. Alter ("A New Theory of Kashrut", 1979) observes, that haphazard elements will operate side by side in any cultural system. Other issues worthy of consideration in relation to Leviticus arise out of Mary Douglas's exploration of the broad social functions of ritual in general (*Natural Symbols*, 1970). Some of these are stressed by R. B. Coote and D. R. Ord (*In the Beginning*, 1991), who show how the cult in Israel parallels the service of a lord and his court. Gifts are offered, sometimes understood as food (Ps. 50:13), tribute is paid, and favours are sought, while expiation sacrifices protect and restore (where necessary) the social order.

One can only speculate about the original rationale of

sacrifice, but the suggestions of A. Baring and J. Cashford
(*The Myth of the Goddess*, 1991) (based in part on the work of
E. Neumann) are worth taking seriously. They fit in well with
our proposals regarding holiness and pollution systems. The
tension between environmental exploitation and nurture
provides a plausible background for understanding sacrifice
and offering generally. As people exploit the earth, through
killing, digging and ploughing, the violation and disruption
entailed, and which is deeply felt, is restored by ritual means.
The violence of killing is re-enacted in the death of the
animal, but abstinence from the blood signifies a profound
respect for the life force, and acknowledges that life and all
that sustains it must be nurtured. The effect is, paradoxically,
that the shedding of blood in sacrifice comes to be under-
stood as a means by which life is renewed.

The views of W. Burkert and of R. Girard help to give more
substance to this general perspective. Both are summarized
by W. W. Hallo ("The Origins of the Sacrificial Cult", 1987).
Burkert focuses on the dangers attaching to the weapons
used in the hunt – hence the need to surround the processes
of catching and killing animals with ritualistic measures. In
pastoral and agrarian societies the killing evokes guilt –
hence the emergence of killing as a ritual act and of the cultic
recitation of myths. Girard stresses the violence entailed, and
the problems it poses for human societies. The killing of
animals in a ritual context becomes channelled violence,
violence under control in an ordered and sacred context.
The sacrificial animal defuses the violence, and helps to
break the cycles of vengeance. The emergence of judicial
systems, from Girard's perspective, is what begins to make
sacrifice obsolete. Hallo's own contribution, based in part on
new Mesopotamian evidence, stresses the fact that for Israel
blood-spilling is an offence against nature. Animal sacrifice
serves therefore to sanctify the act of meat consumption.
Hallo points out how readily sacrifice could therefore be
adapted to sanctify other human activities and to make up for
other human offences.

Why should blood be the supreme substance by which the
unseen powers are acknowledged, and the importance of

environmental nurture symbolized? The equation of blood with life seems to be a strongly Israelite emphasis (D. J. McCarthy, *The Symbolism of Blood and Sacrifice*, 1969/1973), but there can be little doubt of its universal importance in ancient cultic contexts. That the shedding of blood means loss of life is obvious enough; Nancy Jay in her anthropological studies (*Sacrifice*, 1988, *Throughout Your Generations*, 1992) has some further points to make. Noting that blood sacrifice is typical of agrarian and pastoral (not hunter-gatherer or industrial) societies, and with patrilineal descent groups, she sees sacrifice as the means by which men, who are primarily involved, can overcome their dependence on women's reproductive power, and maintain the social order whereby property descends from father to son. Sacrifice is largely a male preserve; she notes that where women do participate it is as virgins or as post-menopausal women, and *not* as mothers. She sees the question of who can participate as crucial; participation affirms and marks out those included from those excluded. Hence the priest who alone is entitled to consume the edible sin offering identifies himself as priest when he eats. The point therefore is not, as with Burkert and Girard, that sacrifice institutionalizes violence, but that it establishes intergenerational continuity between males in particular forms of society.

While it may be true that sacrifice as ritual killing is not a feature of hunter-gatherer societies, it seems likely that rites associated with the blood of hunted animals precede agrarian and pastoral modes of life. To that extent it may be appropriate to look for origins beyond the agrarian. It might also be true that the primacy of the male in hunting helps to explain patriarchy and sacrifice as an appropriate means for establishing patrilineage. Nevertheless, Jay's approach has a number of strengths which make much sense in the agrarian world to which ancient Israel belonged. It helps to explain the otherwise puzzling fact that sacrifice (the shedding of blood) has a purifying power, while childbirth and menstruation are associated with pollution. It also makes sense of the "joining" and "separating" aspects of sacrifice, the way in which it creates community and social solidarity on the one hand (commu-

nion), and separates from defilement, disease and other threats on the other (expiation). Patrilineage is affirmed, the consequences of being born of a woman are done away with.

It is reasonable to conclude that sacrifice has to do with what J. W. Rogerson and P. R. Davies (*The OT World*, 1989) identify as *intelligibility* and *survival*. One factor contributing to a belief in the realm of unseen powers is the recognition that there is much on which life depends which is outside human control. Wherever that realm, and the all-important life forces, impinge on human experience they must be respected and honoured. Ploughing and killing, as a means to survival, will therefore generate feelings of ambivalence and alienation. Ritualized killing and offering helps both to alleviate the feelings, and to acknowledge that the unseen powers are dangerous as well as life-giving, and that their dispositions may be influenced.

I. THEOLOGY

There can be little doubt that a theology of holiness is fundamental to Leviticus. Holiness denotes primarily, not moral or spiritual excellence, but that which is separate, and which belongs distinctly or exclusively to God. In terms of what human beings can see and observe it is a characteristic of particular space, time, actions, people and things. It can be threatened (by impurity and by certain human actions). It can be threatening (in the sense that God may intervene to protect and affirm it).

Its pervasiveness is evident most obviously in the Manual of Purity (Lev. 11:1–15:33), and in the editorial exhortations that bind together the various legal texts in Lev. 18:1–26:46. It is no less crucial in the Manual of Offerings (Lev. 1:1–7:38). The concepts of *atonement, acceptance* and *forgiveness* are best understood in terms of purity and pollution, and the continual insistence that animal offerings for all sacrifices must be "without blemish" is further witness to the theme. Those parts of the Manual which seem to offer special information for the priests reveal a sustained interest in contact and disposal, in the context of holiness and pollution theory (e.g. Lev. 6:10–11; 6:18; 6:26–30; 7:6; 7:15–18; 7:35).

Theology needs to be alert to the modern historical and anthropological approaches previously considered. One way of interpreting holiness, and all that accompanies it, is in terms of the human need to understand and organize experience. This necessarily creates structures which include or exclude various elements. Those excluded are inherently anomalous and threatening to the overall structure. Pollution systems patrol the margins, protecting the boundaries between what is accepted and what is not, and dealing with any doubtful cases.

Another way of understanding the issues is to focus on experiences which pose specific threats to human existence – e.g. disease and death – and which in essence lie outside human control. The emphasis here is on the contrast between nature (an inherently chaotic and uncontrolled world) and culture (that world which human beings control and find secure). Pollution systems are attempts to control such threats, and in the process to protect human society. Other phenomena which are not specifically dangerous but which lie *outside human control,* such as various forms of discharge from the human body, naturally come under the influence of the system.

Whether we see system construction as intrinsic to the human mind, or as a product of the struggle for survival, may in the last resort be a matter of no great difference. In either case the pollution system functions in much the same way as marker of the boundaries, and protector from disorder, chaos and danger. Meaning, value, and ultimately theology, emerge from this fundamental ordering process.

It is not hard to see how ritual, including offerings and sacrifices, fits into the overall pattern, since this too operates on the margins. The disordered world outside human control is inherently ambiguous, because there are potencies within it which are essential to human survival. One of the functions of ritual is to control and harness these powers by creating a world of the sacred in which space, time, rules and actions impose order on the otherwise chaotic realm of arbitrary experience. Ritual serves both to inhibit what is dangerous and channel what is necessary in the interests of those involved.

Priestly theology is built upon the conviction that the cosmos, as created by God in Genesis 1, is an ordered creation. As F. H. Gorman shows (*The Ideology of Ritual*, 1990), its component parts are separated, classified, and provided with boundaries. The priestly writers create their system of holiness and pollution on the basis of this theological conviction. It can be seen with M. Douglas ("Atonement in Leviticus", 1993/4), not as an obsession with impurity, but as "a philosophy of the universe presented in archaic form". The cultic order, and the social system it presupposes, mirrors, or perhaps even constitutes, an aspect of the cosmological order. Holiness distinctions give substance and shape to the differentiated cosmic order; ritual deals with what threatens it, and in the process sustains it. P. Weimar ("Sinai und Schöpfung", 1988) is another who has explored the connections between the priestly views of creation and Sinai; the construction of the tabernacle and the inauguration of its procedures completes, not only the creation of the Israel, but also the creation of the world.

That part of the priestly work embodied in Leviticus provides a particular focus on the theology of holiness. Fundamentally, this is a theology of separation rooted in the principles of the system, and applied to the wider themes of Israel's faith. Accordingly and characteristically the exodus is seen as a great act of separation, which necessarily entails the holiness called for by the system (Lev. 11:45; 20:24–26). The notions of the exodus as liberation (Lev. 19:34; 25:42; 26:13) and the land as fulfilment of a promise to the ancestors (Lev. 26:45) are still attested. The former is an important theme in the earlier code, the Book of the Covenant (e.g. Exod. 20:2; 22:21; 23:9), and both are prominent in Deuteronomy (e.g. Deut. 5:15; 6:10, 12, 18, 21, 23; 13:10; 15:15; 16:12; 24:18, 22; 26:7). Here in Leviticus they are worked into the pervasive idea of Yahweh as "sanctifier", the one who makes Israel separate (Lev. 20:8; 21:15, 23; 22:9, 16, 32).

This theology also uses the basic principles of the pollution system as a means of affirming Israel's separateness and distinctiveness among the nations. The Canaanites (and others) emerge consistently as the chaos figure, that which

must be excluded by the system (Lev. 18:3, 27–30; 20:23, 26). The use of "holiness" categories as a means of affirming Israel's special privilege can be found elsewhere (e.g. Exod. 19:6; Deut. 14:2; 26:19), but it is here in Leviticus that the notion receives sustained theological attention.

It needs to be recognized that this capacity to theologize from the pollution system is not peculiar to Leviticus. It can be found in various forms in Ezekiel, where it exhibits on occasions some affinity with the perspective in Leviticus – see e.g. the review of Israel's history (Ezek. 20:1–44) with its stress on the sanctity of Yahweh's name (vv. 9,14) and on his role as sanctifier of Israel (v. 12). The restoration will be a process of separation (from the nations) and purgation (vv. 33–38, cf. Ezek. 36:25). It seems clear that to the priestly mind pollution theory provided a natural framework for understanding and interpreting the disturbance and dislocation created by the experience of exile.

If the laws in Leviticus express a theology of *separation* the narrative tradition affirms primarily a theology of *divine presence*. This is in accordance with the storyline in the wider priestly tradition where the glory of Yahweh, first witnessed in the wilderness (Exod. 16:10), takes up residence in the newly constructed tabernacle, and continues to guide the journeying community (Exod. 40:34–38; Num. 9:15–23). The centralized tent of meeting (Num. 2:2. contrast Exod. 33:7 (JE)) enforces the point – Yahweh is among his people. This presence is of course a sanctifying power – the assumptions of the pollution system are still present and potent – but it is a presence which can be met, and whose indwelling within the community can be presented as a fundamental objective of the exodus (Exod. 29:43–46). Within the limited narrative section of Leviticus (Lev. 8:1–10:20) the same basic perspective is present. The glory of Yahweh, associated closely with the tent of meeting, appears to the people (Lev. 9:23), and a unique divine fire emerges from this presence (Lev. 9:24; 10:2). Here too there are affinities with Ezekiel, most obviously with the glory as an indicator of Yahweh's presence and indwelling (Ezek. 1:28; 10:4, 18–19; 11:22–23; 43:2–5).

It is also important to try to appreciate the extent to which

social and political forces interact with and exploit pollution theory, its related ritual systems and the theology that sustains and comes to expression through it. The theologies of separation and indwelling, and their associated pollution theory, lie deep in the pre-exilic Temple cult. Both are firmly fixed in the text which portrays the commissioning of Isaiah (Isa. 6:1–13), with its vision of Yahweh enthroned in the Temple, and its stress on holiness and cleansing. In terms of its social and political function the underlying theory served to validate Jerusalem as the sacred site above all other, and the political system (the Davidic monarchy) which founded and sustained its cult. In the new circumstances created by the Judaean exile this same theory serves new ends, the inter- ests and concerns of Babylonian Judaism. The motif of a separate (and purged) community in an alien environment sustains both exiles in Babylon and those who return as they seek to re-establish themselves in the land – in the face of competing perspectives and a well-rooted opposition. The related motif – divine indwelling – has the same function, authenticating this separate community as the nucleus of Yahweh's future, those among whom he is to be met.

Such theology is therefore not easily separated from the struggles for power and influence which are characteristic of all societies. In practice it is not hard to see how it contributed to the priestly theocracy which secured its position in and around Jerusalem, under Persian auspices, in the sixth century BCE onwards. While we may indeed consider pollution systems to be a fixed point there is nothing predetermined about their precise form. M. Douglas ("Atonement in Leviticus", *JSQ* 1, 1993/4) has recently argued that, at least as far as lay people are concerned, Israel's pollution system, in contrast to many, does nothing to encourage social stratification, though she recog- nizes its potential "to douse enflamed political passions", and thereby presumably to sustain and serve priestly interest. To recognize and reshape the systems that prevail may be one of theology's central tasks. Christian theology may have aban- doned aspects of the system which prevails in Leviticus, but needs to be alert to the new forms for which it is responsible.

Another consideration is the question of whether holiness

and pollution systems, along with their associated ritual and theology, are to become agents of social control, by which elite power centres maintain their privileges, or agents of social transformation in the interests of a wider human freedom.

THE MANUAL OF OFFERINGS
(1:1–7:38)

The first major element in Leviticus consists of detailed information about the five main types of offering which the priestly writers identified. It appears to consist of two *collections* – in each of which the sacrifices are dealt with in a different order:

I	II
Burnt Offerings (1:1–17)	Burnt Offerings (6:8–13)
Grain Offerings (2:1–16)	Grain Offerings (6:14–18)
Well-being Offerings (3:1–17)	Sin Offerings (6:24–30)
Sin Offerings (4:1–5:13)	Guilt Offerings (7:1–10)
Guilt Offerings (5:14–6:7)	Well-being Offerings (7:11–21)

The Ordination Offering (6:19–23) is a type of grain offering, so that the food prohibitions (7:22–27) are in effect the only textual element that appears to deviate on grounds of content from the wider context.

The contrasts between these two collections can be depicted in different ways. In (I) we have information about sacrifice for Israelites in general, whereas in (II) we are given specialized information for the priests alone. Some support for this perspective comes from Lev. 1:2; 4:2 which indicate that some or all of the surrounding laws are to be delivered to the people at large, whereas Lev. 6:9, 24 specify Aaron and his sons as recipients.

Alternatively we can see (II) as a collection of laws dealing specifically with the issue of disposal, a matter dealt with less fully in the more broadly based procedures set out in (I). After all, there are laws in (II) that are to be addressed to the

wider Israel (Lev. 7:22, 7:29). Equally there appears to be plenty of special information for priests in (I) (Lev. 1:5, 7–9, 11, 13, 15–17, etc.). To see in (II) a special concern with the matter of disposal helps to integrate the food prohibitions (Lev. 7:22–27) into the wider whole, since eating is sometimes a mode of disposal. Even in the case of the newly introduced ordination offering (Lev. 6:19–23), where special attention is indeed given to content and offering procedure, the question of disposal is the crucial culminating issue. This corresponds broadly with A. F. Rainey's (*The Order of Sacrifice*, 1970) distinction between the didactic material in 1:1–6:7 and the administrative in 6:8–7:38, though we may share R. Knierim's (*Text and Concept*, 1992) doubts about whether any of the material is properly characterized as teaching or training (see General Introduction: Forms and Style).

The essential content of both (I) and (II) can be taken as specialized priestly information, material originating within priestly circles, and preserved and propagated by them. References to "the people" indicate information the priests are required to pass on and clearly touch on issues affecting the laity – when they bring offerings (Lev. 1:2; 7:29), or when they sin (Lev. 4:2), or when their diet is the point at issue (Lev. 7:22). The overall intention of both collections is probably best understood, with R. Knierim (*Text and Concept*, 1992), as an attempt to regularize the cult, to make practice in specific aspects of offering and sacrifice conform to norms.

Each of the collections seems to consist of several independent sections. It is very probable that the repetition of the divine word to Moses (Lev. 4:1; 5:14; 6:1; 6:8; 6:19; 6:24; 7:22; 7:28) marks the beginning of new sections and is an indicator of the component parts in each collection. The first collection consists therefore of four sections and the second of five.

Collection I (Lev. 1:1–6:7)
1:1–3:17 – the burnt, grain and well-being offerings
4:1–5:13 – the sin offering
5:14–19 – the guilt offering: sins involving the sanctuary
6:1–7 – the guilt offering: sins involving neighbours

Collection II (Lev. 6:8–7:38)
6:8–18 – the burnt and grain offerings
6:19–23 – the ordination offering
6:24–7:21 – the sin, guilt and well-being offerings
7:22–27 – the food prohibitions
7:28–36 – the well-being offerings
7:37–38 – the summarizing statement

For the purposes of the commentary a simpler structure will be followed, built around:
A. The Pleasing Odour Offerings (1:1–3:17)
B. Offerings of Expiation and Forgiveness (4:1–6:7)
C. Rules for the Disposal of Offerings (6:8–7:38).

A. THE PLEASING ODOUR OFFERINGS
1. THE BURNT OFFERING
(1:1–17)

The burnt offering (1:1–17) is the first of three "pleasing odour sacrifices" or "offerings by fire", the other two being the grain offering (2:1–16), and the sacrifice of well-being (3:1–17). The prevalence of the terminology justifies the use of these titles as an organizing category for the offerings (1:9, 13, 17; 2:2, 3, 9, 10, 11, 12, 16; 3:3, 5, 9, 11, 14, 16).

Within this opening section there are four main elements:
1:1–2 – introductory material with a narrative base
1:3–9 – burnt offerings of cattle
1:10–13 – burnt offerings of sheep or goats
1:14–17 – burnt offerings of birds.

The **burnt offering** is easily found in the older narrative parts of the Pentateuch (e.g. Gen. 8:20), and in early legislative material (e.g. Exod. 20:24). It is also known to Deuteronomy (e.g. 12:6), and to the Deuteronomistic history (e.g. Josh. 8:31). It occurs in cultic texts from the Temple (e.g. Ps. 40:6), and was evidently familiar to pre-exilic prophets (e.g.

Amos 5:22). Wisdom texts also attest it (e.g. Job 1:5).

In earlier sources the burnt offering is often accompanied by sacrifices of well-being (e.g. Exod. 20:24), or simply "sacrifices" (*NRSV*) (e.g. Exod. 10:25), with the well-being offering perhaps to be assumed. In some texts there are also associations with the grain offering (1 Kgs 8:64). There is a possible connection with the sin offering (Ps. 40:6), and more clearly with vows (Ps. 66:13), though the age of these texts is unknown.

The burnt offering is distinguished primarily by the fact that the victim is wholly burnt, or virtually so. In the pre-priestly texts creatures suitable as burnt offerings are birds (Gen. 8:20), cattle (Exod. 10:25–26), sheep (1 Sam. 7:9), and goats (Jdg. 13:16), and in some instances human beings (Jdg. 11:31).

The circumstances which prompt the offering are very varied, and do not seem to follow any fixed pattern (W. B. Stevenson, "Hebrew Olah", 1950). It was certainly appropriate for a variety of special occasions, and not least the inauguration of new altars and new cult sites (e.g. Exod. 24:5). It would appear that times of thankfulness (e.g. Gen. 8:20) and times of crisis (e.g. Jdg. 20:26) were equally appropriate as occasions for the offering. In some of the texts the expiation of sin seems to be a factor (e.g. Jdg. 20:26). Other texts prior to the priestly writing point to the incorporation of the burnt offering into the regular rites of the Temple (e.g. 1 Kgs 9:25). Its use in private contexts is indicated by texts such as Jdg. 11:31.

These very varied circumstances suggest a need for caution about attempts to specify the "meaning" of the burnt offering. It evidently honours and acknowledges God, and in some contexts may have been intended to attract his attention. This would explain the fact that the creature is wholly burnt. The "pleasing odour" terminology also suggests attention-seeking and a desire to please. The burnt offering often appears first in lists of sacrifices, and this too may signify recognition of the deity and the granting of honour. The idea that the burnt offering is costly to the donor (e.g. 2 Sam. 24:24) suggests that the sacrifice is probably in some sense a gift.

The burnt offering, along with the well-being offering, were probably among the oldest sacrifices practised by the Israelites. The proposal (L. Rost, *Studien*, *BWANT* 13, 1981), based on texts in Jdg. 6:19–24; 13:15–20, and suggesting that it was actually a transformation of the grain offering, is less certain. It is perfectly clear that burnt offerings could be offered to deities other than Yahweh (e.g. 2 Kgs 3:27), and it is reasonable to suppose that they were common among the Palestinian peoples at large. The burnt offering is not immediately obvious in existing Canaanite texts, though it has been suggested that the Keret sacrifice was a holocaust (A. de Gugliemo, "Sacrifice", *CBQ* 17, 1955), and it is possible that *srp* sacrifices were whole burnt offerings (J. Gray, "The Religion of Canaan", 1965). According to W. Zwickel (*Räucherkult*, 1990), the burnt offering can be traced in Mesopotamia and Egypt as far back as the third millenium BCE.

The completion of the Temple, and the institution of a royal burnt offering (2 Kgs 16:13), possibly during the reign of Ahaz (W. Zwickel, *Räucherkult*, 1990), enhanced its status. According to J. Milgrom ("The Two Pericopes", 1983) it may originally have been the only public sacrifice. As others were added to the royal cult they were made to conform perhaps to the general pattern of the burnt offering. The centralization of the cult under Josiah weakened the connection between sacrifice and ordinary life (eating meals), and this may have further enhanced a sacrifice in which God has everything. It is certainly prominent in the restored cult as envisaged in Ezekiel 40–48 (e.g. Ezek. 40:38), and plays a major part in all the main rites described there.

In the priestly literature the burnt offering is clearly separate from the sacrifice of well-being. It also stands out as the first sacrifice for consideration in both main collections in Lev. 1:1–7:38 (i.e. in 1:1–17 and 6:8–13). The emphasis on the blood rites of the burnt offering and on atonement, practices and ideas which connect to processes of purification, are probably to be traced to the influence of Temple and priest. The possibility of the burnt offering as a private rite is now reaffirmed, but it continues to have a major place in

public events. In addition to the daily sacrifices (Num. 28:6), it has a role in the consecration of priests (Lev. 8–9) and in the Day of Atonement rituals (Lev. 16). In the latest texts substances such as flour, wine, oil and incense can be found as accompaniments to the offering (Num. 15:3–16; 28:5–7; Sir. 50:14–15) (a full discussion is provided by W. B. Stevenson, "Hebrew Olah", 1950).

1. The opening sentences of the book set the scene, identifying **the tent of meeting** as the place where the laws are given and received. Canaanite texts indicate that the god El was thought to live in a tent, and this may point to the source of the idea in Israel (R. J. Clifford, "The Tent of El", *CBQ* 33, 1971). The tent as conceived by the priestly writers has its roots in the old narrative tradition (Exod. 33:7), which locates it outside the camp. Priestly thought identifies it with the tabernacle, the construction of which is commanded in Exod. 26:1–37, and carried out in Exod. 36:8–38. That these institutions are one and the same is indicated by Exod. 39:32; 40:2, 6. The word **meeting** makes it clear that this is the place where Israel seeks Yahweh, and where Yahweh confronts and communicates with his people.

It is not difficult to suggest reasons why the priestly writers of the early post-exilic period would wish to describe a tent (not a temple) cult. Their task after all is to revise the ancient traditions, while the circumstances of exile made the thought of a mobile cult attractive. A possibility raised by R. B. Coote and D. R. Ord (*In the Beginning*, 1991) is that the cult between 539 BCE and the building of the second Temple was in fact a tent cult.

It is customary in these sacrificial laws for **Moses** to be identified as the primary recipient of Yahweh's instructions. In some of the laws dealing with ritual purity, where priests had long had a major responsibility, Aaron is linked with Moses as co-recipient (Lev. 11:1; 13:1; 15:1). This privilege is found elsewhere in the priestly writing (Num. 2:1; 4:1; 18:1, 8; 19:1; 26:1), though Moses continues as supreme mediator.

2. The **offering** is a general term for all oblations; it has connections with the verb "to approach", and the offerings to

be described are "brought near" or "presented" to the deity. The **livestock** (*NRSV*) is preferable to "cattle" (*RSV*), signifying all domestic animals, of which **herd** and **flock** are different types.

3. The root rendered **burnt offering** ("whole offering" (*REB*)) also gives the verb "to go up". This is a useful reminder that in the burnt offering the whole of the sacrifice "goes up" to God as a "pleasing odour" (the skin remains the property of the priest – Lev. 7:8). The insistence on **unblemished** offerings is typical of these laws (Lev.1:10; 3:1, 6; 4:3, 23, 28, 32; 5:15, 18; 6:6) and of priestly attitudes in general. It was also a major concern of the prophet Malachi (e.g. 1:8).

Since there were circumstances which required a female animal (Lev. 4:28, 32) it is not the case that a **male** was necessary for a perfect offering. The value of females as mothers could have meant they were deemed a more costly offering (A. T. Chapman and A. W. Streane, *The Book of Leviticus,* 1914).

The **entrance** (better than "door" (*RSV*)) of the tent of meeting is cited only occasionally in these sacrificial rites (Lev. 3:2; 4:4), but it is clearly a key location where much activity takes place in connection with the altar situated there (Exod. 38:1–7; 40:6; Lev. 1:5; 4:18). It may signify the zone between the entrance to the court and the altar, or perhaps the court area as a whole (J. Milgrom, *Leviticus 1–16,* 1991).

The terminology of acceptance – **for acceptance in your behalf** – gives some insight into motivation and purpose. It is a feature of the offerings by fire, but not the expiation sacrifices. *NJB* understands it to mean making the offering acceptable to Yahweh. It is certainly feasible that the term derives ultimately from priestly words of approval about the content and quality of the offering, but in honouring the deity in this way the offerer himself doubtless sought acceptance – recognition, confirmation of his aspirations, and of his well-being in general. B. A. Levine (*Leviticus,* 1989) suggests that it counts in his favour, and is accredited to him; J. E. Hartley (*Leviticus,* 1992) stresses its efficacy. J. Milgrom (*Leviticus 1–16,* 1991) points out that the offerer is being required to take responsibility for the suitability of the offering, that it is in fact without blemish. A discussion of acceptance terminology, and its

place in priestly theology is provided by R. Rendtorff (*Studien*, 1967, pp. 250–260).

4. The imposition of hands (hand leaning with one hand – J.Milgrom (*Leviticus 1–16*, 1991)) has attracted discussion with regard both to its meaning and to the origin of the practice. It is clearly a basic feature of animal sacrifices (Lev. 3:2, 8, 13; 4:4, 15, 24, 29, 33), but does not apply apparently to grain offerings. It could perhaps be taken for granted in vv. 10–17 (burnt offerings of sheep, goats and birds), but the failure to cite it specifically there suggests that it may be an intrusion here in v. 4, and that it belonged originally to either the well-being offering or the sin offering (R. Rendtorff, *Studien*, 1967, pp. 89–115 thinks the latter possible). It is surprising nevertheless that priests who were presumably meticulous about such matters should unthinkingly or inadvertently omit it from vv. 10–17, and other explanations are preferable.

There are certainly texts where some kind of transference theory is plausible (e.g. Lev. 16:21; Num. 27:23), though sin is not necessarily the thing transferred. If originally the imposition of hands had something to do with the transference of pollution there would be good reason for tracing the rite to expiation sacrifices, such as the sin offering (it is absent from the guilt offering). It is possible, however, that the two-handed action of Lev. 16:21 signifies transference (R. Péter, "L'imposition", 1977; J. Milgrom, *Leviticus 1–16*, 1991), and that the one-handed rite here denotes some form of identification. This might signify the worshipper's ownership of the victim; ownership would be obvious for offerings brought by hand, but not so for animals, some of which would have been bought from temple stock (J. Milgrom, *Leviticus 1–16*, 1991). Alternatively, a symbolic identification with death would make sense of the special association with animals (B. Janowski, *Sühne*, 1982, pp. 199–221), though there is little explicit support from other texts. The suggestion that the offerer transfers his person, and that the animal becomes his substitute (M. Noth, *Leviticus*, 1962/1965) in its death has the same problem. The idea that the imposition of hands dedicates or "sets apart" seems clear in Num. 8:10, and would make good sense in Num. 27:23, and B. A. Levine

(*Leviticus*, 1989) accepts this, insisting that the rite marks the victim as God's, and indicates that it can be used for no other purpose.

It has to be recognized that ancient rites readily accumulate a range of meanings, which historians find it difficult to penetrate. Levine's proposal is attractive on the basis of other texts, and it could be that the imposition of the hand on larger animals was felt to be necessary as a "point of no return". No second thoughts could now be entertained or substitution envisaged. Concessions in these matters could be made in relation to smaller animals for burnt offerings, birds, grain offerings, and substitute coins for a guilt offering.

The reference to **atonement** ("expiation" (*REB, NJB*)) is unusual among the offerings by fire (but see a connection with burnt offerings in 14:20; 16:24), and is best discussed in relation to the expiation sacrifices (see Lev. 4:20). Its appearance here may reflect a systematizing tendency according to which the sacrificial system as a whole has the power to atone.

5. The verb **slaughter** (or "butcher"/"slit the throat" – H. C. Brichto, "On Slaughter and Sacrifice", *HUCA* 47, 1976) has strong ritual connotations (discussed also by J. Milgrom, "Profane Slaughter", 1976). In Gk a plural is used, indicating presumably that this is the task of **Aaron's sons the priests** (references to Aaronites are probably an influence from the priestly narrators – see the General Introduction).

The word **bull** denotes a young animal; the probable intention is that it should be a year old (Lev. 9:3). The text suggests that it is the offerer's task to kill the animal. The priests first appear as those who manipulate the blood, and here they have two specific tasks.

One is to **offer** it. The word used has the same root as the **offering** (v. 2), and probably implies some ritual gesture or action which brings the blood near to Yahweh.

The second task involves **dashing** the blood against the altar which stands at the door of the tent of meeting. The word is widely used in cultic contexts such as this, normally in relation to blood; it also has associations with water (Ezek.

36:25), ashes (Exod. 9:8), seed (Isa. 28:25), and burning coals (Ezek. 10:2). The inadequacy of older translations such as "sprinkle" (preserved by *NIV*) is discussed by N. H. Snaith ("The Sprinkling of Blood", *ExpT* 82, 1970/1971); something more dramatic and decisive is required (*REB*'s "fling" is preferable to *NJB*'s "pour it all around"). It may be that these blood rites are not original features of the burnt offering (K. Koch, *Die Priesterschrift*, 1959, pp. 46–49; R. Rendtorff, *Studien*, 1967, pp. 89–115). Do they come from the well-being offering or the sin offering? There is certainly a degree of unevenness in vv. 5–9 as a whole, suggestive of textual adaptations. If the blood rites are an intrusion they probably originate with the well-being offering (see e.g. Exod. 24:5–6; 2 Kgs 16:13, 15; Lev. 17:5–6 where throwing the blood of the peace offering is required). The manipulation of blood in the processes of purification is intrinsically different (cf. e.g. Lev. 4:7).

6. The text returns to the third person singular (see *REB*, *NJB*). Is this the offerer again, or did the original text of vv. 5–6 indicate "the priest" as subject (as in v. 9 and possibly v. 7)? Since possession of the skin is a priestly right (Lev. 7:8) it could be the priest, but v. 12 suggests the offerer. Both Gk and Sam. resolve the issue by using a plural verb, thereby identifying **Aaron's sons** as subject. The cutting up of the animal obviously facilitates the burning process.

7. The singular form **the priest** (contrast vv. 5, 8) may have been the original subject of the procedures in question.

8. It is likely that at an early stage in the history of Israel's cult priests at sanctuaries would have taken responsibility for the altar and its fire, and also for the placing of the sacrificial pieces upon the altar. A distinction needs to be made between the fat referred to here and that which figures in the well-being offering (e.g. Lev. 3:3–4) – hence **suet**. The word used here occurs again in Lev. 1:12; 8:20.

9. The return to singular forms of the verb in v. 9, with **the priest** as subject, is a further hint that the **sons of Aaron** elements are an accretion. Sam. (for the washing) and Gk (for the washing and burning) again smooth out the unevenness with plural verbs. The significance attaching to the

washing of **entrails** and **legs** (*REB/NJB* – "shins") is obscure. The root is commonly used in Leviticus of ritual washings (1:13; 8:6, 21; 9:14; 14:8, 9; 15:16; 16:4, 24; 22:6) and in priestly writing generally.

The description of this sacrifice as an **offering by fire** is problematic. The word can denote baked cakes (Lev. 2:10), flour (Lev. 23:13), and the bread of the presence (Lev. 24:9). It is particularly associated with the sacrifices described in Lev. 1:1–3:17 (see also 1:13, 17; 2:2, 3, 9, 10, 11, 16; 3:3, 5, 9, 11, 14, 16) and often occurs, as here, in close connection with the pleasing odour terminology (1:13, 17; 2:2, 9; 3:5, 16). J. Gray ("The Religion of Canaan", *The Legacy of Canaan*, 1965) thinks that the word occurs in Canaanite sources meaning "gift", and without particular sacrificial associations. W. B. Stevenson ("Hebrew Olah", 1950) thinks it a word, like **offerings**, applicable to sacrifice in general. *REB* renders it more specifically as "food offering", and *NJB* as "food burnt". J. Milgrom (*Leviticus 1–16*, 1991) and J. E. Hartley (*Leviticus*, 1992) both prefer "gift" terminology; J. R. Porter (*Leviticus*, 1976) suspects that the compilers understood it to be a fire offering. J. Hoftijzer ("Das sogenannte", 1967) plausibly proposes that the term is applicable to offerings that go directly to God (by being burnt) or to the priests (who represent God) as food. The contrast here would be with those parts of some offerings that are consumed by worshippers.

In a pre-priestly text (Gen. 8:21) Noah's burnt offering is a **pleasing odour**, and it seems likely that the term has its roots in this particular sacrifice. In the priestly writing in general, the phrase is characteristically applied to burnt, grain and well-being offerings. Its isolated occurrence among the purification/expiation offerings (Lev. 4:31) is in association with the burning of fat, a special feature of the well-being offering. For the priestly writers it is clearly traditional cultic language. It was probably understood to express God's pleasure that the requirements of the sacrifice have been met, and his acceptance of it (P. A. H. de Boer, "An Aspect of Sacrifice", *Studies in the Religion of Ancient Israel*, 1972, pp. 37–47). Appeasement (*JB*) is not necessarily implied. Older

ideas of sacrifice as food for the god may lie behind the terminology.

In vv. 10–13 the text deals with burnt offerings which come from the flocks – whether of sheep or goats. Much of the content of vv. 1–9 is repeated, with the additional information that the slaughter of the victim is to take place on **the north side** of the altar (v. 11). Significant omissions are the acceptance and atonement phrases, the imposition of the hand, the presentation of the blood, and the skinning of the victim.

10. The word rendered **gift** is the same as the **offering** (v. 2), and does not therefore provide any new insight into how burnt offerings are to be understood.

11. The precise reference to the **north side** of the altar is probably to be taken for granted in relation to cattle (v. 5); there is no obvious reason why it should apply only to the flocks. This location is clearly specified in texts which deal with the sin offering (Lev. 4:24, 33; 6:25) and the guilt offering (Lev 7:2; 14:13).

The priests must be **Aaron's sons**; the probable original form **the priest** is retained thereafter in Heb. In Gk the priests are responsible for the slaughter (as in v. 5) and the dissection (Sam. supports the latter), and plural verbs are also used in relation to the placing of the pieces (cf. Vg) and the washing of the entrails (cf. Sam.).

It is natural to ask why certain elements are omitted here in what are apparently meticulously systematic texts. It is possible that some are to be taken for granted, but the natural home of **atonement** language may very well be the expiation sacrifices (see Lev. 1:4). The acceptance terminology is closely connected there with atonement, though its origins may be traced to the pleasing odour sacrifices, and perhaps specifically the declaratory formula pronounced by the priest (1:13). The imposition of the hand is to be traced perhaps to the well-being offering (see Lev. 1:4). The presentation of the blood is implied in the throwing of the blood, the crucial rite (v. 11). The skinning of victims from the herds is important (v. 6) because the skins belong to the

priests (Lev. 7:8); there is no such value in those from the flocks.

In vv. 14–17 the text deals with burnt offerings of birds, sacrifices that less wealthy people could make. The main elements of the rite (presentation–slaughter–disposal of blood-disposal of flesh) remain, and the flesh of the victim, as previously, is consumed by fire. The differences arise mainly from the fact that the offering is a bird, but the rite in general is described in a less systematic fashion. As in vv. 10–13 acceptance and atonement phraseology is omitted, and there is no imposition of the hand.

14. The suitability of **turtledoves** (v. 14) for sacrificial purposes is apparent in a pre-priestly text (Gen. 15:9). The word used here for **pigeons** is different. Together the two words may be intended to cover all the various species of pigeon that could be found.

15. The slaughter in this instance is the responsibility of the priest, perhaps because a specific technique is required (the wringing off of the head), and a statement of the disposal of the flesh by the priest on the altar follows at once. It would be possible to view vv. 14–15a as a brief but complete ritual. The remaining requirements (vv. 15b–17) elaborate and add to the basic rite.

The first of these further requirements expresses a concern about the disposal of the blood (v. 15b). This must, as with other burnt offerings, be applied to the altar, though the quantity involved makes it appropriate that it should be **drained**.

16. A second additional requirement is that prior to the burning the **crop** and **its contents** (see also *REB*) be removed and disposed of on **the east side** of the altar, among the altar ashes. The second word is particularly problematic, and is rendered "feathers" by *RSV* and *NJB*. A sustained discussion is provided by H. P. Rüger ("Dann entfernt", *Wort und Geschichte*, 1973). It appears that, since burnt offerings are essentially offerings of flesh, certain items must be removed. It is possible that these items are equivalent to the **entrails** in other animals (Lev. 1:9, 13), and that in birds they were

deemed too small to be washed (J. Milgrom, *Leviticus 1–16*, 1991).

17. The third additional requirement seems to be that no dissection of the bird must take place; it must be offered as a whole. A tearing of the bird by holding the wings is required, perhaps to facilitate the sacrificial procedures, or to provide something comparable to the cutting in vv. 6, 12. *NJB* does envisage a splitting of the bird into halves, but not a final dissection of the two parts.

The provision of procedures whereby poorer people may take part in the burnt offering rites is an important aspect of priestly legislation (see also Lev. 5:7, 11). For individuals, offerings of this kind would primarily be free will or votive offerings. Such provision can be viewed in different ways. It can be seen as an attempt to affirm the cohesiveness and interdependence of society, that all have something to contribute, and to indicate that Yahweh attaches value to all, whatever their economic status. Alternatively, it may be seen as confirming inequalities, and as an extension of priestly control to all sectors of society.

In retrospect it is of interest to identify the various procedural phases which constitute the structure of the rite in its final form. There are clearly four distinct elements in the ritual process:

1) *Presentation* (vv. 3–4) – the victim is specified, brought to the door of the tent, the hand may be imposed, and the victim is accepted.
2) *Slaughter* (v. 5) – the victim is killed before Yahweh.
3) *Disposal of Blood* (v. 5) – the priest throws the blood against the altar of burnt offering.
4) *Disposal of Flesh* (vv. 6–9) – the skinning and dissection of the victim, the washing of the entrails, the burning of the pieces.

The offerer is the primary actor in the first two phases, the priest in the last two.

It is also important to understand the ritual process within

the context of the cultic topography of Leviticus, which itself reflects a structured world in which the holy and the profane, the clean and the unclean, have their own distinct realms. In approaching Yahweh the offerer is clearly occupying the boundary area (the court of the tent) between the habitation (the camp) and the holy place (the tent sanctuary). The slaughter of an animal and the disposal of its flesh in the form of an offering is a recognition of that boundary and therefore an honouring of the deity whose sanctuary it is; this is rationale enough for the sacrifice. The distinct mode by which the blood is disposed of is likewise an act of recognition. Blood belongs to the realm of the holy. Its presence in the habitation and beyond is an example of how the sacred penetrates the realm of the common and unclean. To throw it against the altar is to recognize its origins and sacred character, and to return it whence it came. The divine order is thereby maintained, the life principle is affirmed in the context of death, and the well-being of the community is preserved.

2. THE GRAIN OFFERING
(2:1–16)

The main elements are as follows:

2:1–3 – grain offerings of flour
2:4–10 – baked grain offerings
2:11–13 – accompaniments to grain offerings
2:14–16 – grain offerings from the first fruits.

The **grain offering** is well represented in early narrative (e.g. Gen. 4:3–5) and prophetic sources (e.g. Isa. 1:13). It is also cited in some psalms (e.g. Ps. 20:3). The word can be used of gifts in general (e.g. Gen. 32:13), particularly those offered to kings (e.g. Jdg. 3:15). The relationship between tribute of this kind and offerings to gods is clarified by G. A. Anderson (*Sacrifices and Offerings*, 1987, pp. 57–75).

In a number of instances the grain offering is cited in close association with other offerings, often the burnt offering (e.g. Jdg. 13:19), and in some cases the well-being offering

(e.g. 1 Sam. 2:29) (often translated "sacrifice"). Other texts attest its independence (e.g. Jdg. 6:18).

The fact that Abel's offering from the flock is so called (Gen. 4:3–5) means that "grain offering" is not always appropriate. The general context in 1 Sam. 2:17 also indicates that meat is in mind (vv. 13–16). Thus in a number of other cases *NRSV* prefers generalized translations such as "offering" (1 Sam. 2:29) or "sacrifice" (2 Kgs 3:20) or "oblation" (1 Kgs 18:29).

There is enough precision in a number of instances to suggest that cereal produce was indeed an important component in offerings from earliest times. In Jdg. 6:18 it clearly includes the unleavened cakes made from an ephah of flour (v. 19), though it seems likely that the kid and the broth are also part of the "present". It is in Jdg. 13:19, 23 that a sharper distinction is made between the animal sacrifice (a burnt offering) and the grain offering (content unspecified).

The circumstances that prompt a grain offering are not very precisely delineated. Apart from a general concern in many texts to honour God and to be accepted and favoured by him, divine visitations call for a grain offering (Jdg. 6:18; 13:19). That it might also be involved with the expiation of sin, in particular with priestly errors, is suggested by 1 Sam. 3:14, and with appeasement generally by 1 Sam. 26:19. At sanctuaries the offering evidently became a fixed procedure at a relatively early stage. A time for making it – morning and/or evening – is indicated by several texts (1 Kgs 18:29, 36; 2 Kgs 3:20; 16:15; Ps. 141:2). Other texts, probably of Deuteronomistic origin, list it as an institution of the Temple, along with other offerings, in a fashion which begins to resemble that of the priestly literature (e.g. 1 Kgs 8:64). A royal grain offering is indicated by 2 Kgs 16:13.

Historically, the more generalized cultic meanings (offering/oblation) could readily have co-existed with the specialized meaning "grain offering". The antiquity of cereal produce as an offering is not in doubt. The first fruits (Exod. 23:19) and the great agricultural festivals (Exod. 23:14–17) are ancient institutions. Voluntary offerings of cereal produce are also evident (e.g. 1 Sam. 1:24). Unleavened

offerings were customary (Exod. 23:18; 34:25), though Amos 4:5 attests the use of leaven at some sanctuaries. It is equally clear that at sanctuaries "holy bread" or "the bread of the Presence" was regularly offered and replaced (1 Sam. 21:6). There is reasonably clear evidence among the Canaanites of meal offerings taken from the threshing floor, along with references to wine, oil and other produce for "the house of El" (J. Gray, "The Religion of Canaan", 1965). That such offerings were widespread in the ancient world is highly probable, and is confirmed by an interesting analysis of two descriptive rituals from Ur where references to a number of the terms found in Lev. 2:4 are likely (B. A. Levine and W. W. Hallo, "Offerings", 1967).

In the priestly literature there is a marked tendency to supplement burnt offerings with grain offerings, notably in Lev. 23:12–13; Num. 8:8; 15:1–10, 24; 28:1–29:40, where each burnt offering has its own. The incorporation of wine offerings in some of these rites is also evident. These grain offerings consist essentially of fine flour in varying quantities.

It is hard to know whether this kind of association is ancient and original. Some kind of supplementary relationship is suggested by Jdg. 13:19, and by the unleavened accompaniments to sacrifices in general (Exod. 23:18; 34:25). It seems to obtain too with the grain offerings in Ezek. 45:24; 46:5, 7, 14–15. Other priestly texts keep the offerings clearly distinct (Exod. 40:29; Lev. 1:1–2:16; 14:10, 20), while some, such as "the grain offering of jealousy" in Num. 5:15 clearly have their own identity. The grain offerings of the people (e.g. 2 Kgs 16:15) and of the king (e.g. 1 Kgs 8:64; 2 Kgs 16:13, 15) are likewise clearly distinct.

Some conclusions about the grain offering can be reasonably drawn:

1) That from earliest times it was customary to offer cereal accompaniments to animal sacrifices – reflected still in the priestly tendency to associate the grain offering closely with animal sacrifices and in some cases to subordinate it to them.
2) That the stipulations in Exod. 23:18; 34:25 represent the

earliest moves to regulate these accompaniments,
precluding the use of leaven.

3) That special gifts of cereal produce, now attested mainly
in the priestly literature, were customary at local
sanctuaries.

4) That the pre-exilic Temple was influential in standard-
izing the varied practice and usage of the local
sanctuaries, in introducing the daily and the royal grain
offerings, and in contributing to the development of the
offering as it now appears in Leviticus.

These opening verses (vv. 1–3) deal with grain offerings
consisting of flour. Oil and frankincense are to be added.
The priest is to take a handful and burn it on the altar,
thereby making of it a pleasing odour like the burnt offering.
The remainder, however, is an entitlement of the priests.

1. The **grain offering** ("oblation" – *JB*) is primarily a gift.
The **choice flour** ("semolina" – J. Milgrom, *Leviticus 1–16*,
1991) specified here occurs commonly in law of this kind
(e.g. Lev. 5:11; 6:20; 7:12; 14:10, 21; 23:13, 17; 24:5; Num.
6:15; 7:13; 8:8). That it had normal domestic uses is
suggested by some texts (e.g. 2 Kgs 7:1; Ezek. 16:13).

The **oil** ("wine" – *NJB*) is presumably olive oil. In priestly
usage it has several other functions. It is required for the
sanctuary lights (Lev. 24:2) and is a component in the oil for
the anointing of priests (Exod. 30:22–25). The cultic pouring
of oil is also evident in Canaanite texts (see A. de Gugliemo,
"Sacrifice", *CBQ* 17, 1955), and in early narratives where
stones (Gen. 28:18; 35:14) are anointed in this way. Objects,
persons or offerings become holy, set apart for special
purposes.

The **frankincense** (a fragrant gum resin – H. F. Beck,
IDB:II, pp. 324–325) has a similar function. It had uses else-
where (e.g. Song 3:6), but was clearly favoured for cultic
purposes, and its use sometimes criticized by the prophets
(e.g. Isa. 43:23; 60:6; Jer. 6:20). It is not to be confused with
the holy incense, of which it is just one component (Exod.
30:34). It is associated elsewhere in Leviticus with grain offer-
ings (Lev. 6:15) and in Lev. 24:7 with the holy bread. Two

priestly texts preclude its use (along with the oil) in situations where grain offerings are rites involving sin and purification (Lev. 5:11; Num. 5:15). This may confirm the suspicion that the addition of oil and frankincense identifies the flour as a grain offering and sets it apart as God's. They have a dedicatory rather than a purificatory function. The process is akin perhaps to the imposition of the hand in burnt offerings.

2. As in the burnt offering rites the latest form of the text reveals a concern to stress at the first opportunity that priests are **Aaron's sons** (v. 2). The original subject **the priest** with singular verbs obtains in the rest of the verse. Lev. 2:9 makes it clear that it is the priest, not the offerer, who takes the handful.

This handful is described as a **token portion** ("memorial portion" – *RSV, NIV*; "token" – *REB, GNB*; "as a memorial" – *NJB*). The word is not widely used, and is normally found in contexts such as this. The holy bread and the frankincense placed with it can also be so described (Lev. 24:7). Translations embodying "memorial" presuppose a connection with the verb "to remember"; the natural supposition here would be that the bread, the frankincense, and this selected part of the grain offering bring the worshipper, his thoughts, feelings and needs, to God's attention and remembrance. It is probably preferable to highlight the fact that the handful is a representative sample or substitute for the whole offering – hence **token** (G. R. Driver, "Three Technical Terms", 1956; B. A. Levine, *In the Presence of the Lord*, 1974). God is pleased to remit the rest for consumption by the priests. The action is akin in some respects to the slaughter of animals before Yahweh. The burning process evidently links the grain offering with the burnt offering as **offering by fire** and **pleasing odour** (see on 1:9).

3. It is obvious that the rest of the offering can only be disposed of in a way which is consonant with its holy status; it becomes the property of the priest, described here as **Aaron and his sons**. As B. A. Levine (*Leviticus*, 1989) points out, the offerings must be consumed both in the proper place and in a proper time span if they are to be effective.

The phrase **most holy**, when used with the definite article,

denotes the holy of holies, the inner sanctum within the tent (e.g. Exod. 26:33). Objects within this sanctum, such as the incense altar and its incense, also have this status (Exod. 30:10, 36). So too does the altar of burnt offering in the courtyard of the tabernacle, especially perhaps at its consecration and during the rites of priestly ordination (Exod. 29:37; 40:10). Indeed the implements and furniture generally can be so described when consecrated (Exod. 30:29; Num. 4:4, 19). Other items freely devoted to Yahweh also become **most holy** (Lev. 27:28). Other offerings with this special degree of sanctity are the sin and guilt offerings (Lev. 6:17, 25, 29; 7:1, 6; 14:13; Num. 18:9–10) and the holy bread (Lev. 24:9). A study of these texts makes it clear that **most holy** offerings must be eaten by holy people (the priests) in holy places (the confines of the sanctuary). In short, they must not be exposed to risks of contamination by their removal to other places. J. Milgrom (*Leviticus 1–16*, 1991) refers to degrees of holiness in Egyptian and Hittite texts.

The main concern of the instruction in vv. 4–8a and the ritual in vv. 8b–10 is to show that grain offerings can also be given in the form of baked cakes or wafers, and to indicate the procedures necessitated by such an option. A variety of such offerings is envisaged, including those baked in an oven (v. 4), on a griddle (vv. 5–6), or cooked in a pan (v. 7). Once the appropriate preparatory actions have been taken the task of the priests is essentially the same as in vv. 1–3.

4. That the material in vv. 4–8a (Gk is framed as ritual throughout v. 8) is set out in the form of instruction is scarcely surprising, since it deals directly with the preparatory procedures offerers would need to adopt.

Whichever of the three methods is adopted (oven, griddle, or pan), there are certain requirements which are the same. **Fine flour** must be used and **oil** must be added (as in vv. 1–3).

There is the further requirement that the baked product must be **unleavened** ("without yeast" – *GNB, NIV*). The word used here is also the name of a feast, that of unleavened bread, an event firmly attested in earlier collections of law (Exod. 23:15; 34:18), and which Deuteronomy connects with

Passover (Deut. 16:1–8). The use of unleavened bread occurs in domestic narratives (Gen. 19:13; Jdg. 6:19; 1 Sam. 28:24), though in two cases heavenly visitors are present. The special status of such bread is clear from the fact that it is the food of the Levite priests (2 Kgs 23:9). Throughout the priestly writing it is a consistent requirement that most bread associated with the cult should be **unleavened** (see e.g. vv. 11–12). The exceptions to this rule are the occasion of a thank offering, when a well-being offering is accompanied by leavened bread (Lev. 7:13), and presumably eaten by the worshipper, and at the feast of weeks when two **waved** loaves are to be baked with leaven (Lev. 23:17). It should also be noted that in these exceptional cases a different, and possibly not synonymous, root word is used.

The ultimate explanation for this old rejection of leaven is unknown. One biblical answer is contained in the early narrative tradition, where it is suggested that the Israelites, escaping from Egypt, had no time to prepare provisions in what was evidently the customary way – i.e. with leaven (Exod. 12:39). This concern to link practice to the history of salvation is probably a derivative rather than an ultimate explanation. It may be that the fermentation associated with leaven, its capacity to effect change in substances, rendered it suspect; priestly preoccupations with "order" and with "each in its proper place", "according to its kind", are familiar. The association of fermentation with corruption (J. Milgrom, *Leviticus 1–16*, 1991), or the fact that yeast was a living organism and therefore inappropriate on an altar where offerings were dead (G. J. Wenham, *The Book of Leviticus*, 1979) are further possible factors.

The addition of frankincense in these situations (contrast vv. 1–3) may simply have been impracticable; the oil is sufficient by way of preparation.

6. The breaking up of offerings baked on a griddle is probably a practical matter, enabling the priest to select the **token portion**.

8. Here and in v. 9 a fuller description is given (cf. vv. 1–3) of the priestly acts of presentation.

10. In view of the problem of reconciling the distribution

to all priests with Lev. 7:9, where only the officiating priest has the grain offerings, J. Milgrom (*Leviticus 1–16*, 1991) takes this verse and v. 3 to be glosses.

In vv. 11–13 there are further prohibitions about the use of leaven. It becomes clear that leaven and honey are unacceptable in grain, bread or cakes whose destination is the altar (v. 12). There is the further requirement that salt be added as a seasoning agent to all grain offerings (v. 13).

The presence of statutes (vv. 11–12), cast in the second person plural and addressed to the nation, indicate an editor's influence. He reiterates, clarifies and develops the principles embedded in the traditions in vv. 4–5. Singular verbs occur throughout v. 13 and at one point in v. 11, suggesting that he has worked with an older text on the subject of leaven (v. 11) and salt (v. 13). In Gk there is some adaptation of these singular verbs in favour of the prevailing plural.

11. A different root word is used to denote **leaven** (contrast **unleavened** in vv. 4–5). B. A. Levine (*Leviticus*, 1989) notes that a cognate adjective in Akkadian can describe beer or vinegar as well as dough. This "leaven" is precluded in ancient laws (Exod. 23:18; 34:25) and in old traditions about the feast of unleavened bread (Exod. 13:3,7). Priestly tradition precludes it, as here, in relation to grain offerings (Lev. 6:17), and the feast of Passover and unleavened bread (Exod. 12:15), but permits its use at the feast of weeks (Lev. 23:17), and in connection with thank offerings (Lev. 7:13), a custom attested in Amos 4:5.

Honey (possibly also "nectar" – B. A. Levine, *Leviticus*, 1989) is also forbidden as a fire offering and pleasing odour sacrifice. The word is frequently used to describe the fruitfulness of the promised land, but occurs very rarely in cultic contexts. There is an indication in 2 Chr. 31:5 that it could be one of the components offered as **first fruits** (see vv. 14–16), and this is evidently in mind here (v. 12). As such it would presumably come from domesticated bees (cf. J. F. Ross, *IDB*:II, p. 639).

The reasons for the rejection of **honey** (as with **leaven**) are not fully understood. The process of fermentation (see v. 4)

may be the significant factor; like the blood it represents a life force which cannot be burnt (thus J. R. Porter, *Leviticus*, 1976).

13. Reference to **salt** in cultic contexts is infrequent. It is to be added to the burnt offerings on the occasion of the dedication of the altar (Ezek. 43:24), and here apparently to all other offerings, as well as the grain offering (v. 13). There is some evidence that salt had connections with holy war (Jdg. 9:45); the scattering of the salt may be associated with a curse on the destroyed city, or signify its dedication to the deity. It is also associated with procedures that bring health and healing (2 Kgs 2:20–21). Here in v. 13 the covenantal connections are clearly important. The Chronicler describes Yahweh's commitment to the Davidic dynasty as **a covenant of salt** (2 Chr. 13:5). The association is possibly to be traced to the practice of sealing agreements with meals (at which salt was presumably used). Later Yahweh's promise to give the holy offerings to the priests is described as a salt covenant (Num. 18:19).

As B. A. Levine (*Leviticus*, 1989) points out, salt would deal with any blood remaining after the slaughter; its application to the grain offerings would reflect systematizing and universalizing tendencies within the laws. It may be that the symbolism of the covenant was (G. J. Wenham, *The Book of Leviticus*, 1979), or became, a factor in its use.

In vv. 14–16 it becomes clear that the first fruits can be presented as grain offerings. The contents must be new grain from fresh ears. Preparatory requirements are that the grain be parched with fire, and that oil and frankincense be added in the usual way. The token portion (see on Lev. 2:2) is handled in the customary fashion by the priests.

The unit is framed in a similar way to the instructions in Lev. 2:4–10. The introductory remarks and the preparatory requirements are cast in the second person singular (vv. 14–15a). The priestly declaration follows (v. 15b) and the description of the priest's actions (v. 16) is set out as ritual. Here it seems the law-giver has appended ritual elements of the grain offering to older instruction.

14. The demand that the **first fruits** of the land be given to Yahweh is well established in ancient laws. It is linked with the feast of harvest (Exod. 23:16, 19; 34:22, 26). Priestly tradition identifies the occasion as the feast of weeks and fixes it precisely – fifty days after the feast of unleavened bread (Lev. 23:17; Num. 28:26). This corresponds with the time of the wheat harvest. An old prophetic story suggests that such produce might be received by any men of God (2 Kgs 4:42), but in the priestly perspective such gifts go to the priests (Lev. 23:20; Num. 18:13; Ezek. 44:30). The same root word is used in old traditions to denote the first-born of human beings (e.g. Exod. 13:13), and of animals (e.g. Gen. 4:4), and the first pickings of fruit (e.g. Num. 13:20).

It is important to distinguish these first-fruit offerings (*bikurim*) from the first fruits referred to in v. 12 (*re'shith*), of which leaven and honey can be components. These (*re'shith*) are the offerings of which Deut. 18:4; 26:10 speak, and which there go to the Levitical priests. The word does not occur in obviously ancient texts, but is familiar to both prophetic (Jer. 2:3; cf. Ezek. 20:40; 48:14) and wisdom writers (Prov. 3:9). Priestly tradition seems to associate the **re'shith first fruits** with the barley harvest, some seven weeks earlier than the feast of weeks, and at the end of the feast of unleavened bread (Lev. 23:10–11). These offerings also go to the priests (Num. 18:12). It is best to conclude, with J. Milgrom (*Leviticus 1–16*, 1991), that within the priestly writing *bkr* denotes "first-ripe" while *rst* denotes "first-processed". In this case *rst* is not a technical term, but the adjective "first". J. E. Hartley (*Leviticus*, 1992) understands *re'shith* to be first and best.

It is clear from Num. 28:26 that grain offerings from the *bikurim* **first fruits** became a public event; here in vv. 14–16 it seems that individuals could choose to offer a part of their first fruits in this form. The crushing of the grain reduces it to a form appropriate for a grain offering. The parching or roasting process makes the first fruits suitable to be a good offering, and is attested in other texts (Josh. 5:11; Ruth 2:14; 1 Sam. 17:17; 2 Sam. 17:28) where the stress seems to be on the edibility of the grain.

15 The addition of **oil** and **frankincense**, and the selection

of the **token portion** (v. 16) is to be expected (see v. 2). The rite is an **offering by fire** (or **food offering**) (see Lev. 1:9), and presumably also a pleasing odour.

These rules about grain offering reveal already familiar priestly perceptions about holiness and cultic topography. The process, based on the rites of vv. 1–3 can be set out thus:

1) *Presentation* – the prepared offering is brought to the priests, having been suitably identified and acknowledged by the addition of oil and frankincense.
2) *Selection of the Token* – the handful is drawn by the priest.
3) *Disposal of the Token* – the handful is burned by the priest on the altar.
4) *Disposal of the Remainder* – the remainder is consumed by the priests within the confines of the sanctuary.

Here the offerer is active in the first phase, and the priest in the other three. As with the burnt offering the grain offering is a gift to Yahweh which honours him as the source of life and fertility on the land.

These procedures also respect the boundaries between the realm of the sacred (the holy area or sanctuary) and the realm of the common (the camp or habitation). The addition of oil and frankincense, and the selection of the token, mark the processes of transition. The burning of the token and the consumption of the remainder by priests is an indication that the process is complete, that the offering is now wholly God's, and that the integrity of the divine realm has been fully honoured and preserved.

Leaven and honey are not admissable as fire/pleasing odour offerings; they have their place in the camp, but cannot cross the boundary into the realm of the holy. Salt, by contrast, is an essential accompaniment to all items that make the transition. The sense of an ordered and secure world in which familiar products all have their place is further consolidated.

The first fruits which normally move from the camp (the habitation) to the dwellings of the priests (a low level of

holiness) may, by these rites, move on into the sanctuary itself, and specifically to the altar in the courtyard (a higher level of holiness).

No quantities are specified for the grain offering, and like the burnt offerings of birds (Lev. 1:14–17) this is a gift which would be well within the means of poorer people. It attests a value attaching to all members of the community, while at the same time encompassing them within an all-embracing social and religious system.

3. THE WELL-BEING OFFERING
(3:1–17)

There are four elements here:
3:1–5 – well-being offerings of cattle
3:6–11 – well-being offerings of sheep
3:12–16a – well-being offerings of goats
3:16b–17 – the consumption of fat and blood forbidden.

The background to the **well-being offering** is particularly difficult to clarify. In the earlier literature the two words which make up the name ("sacrifice" and "peace") normally occur independently of one another. This feature has led R. Rendtorff (*Studien*, 1967) to argue that they were originally different and separate offerings, linked subsequently to form the well-being offering familiar in the priestly writing. This view of the history has not been generally accepted by recent commentators, but the distinction provides a vantage point from which the usage of "sacrifice" and "peace" can be considered.

In Exod. 20:24 "peace" is specified, along with the burnt offering; here "sacrifice" occurs as a verb and simply means "to slaughter". In Exod. 32:6 "sacrifice" is absent altogether (cf. also Jdg. 20:26; 21:4; 1 Sam. 13:9; 2 Sam. 6:17; 1 Kgs 3:15).

Independent usage of "sacrifice" is easily found in early literature. In many instances it occurs on its own (e.g. Gen. 31:54; Exod. 23:18; 34:15, 25; Jdg. 16:23; 1 Sam. 1:21; 2 Sam. 15:12; 1 Kgs 8:62; Isa. 34:6; Jer. 46:10; Hos. 3:4; Amos 4:4;

Zeph. 1:7); in others it occurs in close association with burnt offerings, sometimes cited first (Exod. 10:25; 2 Kgs 10:24; Isa. 1:11; Hos. 6:6), but usually second (Exod. 18:12; Deut. 12:6; 1 Sam. 6:15; 2 Kgs 5:17; Jer. 6:20). The Passover can evidently be described as such (Exod. 12:27; 34:25). Occasionally it occurs in close association with wine offerings (e.g. Hos. 9:4), or with the grain offerings (1 Sam. 2:29), or with a wider range of offerings (2 Kgs 16:15). It is also common in the psalms (e.g. Ps. 4:5) (Heb. v. 6), and in what may be early wisdom texts (e.g. Prov. 15:8).

The well-being offering is distinguished by the fact that the victim is in large measure consumed by the offerers in a sacrificial meal; only the fat parts and the kidneys are burnt as offerings to God (Lev. 3:3–5). That the fat parts were always considered God's is indicated by earlier texts such as Exod. 23:18; Isa. 1:11. Domestic flocks and herds provided the substance of well-being offerings (Exod. 10:25; 20:24; 24:5; Deut. 18:3; 1 Kgs 8:63; Isa. 34:6).

The circumstances that prompt the offering are again very varied, but certain trends can be distinguished. Rendtorff (*Studien*, 1967) proposed that the "peace" belonged to great public occasions, and that it always occurs in association with other offerings (usually the burnt offering). Occasions varied from celebration and rejoicing (Exod. 32:6; Deut. 27:7; 1 Kgs 9:25) to crisis and lamentation (Jdg. 20:26; 21:4; 1 Sam. 13:9; 2 Sam. 24:25). Other occasions would be when sanctuaries are established and cults inaugurated (Exod. 32:6; 2 Sam. 6:17–18; 24:25; 1 Kgs 8:64; 2 Kgs 16:13).

By contrast Rendtorff suggested that the "sacrifice" had strong connections with individuals and families (Gen. 31:54; 46:1; Deut. 18:3; 1 Sam. 1:21; 2:19; 3:14; 20:6, 29; 2 Sam. 15:12; 2 Kgs 5:17; 10:19, 24). Clearly it can have a generalized application to all slain offerings (1 Kgs 8:62). There are numerous occasions on which it is appropriate to offer a "sacrifice". Jacob and Laban seal their agreement this way (Gen. 31:54), and the former offers one on hearing that Joseph is alive (Gen. 46:1). Some families evidently offered it yearly (1 Sam. 1:21; 20:6). It was also associated with the fulfilment of vows (2 Sam. 15:12), and apparently with expiation

of sin (1 Sam. 3:14). Jethro marks the deliverance from Egypt with a "sacrifice" (Exod. 18:12).

The few pre-priestly allusions to a **well-being offering** ("sacrifice" and "peace" together) correspond rather to the "peace" in terms of circumstance. The occasions are essentially national, involving covenant-making at Sinai (Exod. 24:5), Samuel at Gilgal (1 Sam. 10:8), king-making at Gilgal (1 Sam. 11:15), and the dedication of the Temple (1 Kgs 8:63).

"Meanings" for the well-being offering are elusive. The victim is shared between God and the offerer – hence "shared offering" – *REB*. The involvement of the word for "peace" is suggestive – hence the traditional "peace offering" (preferred by G. J. Wenham, *The Book of Leviticus*, 1979). The stress on agreement or covenant in some texts (Gen. 31:54; Exod. 24:5) has led some to see it as a "communion" sacrifice (*NJB*). R. Schmid (*Das Bundesopher*, 1964) argues that the well-being offering, and the associated meal, establish and reinforce the covenant. It may well be the case that special relationships (involving humans and gods) were sealed by sacrifice, and that elements of the well-being offering were deemed appropriate for such purposes, but it is not clear that "covenant" accounts for all the evidence about this particular sacrifice or that it takes us to its essential meaning. "Communion" is certainly a speculative interpretation of the well-being offering, and the fact that it readily lends itself to misplaced devotional understandings makes its usefulness questionable. It is sufficient perhaps to point out that, like other sacrifices, this offering honours and acknowledges God, and seeks his favour, in many and varied circumstances. One of its key roles is to express, through the sharing of the sacrifice, a solidarity between deity and society. W. B. Stevenson ("Hebrew Olah", 1950) describes it as a thanksgiving and a tribute of honour to God (Isa. 43:23; Ps. 50:23). B. A. Levine (*In the Presence*, 1974, *Leviticus*, 1989) thinks of it as a gift of greeting, which follows the attention-attracting burnt offering. Its distinctive character as a meal probably derives from its background among the smaller social units that constitute Israel – the families, extended families, villages and towns.

Attempts to reconstruct the history of the well-being offering face obvious problems. In addition to the usual paucity of evidence, the way in which "sacrifice" and "peace" should be connected is highly debatable. In historical terms the two words may be verbal variants for essentially the same sacrifice (as Stevenson supposes), rather than two quite separate sacrifices as Rendtorff (*Studien*, 1967) suggests. It is possible that the two words have different functions, with "sacrifice" denoting the **manner** in which the rite is performed (slaughter) and "peace" the religious attitude which calls forth the sacrifice – a distinction drawn from B. A. Levine's (*In the Presence*, 1974) analysis of cultic language. Stevenson finds that the usage indicates simple interchange-ability. One proposal he makes is that the full form (well-being offering) may have been the official term in priestly circles, the two words occurring separately as popular variants and abbreviations. He also suggests that "sacrifice" may have a Canaanite background (Exod. 34:15; Num. 25:2; Jdg. 16:23), and that in practice it was virtually the equivalent of the Israelite "peace".

It is clearly the case that this issue cannot easily be resolved. There are certainly some occurrences of "sacrifice" where the term could simply denote a slaughtered offering of any kind (or perhaps even the cult as a whole), but there are also those where, though closely associated with the burnt offering, it is apparently a distinct and separate sacrifice, and not simply a description of the method whereby offering is made. Moreover, if we assume that the two words ("sacrifice" and "peace") are simply variants for the same sacrifice we have to acknowledge a surprising looseness of usage in distinct and discrete literary contexts (e.g. the Book of the Covenant (Exod. 20:24; 23:18); Deuteronomy (27:7; 18:3); the Saul stories (1 Sam. 13:9; 9:12, 13; 16:3, 5). A further factor is the evidence, previously noted, for the use of the words in diverse social settings. Rendtorff's theory of two quite distinct and discrete sacrifices is perhaps too simple or too sharply drawn, but the interaction between different social contexts is probably part of the overall history of the well-being offering. It seems appropriate to use "sacrifice"

terminology in relation to the well-being offering's ancient rural and family associations; the "peace" by contrast was perhaps urban and temple-based. The offering itself was probably in all essentials the same.

It is important to note that the well-being offering is attested in Canaanite texts (A. de Gugliemo, "Sacrifice", 1955, J.Gray, "The Religion of Canaan", 1965, B. A. Levine, *In the Presence*, 1974), and often occurs in association with what may be an equivalent for the Israelite burnt offering. Further explorations of the place of the well-being offering in other cultures have been conducted by R. Schmid (*Das Bundesopher*, 1964), B. A. Levine (*In the Presence*, 1974) and most recently by B. Janowski (*Sühne*, 1980). The Canaanite connections raise the possibility that the offering enters Israelite life through the Jerusalem Temple, with its various Canaanite affinities. Levine suggests that it was originally pre-monarchic, but that it came to have a distinctively royal and national character. For him the earlier essential features of this offering are dedicatory and commemorative. The offering might have concluded ceremonies (R. Rendtorff, *Studien*, 1967 – hence its position after the burnt offering), or been a gift of greeting which appropriately follows the invocation of the deity by the burnt offering (B. A. Levine, *In the Presence*, 1974).

The process by which "sacrifice" and "peace" became linked is, of course, obscure. Rendtorff's main proposal is that the blood rite of the "peace" (in his view a primary characteristic of that offering) was introduced into the "sacrifice" (distinguished by its meal – Exod. 34:15; Ps. 106:28) to create the well-being offering now familiar in the priestly writing. As J. Milgrom ("Sin-Offering", 1971) points out, this view needs to confront those relatively early texts which suggest that "sacrifice" included blood rites (Exod. 23:18; 34:25; Deut. 12:27; 2 Kgs 16:15). If we assume that the rites were essentially the same, the linking process is terminological. It would have been encouraged by increasing influence from the centre and the clericalization of the cult, beginning with the monarchy, and formalized and hastened under Josiah. The demand that every "sacrifice" be brought to the priest, who subsequently makes of it a well-being offering, is actually explicit in Lev. 17:5–7.

In Ezekiel's cultic system both words are still used independently of one another, but in a broadly similar fashion and for similar purposes. Both are associated with the burnt offering as a phrase applicable to the cult as a whole – e.g. "peace" in Ezek. 43:27 and "sacrifice" in Ezek. 40:42. In Ezek. 46:24 there is an isolated reference to the "sacrifice" as a boiled offering. A terminological linking of the two words, as in the priestly writing, is not yet the norm, but, as Ezek. 44:11 makes clear, cultic personnel must slaughter the "sacrifice".

Rendtorff points out that in the priestly literature the well-being offering seems to play a less important role than the burnt offering. In a sense this is a natural consequence of the assimilation of the "sacrifice", the centralization process, and the increased significance of the burnt offering. On the other hand, as Levine observes, the Jerusalem priests have developed and extended the function of the well-being offering, so that it emerges in the priestly writings as an offering which all can make, and particularly in connection with thanksgiving and the fulfilment of vows (cf. e.g. Lev. 7:11–18). It can now be seen as the supreme "sacrifice", rivalled only by that of the Passover. In addition to the well-being offering of the individual described in Lev. 3:1–17, the priestly literature attests an ordination well-being offering (Lev. 8:31–36), and another which terminates the vows of Nazirites (Num. 6:13–20).

In vv. 1–5 the text deals with the procedures required when the well-being offering comes from the herds. The most obvious difference between this and the burnt offering is that here only certain parts are burnt on the altar, some of the fat (the suet) and the kidneys (vv. 3–5).

1. As previously noted **well-being offering** ("communion sacrifice" – *NJB*; "shared offering" – *REB*; "fellowship-offering" – *GNB, NIV*) consists of two roots. One of these signifies "sacrifice" or "slaughter", and the other "peace" (hence "peace offering" – *RSV*) (see the discussion above). Several of the preliminary requirements and procedures are the same as those for the burnt offering (see Lev. 1:1–9). It is insisted that the animals must be **without blemish**, and there

is an act of presentation **before Yahweh** (i.e. at the "entrance of the tent of meeting").

One difference is that female animals are acceptable. No explanation is given; the law presumably embodies traditional custom.

2. There is also an imposition of the hand (cf. Lev. 1:4). The slaughter takes place at the **entrance of the tent of meeting** (i.e. "before Yahweh"). The handling of the blood, apart from the lack of any reference to its presentation, is essentially as in the burnt offering. The sons of Aaron as priests are required to **dash** the blood against and around the altar. It may be that this blood rite has its origins in the well-being offering. The concern to identify the priests as **Aaron's sons** probably belongs, as in Lev. 1:1–9, to later phases in the editing process.

One point of difference is that editors have not chosen to associate the language of acceptance and atonement with the well-being offering (contrast Lev. 1:4).

3–4. The major differences from the burnt offering emerge here in the disposal of the flesh. In Gk and Vg there are plural verbs in v. 3, implying that the priests, the sons of Aaron, separate the fat parts. It is possible that the singular in Heb. originally denoted **the priest** (cf. evidence for this in Lev. 1:5–9, 13, 15, 17). Only parts of the sacrifice become **an offering by fire** (see on Lev. 1:9). There appear to be three distinct elements which must be separated for this purpose:

a) The **fat that covers the entrails** (the omentum – a membrane enclosing the intestines) and any other fat on the entrails (v. 3).

b) The **kidneys** and their fat at the **loins** (or "sinews/tendons" – B. A. Levine, *Leviticus*, 1989; J. Milgrom, *Leviticus 1–16*, 1991) (v. 4).

c) The **appendage** upon the **liver** (the caudate lobe) (v. 4).

It is possible that ancient custom, based on divinatory interests, lies behind the selection of these items, but such interests are no longer present in the biblical texts (J. R. Porter, *Leviticus*, 1976).

Acceptance of Rendtorff's speculative view that originally "sacrifice" and "peace" constituted two independent sacrifices might lead to the supposition that the separation of these distinct inner parts of the animal can be traced to the "peace", along with the blood rite mentioned in v. 2 and Lev. 1:5; the meal and the burning of fat in general could be traced to the "sacrifice", which had its own blood rite using a different word for the manipulatory procedures (R. Rendtorff, *Studien*, 1967, pp. 129–132; 144–148; 153–161).

The association of **fat** with Yahweh's share of an offering is well established in ancient texts (Gen. 4:4), probably because it was considered the best part (cf. the use of the word in Gen. 45:18; Deut. 32:14). The burning of the fat is evidently a feature of the ancient rites at Shiloh (1 Sam. 2:15, 16). Whatever the observance in mind in the old law of Exod. 23:18, it is clear that the fat cannot be left till morning; in some sense it is specially God's. The fat is also depicted as an element of the sacrifice which gods eat (Deut. 32:38; Isa. 1:11; 43:24; Ezek. 44:7), and can virtually be a synonym for sacrifice itself (1 Sam. 15:22; Isa. 34:6; Ezek. 44:15). A special link with the well-being offering is already established in 1 Kgs 8:64, and becomes very common in the priestly writings, sometimes in the form of a wave or elevation offering (see e.g. Lev. 7:30, 31, 33; 8:25, 26; 9:19, 20; 10:15; 17:5–6). Other offerings that require special procedures with the fat are the sin offering (cf. e.g. Lev. 4:8), the guilt offering (cf. e.g. Lev. 7:3), and the offering of firstlings (Num. 18:17). Some basic principles about the use of fat are strongly affirmed in Lev. 7:22–27. J. Heller ("Die Symbolik", 1970) suggests that the fat denotes "strength", in much the same way that blood denotes "life", and points to several passages in support of this view (2 Sam. 1:22; Isa. 34:6; Deut. 32:15; Jer. 17:4). The description of Eglon (Jdg. 3:17) would therefore express amazement at his strength rather than amusement at his size.

The **kidneys** have a similar cultic significance in two non-priestly texts (Deut. 32:14; Isa. 34:6), and occur commonly along with the fat in priestly texts. The caudate lobe (**appendage**) occurs only in these contexts, and the **liver** usually so. The latter was widely used in divination (cf. Ezek.

21:21). The anatomical features are discussed in detail by L. Rost ("Der Leberlappen", 1967) and J. Milgrom (*Leviticus 1–16*, 1991).

5. As is customary in these pleasing odour sacrifices **Aaron's sons** are responsible for burning the special parts of the offering. *NRSV* and *REB* assume that the well-being offering will accompany a burnt offering, hence the requirement that the special parts of the former be placed upon the pieces of the latter (cf. Lev. 1:8). *NJB* reads "in addition to the burnt offering". For other aspects see Lev. 1:9.

In vv. 6–11 well-being offerings taken from among the sheep are discussed. In all essentials the requirements and procedures are the same as those for cattle (vv. 1–5). The only difference in substance relates to the tail of the animal, which must here be offered to Yahweh along with the other select fat parts and the kidneys (v. 9).

7. The age of the **sheep** is not specified, though the lambs for Passover (Exod. 12:5), public occasions (Exod. 29:38; Lev. 9:3; 23:12; Num. 7:15; 28:3; Ezek. 46:13) and purification rites (Lev. 12:6; 14:10; Num. 6:12, 14) had to be a year old. Outside the priestly texts there is one allusion to the offering of a sucking lamb (1 Sam. 7:9), though a different word is used there (as also in Exod. 12:5. cf. Lev. 5:7).

8. For the imposition of the hand, the slaughter of the animal, and the throwing of the blood see the discussion of Lev. 1:1–9.

9–10. The **broad tail** occurs only in priestly texts of this type (Exod. 29:22; Lev. 7:3; 8:25; 9:19). It is a characteristic of Palestinian sheep (N. H. Snaith, *Leviticus and Numbers*, 1967; J. Milgrom, *Leviticus 1–16*, 1991). The other parts of the animal to be given to Yahweh are discussed in connection with Lev. 3:1–5.

11. Yahweh's share is here described as **food** (cf. also v. 16). This gives support to the supposition that at some point in their history sacrifices could be considered as sustenance for the deity. The close association of this with **by fire** may offer some support to *REB*'s preference for "food offering" over **offering by fire** (see on Lev. 1:9). The singular **the priest**

(rather than **Aaron's sons** (v. 8)) may have been the norm originally throughout the text.

In vv. 12–17 attention focuses on well-being offerings taken from the goats. In all essentials the procedures are the same as for cattle (vv. 1–5) and sheep (vv. 6–11). Distinctive features are the stipulation that all fat is Yahweh's (v. 16b), and the command which proscribes the consumption of fat and blood (v. 17).

12. The Old Testament has a variety of words for **goat** (v. 12). It may be that the word used here (and in Lev. 1:10) denotes a female (see Gen. 30:35; 31:38). On the other hand priestly writers seem to use it in a very general sense – "the goat herds", often specifying in different ways that a male must be chosen (e.g. Exod. 12:5; Lev. 1:10; 4:23; 9:3; 16:5; 22:19; 23:19; Num. 7:16; 15:24; 28:15, 30; 29:5; cf. Ezek. 43:22; 45:23), or in a few cases a female (Lev. 4:28; 5:6; Num. 15:27). Here in Lev. 3:12 the meaning is determined by vv. 1, 6; either a male or female may be chosen.

13. The imposition of the hand, the slaughter, and the throwing of the blood (v. 13) all proceed in the usual way for pleasing odour sacrifices (see on Lev. 1:1–9) (Gk has a plural for the verb **slaughter** which may imply priestly involvement).

14–15. The select parts to be burned on the altar (the fat and kidneys) are precisely those to be cut from cattle (see on Lev. 3:3–4).

16. As in v. 11 these parts are described as **food**, and in the customary fashion as **offered by fire** (see on Lev. 1:9). There is the final reminder that this, as a well-being offering, is one of the **pleasing odour** sacrifices.

17. The concluding statements are cast in the second person plural as statutes (cf. the warnings about leaven in Lev. 2:11–12). The comment about **all fat** (v. 16b) belongs to this material too. There is an evident concern, which re-emerges in Lev. 7:23, to make it clear that all the fat of animals, and not just those parts specified in the well-being offerings, has the same status as blood. It belongs to God.

Priestly editors often employ the phrase **perpetual statute**

(v. 17) (or "covenant") to enforce a point of some importance – Exod. 27:21; 28:43; 29:9, 28; 30:21; 31:16; Lev. 6:18, 22; 7:34, 36; 10:9, 15; 16:29, 31, 34; 17:7; 23:14, 21, 31, 41; 24:3, 9; Num. 18:11, 19, 23; 19:10, 21 (cf. Ezek. 46:14).

The fat in any sacrifice is evidently God's. Either because it represents the best part or because it symbolizes divine strength (as the blood symbolizes divine life) it is his. It therefore belongs to the realm of the holy, the boundaries of which must be respected by its return to God when Israelites draw near to seek him.

As with the burnt offering (Lev. 1:3–9) it is possible to identify distinct procedural phases which make up the well-being offering rite. The essential structure is the same:

1) *Presentation* (vv. 1–2a) – the victim is specified, brought before Yahweh, and the hand is imposed.
2) *Slaughter* (v. 2a) – the victim is killed at the door of the tent.
3) *Disposal of Blood* (v. 2b) – the priests throw the blood against the altar of burnt offering,
4) *Disposal of Flesh* (vv. 3–5) – the select fat parts are separated from the rest of the victim and burned on the altar. At this point Leviticus is interested only in those parts of the well-being offering that are Yahweh's.

The offerer is the primary actor in the first two phases and the priest in the third. Responsibility for the separation of the fat parts in the fourth phase probably lay with the priest; there is no doubt that the priests burn these parts. The essential difference between this and the burnt offering lies in the disposal of the flesh; instead of being wholly burned a large part of the animal remains for the use of the offerer and his family.

At the centre of the presentation process is the imposition of the hand, whereby the victim is set apart for the special purposes of the rite. The slaughter of the animal and the disposal of its blood are ways of recognizing the boundaries between the sanctuary and the camp, and thereby honouring the deity who instituted them. The disposal of the select fat parts is a further act of recognition, in one sense a

gift, but in another a recognition of that which is already
God's; the offerer thereby honours God and seeks continued
well-being for himself and his family.

B. OFFERINGS OF EXPIATION
AND FORGIVENESS
1. THE SIN OFFERING
(4:1–5:13)

The information about the sin offering contains eight main
sections:

4:1–12 – sin offerings (priests)
4:13–21 – sin offerings (the whole congregation)
4:22–26 – sin offerings (rulers)
4:27–31 – sin offerings (the common people (goats))
4:32–35 – sin offerings (the common people (sheep))
5:1–6 – sin offerings in doubtful situations
5:7–10 – sin offerings (the poor)
5:11–13 – sin offerings (the very poor).

The offerings in Lev. 1:1–3:17, though varied, have common
characteristics which make them "pleasing odour sacrifices"
or "offerings by fire". The sin and the guilt offerings (Lev.
4:1–6:7), by contrast, are "expiation sacrifices". Concepts of
"sin", "atonement", "forgiveness", "purification" and "restitu-
tion" prevail.

It has long been observed that the **sin offering** is to be
found only in relatively late literature, and in texts that
exhibit strong priestly influences. There are some prophetic
texts which could have sin offerings in mind (Hos. 4:8; Mic.
6:7; Isa. 53:10), but this is not certain, and little can be
deduced from them. According to conventional datings, the
sin offering first appears in Ezekiel (e.g. 40:39) and the
Holiness Code (Lev. 23:19). It has a major presence in the
priestly writing (particularly in Lev. 4:1–16:34), and there-
after (excluding a possible reference in the psalms – Ps. 40:6
(Heb. v. 7)) it is found only in the Chronicler's writings (e.g.
Ezra 6:17; Neh. 10:33; 2 Chr. 29:21).

The key features that distinguish the sin offering from the "offerings by fire" are the distinctive blood rites (involving among other things the anointing of the horns of the altar), and the way in which the flesh is disposed of. With regard to the flesh there are two possibilities: in some cases it must be burnt outside the camp (e.g. Lev. 4:12); in others it must be eaten by the priest in the tabernacle court (e.g. Lev. 6:26).

Outside the priestly writing the circumstances that prompt a sin offering, insofar as they can be identified, have certain common characteristics. In Ezek. 43:18–26 it has an important place in the rites by which the new altar is consecrated; here it is evidently a purificatory procedure which prepares the altar for use. An inaugural function also seems to be implied with regard to the ministry of priests in Ezek. 44:27, the beginning of the year (Ezek. 45:18–19), and the commencement of Passover (Ezek. 45:22). At Passover a daily sin offering is necessary (Ezek. 45:23). It would appear that from Ezekiel's point of view the sin offering deals with cultic mistakes and errors arising from ignorance, and thereby protects the Temple from defilement (Ezek. 45:20). This inaugurating role is also evident in Ezra 6:17; 8:35; 2 Chr. 29:21, while the need for frequent sin offerings is clear from Neh. 10:33. The people at large (as well as the Temple and altar) will require these apparently purificatory procedures (Neh. 10:33; 2 Chr. 29:21, 24).

The lack of reference to the sin offering in earlier literature makes for obvious difficulty in reconstructing its history. It should not be supposed that the terminology is a creation of exilic times; older generations of critical scholars were well aware of the inherent improbability that the circumstances of exile would encourage the invention of rites *ex nihilo* (see e.g. G. B. Gray, *Sacrifice in the OT*, 1925, p. 66). Its absence from 2 Kings 16:10–16 is explicable in terms of the text's interest in royal offerings, while various texts in Deuteronomy (e.g. 21:1–9), based probably on ancient practice, exhibit an awareness of the need for ritual purification. It is impossible to judge how old the actual title **sin offering** might be.

It is probable that the beginnings of the rite are traceable to the need to deal with inadvertent errors in cultic practice;

these would necessarily threaten the holiness of the sanctuary. It would be natural for such rites to be developed for the inauguration of new altars and sanctuaries. The possibility that there are comparable offerings in Canaanite sources is still an open issue. The initial confidence that there are, associated with Dussaud's early investigations of the literature, has been modified somewhat (see the discussion in e.g. A. de Gugliemo ("Sacrifice", 1955), R. J. Thompson (*Penitence*, 1963, pp. 21–47), J. Gray ("The Religion of Canaan", 1965)). If the origins of the sin offering in Israel can be traced to a concern for the holiness of sanctuary and altar then, given Israel's dependence on Canaanite cultic models in other aspects of its life, it is plausible that the rites do have Canaanite origins.

It is arguable that historically the two ways of disposing of the flesh reflect two different forms of purificatory practice, and it is feasible that two distinct blood rites have been amalgamated to make the sin offering as we see it in Leviticus. One of these entails a sprinkling of blood for the sanctuary (Lev. 4:6) and the other the anointing of the altar horns (Lev. 4:7) (K. Koch, *Die Priesterschrift*, 1959, pp. 53–58; R. Rendtorff, *Studien*, 1967, pp. 199–250; B. Janowski, *Sühne*, 1982, pp. 183–276). According to B. A. Levine (*In the Presence*, 1974, pp. 101–108) one was "a rite of riddance", protecting sanctuary and priests from contamination, and requiring the burning of the remains in a clean place outside the camp (as e.g. in Lev. 4:1–21). The other was a "gift of expiation" to deal with the offences of certain groups and individuals, and as a gift it is appropriately consumed by priests (as in the practice of Lev. 4:22–35). Levine is able to link different aspects of the blood manipulation with the two different rites. The rite of riddance requires sprinklings within the holy place, on the curtain and incense altar (Lev. 4:6–7). With the expiation gift, by contrast, the blood is applied only to the horns of the altar of burnt offering in the outer court (Lev. 4:25).

This kind of explanation for the peculiarities of the sin offering rites has obvious attractions, but there are other possibilities. J. Milgrom ("Sin-Offering", 1971) has done much to focus attention on purification rather than sin as the

central issue in these sacrifices, and further work of his ("Two Kinds of ḥaṭṭa't", 1976) expresses dissatisfaction with the notion that there were ever two kinds of sin offering. He observes, for example, that the goat brought on the day of atonement for purposes of expiation was not eaten but burnt outside the camp (Lev. 16:27). Milgrom's view is that both burnt and eaten sin offerings have a purificatory purpose; the point at issue is a difference of degree. Some such offerings, he maintains, purge the outer altar, and at this lower level of purity are eatable. Other situations, such as the inadvertence of the high priest, or the community, threaten the inner sanctuary, and at this level must be removed from the camp and burnt. They are highly contagious, hence the need for the priest to wash (Lev. 16:23–24). Sin offerings made by priests, Milgrom suggests, must be burnt because priests cannot eat their own sacrifices (Exod. 29:14; Lev. 8:17). This approach receives support in Lev. 10:16–22. Here Moses makes it very clear that the sin offering should have been eaten because the blood had not been brought into the inner sanctuary (v. 18); differences of disposal depend upon the use to which the blood has been put. Thus for Milgrom it is not the case that there were ever two kinds of sin offering; there is evidence rather of development within the rite, indicated by the priestly writer's preference for the eaten offering. More recently D. P. Wright (*The Disposal of Impurity*, 1987, pp. 131–132) has proposed another perspective. He accepts that there were two kinds of sin offering, but not that they were of a radically different nature. Both were purificatory; the difference lies in the holy objects they purify. Wright takes the permission to eat offerings whose blood is not used in the inner sanctuary as a later concession. This might explain the fact that while Moses is angry about the disobedience of Aaron in Lev. 10:16–20 no serious consequences ensue; it is error within a concessionary framework.

A. Marx ("Sacrifice de Réparation", 1989) draws attention to the sin offering as a rite of transition, and proposes that it be rendered "a sacrifice of separation". The separation of sinner from sin does indeed occur in the processes surrounding the rite, but it is still arguable that purification is the

prerequisite, and that that is what the sacrifice is about (J. Milgrom, *Leviticus 1–16*, 1991, pp. 289–292; J. E. Hartley, *Leviticus*, 1992, pp. 56–57).

A further issue for discussion concerns the function of the blood, and here there are a variety of perspectives. B. A. Levine (*In the Presence*, 1974, pp. 67–77) sees impurity as demonic and the blood as apotropaic. This has been strongly opposed by Milgrom ("Israel's Sanctuary", 1976) who of course favours a "purgative" view. B. Janowski (*Sühne*, 1982) prefers to see the application of blood to altar and sanctuary as the symbolic surrender of life to the holy. N. Kiuchi (*The Purification Offering*, 1987) puts some stress on the role of the priest as manipulator of the blood. The priest bears guilt, says Kiuchi, as he engages in the act of purification, while the blood in a symbolic way substitutes for the death sin and uncleanness cause. Milgrom's thesis that only the sanctuary is purified by sin offering rituals has been queried by N. Zohar ("Repentance and Purification", 1988) who wishes to stress also the personal purification of the sinner. A key element in the argument is a process of transference whereby sin moves from the sinner, to the animal, to its blood, to the sanctuary. For Zohar the disowned sin purifies the sinner and the sanctuary; the nature of the blood as life connects to the life of the sinner, and thereby repentance is intimately bound up with the ritual itself. On this view God either eliminates the impurity as the blood comes into contact with the holy things or contains it until the forthcoming day of atonement (Lev. 16).

It seems reasonable to conclude that the sin offering was essentially purificatory, "a rite of riddance"; it protected the sanctuary and all persons and objects associated with it from the contamination of sin. Different procedures were developed for different objects, and these depended largely on their position within the overall topography of the sanctuary. Human error is of course a primary source of danger, and in so far as contamination had to be carried away and disposed of, the sin offering lent itself to the idea that human sin is expiated or done away with. The crucial consideration, however, is that the realm of the sacred should remain so.

The two "types" of sin offering may perhaps arise from the ambiguity of the position occupied by priests. Sometimes they represent God, sometimes the community. The polarities of offering must clearly be preserved. So when the priests are in some way implicated in the sin blood must be carried into the holy place, and the flesh cannot be eaten by them. The carcase has the same status as altar ashes (6:11) and is disposed of in the same way. When the priests are not implicated it is sufficient for the blood to be brought into the court, while the flesh is available for their use.

At the heart of the sin offering are the blood rites – these provide the protective and purificatory elements. The blood can prevent contamination, and it can purge, without itself becoming contaminated. Therein lies its unique power. On this view there is no need to suppose that the flesh becomes contaminated or carries contamination away. If it did it seems unlikely that priests would ever be allowed to eat it, or that in other circumstances it would be carried away to a clean place.

1–2. The initial verses make it clear that sin offerings are for inadvertent errors of commission. J. R. Porter (*Leviticus*, 1976) suggests that the key point is that these are relatively less serious sins than others. Inadvertence, arising from negligence or ignorance, seems to be the key factor (J. Milgrom, *The Cultic Śegāgāh*, 1967, *Leviticus 1–16*, 1991). **Commandments** here denotes those offences which fall entirely under God's jurisdiction (J. Milgrom, *Leviticus 1–16*, 1991).

3. The procedures described first are those which must be followed in the case of a priest.

The priest is **anointed** (n.b. the procedures described in Exod. 29:21, and the composition of the oil in Exod. 30:22–25). M. Noth (*Leviticus*, 1962/1965) traces this unusual phrase to the time of the exile, or shortly after. As B. A. Levine (*Leviticus*, 1989) points out, the sin would be connected to the priest's performance of the priestly office.

His error is said to bring **guilt** on the people. The meaning of this word poses problems; some of these can best be

discussed in the context of the guilt offering (see 5:14–6:7). According to Milgrom (*The Cultic Ŝegāgāh*, 1967, p. 124 n.11) the root describes "contrition for an act either known or suspected". In this context the error of the priest, which inevitably implicates the people he represents, makes the community conscience-stricken. It is important to appreciate also that while the sin offering protects the sanctuary (and this appears to be its primary purpose) any threat to the realm of the sacred is also a danger to the well-being of the community; if the established boundaries are infringed then wrath may break forth.

The offering required is an unblemished bullock (see on Lev. 1:3).

4. The initial procedures are essentially the same as those for the burnt offering – namely a presentation at the door of the tent of meeting, the imposition of hands, and the slaughter of the animal (v. 4; cf. Lev. 1:3–5). R. Rendtorff (*Studien*, 1967, pp. 214–216) has taken the view that the imposition of hands has its beginnings in the sin offering. This is closely associated with the supposition that the transference of pollution is implied (assumed here by M. Noth (*Leviticus*, 1962/1965) and N. H. Snaith (*Leviticus and Numbers*, 1967); see the discussion of Lev. 1:4). If we assume rather that the action identifies the victim and dedicates it, making a connection between offerer and animal, as arguably in Lev. 1:4, then that also could be its significance here.

5. The distinctive features of the sin offering first become apparent in the manipulation of the blood. In Gk and Sam. the blood fills the priest's hand (a phrase reminiscent of the ordination terminology in Exod. 32:29). Three procedures are required.

6. (i) There must be a sevenfold sprinkling of blood inside the Tent of the Tabernacle in front of **the curtain**. The making of the veil or curtain is commanded in Exod. 26:31–33; its purpose is clearly to mark the boundary between the holy of holies where the ark is placed, and the holy place which constitutes the rest of the tent of meeting. The purpose would appear to be the purification of the holy of holies, to which the curtain marks the entrance. The

sprinkled blood protects this holiest place from any encroaching defilement. The verb **sprinkle** is rare outside the priestly literature (cf. e.g. Isa. 52:15); within the priestly writing it can be used of oil (Exod. 29:21; Lev. 8:30; 14:16, 27) and water (Num. 8:7; 19:18, 19, 21) (see also N. H. Snaith ("The Sprinkling of Blood", 1970/1971, p. 24). **Seven** is widely recognized as "sacred and effective" (N. H. Snaith, *Leviticus and Numbers*, 1967).

7. (ii) The horns of the incense altar must be anointed. The **horns** were protuberances at the four upper corners of the altar. They may have been survivals from a bull cult. These extremities are probably thought of as encompassing the whole (cf. the anointing of priestly extremities in Exod. 29:20). The incense altar, like the curtain, is situated within the tent in the holy place, and its construction is commanded in Exod. 30:1–10. It is not necessary to suppose that this altar is a late intrusion in priestly tradition. The use of incense in the cult is undoubtedly ancient (M. Haran, "The Uses of Incense", 1960; K. Nielsen, *Incense*, 1986). While other sin offerings clearly specify the altar of burnt offering, situated in the court (vv. 25, 30, 34), it is entirely appropriate that in the case of a sin offering for priests the altar chosen should be the one situated within the holy place. Only priests were allowed there, while the function of the altar, the offering of incense, was a peculiarly priestly task. This altar and the tasks performed in its service must obviously be protected from any defilement a priest might bring.

(iii) The rest of the blood must be poured out at **the base** of the altar of burnt offering (v. 7) (that situated at the entrance of the tent of meeting in the courtyard). The verb **pour out** is that used for the manipulation of blood in the Deuteronomic cult (Deut. 12:27). For reasons which are obscure, the application of the blood to this altar is different from the procedures required in the pleasing odour sacrifices of chapters 1–3 (essentially throwing against the altar). The methods may indicate a different function for the blood in the two types of rite. With the pleasing odour offerings the blood is returned to where it belongs, the realm of the holy; here in the expiation sacrifice it is protective, barring the way

before any uncleanness which the priest may bring to the
sanctuary. D. P. Wright (*The Disposal of Impurity*, 1987, pp.
147–159) maintains that the blood is now impure (see Lev.
6:27); for him this is not part of the essential ritual, but a
means of discarding something now unusable to prevent
profanation and sacrilege. It may be nevertheless that Lev.
6:27 is not dealing with impurity. It is possible therefore that
the pouring is part of the rite, and that this is the way the
blood, not employed inside the tent (on the curtain and
incense altar), must be used. An impure substance would
probably need to be disposed of in an unclean place. The
blood guards against and does away with impurity, but does
not thereby become contaminated; therein perhaps lies its
special quality.

8–10. The disposal of the fat parts of the animal by burning
on the altar of burnt offering are exactly the procedures
required for the well-being offering (see on Lev. 3:3–5), and
it is possible that they originate there. If so, this would be
another illustration of the way in which in the history of their
development different rites have influenced one another.

11–12. The disposal of the rest of the flesh by the priest
(plural in Gk and Sam.) is also distinctive (D. P. Wright (*The
Disposal of Impurity*, 1987, pp. 129–146)). In this instance (as
also in v. 21) it must be removed from the camp and burned
in the place where altar ashes are taken (see Lev. 6:11). This
also differs from what is said about sin offerings in Lev. 6:26.
As Lev. 6:30; 10:16–20 make clear, the crucial question is
whether the blood has been brought into the holy place. If it
has, as here, then the flesh must not be eaten. While it is
possible, as discussed above, that there is evidence here of
two sin offering rites, it seems unlikely that they had a radi-
cally different purpose. The priestly sin offering is not the
norm. The point is that the priest cannot represent both God
and the community at the same time; the polarities of
offering have to be preserved. It is therefore necessary that
offerings brought by priests on their own account be suitably
disposed of. Burning on the altar is not appropriate; that
would confuse the sin offering with pleasing odour offerings.
The procedures used for the ashes provide the model. The

flesh is not contaminated by sin, any more than the blood. If it were, other sin offerings could not appropriately be eaten by priests. The flesh is still holy, and must be carried to a **clean place** outside the camp. Thus the remains are protected from any misuse, and the priest does not profit from his sin (J. E. Hartley, *Leviticus*, 1992).

Attention turns in vv. 13–21 to sin offerings made on behalf of the whole community. Again inadvertent errors of commission are envisaged. The error is initially unknown to the assembly (v. 13), but in some way its nature and effects have become clear (v. 14). The procedures are the same as those for errors by priests (vv. 1–12). One new feature is the introduction of "atonement" and "forgiveness" terminology (v. 20); this continues to be prominent in the description of other expiation sacrifices.

One problem about this passage is its relationship to Num. 15:22–31, which appears to deal with the same situation (the inadvertent errors of the whole congregation), but which requires a burnt offering as well as a sin offering. In recent years J. Milgrom ("The Two Pericopes", 1983) has explored the matter in some detail, and concludes that the two texts represent independent traditions about the sin offering – in one (Lev. 4) the sin offering makes atonement, in the other, in its original form, (Num. 15) the burnt offering. It seems equally possible that within Numbers there is a certain reworking of earlier priestly material in Exodus and Leviticus. On this view later priestly editors add the burnt offering to the rite. There is indeed some ground for supposing, with Rendtorff and Milgrom, that the burnt offering was originally the sole public sacrifice for expiation (see e.g. Jdg. 20:26; 21:2–4), but this may have been precisely the factor leading late editors to incorporate it. Some priestly texts do indeed add sin offerings to burnt offerings for fixed public sacrifices (see e.g. Num. 28:15; 29:5), but it seems perfectly feasible that the reverse process would operate in a situation where sin is the particular issue to be dealt with.

13. The words **congregation** ("community" – *NJB, REB, GNB, NIV*) and **assembly** (also vv. 14, 15) seem to be used

interchangeably within the priestly writings. The former is used very extensively (elsewhere in Leviticus in 8:3, 4, 5; 9:5; 10:6, 17; 16:5; 19:2; 24:14, 16) and normally denotes the whole Israelite community (**the people/Israel/the people of Israel** in JE). Occasionally it can refer to a particular group, as in the case of Korah's congregation (Num. 16:5). The **assembly** in P is less common (elsewhere in Leviticus only in 16:17, 33), and also generally denotes the whole community. The two words are sometimes used in close association (e.g. Exod. 12:6), and if a distinction is to be made **assembly** appears more specific – the congregation gathered together before God for some special purpose. J. Milgrom ("Priestly Terminology", 1978) has taken the view that **congregation** was an ancient institution from pre-monarchic times. M. Noth (*Leviticus*, 1962/1965) prefers the view that, from a redactional perspective, **assembly** is primary and **congregation** secondary.

On **unintentionally** and **guilt** see on vv. 2–3.

14. It is clear here that the sin offering is made in full consciousness of the error in question. It has been identified and made clear to all.

There are minor textual variants; the victim must be **unblemished** (Gk and Sam.), and in Gk the **entrance** of the tent is specified.

15. Here the imposition of hands is carried out by representative **elders**; the animal is identified as the congregation's. The slaughter is apparently carried out by the priest; a reversion to the third person singular in Heb. (plural in Gk – the elders?) is obscured by the passive in English versions.

16–19. The account of the rite is abbreviated, but it is clearly intended that it should continue as in vv. 5–10 – hence the reference to **the bull of the sin offering** in v. 20. The allusion to **the altar of sweet incense** in v. 18a (Gk and Sam.) is presumably a clarification.

20. The meaning of **atonement** ("makes expiation" – *REB*) has been much discussed. For earlier contributions to the argument see G. B. Gray (*Sacrifice in the OT*, 1925, pp. 67–81). The word clearly has a special place among these expiation sacrifices (cf. Lev. 4:26, 31, 35; 5:6, 10, 13, 16, 18; 6:7). The

isolated occurrence among the pleasing odour sacrifices (Lev. 1:10) is possibly editorial, offering a standardized interpretation of sacrifice in general. In broad terms there have been two main etymological explanations of the word and its derivatives.

Some favour the more traditional view that it has the sense of to **cover**, and Arabic usage has sometimes been cited to support this (for discussion see B. Janowski, *Sühne*, 1982, pp. 95–102). The lid (**mercy seat**) which covers the ark in Exod. 25:17 embodies the same root word.

Others draw attention to Akkadian rites (for a recent discussion see D. P. Wright, *The Disposal of Impurity*, 1987, pp. 291–299) in which the word appears to occur in connection with rites of elimination; they maintain strongly that it means to **wipe off** or **render pure** (B. A. Levine, *In the Presence*, 1974, pp. 63–67; J. Milgrom, "Sin-Offering", 1971). Levine (*Leviticus*, 1989) sees the sense here as functional – "to perform rites of expiation over, with respect to. . .".

Others are less persuaded of the relevance of non-Israelite usage. H. C. Brichto ("On Slaughter and Sacrifice", 1976) accepts the view that when the verb governs an object directly it means to purify or purge, but when sins or sinners are indirect objects governed by prepositions, as here, this is not evidently so. He prefers to think that the basic force of the word hinges on the fact that every offence against deity requires some act of compository payment or "consideration" (i.e. **atonement**). He suggests because this is close to the need to decontaminate the sanctuary that by a process of metonymic extension the word comes to mean "cleanse" or "purify".

B. Janowski (*Sühne*, 1982, pp. 27–102), while recognizing that the Hebrew word owes something to Akkadian, does not consider this decisive for interpretation. He points out among other things that the Akkadian procedures are not offerings, and that Mesopotamian religion is unfamiliar with rites such as the Israelite sin offering. His investigations outside the priestly writing lead him to the conclusion that the most fundamental principle is the notion of the forfeited life for which ransom is sought or paid; it is on this basis that

the priestly theology of cultic sin is built. He maintains that in priestly and related literature the meaning of the word focuses on the cover of the ark where the divine presence graciously encounters Israel to deal with sin; the rendering **to make expiation for** is therefore appropriate (pp. 183–354). For criticism of this view see J. Milgrom ("Review of *Sühne*", 1985, pp. 302–304).

M. Douglas ("Atonement in Leviticus", 1993/1994) has recently proposed that notions of cleansing and purging are misleading and fail to do justice to the concept of **atonement**. For her, rites of atonement are remedial or corrective, and the meaning "to cover" is preferable. The sense she attaches to this is not that sin is covered and thereby hidden from God, but that something damaged, rotten or broken is made good. There is something here which may help to confirm that sin offerings have to do with "protection" as well as "purification".

Outside priestly and related literature there are places where some such meaning as "to placate", "to mollify" or "to make amends" is appropriate (e.g. Gen. 32:21; Exod. 32:30; 2 Sam. 21:3; Prov. 16:14; Isa. 47:11) (see further A. Schenker, "Kōper et expiation", 1982). It seems to be the case nevertheless that within the priestly writing the process of purification conducted by the priest is the primary dimension of meaning, and that the concept of **atonement** has its natural home within the rites of the sin offering. The priest's sacrificial work, and in particular his manipulation of the blood, protects and cleanses the sanctuary from any defilements with which the congregation's errors may threaten it. As such it **atones**, and, as Milgrom ("Review of *Sühne*", 1985) argues, the atonement (purification) is made **upon them** (i.e. the holy objects in the sanctuary). It is true, of course, that such defilements also threaten the congregation – holiness may re-assert itself in the form of divine wrath – and there is thus a secondary sense in which the priestly action can be described as **for them** (i.e. the congregation). The sense is essentially protective rather than propitiatory. Moreover, inasmuch as the whole sacrificial process deals with the problem of sin (inadvertent error), the sin offering, and the

act of atonement it entails, may fairly be described as expiatory. Furthermore, inasmuch as it requires a compensatory and costly gift (the bullock), there is also a sense in which it makes amends. Such secondary dimensions of meaning are coherent and natural enough, but they should not obscure the likelihood that within priestly thought atonement has a fundamentally purificatory and protective character. It is hard to know what kinds and directions of influence existed between cultic and non-cultic usages of the word, but it is perfectly feasible that the cultic concept is primary, and that the other senses (e.g. "to placate/make amends") are derivative.

The idea that **they shall be forgiven** commonly occurs in P in close association with the atonement formula (Lev. 4:26, 31, 35; 5:10, 13, 16, 18; 6:7; 19:22; Num. 15:25, 28). The root is common enough elsewhere – in D (Deut. 29:20), and in literature under Deuteronomic influence (e.g. Exod. 34:9; Num. 14:19; 1 Kgs 8:30; 2 Kgs 5:18; Jer. 31:34). It is also evident in cultic poetry (Ps. 25:11) and prophecy (Amos 7:2; Jer. 5:1, 7). It may be derived from a root meaning "to wash" (B. A. Levine, *Leviticus*, 1989). J. Milgrom (*Leviticus 1–16*, 1991) points out that more than "forgiveness" is at issue here; the pollution of the altar requires the restoration of a broken relationship. The application of the idea to the processes of atonement may indeed be an influence from Deuteronomic literature; because the sin offering deals with sin the presence of a gracious and forgiving God is naturally and readily to be assumed. This would appear to belong to that relatively late level in the development of the tradition in which the whole sacrificial system is seen as gracious provision for God's chosen people.

21. It is not hard to see why this version of the sin offering, like that for priests (vv. 1–12), must be burned outside the camp. Because the priest represents the whole community, and to that extent has a share in community errors, he cannot be allowed to benefit from the same. The priest cannot represent both God and community at the same time; the polarities of the offering process must be preserved. Steps must therefore be taken to dispose of the flesh

remaining in an appropriate fashion. Gk has plural verbs suggesting perhaps that the tasks assigned here are the responsibility of the elders.

This unit deals with the inadvertent errors of rulers. The key differences here (as compared with the rites of vv. 1–12 and 13–21) are that the animal slaughtered is a goat (v. 23), and that the blood is not taken inside the holy place. There is thus no sprinkling of the curtain or anointing of the incense altar; only the horns of the altar of burnt offering in the court are smeared (anointed) with blood. There is no reference to the disposal of the flesh outside the camp (as in vv. 1–12 and 13–21); it is reasonable to assume that this is one of the sin offerings (along with those in the rest of this section (4:27–5:13)) which are to be eaten by the priests (as required in Lev. 6:26).

22. The word **ruler** ("leader" – *NIV*; "chieftain" – B. A. Levine (*Leviticus*, 1989); J. Milgrom (*Leviticus 1–16*, 1991)) seems to denote any person with an important position of leadership (e.g. Gen. 17:20; 23:6; 34:2; Exod. 22:28), and can also be used of Israel's kings (1 Kgs 11:34). Ezekiel in particular uses it widely – of an existing king (e.g. 7:27), of a future king (e.g. 34:24), but also of other leading men in Judah (e.g. 21:17) and of foreign princes (e.g. 26:16). Its prevalence in Ezekiel may account for its widespread use in the priestly writing, where in an Israelite context it normally denotes tribal leaders (e.g. Num. 1:16), some or all of whom function, as here, as leaders or representatives of the congregation.

23. It is clear, as in vv. 1–12 and vv. 13–21, that the ruler has acted inadvertently, committing errors through negligence or ignorance, and that this **has been made known to him**. The animal to be offered is a male **goat** (a long-haired variety – A. T. Chapman and A. W. Streane (*The Book of Leviticus*, 1914)). On the requirement that it be **without blemish** see Lev. 1:3.

24. The imposition of the hand and the slaughter of the animal proceed in the normal way; the reference to **the spot where the burnt offering is slaughtered** is more precise, indicating what is presumably implicit in vv. 4,15. *NRSV* corrects

the impression given by *RSV* that the ruler kills the animal. Gk uses a plural verb here (cf. also v. 29, 33), presumably with the priests in mind.

This is apparently the first account of a sin offering in which the flesh is eaten by the priest. In this situation he can fully and unambiguously represent the divine polarity in the offering process, and is therefore entitled to receive and use the flesh of the sacrificial animal (cf. Lev. 6:26). It is also the case that because priests (vv. 3–12) and the congregation (vv. 13–21) are holy in a special sense, their errors pose special threats to the tabernacle. Laymen such as rulers seem to lack this status. There is therefore no need to bring the blood inside the tabernacle, and perform purification there. The value of the animal to be offered can also be correspondingly reduced; further reductions relative to status are evident in vv. 27–35.

In vv. 27–31 there is provision for sin offerings to be offered by ordinary people. In all essentials the circumstances that require a sin offering and the procedures to be followed are exactly the same as those for the ruler (vv. 22–26). The terminology employed is for the most part already familiar from the rites previously described in vv. 1–12, 13–21, 22–26. The distinguishing feature is that the animal offered is a **female** goat (v. 28) (contrast the male (v. 23) for a ruler), denoting possibly the lower status of the offering.

27. The phrase **ordinary people** ("common people" – *GNB*) means literally "people of the land". It has been much discussed, since in later texts it took on negative connotations (cf. e.g. Ezra 4:4 where it denotes the settled people who opposed the returning exiles), while in rabbinic Judaism it was applicable to those who failed to observe the law. Here, as is customary in the Old Testament, it appears to refer, not as has sometimes been supposed to a distinct class or interest group, but to any who do not belong to the leadership, clerical or lay – that is to the priests (v. 3) or rulers (v. 22).

31. There is a curious and uncharacteristic reference to the sacrifice as a **pleasing odour** (v. 31) (see on Lev. 1:9). This

is possibly a late intrusion from the rites described in Lev. 1–3 (cf. the isolated allusion to **atonement**, perhaps from the expiation sacrifices, in 1:4). If so, these reflect tendencies towards terminological standardization within the sacrificial system. I. Knohl ("The Sin Offering Law", 1991) comments on the concern of priestly law-makers to avoid giving the impression that forgiveness can be secured with pleasing odours; the reference to them here could therefore be a deliberate attempt to interpret them in the wider and larger context of blood sprinkling and purification.

It is to be assumed that this offering, like that for the ruler, is to be eaten by the priests (contrast the disposal in vv. 11–12, 21). The inadvertent errors do not threaten the holy of holies, and therefore the blood does not have to be taken into the tabernacle (see the discussion of vv. 22–26).

This unit makes it possible for a sheep to be offered by ordinary people as a sin offering. As with the goat (vv. 27–31) it must be **female** (v. 32). Procedures are the same. The terminology is already familiar from other sin-offering rites (vv. 1–12, 13–21, 22–26, 27–31).

35. There is specific reference here to the fact that the fat must be burned with ("upon" – *RSV*) **the offerings by fire** (see on Lev. 1:9). The meaning may be "in the same way as" (A. T. Chapman and A. W. Streane, *The Book of Leviticus*, 1914).

In 5:1–6 specific situations that call for a sin offering are itemized. The word rendered "guilt offering" by *RSV* in v. 6 may better be understood as "for his guilt" ("culpability" – B. A. Levine, *In the Presence*, 1974, pp. 108–112), or "by way of reparation"– hence **as your penalty** (*NRSV*). The overall context is evidently the **sin offering** (v. 6). The situations listed are mostly the result of inadvertence, arising from ignorance, negligence or even accident, and are thus appropriate for the sin offering. As M. J. Geller ("The Šurpu Incantations", 1980) has shown, the list has some affinities with the Mesopotamian incantations, particularly with regard to the problem of oaths, contact with impurity, and the man's ignorance of his sin.

J. Wellhausen (*Prolegomena*, 1878) maintained that these verses, along with vv. 7–13, are an independent treatment of the same material as that contained in 4:27–35. In this tradition (5:1–6), as he saw it, **sin offering** and **guilt offering** are used interchangeably. As we have suggested there is no obligation to translate the word in v. 6 as **guilt offering**, while the primary concern in vv. 1–6 is not to describe the rites, as in 4:27–35, but to specify situations in which the sin offering would (or would not) be required.

It has sometimes been supposed nevertheless that these verses actually relate to the **guilt offering** (see Lev. 5:14–6:7). Rendtorff (*Studien*, 1967, pp. 207–211) proposes that the guilt offering may in fact be the older form of the individual's sin offering; as the sin offering progressively takes over this role the guilt offering is left as a form of recompense. The relationship between the two offerings is admittedly close, but Leviticus as we know it maintains a distinction. The guilt offering has its own sacrificial procedures as well as its compensatory element. Levine (*In the Presence*, 1974, pp. 108–112) sees adaptations of the sin offering here in vv. 1–6. There are elements of omission, in contrast to the acts of commission dealt with in chapter 4. For him a guilt offering would apply only if there were some kind of misappropriation. It seems best to take it that these verses deal with borderline cases in relation to the individual's sin offering; as such they pose no major problem.

1. The first situation is one in which the person in question is apparently a knowing witness who ignores a solemn call to testify; the feeling that this is not inadvertent is confirmed by the absence of the phrase **and are unaware of it** which characterizes the situations envisaged in vv. 2, 3, 4. The comment that the man must be **subject to punishment** ("bear his iniquity" – *RSV*; "suffer the consequences" – *GNB*; "held responsible" – *NIV*) is also distinctive. This suggests that he must carry the (legal) consequences for his sin. It is therefore likely that v. 1 depicts a situation for which a sin offering cannot be made (though B. A. Levine (*Leviticus*, 1989) suggests that negligence could be a form of inadvertence). The situations in vv. 2–4 do qualify for the sin offering (and v. 5 would

be referring to these); the situation in v. 1 does not.

The **public adjuration** (v. 1) is a kind of curse, which presumably called down dire consequences on any who ought to testify ("give evidence in court" – *GNB*) but failed to do so. Further insights are offered in 1 Kgs 8:31; Prov. 29:24 (cf. 1 Sam. 14:24, 26). The text here may also have in mind a situation when someone is initially ignorant, but subsequently discovers relevant information; he must act at once. Other situations in which a man must **be subject to punishment** ("bear his iniquity" – *RSV*) are obviously of interest. In Lev. 5:17 the phrase is used in the context of the guilt offering, situations in short where reparation can and must be made. It may therefore be the case that a guilt offering would be acceptable from a man who makes a delayed response to the public adjuration. Infringements such as those described in Lev. 7:18; 17:16; 19:8 might sometimes be inadvertent, but seem sufficiently serious to make a sin offering inappropriate or insufficient. Other situations are clearly wilful (Lev. 20:17, 19; Num. 5:31; cf. Num. 9:13 where the man bears **sin**), and entail exclusion from the community or worse. In Lev. 10:17 it seems clear that the reception of the sin offering by the priest "bears the iniquity" of the error in question; the fact that here in v. 1 the man must bear his own offers a further hint that in this case no sin offering can be made.

The other three borderline cases involve a man's inadvertence; the man is initially **unaware of it** (vv. 2, 3, 4) ("the fact escapes him" – J. Milgrom (*Leviticus 1–16*, 1991)), and subsequently he discovers his error.

2. The first situation is contact with the carcases of unclean creatures. The word translated **beast** denotes any living creature; the **livestock** and **swarming things** are categories within the wider group. A fuller classification of creatures emerges in Leviticus 11. The concept of **guilt** (vv. 2, 3, 4) is discussed in connection with Lev. 4:3.

3. The second situation envisages inadvertent contact with the various forms of human uncleanness. These are given detailed analysis and consideration in Leviticus 12–15.

4. The third situation was perhaps the most problematic of

all. To what extent is a **rash oath** ("careless vow" – *GNB*) to do something a deliberate action? Elsewhere the word **rash** denotes hurtful, thoughtless or ill–advised speech (Num. 30:6, 8; Ps. 106:33; Prov. 12:18). The legislation recognizes that even here there may be elements of inadvertence, arising perhaps from an ignorance of the full circumstances and implications of the action. The benefit of any doubt is granted, and a sin offering is acceptable should the man wish to withdraw his oath.

5. Inadvertence does not therefore remove responsibility, and it is necessary that the man should **confess**. The basic idea here seems to be "acknowledgement" since the same word serves for situations in which Yahweh is praised or thanked (i.e. acknowledged). Other situations within the priestly writing that call for the acknowledgement of sin can be found in Lev. 16:21; 26:40; Num. 5:7.

6. The animal to be sacrificed is one of those prescribed in Lev. 4:27–35. The notion of **atonement** is discussed in connection with Lev. 4:20.

In vv. 7–10 provision is made for ordinary people, who cannot afford a lamb, to offer birds as their sin offering. It therefore connects naturally and easily with 4:27–35. As v. 9 makes clear the theme is still the **sin offering**, with **atonement** and **forgiveness** (v. 10) as the main requirements.

Some commentators consider these verses (along with vv. 11–13) to be a later humanitarian concession (K. Koch, *Die Priesterschrift*, 1959, pp. 58–60). This is preferable to Wellhausen's view (*Prolegomena*, 1878) that 5:1–13 are an independent treatment of the same material as that contained in 4:27–35. If it is a later concession it is certainly made within the outlook, perspectives and spirit of Leviticus as a whole.

7. *NRSV* (cf. also *GNB*, *NIV*) is wise to suggest **as your penalty** (rather than "guilt offering" – *RSV*). Some such understanding as "for his guilt" or "by way of reparation" would be acceptable. Gk reads here "for his sin". The birds required are those which may also constitute a burnt offering (1:14–17), but here two of either sort (**turtledove** or **pigeon**)

are necessary. One of the pair is to be offered as a burnt offering (v. 10).

The word rendered **sheep** (different from that employed in 4:32) may denote the young of goats as well as sheep, thereby incorporating also the situation envisaged in 4:27.

8. The first of the two birds is to be the sin offering. It is killed in much the same way as the burnt offering (1:15–16) (according to S. Daiches ("The Meaning of 'rp in Lev. 5.8", 1927/1928) it was probably the second cervic vertebra which had to be broken), but, though the blood must obviously be available (v. 9), there must be no severing of head from neck. This evidently distinguishes it from the burnt offering.

9. The manipulation of the blood requires that the priest **sprinkle** it on the **side** of the altar. It may seem surprising that there is no reference to the horns of the altar (4:7, 18, 30, 34), the anointing of which seems to be a vital part of the sin offering. The use of the altar side is a feature of the burnt offering (1:15), and is perhaps traditional custom with regard to birds. It may also be the case, as N. H. Snaith ("The Sprinkling of Blood", 1970/1971) implies, that the small size of birds and the relative shortage of blood has affected the rites. The same may be true of the "draining" (or "squeezing out"?) terminology. It is quite possible that practicalities and tradition had an influence on the sin-offering rites. On the other hand, the act of "sprinkling" (v. 9) marks this out clearly as a sin offering (cf. 4:6, 17) as also does the disposal of the rest of the blood at the altar **base** (cf. 4:7, 18, 25, 30, 34). The important point is that the altar is purified, according to custom, and thereby protected from defilement.

10. The second bird is a **burnt offering**; it is perhaps equivalent to the burning of the fat parts in 4:8–10, 19, 26, 31, 35. The **regulation** in mind is that described in 1:14–17. For consideration of **atonement** and the fact that the offerer is **forgiven** (v. 10) see on 4:20.

In vv. 11–13 there is a further concessionary provision for those too poor to be able to afford the birds cited in vv. 7–10. A small offering of cereal ingredients (**choice flour**) will suffice (v. 11), the absence of oil and frankincense making a

clear distinction between this and the cereal offering (2:1–3). The **memorial portion** (v. 12) (cf. 2:2) is required, and as with the cereal offering, and other sin offerings where blood is not taken inside the tabernacle, the priest may retain what is left for his own use.

11. Choice flour is discussed in connection with the cereal offering (2:1). **One tenth of an ephah** is probably about one kilogramme, and is evident elsewhere in P as a cultic measure (Lev. 6:20; Num. 5:15; 28:5). M. J. Geller ("The Šurpu Incantations", 1980) points to the use of flour in Mesopotamian incantations. It was suggested in 2:1–3 that the oil and frankincense which accompany the cereal offering have a dedicatory rather than a purificatory purpose; that they should be excluded here is therefore appropriate as well as a clear indicator of the difference between the two offerings.

12. The **memorial portion** is the representative sample wholly made over to God (see on 2:2). This evidently functions as an equivalent to the burning of the fat parts in sacrificial sin offerings (4:8–10, 19, 26, 31, 35) and the burnt bird in 5:10. For comment on the **offerings by fire** see on 1:9.

13. The meaning of **atonement** and the need to **be forgiven** are discussed in relation to 4:20. The benefits received by the priests from grain offerings (v. 13) are indicated in 2:1–10.

These concessionary measures, along with those in vv. 7–10, offer further insights into the cohesive view of society which is held in Leviticus (see also on 1:14–17). Provision must be made even for the poorest, because they too are part of the wider community whose well-being is safeguarded by the holiness of the sanctuary and the ordered system it exhibits. The concessions therefore affirm the identity of the poorest as members of that community, but also effectively consolidate their subordinate place within it, by drawing on their resources and by persuading them to recognize the hierarchies of power and privilege enshrined within the structure of the cultic system.

The fact that flour can accomplish the purificatory functions of the sin offering is a reminder that animal sacrifice

and the shedding of blood, while dominant in the surviving rites, are not a sine qua non of the system. More important is the principle of recompense whereby something costly in relative terms is offered for the sin committed.

The sin offering clearly exhibits the four-fold sacrificial structure that has become familiar in the pleasing odour sacrifices of chapters 1–3:

1) *Presentation* (4:3–4) – the animal is specified, brought to the door of the tent, and hands are imposed.
2) *Slaughter* (4:4) – the animal is killed before Yahweh.
3) *Disposal of Blood* (4:5–7) – there is a sevenfold sprinkling of blood before the veil within the Tent of the Tabernacle, an anointing of the horns of the incense altar, and a pouring out of the rest of the blood at the base of the altar of burnt offering.
4) *Disposal of Flesh* (4:8–12) – the fat parts are burnt (as with the peace offering), and the rest of the animal is burnt outside the camp in the clean place to which altar ashes are taken.

The topography of the priestly writing is again a crucial factor in understanding the processes involved. The priest's inadvertent error, for example, poses a threat to the ordered structured world the priests envisaged, and therefore to the well-being of the community; action is vital. Moreover, since the priest moves about in court and tabernacle it is essential that action be taken there. As usual boundaries must be preserved and protected – hence the sprinkling of the veil that marks the transition from holy place to holy of holies. The blood can be seen as both protecting against contamination and purifying any which may have occurred. The incense altar, at which the priest exercises a special and peculiar ministry, must likewise be protected and cleansed. The rites at the altar of burnt offering also mark a point of transition (between the camp and the court of the tabernacle), and the boundaries are thereby recognized, protected and purified.

2. THE GUILT OFFERING
(5:14–6:7)

This section on the guilt offering consists of three main elements:

5:14–16 – guilt offerings (neglected duties)

5:17–19 – guilt offerings (unwitting sins)

6:1–7 (Heb. 5:20–26) – guilt offerings (damage done to neighbours).

The guilt offering is evidently one of the expiation sacrifices, along with the sin offering, and in this respect is to be distinguished from the offerings by fire or pleasing odour sacrifices of Lev. 1:1–3:17.

As with the sin offering, the guilt offering is most clearly discernible in late literature of a priestly kind. In Ezek. 40:39; 42:13; 44:29 it is clearly differentiated from the burnt, sin and cereal offerings, and it is also distinguishable in the Holiness Code (Lev. 19:21, 22). It continues to figure in later parts of the Manual of Offerings (Lev. 6:6, 17; 7:1, 2, 5, 7), and also has a place in the Manual of Purity (Lev. 14:12–14, 17, 21, 24, 25, 28). It is familiar in the priestly legislation in Numbers (5:7–8; 6:12; 18:9). There are also two interesting contexts outside the priestly literature (1 Sam. 6:3–4, 8, 17; 2 Kgs 12:16). The word for guilt offering occurs in Isa. 53:10 in what appears to be a sacrificial context, but there are many textual uncertainties there.

As with the sin offering, concepts of **atonement** and **forgiveness** are prominent (Lev. 5:16, 18; 6:7). Some detail concerning the rites is found in 7:2–5. Again, as with the sin offering, inadvertence is a factor (Lev. 5:18). The main distinguishing feature is an act of restitution (Lev. 5:16; 6:5).

The evidence in Ezekiel gives no clues as to the circumstances that would warrant a guilt offering. The same is true of 2 Kgs 12:16, though the text does attest some kind of monetary recompense for offences. The situation in 1 Sam. 6 links guilt offerings with the attempts by the Philistines to be rid of the plague associated with their possession of the ark. The guilt offering here consists of five gold tumours and five

gold mice (1 Sam. 6:4), which presumably constitute a monetary gift. They are prescribed by the local priests and diviners (1 Sam. 6:2).

Some scholars have claimed to find evidence of a Canaanite guilt offering (see discussion by R. J. Thompson, *Penitence*, 1963, pp. 30–33), though many would consider the evidence inadequate (e.g. J. Gray, "The Religion of Canaan", 1965, pp. 152–217). The doubts are confirmed in a technical study by D. Kellermann ("Asham in Ugarit?", 1964), who maintains that there is no known equivalent to the term for guilt offering in Ugaritic.

There have been numerous attempts to specify the difference between sin and guilt offerings, and to trace their development. One proposal by P. P. Saydon ("Sin-Offering", 1946) was that sin offerings covered sins arising from human frailty, as opposed to high-handed disregard for the Law for which there could be no sacrifice (Num. 15:30). The guilt offering covered sins of ignorance and inadvertence. Such a view would clearly have to reckon with a tendency in priestly literature to blur these distinctions. A popular alternative has been the supposition that sin offerings deal with offences involving God alone, while guilt offerings, with their restitution to the neighbour principle (Lev. 6:5) were for offences which also involved other people. Here again some blurring of the difference within priestly tradition may be presupposed.

R. Rendtorff (*Studien*, 1967, pp. 207–211) has suggested that historically the guilt offering may have been an older form of the sin offering, perhaps for the individual, and that subsequently the sin offering progressively took over this role, leaving the guilt offering as a form of recompense only. A more thorough account, based on the evidence of the Philistine guilt offering, is proposed by B. A. Levine (*In the Presence*, 1974, pp. 91–101). The context suggests the misappropriation of sacred property. The guilt offering is a gift to the offended deity, something in addition to the restitution of the property. The action of the Philistines in appropriating the ark is not inadvertent as such, but they are unaware of the extent of the offence and the severity of the penalties.

This entails therefore the feasible proposition that originally the guilt offering was not an animal sacrifice at all, but a monetary gift to the deity to placate him for offences committed and to alleviate the evidences of his wrath (N. H. Snaith ("The Sin Offering", 1965) calls it a "compensation offering", B. A. Levine (*In the Presence*, 1974) an "expiatory penalty" and J. Milgrom (*Leviticus 1–16*, 1991) a "reparation offering"). As such it was an alternative to animal sacrifice, though the latter may have been deemed appropriate for specific kinds of offence, such as the misuse of sacred property. The priests would normally be the recipients of such financial offerings. As B. A. Levine (*In the Presence*, 1974, pp. 91–101) observes the guilt offering was never apparently part of the Temple cult, and no provision is made for offences by priests. A. Marx ("Sacrifice de Réparation", 1988) sees rites of sanction removal in various earlier texts, and the function of the guilt offering as a means of bringing to an end any reprisals to which the offender was exposed.

In the course of time the guilt offering was drawn into the sacrificial system, with the modifications and developments now evident in the priestly writing. The basic principle of offering money to the priests is preserved (Lev. 5:16), but with the additional requirement of a ram, offered (presumably) in accordance with the rites of the sin offering (Lev. 5:16,18). Further developments would involve the extension of guilt offerings to cover a wider range of offences, particularly those involving fellow Israelites, and the requirement that restitution be made to any adversely affected by the offence (Lev. 6:5). The principle of restitution to other people, sometimes in monetary form, was well established in ancient law (Exod. 21:19, 22, 32, 34, 36; 22:1, 4, 5, 6, 7, 12, 14, 17), and is a natural enough development in the history of the guilt offering.

Other situations that call for a guilt offering fit the general picture. The examination of a skin disease causes damage to the priest concerned (Lev. 14:12–14). The Nazirite is also sacred property (Num. 6:12). In Lev. 19:21 and Num. 5:7–8 there is damage to, or misappropriation of, the property of others.

In vv. 14–16 the guilt offering is introduced. As with the sin offering the circumstances that warrant it entail some degree of inadvertence (**unintentionally** (v. 15)). The way in which the circumstances are differentiated from those that call for a sin offering is by the word **trespass** ("breach of faith" – *RSV*; "violation" – *NIV*) (v. 15), and which has something to do with **the holy things of Yahweh** (vv. 15, 16). A further point of distinctiveness relates to the animal to be offered, a **ram** valued according to the norms of the sanctuary (v. 15). Full financial restitution, plus a further penalty of twenty per cent (v. 16), are additional features that distinguish the guilt offering. They are a necessary precondition for the purification process that the priest undertakes (**atonement**) and for the **forgiveness** that ensues (v. 16) (see on 4:20).

15. The word **trespass** often carries the sense "to act unfaithfully" or "treacherously". It is most commonly found in the priestly writing (Lev. 6:2; 26:40; Num. 5:6,12, 27; 31:16; Josh. 7:1; 22:16, 20, 31; Deut. 32:51), and in other relatively late texts that have been subject to priestly influence (e.g. Ezra 9:2; Neh. 1:8; Ezek. 14:13; Dan. 9:7; 1 Chr. 2:7). There are occasional occurrences in wisdom literature (Prov. 16:10; Job 21:34). The vast majority of these "trespasses" are against God, the situation in Num. 5:12, 27 (against a husband) being the exception.

At first sight it seems difficult to see how an action could be done both "unfaithfully/treacherously" and **unintentionally**. The principle of inadvertence seems to be fundamental – there could be no sacrifice for high-handed sin (Num. 15:30–31) – but trespass errors are serious and cannot be treated lightly. B. A. Levine (*In the Presence*, 1974, pp. 91–101) understands "misappropriation" to be the issue. These errors relate to **the holy things of Yahweh** (v. 15), and would presumably involve any misappropriation or misuse of sacred objects (thus Levine). Since a financial measure is given by which restitution is to be assessed (v. 16) it may be the case that financial dues are principally in mind (hence *REB* – "defaulting in dues"). An inadvertent failure to render Yahweh what he requires might be the point at issue.

The **ram** makes its first appearance here in Leviticus, as a

suitable animal for sacrifice; it has an important place within the priestly ordination rites of Exodus 29 and Leviticus 8. Its use for sacrificial purposes is well attested in earlier literature (e.g. Gen. 15:9; 22:13; Num. 23:1; 1 Sam. 15:22; Isa. 1:11; Mic. 6:7; cf. Ps. 66:15).

The phrase **convertible into silver by the sanctuary shekel** ("according to the official standard" – *GNB*) is obscure. It may mean that Moses himself (in practice the priests) is to decide how valuable the ram must be for the offence in question (thus *REB*). B. A. Levine (*In the Presence*, 1974, pp. 91–101) discusses Speiser's view, based on Lev. 27:2, that the phrase means "convertible into silver shekels". G. J. Wenham (*The Book of Leviticus*, 1979) comments unsympathetically on Jackson's view that, in addition to the return of the property and the twenty per cent fine, a sum equivalent to the value of the property must be paid. The phrase possibly reflects older custom in which guilt offerings were essentially a financial offering (reparation).

The **sanctuary shekel** is also referred to in Exod. 30:13; Lev. 27:25; Num. 3:47; 18:16; Ezek. 45:12. It presumably needed to be mentioned here because it differed in weight from that used in other transactions.

16. The word **restitution** was already well established in older legal texts (Exod. 22:3, 5, 6, 12) and probably reflects something of the original and essential character of the guilt offering. The addition of a **fifth**, a twenty per cent fine, corresponds with the requirements of Lev. 6:5; Num. 5:7. In some of the older legislation there is a tendency for certain offences to demand higher rates of recompense (Exod. 21:37–22:3, 4, 9); the usual explanation is that here the offender has confessed.

The action of the priest in making **atonement** and securing **forgiveness** is familiar from the sin offering (see 4:20).

This small textual unit contains no information about the guilt offering rite – for this reference must be made to Lev. 7:1–10. The reparation principle is thus easily recognized as integral to the priestly interest. Damage done, whether to the sanctuary or to members of the community, particularly

damage with financial implications, must be rectified by means of an offering, restitution and a fine. In this way disorder and social fragmentation is checked and the priestly world view of God–Sanctuary–Community, as embodiments of holiness, is sustained.

In vv. 17–19 the distinction between the guilt offering and the sin offering seems blurred (K. Koch, *Die Priesterschrift*, 1959, pp. 58–60). The circumstances envisaged seem to be precisely those for the sin offering in Lev. 4:27. Some positive infringement of divine requirements has taken place (v. 17) – and the action has been done **unwittingly** (v. 18). Yet the sacrificial demand (v. 18) is for a guilt offering of a ram, just as it is in v. 15.

It might be argued that this piece of text simply reflects a phase in the development of sacrificial institutions when the distinctions between the two offerings had been confused, and it can certainly be maintained that the guilt offering has been subject to systematizing influences from elsewhere, particularly perhaps in the demand that it include an animal sacrifice. It is also possible that divergent custom lies behind the final form of Leviticus, though it is difficult to determine from where such divergence could have come; the traditions of the Jerusalem Temple remain the only likely source for such material.

In fact, such explanations do not do justice to the final editors of Leviticus. It is reasonable to assume that they were not unaware of the point at issue, and some account of how they might have understood it is desirable.

It is commonly held that the kind of guilt offering envisaged here was of a precautionary nature (e.g. A. T. Chapman and A. W. Streane, *The Book of Leviticus*, 1914 and N. H. Snaith, "The Sin Offering", 1965 cf. Job 1:5). B. A. Levine (*Leviticus*, 1989) calls it an offering of contingency. The man does not know whether he has offended and is taking action in case he has. It needs to be recognized that **unwittingly** (v. 18) is different from the word used in Lev. 4:1. J. Milgrom (*The Cultic Ṣegāgāh*, 1967, *Leviticus 1–16*, 1991) sees in this distinctive phraseology a new category of sin, one which was a major concern in the ancient near east, namely an act of sacrilege

which was feared, but not known. G. J. Wenham (*The Book of Leviticus*, 1979), adopting a similar perspective, stresses the uncertainty and feelings of guilt.

These suggestions are certainly possible, and would involve reading **incurred guilt** as "feels guilt" (Milgrom) or "suspects guilt". The supposition would have to be that these feelings and suspicions actually constitute "guilt", since in v. 19 liability seems to be assumed.

If we think that the references to **incurred guilt** imply that the truth has come to light we may favour the proposal of N. Kiuchi (*The Purification Offering*, 1987, pp. 25–31) that the action was not known to be an offence when it was committed.

One further substantial point of difference in the account of v. 17, as compared with Lev. 4:27, is that the offence is such that the man must be **subject to punishment** ("bear the consequences of his fault" (*NJB*)). This phrase is not used in relation to the sin offering; its only previous occurrence (in Lev. 5:1) relates to a borderline case in which we have suggested that a sin offering could **not** be offered (whether a guilt offering could be made for that offence is unclear). It may be suggested tentatively that this stress on the offender's carrying the consequences relates to the restitution and fine which are characteristic of guilt offerings, and that in this text they are simply taken for granted. In other words there are errors (of the type for which sin offerings are appropriate) which also entail financial damage and for which the appropriate compensation or reparation must be made. This point was probably clear enough to the priestly traditionalists; what they were particularly concerned to stress in vv. 17–19 was that the ram of the guilt offering must be offered as well. The primary purpose of the sin (or purification) offering was protection of the sanctuary in situations where negligence or ignorance of divine commands posed a threat. If that ignorance had also caused financial loss (to the sanctuary or to a neighbour) then the compensation and fine must be paid and the compensation offering (the guilt offering) made.

The concluding section (6:1–7) is mainly concerned to illustrate situations in which the damage caused is to a neighbour; the damage relates essentially to the misuse or misappropriation of property, and therefore has financial implications. By contrast the situations envisaged in Lev. 5:14–19 are those in which the sanctuary has suffered. It becomes clear that in these cases to sin inadvertently is not a crucial factor; there may be deceit (v. 2) or lies (v. 3).

The remedy in such cases is the same as in those situations affecting Yahweh and the sanctuary; there must be full restitution, the payment of a twenty per cent fine, and the offering of a suitable ram as a compensation or reparation offering.

2. As in Lev. 5:15 the offences warranting a guilt offering are described as a **trespass** (v. 2), best understood, with Levine, as misappropriation (see on Lev. 5:14–16). The point is made very clearly that while these offences affect a neighbour they are also **against Yahweh**. Four types of misappropriation appear to be described:

a) a **matter of deposit or a pledge**. A **deposit** is evidently property left in the care of the offender. In Gen. 41:36 it is used of the grain stored up against the seven years of famine. The root of the word rendered **pledge** is common enough, but is used only here in a technical sense in relation to property (a "contract" in *REB*). Any difference in meaning between the two words is hard to recover. An illustration from older legislation of problems that could arise in relation to deposits or security is found in Exod. 22:7–8.

b) **robbery** is commonly used elsewhere, but often in a general and unspecific way. Where it is used with more precision it suggests the seizure and exploitation of the property of others – e.g. in Gen. 21:25 (a well), Job 20:19 (a house), 2 Sam. 23:21 (a spear), Deut. 28:31, Job 24:2, Mal. 1:13 (livestock), Jdg. 21:23 (womenfolk).

c) **defrauded a neighbour** probably refers to various kinds of "extortion", though there are few indications elsewhere as to the forms this might take in ancient Israel. On a

number of occasions it occurs in close association with **robbery**, and the poor or weak are often the victims (e.g. Eccl. 4:1; Ps. 72:4). Deut. 24:14–15 and Mal. 3:5 suggest that the witholding of wages would constitute oppression of this kind (cf. Lev. 19:13).

3. d) **found something lost and lied about it** suggests that the offender has taken an oath to the effect that the property was **not** in his possession – hence **swear falsely**. Oath-taking on a wide range of issues is familiar in the Old Testament. There are examples in the older legislation of its use to settle disputes about property (Exod.22:11, and probably 23:8, 9), particularly in relation to deposits and lost property. It is possible to conclude, with J. Milgrom ("The Priestly Doctrine", 1975), that all the offences delineated in vv. 2–3 are understood to be accompanied by false oaths. It is also possible with *NJB* to see here two offences – failing to return lost property to its rightful owner, and perjury.

4. The four situations are repeated, and in each case full restitution is required.

5. It is recognized here that there could easily be other situations in which a deceitful oath had been taken. The further fine of twenty per cent of the value of the property is the customary measure (see Lev. 5:16), and is payable to the offended party on the day the reparation offering is made.

6. The sacrifice is made according to the principles set out in Lev. 5:16, 18.

Supplementary regulations relating to situations of this kind occur in Num. 5:5–10; they imply that if for some reason restitution cannot be paid to the offended party it should go to his kinsmen, and indicate that if there are no close relatives restitution should be made Yahweh (the priest).

An obvious difficulty raised by this legislation is the apparent contradiction between these verses in Lev. 6:1–7 and those in Num. 15:30–31 where deliberate sin (with a "high hand") precludes any possibility of sacrifice. J. Milgrom ("The Priestly Doctrine", 1975) addressed this issue with his view that "feeling guilty" best renders the sense of v. 4 – contrast

"become guilty" (*RSV*) with **realize your guilt** (*NRSV*). For Milgrom remorse and confession reduce deliberate sin in the priestly scheme of things to an offence of inadvertence. The deceit clearly entailed in Lev. 6:1–7 is therefore not with a "high hand", and can be dealt with by restitution and sacrifice. A. C. J. Phillips ("The Undetectable Offender", 1985) prefers to conclude that Lev. 6:1–7 (along with 5:1) provide for deliberate but undetectable cases. On this view the legislators are anxious to encourage confession for offences which would normally require that the offenders be "cut off" (as in Num. 15:30–31), by providing a relatively lenient alternative. Their overriding anxiety is to avert the contamination that undetected sin causes to the sanctuary.

C. RULES FOR THE DISPOSAL OF OFFERINGS
1. THE BURNT OFFERING
(6:8–13)

These verses seem to mark the beginning of a second major collection of priestly laws within the Manual of Offerings (see The Manual of Offerings – Introduction). The first section has one component:
6:8–13 (Heb. 6:1–6) – concerning burnt offerings.

That this material is specifically for the attention of the priests is suggested by the beginning of v. 9 and by the general content. R. Rendtorff (*Die Gesetze*, 1963), following J. Begrich, is happy to designate it as priestly knowledge, to distinguish it from the torah or teaching which was information needed by the laity. It is the case nevertheless that **torah** is the specific word used to describe the content (vv. 9, 14) (see also K. Koch, *Die Priesterschrift*, 1959), and it is probably best to depict all such material as "laws" or **ritual**. In any event it is clear that this is yet another body of material drawn from the accumulated traditions of priestly expertise.

These verses offer further information about the procedures surrounding burnt offerings. In effect they supplement the section that deals with the disposal of the flesh in

Lev. 1:6–9. The focus is essentially on the altar fire, and the ashes of the offering. In the priestly scheme there are public burnt offerings morning and night (Exod. 29:38–42), in addition to the private sacrifices with which Lev. 1:2–3 seem to be concerned.

9. Here the priests are required to ensure that burnt offerings remain on the altar overnight, and that the altar fire is kept burning throughout.

The phrase **this is the ritual of** (i.e. **torah**) is characteristic of the regulations in this second main collection (6:14, 25; 7:1, 11, 37). Though the content of these regulations concerned the priests rather than the laity the suggestion by J. Begrich (*Die Priestersliche*, 1938) that the word has its background in the responsibility of priests to teach the laity the difference between clean and unclean remains plausible (cf. Lev.11:46–47).

The phrase **on the hearth** is usually taken to refer to the plate or top of the altar on which the burnt offering was laid (*BDB*). N. H. Snaith (*Leviticus and Numbers*, 1967) comments on the possibility that it means "burning mass".

10. In the morning the priest, suitably robed, is to place the ashes beside the altar. The word for **vestments** can occur in relation to a variety of types of clothing (Jdg. 3:16; 1 Sam. 17:38, 39; 18:4; 2 Sam. 20:8), but here, made of **linen**, evidently denotes specific priestly vesture. The **linen undergarments** ("shorts" – *REB*, *GNB*) are peculiarly priestly (Ezek. 44:18; Exod. 28:42; 39:28; Lev. 16:4); their function is to protect against any unseemly exposure (before the altar rather than to the eyes of the people – N. H. Snaith (*Leviticus and Numbers*, 1967)). It seems probable that the special status of these clothes is intended to contrast with the **other garments** (v. 11) in which the priest is to carry the ashes outside the camp.

11. Having changed into ordinary clothes, thereby protecting the sanctuary garments from any impurity, the priest must carry the ashes to a clean place outside the camp (cf. Lev. 4:12). Since holiness can itself be dangerous it may also be that the ordinary clothes eliminate risk to anyone he might meet (J. R. Porter, *Leviticus*, 1976). The basic require-

ment is a reminder that the burnt offering, even when reduced to ashes, has a special status as God's property. Outside the camp there are both **clean** (v. 11) and **unclean** (Lev. 14:40) places.

12. Further regulations insist that the fire on the altar of burnt offering must be kept burning continually, even after the offerings have been consumed. There is a reminder that this altar of burnt offering is also the place where the fat of the peace offerings is burned (cf. Lev. 3:5).

The way in which ashes are to be disposed of must again be understood in the light of the priestly writing's cultic topography and the theory of holiness which accompanies it. The burnt offering belongs to the deity, and the remains are evidently holy. In removing them from the altar in his holy vestments the priest recognizes these crucial distinctions. The change of clothing for the journey from divine space through the camp to the wilderness outside is a further recognition of the decisive boundaries. The ash tip outside the camp is a unique sector of divine space and an essential acknowledgement of the burnt offering as wholly God's. The fire must be kept alight at all times so as to ensure that all parts of the sacrifice, whether private or public, are wholly consumed, and to ensure that there is always fire available. In these ways the priestly system of an ordered community is sustained, and threats to its stability and well-being are averted.

2. THE GRAIN OFFERING
(6:14–18)

This section contains:
6:14–18 (Heb. 6:7–11) – concerning grain offerings.

Just as 6:9–13 provide additional instructions about the disposal of the flesh in burnt offerings, so these verses offer further information about the disposal of the remainder from grain offerings (see Lev. 2:3,10). The further clarifications occur in vv. 16–18.

14–15. Little is added to the regulations in Lev. 2:1–3, 4–10, though there is a note that some act of offering (a ritual gesture?) should take place **in front of the altar**.

16. In Lev. 2:3, 10 all that is said about the remainder is that it belongs to the sons of Aaron and that it is **most holy**. Here there is indication of the use to which it must be put. In brief the requirements are that it must be eaten. Initially a **holy place** (the phrase is discussed by D. P. Wright (*The Disposal of Impurity*, 1987, pp. 232–235)) is defined as the appropriate location (v. 16), but this is then more narrowly specified as the **tent of meeting** (cf. on Lev. 1:1).

17. The further insistence that no leaven must be baked with it is in accordance with the exclusion of leaven from the offering process (Lev. 2:11). For the phrase **offerings by fire** see on Lev. 1:9. The grain offering is then depicted, like the sin and guilt offerings, as **most holy** (Lev. 2:3,10); the point of this phrase appears to be that what remains of the offering can only be disposed of in a special way, and in particular by eating.

18. Only males in Aaron's family ("priests" in Gk) have this right to eat. Their families are supported in other ways. The priests are a holy location in the same way as the clean place which receives the ashes of the burnt offering (Lev. 6:11).

The final phrase indicates that the same is true of Yahweh's offerings by fire – **anything that touches them shall become holy**. There were situations in which holiness, unlike uncleanness, was not passed on through contact (cf. Hag. 2:10–13), but in the circumstances envisaged here (cf. Lev. 6:27) the holiness seems to be contagious and possibly dangerous (cf. Exod. 19:12; 2 Sam. 6:6–7). The point may well be that the offering is **most holy**. *GNB* renders it ". . .will be harmed by the power of its holiness". B. A. Levine (*Leviticus,* 1989) (supported by J. E. Hartley (*Leviticus,* 1992), but not by J. Milgrom, (*Leviticus 1–16,* 1991, pp. 443–456)) thinks the phrase could be better rendered as "Anyone who is to touch these must be in a holy state", which avoids the supposition that sometimes holiness is contagious. Milgrom, by contrast, insists, among other things, that "become holy" (not "must be holy") is inescapable (cf. also A. T. Chapman

and A. W. Streane (*The Book of Leviticus*, 1914); N. H. Snaith (*Leviticus and Numbers*, 1967)). Anything which is **most holy** is contagious, and contact with it absorbs its holiness. *REB* reads "Whoever touches it is to be treated as holy" (cf. *NEB*'s "forfeit as sacred").

As with the further regulations about the disposal of the burnt offering (Lev. 6:8–13), the topographical factors are crucial. The grain offering is holy and its holiness must be preserved; it is therefore consumed by holy people (the priests) in a holy place (the precincts of the tent of meeting). Here again theory about the structure, operation and location of holiness serves the interests and stability of the society the priests sought to build. The priests have privileges and responsibilities that set them apart, a separation that must be carefully maintained.

3. THE ORDINATION OFFERING
(6:19–23)

This section appears to supplement material in Exod. 29:1–37 about the ordination of priests – see also Lev. 8–9. It consists of one textual unit:
6:19–23 (Heb. 6:12–16) – concerning the priests' ordination offering.

20. The ordination offering is clearly in all essentials a grain offering (cf. Lev. 2:1–10). The offering consists of **choice flour** (cf. Lev. 2:1). It must be offered in two parts, half in the morning and half in the evening. The twice-daily offering of cereals and a libation in association with the continual burnt offering is already established in Exod. 29:38–42 (cf. Num. 28:3–8).

The **tenth of an ephah** is a familiar measure (see Lev. 5:11); it is also specified in Num. 28:5 for the daily public grain offering. The word **regular** denotes "continuity" (BDB), the point of which is unclear. Does it denote the daily presentation or what must obtain at all subsequent ordinations?

Differences between this and what is said to occur in 8:26–28 add to the difficulties. B. A. Levine (*Leviticus*, 1989) (supported by J. E. Hartley, *Leviticus*, 1992) takes these verses to be the pattern for the daily grain offering.

21. It is mixed with **oil** and made on a **griddle** (cf. Lev. 2:5). It is described as a **pleasing odour** offering (cf. Lev. 2:2), and explicitly compared to the grain offering. There is no reference to frankincense, however, and above all no **token portion**; the whole of the offering is to be burned. In this latter respect the ordination offering is comparable to the burnt offering.

The word rendered **well soaked** ("mixed" – *RSV*; "well mixed" – *NIV*, and favoured by some commentators) is uncommon and is always used in a technical sense in relation to offerings (cf. Lev. 7:12; 1 Chr. 23:29). J. Milgrom (*Leviticus 1–16*, 1991) raises the possibility, based on non-biblical sources, that "boiling down" may cast light on the word.

Whether **baked** is correct is uncertain, the word occurring only here (thus B. A. Levine, Leviticus, 1989) – "baked (slices)". Some suspect that the verb **to break** (i.e. into pieces like a grain offering – cf. Lev. 2:6) is the intended meaning (BDB, *BHS*; *NIV*) – hence **several pieces** (*NJB*), **crumbled in small pieces** (*REB*; cf. *GNB*). A proposal by J. H. van Leeuwen ("The Meaning of tuphîn", 1988) reads it as "folded parts of the meal offering of pieces".

22. No part may be eaten, even by the priest (cf. v. 23). This means that the ordination offering must be clearly distinguished from the grain offering. As part of a large collection which deals in the main with the question of how the remains of offerings are to be disposed of (Lev. 6:8–7:21) it is appropriately placed as a useful reminder that there are offerings with cereal content which must not be eaten.

The phrase **a perpetual due** echoes v. 18, and emphasizes the binding authority of the regulations in question.

The phrase **turned entirely into smoke** embodies a word that can denote the burnt offering (Deut. 33:10; cf. also v. 23).

Though Exod. 29:1–46 contains references to cereal products in the rites of ordination, the offering here in Lev.

6:19–23 appears to be additional. The cereals referred to in Exod. 29:2–3 apparently function as a distinct "elevation" or "wave" offering (Exod. 29:24). Nor is there any further reference to this ordination offering in Leviticus 8–9 (the account of the ordination), suggesting that vv. 19–23 here may be a relatively late insertion. Their function is apparently to high‑ light the importance of the ordination rites in a distinctive way – a grain offering that is wholly burnt – thereby enhancing the dignity and separateness of the priesthood and its favoured place within the community.

4. THE SIN OFFERING
(6:24–30)

This section has obvious affinities with Lev. 6:8–18. There additional information was given about the disposal of the burnt and cereal offerings. Here further regulations, drawn from the stock of priestly experience and expertise, are provided about the disposal of the sin offering:
6:24–30 (Heb. 6:17–23) – concerning sin offerings.

As previously noted there is evidence of two methods of disposal in relation to the sin offering – that which is burnt outside the camp (Lev. 4:12, 21) and that which, as here, is eaten. It was suggested that this difference could be explained in the light of the inherent ambiguity of the priest's position, sometimes representing the human pole in the offering process, and sometimes the divine. When the sin offering is for priests (Lev. 4:1–12) or the whole community (Lev. 4:13–21) they obviously have a part in the errors that are being expiated. On the other hand, when the sin is committed by a ruler (Lev. 4:22–26) or lay person (Lev. 4:27–31) priests can represent the deity, and properly receive the flesh of the offering. It is this latter situation, the sin offering of a ruler or lay person, which is in mind here in Lev. 6:24–30. The different methods of disposal are also accompanied by different blood rites. The sin offerings for priests and the community involve rites of purification within the tent of

meeting (Lev. 4:6–7, 17–18); other sin offerings do not. An example of Aaron's failure to observe the distinction correctly is recorded in Lev. 10:16–20.

25. The requirements are described as **ritual** (or "law" – **torah**), as is frequently the case with regulations dealing primarily with the disposal of offerings (cf. 6:9, 14, 19; 7:1, 11).

The place at which the sin offering is to be killed has already been specified (Lev. 4:24), while the phrase **most holy** is familiar as a way of describing parts of offerings which belong to the priests (Lev. 2:10; 6:17).

26. The regulations require that the priest who makes the offering must eat it in the court of the tent of meeting.

27. As with the offerings by fire (v. 18) objects coming into contact with the flesh or the blood become holy, and steps must be taken to restore the situation to normality (cf. v. 28). As in v. 18 B. A. Levine (*Leviticus*, 1989) prefers "must be in a holy state" to the notion that holiness is contagious. J. Milgrom (*Leviticus* 1–16, 1991) stresses the ambiguity of the blood in the sin offering, the fact that it can be most sacred and also a source of impurity. For him it is not the case that the garment becomes holy; it is because of the impurities that the blood absorbs that washing is required. It seems desirable nevertheless to read **become holy** in v. 27 as in v. 18, and this is not impossible.

Three particular situations are envisaged:

a) that of a garment with blood stains from the sin offering. This must be washed in a holy place. Washing, as a means of restoring normality to situations, is frequent in priestly legislation (e.g. Lev. 11:25, 28; 13:6, 34; 15:11; Num. 8:9), and this may do better justice to it than the concept of purification. Whether or not we accept the view that the blood absorbs impurity the point is not so much that the garment needs to be purified, but that the blood not disposed of as prescribed must be eliminated.

28. The other situations are:

b) that in which an **earthen vessel** ("clay pot" – *GNB*; *NIV*)

has been used to boil the flesh. This must be broken. It may be that, because the earthen vessel was absorbent, the problem could not be solved by washing alone; only destruction would be effective. D. P. Wright (*The Disposal of Impurity*, 1987, pp. 93–113) finds Hittite and Indian parallels for this practice, and suggests that clay containers were readily available and inexpensive. Their disposal, he proposes, is an example of the readiness of the priests to accommodate ritual to economics; other less available items need not be discarded provided they are purified in prescribed ways.

c) that in which a **bronze vessel** ("copper" – *REB*; "metal" – *GNB*) has been used. This need not be discarded, but must be thoroughly **scoured** and **rinsed** in water.

These verses (vv. 27–28) are curious in that they seem to indicate that the flesh is "holy", and yet they prescribe procedures which look very much like purification rites to deal with "impurity". They may reflect beliefs, possibly of some antiquity, to the effect that "holiness" was also dangerous and needed to be guarded against. There was the danger too that holy items might be unwittingly profaned. A garment with blood on it is exceptionally holy; it is God's alone. If it is to be restored to normal priestly use it must be washed. The earthen vessel is discarded because it is God's; it is holy and, like the ashes of the burnt offering (Lev. 6:11), must be safeguarded from subsequent profanation. The regulations regarding bronze vessels are concessionary; the rigorous cleaning procedures are held to prevent any such profanation and restore the object to normal use. For further discussion see 11:33–35.

30. The blood rites characteristic of sin offerings for priests and the community are identified as the guidelines which determine whether or not the sin offering may be eaten.

This section is consonant with the view that sin offerings do not "carry" impurities; the function of the offering rather is to "protect" and "purify" the realm of the holy from defilement, and in this they are effective because they have an

intrinsic holiness that can actually be transmitted to other objects. In sin offerings made by lay individuals the priests represent the divine pole. The blood which protects has not been brought into the holy place, and consumption by the priests who represent God is therefore an appropriate way of disposing of the flesh. The sacred order which distinguishes holy and profane is acknowledged, and the proper social order, as the priests perceived it, is preserved.

5. THE GUILT OFFERING
(7:1–10)

This section continues the discussion of how various sacrifices are to be disposed of:
7:1–10 – concerning the disposal of guilt offerings.

1. Once again rites of this kind are described as **ritual** (*NRSV*) (or "law" – **torah**) (6:9, 14, 25; 7:11) The words **most holy** (cf. v. 6) indicate that the offering belongs to the priests and must be eaten by them in a holy place. Restitution is an important feature of the guilt offering (Lev. 5:16; 6:5), but sacrifices were also demanded (Lev. 5:15, 18; 6:6), and it is with these that vv. 1–7 are concerned.

2. Aspects of the rite are described for the first time in vv. 2–5, and though these have affinities with the sin offering (4:8–9; 5:24), particularly with regard to the fat and entrails, the closest connection is with the well-being offering (cf. 3:9–10). One point of contact is the requirement that the blood be **dashed against all sides of the altar** (v. 2, cf. 3:8). In this the guilt offering is distinct from the sin offering. The prime concern is not protection of the sanctuary, but the restitution that the offender must make.

3. In Gk and Sam. (of vv. 3–4) an account of the fat is given that corresponds exactly with the peace offering.

5. The description of the sacrifice as an **offering by fire** is a further link with the well-being offering (cf. 3:11), and a point of difference from the sin offering.

6. The guilt offering does resemble the edible sin offering

in that the flesh, once the fat has been burned, belongs
exclusively to the priests (cf. v. 7).

8. This fact prompts a further concession to priestly inter-
ests in relation to the burnt offering. The officiating priest is
entitled to the skin.

9. The unit concludes with further clarifications about the
grain offering (cf. 6:14–18). Those which have been baked in
some way, as described in 2:5–7, belong to the officiating
priest.

10. Other grain offerings belong to the sons of Aaron as a
whole and must be shared. This is the usual way of inter-
preting a text which in Hebrew could be hard to reconcile
with v. 9. J. Milgrom (*Leviticus* 1–16, 1991) thinks the point is
the same as in 6:26, 29, and that the meaning of vv. 9–10 is
that the officiating priest has the right to distribute his share
among his fellow priests.

6. THE WELL–BEING OFFERING
(7:11–18)

These verses look more closely at different kinds of well-
being offering, as well as the matter of their disposal:
7:11–18 – concerning the disposal of well-being offerings.

New aspects of the text distinguish various motives for
making a well-being offering. It may be an act of thanks for
benefits received (a thanksgiving offering (v. 12)) ("praise" –
NJB), or to fulfil a vow (a votive offering (v. 16)), or an action
in honour of the deity unprompted by specific circumstances
(a freewill offering (v. 16); "voluntary offering" (B. A. Levine
(*In the Presence*, 1974, pp. 3–8))). For some discussion of the
thank offering see G. Couturier ("Le Sacrifice", 1982) who
argues that it was a community rather than a private event. A
discussion of the votive offering and its association with the
well-being offering is provided by B. A. Levine (*In the Presence*,
1974, pp. 42–45). Additional rites, similar to those which
constitute the grain offering, are required in the case of a
well-being offering for thanksgiving (vv. 12–13). Nevertheless

the question of disposal continues to dominate (vv. 14–18).

11. The procedures are **ritual** (or law – **torah**) (cf. 6:9, 14, 25; 7:1).

12. Well-being offerings for thanksgiving ("an expression of gratitude" – B. A. Levine (*Leviticus*, 1989)) must also contain cereal products:

– **unleavened cakes mixed with oil**
– **unleavened wafers spread with oil**
– **cakes of choice flour well soaked in oil** ("flat bread cakes"– *REB*).

The demand here for **oil** is of interest – contrast Lev. 5:11 where in the case of cereal products which are part of a sin offering the use of oil is prohibited. The oil dedicates the cereal products to God; it cannot be used for rites which purify or protect. The cereal products and the oil make a well-being offering a thank offering.

13. The thanksgiving offering must also contain:
– **cakes of leavened bread** ("flat cakes" – *REB*).
In all essentials the terminology here agrees with the products suitable for a cereal offering (Lev. 2:4).

14. One of the cakes, presumably from each of the kinds offered (Gk seems to suggest from one only), has a different status from the rest. The special word **terumah** is somewhat obscured by *RSV*'s generalized translation **an offering** (v.14) – hence *NRSV*'s **gift**. (This is the "heave offering" of old translations (*RV*)). BDB suggests "contribution" (also *NEB*; *NIV* and B. A. Levine (*In the Presence*, 1974, pp. 3–8); "special contribution" – *GNB*). Outside the priestly writing it first occurs in Deut. 12:6, 11, 17 – "your donations", and cereal products are probably in mind (n.b. the close link with tithes in vv. 6, 11). This connection with the land is confirmed in Ezek. 45:13, 16; Num. 15:19–21, and indeed the word can be used of a holy portion of land (Ezek. 45:1; 48:8, 9, 10, 18, 20, 21). In the priestly writing the word sometimes denotes, as here, cereal products that have been set apart for the use of priests or levites (cf. Lev. 22:12; Num. 5:9; 18:8, 11, 19, 24, 26–29). But a **terumah** can also be the thigh of animal sacrifices (Exod. 29:27, 28; Lev. 7:34; 10:14, 15; Num. 6:20), materials offered for the construction of the tabernacle and its

service (Exod. 25:2, 3; 35:5, 21, 24; 36:3, 6), the sanctuary tax (Exod. 30:13–15), or booty won in war which is to be offered to God (Num. 31:29, 41, 52).

It seems reasonable to suppose that the term was originally closely linked with the tithe (tenth) of cereal produce; perhaps **terumah** signifies that the tithe belongs to the priests. The older idea that some ritual action is implied involving vertical movement (M. Noth, *Leviticus*, 1962/1965) – hence "heave offering" (*RV*) – or lifting off of a portion (N. H. Snaith, *Leviticus and Numbers*, 1967) is not now widely accepted. G. R. Driver ("Three Technical Terms", 1956) maintained that the word was derived from the verb "to levy", and that the **terumah** was therefore a levied contribution (see also A. Vincent ("Les rites du balancement", 1939) who further maintained that it was not a rite as such). J. Milgrom ("shôq hattᵉ rumāh", 1972/1973) has conducted a detailed study of the term, incorporating Akkadian evidence, and is content to consider it a "gift" (for Yahweh or the priest) (G. A. Anderson, "Sacrifices and Offerings", 1987, pp. 137–144) has a slight preference for "to give"). Milgrom also believes that the **terumah** presentation was not accompanied by any rites, and suggests that it took place outside the sanctuary. On this view it might consist of an oral declaration by the offerer, or an act by which the contribution is handed over to the priest. The word's use has clearly been extended in priestly legislation to cover a wider range of offerings dedicated to God and the sanctuary. The particular point here is to stress that the **terumah** cake is disposed of by making it available to the particular priest whose task it is to throw the blood of the well-being offering animal.

15. The flesh of the well-being offering is consumed by the worshipper and his family, and it was thought important that time limits should control this privilege. The motive may have been to guard against ritual contamination or profanation. The flesh must therefore be consumed on the day that the sacrifice is made (cf. Lev. 19:5–8; 22:30). A similar requirement can be found in older legislation in relation to Passover (Exod. 34:25, cf. Exod. 23:18b; Deut. 16:4).

16. D. P. Wright (*The Disposal of Impurity*, 1987, pp.

135–138) argues that within the priestly legislation itself two stages of development in relation to the time limits can be discerned, the later being less strict than the earlier. Consumption of votive offerings and freewill offerings may extend to the day after the sacrifice, though no indication is given as to why this distinction is permitted. It may be that more than one type of offering could be made at the same time, in which case to expect their consumption in a single day would be unrealistic.

17. The time limits are important, however, and any flesh remaining to the third day must be burned.

18. The priestly legislators obviously took a serious view of any failure to observe the time limits. An infringement would negate the intention lying behind the sacrifice. The flesh is to be considered an **abomination** ("tainted" – *REB*; "rotten" – *NJB*; "impure" – *NIV*; "unclean" – *GNB*), a relatively rare word which is used only of unclean sacrificial flesh (Lev. 19:7; Isa. 65:4; Ezek. 4:14). We could take this to mean that the food would literally deteriorate and become inedible (G. J. Wenham, *The Book of Leviticus*, 1979; J. E. Hartley, *Leviticus*, 1992). More probably the word denotes the cultic status of meat thus left – it is "desecrated" (D. P. Wright, *The Disposal of Impurity*, 1987, pp. 140–143; J. Milgrom, *Leviticus 1–16*, 1991), because the time limit prescribed has been exceeded.

The offender must **incur guilt** (the phrase rendered **subject to punishment** in 5:1) – i.e. accept the consequences (here unspecified) of his sin.

7. THE WELL-BEING OFFERING: SUPPLEMENT (7:19–21)

These verses supplement the instructions given in 7:11–18 about disposing of the well-being offering:
7:19–21 – concerning the disposal of well-being offerings.

This sacrifice was the only one in which the laity were entitled to a share of the flesh, and this prompts the inclusion here of two restrictions about its consumption.

19. The first makes it clear that if the flesh comes into contact with any impurity it too becomes contaminated and must be burned. This is clearly not the kind of burning which offers flesh to God. There is no reference to an altar, and the assumption must be that the burning takes place outside the sacred precincts. It is a way of disposing of flesh that carries impurities. Flesh that belongs to Yahweh has the power to transmit holiness (6:18, 27); this flesh does not belong to him and is therefore open to contamination.

20. The second restriction insists that people in an unclean condition must not eat the flesh of the well-being offering; if they do they must be **cut off** from the community (cf. v. 21). This phrase is widely used in the priestly writing (e.g. Gen. 17:14; Exod. 12:15, 19; 30:33, 38; 31:14; Lev. 7:25, 27; 17:4, 9, 14; 18:29; 19:8; 20:17,18; 22:3; 23:29; Num. 9:13; 15:30, 31; 19:13, 20). In many of these situations some form of excommunication is possible (e.g. "outlawed" (*NJB*)). *GNB* interprets the word to mean "no longer . . . considered one of God's people". There is no real likelihood that capital punishment, administered by human beings, is in mind. It is true that in Exod. 31:14 **cut off** occurs in close association with the capital penalty for sabbath breaking, but it is unlikely that "put to death" and "cut off" are equivalents. The wider context of Lev. 18:29 deals with offences which would require that people be put to death. It may well be that the legislator expects God to intervene directly against the offender, presumably with death in the case of sabbath breaking, and to "cut off" his membership of the people of God (B. A. Levine, *Leviticus*, 1989, pp. 241–242; J. Milgrom, *Leviticus* 1–16, 1991, pp. 457–460). It may therefore be a threat, indicating that God will judge cases which human courts would find difficult to prove (G. J. Wenham, *The Book of Leviticus*, 1979). W. Horbury's ("Extirpation and Excommunication", 1985) investigation also accepts that it is divinely inflicted, and that it is distinct from excommunication, though linked with it in some instances. It seems likely that being "cut off" had implications regarding family and property. The phrase **from your kin** suggests disinheritance, and that the offender is deprived of his family and property

rights. D. P. Wright (*The Disposal of Impurity*, 1987, pp. 163–167) offers further discussion on "cutting off" as punishment for the misuse of offerings.

21. This is largely repetitive, but it does serve the purpose of clarifying what **while in a state of uncleanness** (v. 20) might mean. Contact with unclean human conditions, or with unclean creatures of different kinds would disqualify anyone from the sacrificial meal; these creatures and various forms of uncleanness in human beings are discussed at length in Lev. 11–15. The phrase **unclean creature** ("abomination" – *RSV*) denotes the water creatures cited in 11:10–12, the birds of prey in 11:13, and various other forms of life (11:20, 23, 41, 42). There is some support in Sam. and some Heb. mss. for the reading **swarming things** (cf. 5:2); this also occurs in Lev. 11 (vv. 10, 20, 21, 29, 41, 42, 46) and denotes primarily small reptiles and quadrupeds.

These verses offer significant insights into the way that uncleanness was perceived to be contagious and contaminating (cf. Hagg. 2:13). By insisting on this perception and guarding against such contamination the social and religious order is legitimized and sustained.

8. FOOD PROHIBITIONS
(7:22–27)

This section appears to be an insertion prompted by the presence of the rules about eating the peace offering in 7:15–21. It consists of:

7:22–27 – statutes about diet.

The second person plural in vv. 23, 24, 26 marks out material which we have designated "statutes", a form which may be traceable to the public propagation of law at major festivals. It is accompanied by "judgements" – **every person who . . .** (v. 25) and **whoever . . .** (v. 27) which pronounce the appropriate penalty for deviation from the laws proclaimed.

The section indicates very clearly how pervasive the purity

system was. It had penetrated and shaped, not only the practice of the cult, but also everyday life, in the form of dietary principles. This influence is clearly far older than the priestly legislation, and is well represented in the early Yahwistic story of the flood (Gen. 7:1–10). The oldest prohibition is probably that concerning the consumption of blood, represented here in vv. 26–27. The priestly perspective seems to take the view that initially the divine plan was that human beings should be vegetarian (Gen. 1:29); after the flood meat-eating becomes permissable (Gen. 9:3). For further discussion see 11:1–47.

There are three distinct prohibitions affecting the consumption of animals. Two of these deal with the fat.

23. If the animals are those which can be offered in sacrifice (v. 23), then the fat must not be consumed.

The word rendered **ox** usually denotes a single animal (cf. 4:10), while **sheep** is the same as the **lamb** in 1:10; 3:7; 4:35; (cf. 17:3; 22:27). For **goat** cf. 1:10; 3:12; 4:23, 28; 5:6.

24. If they have died in ways other than by human hands, then again the fat must not be consumed.

The word **died** ("of itself" – *RSV*) has the same root as **carcase** in 5:2 (cf. 11:8, 11, 24, etc.; 17:15). On one **torn by wild animals** cf. 17:15; 22:8. Further regulations about the consumption of animals not killed by human hand are contained in 17:15–16.

Legitimate uses for the fat would be for lighting or for polish (G. J. Wenham, *The Book of Leviticus*, 1979), or for the greasing of equipment and instruments (M. Noth, *Leviticus*, 1962/1965).

25. The penalty for any deviation in these matters is divine punishment and disinheritance (cf. v. 27 and see the discussion on v. 20). It is reasonable to suppose that the second prohibition is covered by this penalty, though no explicit connection is made.

On the **offering by fire** see 1:9.

26. The third prohibition deals with the consumption of blood, which in all circumstances is strictly forbidden. Prohibitions of this kind are repeated in 17:10–14.

These prohibitions clearly help to enforce the systematic distinctions that are important to the priestly perspective. The blood is in all circumstances Yahweh's and must not be appropriated; the same is true of the fat of animals that can be offered. Contact with any form of death which is outside human control poses threats to the priestly system because of the risks of contamination and of misuse of the blood; consumption in these situations must therefore be avoided.

9. THE WELL-BEING OFFERING: FURTHER SUPPLEMENT (7:28–38)

This section returns to issues connected with the well-being offering (7:11–21), following the inserted prohibitions about diet (7:22–27):
7:28–36 – concerning the disposal of well-being offerings
7:37–38 – conclusion to the Manual of Offerings.

The new information this section contains is the fact that there are parts of the well-being offering which belong to the priests. Hitherto there has only been reference to the fat parts and the entrails (3:3–4), and these are the parts which must be burned as a food offering (or offering by fire) to Yahweh (3:5). These points are repeated (vv. 30–31). There is, however, the further insistence that the breast (v. 30) and the right thigh (v. 32) are to go to the priests. This requirement is said to have its origin in the ordination ceremonies (vv.35–36; cf. Exod. 29:27; Lev. 8:26); it is here applied to private well-being offerings (vv. 29–30).

30. There is some initial stress on the fact that the individual worshipper is responsible for bringing the fat with the **breast**. The latter is described as **tenuphah** (**elevation offering** – *NRSV*), understood by *RSV*, *NIV* and older translations as a "wave offering". The breast as tenuphah seems to imply special status, and is reminiscent of the terumah cakes in 7:14 (the thigh in v. 32 is also described as **terumah**).

The connotation "wave" or "waving" is suggested by the use of the root in such texts as Isa. 19:16; 30:32 (brandishing

movements). This horizontal movement has sometimes been identified as the difference between the **tenuphah**, and the supposed vertical movement of the **terumah** (7:14) (see further A. T. Chapman and A. W. Streane, *The Book of Leviticus*, 1914, pp. 183–185; M. Noth, *Leviticus*, 1962/1965). *NJB* has "the gesture of offering".

The usage in the priestly writing usually denotes, as here, a part of the sacrifice that belongs to the priests (Exod. 29:24, 26; Lev. 8:27; 10:14, 15; 14:12, 21, 24; 23:15; Num. 6:20; 18:11, 18). It is even possible to think of the Levites as **tenuphah** – i.e. as a gift to the priests from the people as a whole (Num. 8:11, 13, 15, 20). It seems feasible that the meaning of the word was extended to take in offerings for the tabernacle itself (Exod. 35:22; 38:24, 29).

The **tenuphah** and its origins have been widely discussed. Evidence for its presence in Canaanite sources had been claimed by T. H. Gaster, but J. Gray ("The Religion of Canaan", 1965) expressed reserve. More recently D. R. Hillers ("Ugaritic šnpt", 1970), with the help of new evidence, has confirmed a connection between **tenuphah** and a Ugaritic rite. G. R. Driver ("Three Technical Terms", 1956) dismissed "wave offering" as unsatisfactory, among other reasons because of the range of offerings which can be so described. His preference, taking the sense of "elevation" or "height" as a clue (Ps. 48:3), and drawing on neo-Babylonian parallels, was to postulate a root "to be supereminent", and giving the idea that the **tenuphah** is a **special contribution** (hence *NEB*; *REB* – "dedicated portion"; GNB – "special gift") or additional gift, a work of supererogation (cf. also G. A. Anderson ("Sacrifices and Offerings", 1987)). N. H. Snaith ("The Wave Offering", 1963) is less inclined to dismiss "wave offering" as appropriate, at least for many of its occurrences (see also A. Vincent, "Les rites du balancement", 1939). B. A. Levine (*In the Presence*, 1974) has called it "a raised offering", and J. Milgrom ("The Alleged Wave-Offering", 1972; *Leviticus 1–16*, 1991, pp. 461–473) concludes in detailed studies that **tenuphah** is an actual or symbolic elevation rite of dedication (cf. J. E. Hartley, *Leviticus*, 1992).

32. The **right thigh** seems to be yet a further benefit accruing to the priests. Like the cakes in 7:14 it is described as **terumah** (**offering** – *NRSV*) – i.e. a contribution or gift made to the priest (possibly outside the sanctuary and without rites – see on **gift** in 7:14). Like the breast this was probably considered a desirable part of the animal; it was apparently set before Saul in 1 Sam. 9:24.

33. The regulations make it clear that the thigh is the entitlement of the officiating priest. J. Milgrom ("shôq hatt^e rumāh", 1972/1973) discusses in detail the problem of the thigh as **terumah**, particularly in relation to Lev. 8:26–27; 9:21 and concludes that its incorporation into **tenuphah** ritual in those verses is a late development.

The description of the thigh as a **portion** is familiar in the priestly ordination rites (Exod. 29:26; Lev. 8:29); the word is normally used of food (e.g. 1 Sam.1:4–5; 9:23; Neh. 8:10, 12).

34. These entitlements are also described as **a perpetual due**; this phrase has already been used of priestly income in 6:18 (see also in Exod. 29:28; Lev. 10:13–15; 24:9; Num. 18:8, 11, 19; cf. Ezek. 45:14). Elsewhere the phrase has a much wider application in relation to anything divinely prescribed. J. R. Porter (*Leviticus*, 1976) sees in the use of the divine first person singular an attempt to authenticate an innovation; it is a feature of that stage in the editing of the Holiness Code (see General Introduction: Sources and Component Parts).

35. Here a different word for **portion** occurs, a word more customarily used of the oil employed in the ordination rites (Exod. 25:6; 29:7, 21; 30:25, 31; 31:11; 35:8, 15, 28; 37:29; 39:38; 40:9; Lev. 8:2, 10, 12, 30; 10:7; 21:10; Num. 4:16) – hence "anointing portion" (*RV*). The unusual usage here may be intended to justify this apparent extension of priestly privilege. The priests do have a right to these parts of the well-being offering because the ordination rites prescribe them; the breast and the thigh are therefore an "ordination portion".

The section provides evidence of an increasing priestly interest in the benefits and privileges accruing from the sacrificial system. Rights to significant parts of the private well-

being offering are affirmed (over against 3:1–17), and the priests' place in the social system, sustained by purity/impurity distinctions, is thereby strengthened.

The short section in vv. 37–38 concludes the Manual of Offerings. It seems likely that it served originally as a conclusion to the laws of 6:8–7:36. The offerings are listed in the order adopted by that collection (v. 37), including the **ordination**) offering (6:19–23) (not cited in 1:1–6:7), and with the well-being offering mentioned last (as in 7:11–36). It is also to be noted that v. 38 locates the law-giving **on** Mount Sinai in contrast to the tent of meeting location in 1:1. The description of the regulations as **torah** (**ritual** – *NRSV*) (v. 37) is also characteristic of 6:8–7:36 (6:9, 14, 25; 7:1, 11).

PRIESTS AND THE CULT
(8:1–10:20)

The second major block of textual material is cast primarily as narrative (for further discussion see two sections in the General Introduction: Authorship and Redaction and Sources and Component Parts). It describes the ordination rites that mark the beginning of the priestly ministry of Aaron and his sons, and goes on to describe the rights of the eighth day which effectively inaugurate the public cult. The circumstances surrounding the deaths of two of Aaron's sons are revealed, and this provides the basis for further clarification of the duties of priests and the precautions they must take. A detailed indication of how different scholars have attributed the chapters to the basic priestly narrative is given by P. P. Jensen (*Graded Holiness*, 1992, pp. 220–224). The basic units are:

1. 8:1–36 – the ordination of the priests
2. 9:1–24 – the inauguration of the cult
3. 10:1–20 – the deaths of Nadab and Abihu.

Within 10:1–20 there are elements which are arguably accretions to the story:

10:8–11 – priestly precautions and duties
10:12–15 – priestly rights regarding the grain and well-being offerings
10:16–20 – priestly duties concerning the eating of sin offerings.

These chapters resume the narrative thread last evident in Exod. 40:34–38 and Lev. 1:1. They encapsulate two of the major achievements of the priestly historians – demonstrating that the cult of the second Temple is Sinaitic in origin, and that the priesthood instituted by Yahweh was

Aaronide. It is obvious enough that the basic ideas about sacrifice, sacred space and boundaries, which pervade the Manual of Offerings (Leviticus 1–7), continue to operate here. The narrative thread is resumed in 16:1–34.

1. THE ORDINATION OF THE PRIESTS
(8:1–36)

The priestly narrative is resumed with an account of the ordination of the priests. In general it puts into effect the divine commands given in Exod. 29:1–37. The textual units provide a basic outline for the ordination procedures, and can be distinguished as follows:

8:1–4 – preparation
8:5–9 – vesting procedures
8:10–12 – anointing rites
8:14–17 – the sin offering
8:18–21 – the burnt offering
8:22–29 – the ordination offerings
8:30 – further anointing rites
8:31–32 – disposal of the ordination offerings
8:33–36 – further requirements for the second to the seventh days.

The history of the priesthood, and the development of the ordination rites, are issues clouded with many uncertainties; full discussions are provided by A. H. J. Gunneweg (*Leviten und Priester*, 1965) and A. Cody (*A History of OT Priesthood*, 1969). From earliest times Levites were specially valued for their priestly expertise (Jdg. 17:13), and this in itself suggests that they were far from being the sole practitioners. Early evidence indicates that their skills included the manipulation and interpretation of the Urim and Thummim (Deut. 33:8); these were evidently some kind of consultative and oracular device. Whether or not the Levites had always been a priestly group is hard to assess. There are certainly texts of a reasonably early age that identify Levi as a tribe, no different from the others, and with no hint of a special priestly status,

either in the present or future (Gen. 29:34; 34:25-31; 49:5-7). Yet these texts are all integral to the point of view which sees "Israel" as a simple genealogical construction, the twelve sons of Jacob, and in the opinion of most historians this perspective can scarcely be earlier than the united monarchy. Moreover, the Levite in Jdg. 17:7 is said to have been "of the clan of Judah". One solution is to see Levites as special exponents of the Yahwism which had the ark as its central symbol, and to associate them with Yahwism in its earliest forms. In early narratives Moses and Aaron are both identified as Levites (Exod. 2:1-12; 4:14), and Levites in turn are associated with the ark (1 Sam. 6:15; 2 Sam. 15:24). Testimony to their zeal on Yahweh's behalf is preserved in their earliest surviving ordination tradition (Exod. 32:25-29). Their close association with Simeon (Gen. 34:25-31; 49:5-7) suggests early southern origins, but as those practising a priestly skill they evidently travelled widely, and might settle down for periods of time (Jdg. 17:7, 11; 19:1).

David's attempts to unite Yahwism (Ark/Tent/Levites) with the worship of El Elyon (Jerusalem/Temple/Zadok) produced Judah's pre-exilic royal cult, but the fortunes of the Levites in the south declined with the expulsion of Abiathar (1 Kgs 2:27), and the emergence of the prophets in a major consultative role (1 Kgs 22:6; 2 Kgs 3:11). To what extent they continued to work at local shrines, and as a counter movement to the northern cult, is difficult to judge, but they were enough of a force for supporters of the Deuteronomic reform in the seventh century to insist on their exclusive rights with regard to the priesthood (Deut. 18:5). It would appear that the sons of Zadok therefore came to regard themselves as Levitical priests (Ezek. 43:19; 44:15), and that they subsequently contested the claims of other Levites, relegating them to subordinate roles on the grounds of alleged idolatry (Ezek. 44:9-14). The major revision of pentateuchal tradition undertaken by the priestly writers, with its prime interest in maintaining that the cult was instituted at Sinai, naturally makes Aaron the founding father of Israel's priesthood (H. G. Judge, "Aaron, Zadok and Abiathar", 1956; E.

Auerbach, "Das Aharon Problem", 1969). The sons of Aaron may in fact have been an ancient priesthood, serving Bethel and Jerusalem, and possibly Hebron (these and related issues have been explored by R. H. Kennett ("The Origin", 1905); F. North ("Aaron's Rise", 1954); F. M. Cross ("The Priestly Houses", 1973); S. Olyan ("Zadok's Origins", 1982). Their connection with Bethel is persuasively disputed by M. White ("The Elohistic Depiction", 1990). The Deuteronomic insistence that priesthood must be Levitical was thereby affirmed and incorporated, and the Zadokite distinction between altar priests and subordinate ministers was institutionalized in the distinction between sons of Aaron and other Levites.

Little is known of the history lying behind the ordination rites described here in Lev. 8:1–36. The phrase **to ordain you** (v. 33) means literally "to fill the hand", and is evidently traditional terminology (Exod. 32:29; Jdg. 17:5, 12; 1 Kgs 13:33; Ezek. 43:26; cf. Lev. 9:17). It seems possible therefore that from earliest times rites of investiture entailed the symbolic reception by the priests of gifts/tithes appropriate to their office, or else of the tools of their trade (e.g. the Urim and Thummim – Deut. 33:8). The latter explanation would account for the fact that such rites no longer survive in the priestly ritual. The priestly writing retains the recollection that these objects had functions (Num. 27:21), and it would appear that in post-exilic times a return to those functions could be anticipated (Ezra 2:63; Neh. 7:65). For the priestly writers the objects are essentially decorative (Exod. 28:30), as part of the high priest's robe; only the traditional language ("filling the hand") survives in the ordination rite as a virtual synonym for ordination itself.

In vv. 1–4 the scene is set for the ordination ceremonies. Moses is ordered to assemble Aaron and his sons, along with the congregation, at the door of the tent of meeting. In addition the vestments, the oil, a bull, two rams, and a basket of unleavened bread must be provided.

2. The priestly **vestments** are those alluded to in Exod. 28:1–42, and made in Exod. 35:19; 39:1–31. Special vest-

ments for priests were clearly customary, and are attested in older texts (e.g. 1 Sam. 2:18; 2 Sam. 6:14). A detailed account of the relationship between Exodus 29 (where the ordination rites are prescribed) and this chapter is provided by J. Milgrom, who also draws on evidence from the dedication of temples in Mesopotamia to illuminate the connections (*Leviticus 1–16*, 1991, pp. 545–553).

The **anointing oil** had also been previously commanded, and detailed instructions about its composition given (Exod. 30:22–23). It was to be used for ceremonies other than the ordination of priests – the anointing of tent, ark, and other sanctuary furniture – but it could not be put to common use. The purpose of anointing is to symbolize an elevation in status (J. Milgrom, *Leviticus 1–16*, 1991, pp. 553–555). The basic component was olive oil (Exod. 31:24) which clearly did have a wide variety of uses; the anointing oil was distinguished by the addition of various aromatic substances. There are no clear indications that priests were anointed in pre-exilic times, and it has often been supposed that the rites in P are a post-exilic application of royal ideology and practice to the priestly office. Anointing rites involving kings are well attested (e.g. 1 Sam. 10:1; 16:1,13; 1 Kgs 1:39; 2 Kgs 9:1,3; Ps. 89:20).

The **bull** is explicitly described as for **the sin offering** (see Lev. 4:1–35). One of **the two rams** (v. 2) will be used as a burnt offering (v. 18: see Lev. 1:1–17), and the other as an ordination offering (v. 22). The **basket of unleavened bread** (v. 2) recalls the requirements about leaven in Lev. 2:11. This basket will, in the forthcoming rites, be **tenuphah** (see Lev. 7:28–36). There is no reference here to the cereal offering of ordination discussed in Lev. 6:19–23.

3. On **congregation** see Lev. 4:13. J. Milgrom (*Leviticus 1–16*, 1991) prefers the view that the entire community (men, women and children) are assembled here.

On **tent of meeting** see Lev. 1:1.

These verses (vv. 5–9) describe the vesting procedures. After Aaron and his sons have been washed (v. 6) – a preparatory process which ensures their readiness – Aaron himself is

clothed with the high priestly garments (vv. 7–9). No account
of the vestments worn by Aaron's sons is given at this point.
Some of the vestments may well have been worn by royalty
before the exile (J. R. Porter, *Leviticus*, 1976).

7. The **tunic** is described more fully in Exod. 28:39 as
"checkered", and made of "fine linen".

The **sash** is mentioned in Exod. 28:4, but not fully
described until Exod. 38:29.

A full account of the **robe** ("mantle" – *REB*) is given in
Exod. 28:31–35. It was blue, and was worn over the coat and
the girdle. It had a hole for the head (like a chasuble), and
had alternating bells and coloured pomegranates around
the fringes of the skirt (cf. Exod. 39:22–26).

The **ephod** and the **decorated band** ("skilfully woven
band" – *RSV*) which accompanied it are described in detail in
Exod. 28:5–14; 39:2–7. They were worn under the robe, with
the band as a kind of belt which bound the ephod to the
body. The ephod itself (discussed extensively by N. H. Snaith
(*Leviticus*, 1967)), was made of linen and coloured fabric,
covered shoulders and chest, and held two onyx stones on
which were inscribed the names of the twelve tribes. In
earlier texts (Jdg. 8:7; 18:18) the word seems to denote
images rather than garments.

8. The **breastpiece** was a decorated square of fabric, worn
across the chest, and with four rows of precious stones set
within it. Each stone carried the name of one of the tribes. It
was worn on top of the ephod, and attached to it with blue
lace. A detailed description is given in Exod. 28:15–30;
39:8–21.

The breastpiece also carried the **Urim and Thummim**
(extensively discussed by J. Milgrom, *Leviticus 1–16*, 1991,
pp. 507–511). These were probably two stones, used for
consultative purposes in earlier times (J. Lindblom, "Lot
Casting", 1962). In the priestly writing they are part of the
high priest's vestments, and essentially symbolic. Along with
the precious stones of the breastpiece they in some way
represent Israel before Yahweh when the high priest enters
the holy place (Exod. 28:30). The allusion in Num. 27:21
recognizes their older purpose, but puts the stress on the

shepherding (i.e. authority) of the priests (Num. 27:17). The role of priests in earlier texts as sources of divine guidance on specific issues of policy (e.g. war, migration) is well attested in Jdg. 18:5–6; 1 Sam. 14:37; 22:10; 23:2; 28:6; 30:7–8, and is probably implied in Jdg. 1:1–2; 20:18; 2 Sam. 2:1; 5:23. Some texts (e.g. Jdg. 18:20; 1 Sam. 14:3, 18–19 (Gk); 23:9–10; 30:7–8) specify the **ephod** as a consultative device, though it may have been the container (1 Sam. 23:6; 30:7–8) or vestment in which the device was kept (1 Sam. 2:18; 2 Sam. 6:14). **Urim** is cited in 1 Sam. 28:6, and with **Thummim** in the ancient Mosaic blessing of Levi (Deut. 33:8–11). If we follow the Septuagint in 1 Sam. 14:38–42 there is some evidence of the use of the sacred objects to resolve difficult cases and determine guilt.

9. The final items in Aaron's dress are the **turban** and the **golden ornament, the holy crown** ("gold medallion" – *REB*: "golden flower" – *NJB*: "gold plate, the sacred diadem" – *NIV*). The turban is merely mentioned in Exod. 28:4 (cf. Zech. 3:5), but the crown receives special attention in Exod. 28:36–38 (Exod. 39:30–31). It carried an inscription "holy to Yahweh", and was fastened to the turban with blue lace. It gives a regal aspect to Aaron, and may have been drawn in post-exilic times from older royal rites. Within the perspectives of priestly theology, however, it also has (and perhaps primarily) a purificatory and protective significance (Exod. 28:38). It is essentially **the golden ornament**, and as such may fulfil a similar function to the gold overlay which covered the altar of incense (Exod. 30:3).

13. The vesting of Aaron's sons is described here. They share with Aaron the **tunics** and **sashes**, and they wear **head-dresses** (of fine linen – Exod. 39:28). This follows the requirements set out in Exod. 28:40, which makes the further point that these clothes are intended to dignify the priests – "for their glorious adornment". The items of priestly dress not mentioned here in Leviticus 8 are the "linen undergarments" which were required for both Aaron and his sons (Exod. 28:42–43; 39:28). These vesting procedures mark the beginning of the priest's progression from the realm of the common (culture) to the realm of the holy (the divine

order). As with the sacrificial procedures in Leviticus 1–7, the rites mark the processes of transition from one state to another, and thereby confirm and protect the social and religious order which the priestly writers wished to sustain. The washing removes any inadvertent contamination which may, unknown to the priest, attach to him. The vestments clearly belong to the realm of the holy, and they are the first visible indications of the new status which the priest is to acquire.

In vv. 9–12 various anointing rites are described. The tabernacle and its contents are anointed first (v. 10). (In Gk this comes after the consecration of the laver at the end of v. 11). A seven-fold sprinkling of the altar and its utensils, and the anointing of the basin or laver are referred to specifically (v. 11). Some of the oil is then used to anoint Aaron (v. 12); there is no reference here to the anointing of his sons, though this is clearly intended in Exod. 28:41; 30:30. This part of the ceremony is prescribed in Exod. 29:7.

10. The **anointing oil** and its composition is described in detail in Exod. 31:22–33. It consisted of olive oil, various spices and other aromatic substances. The procedure is clearly intended to set the tabernacle and the priests apart as **holy** (i.e. separate from the rest of the camp and people). To come into contact with anything thus anointed is to become holy (Exod. 30:29). The use of oil also consecrates the cereal offering at an early stage in the rite (Lev. 2:1, 6, 15).

The **tabernacle** occurs for the first time here in Leviticus as a word for the holy place (cf. also Lev. 15:31; 17:4; 26:11). The word means "dwelling place", and draws attention to the sanctuary's role as divine habitation. It may have entered the Temple cult from Canaanite sources (W. Schmidt, "Mishkan", 1963). It is used freely in the priestly parts of Exodus to describe the tent at the centre of the holy place (e.g. Exod. 26:1). In P's story Moses had already erected the tabernacle (Exod. 40:16–33), and the divine glory had come to inhabit it (Exod. 40:34–38), but here in Lev. 8:10 it is the first act of consecration, which thereby inaugurates the cult.

11. The seven-fold sprinkling is reminiscent of those sin offering rites (Lev. 4:6,17) where blood is sprinkled before

Yahweh. It is not cited in the main body of the rites in Exodus 29, but seems to be assumed for each of the seven days that follow (Exod. 29:37). This sprinkling seems to be intended to protect the holiest place from defilement. The **altar** is presumably the altar of burnt offering close to the door of the tabernacle. The bronze **basin** stood close by, and was used by priests for washing whenever they entered the tabernacle. Its construction is commanded in Exod. 30:17–21.

12. The final act is the anointing of Aaron himself, to **consecrate** him (v. 12) – i.e. to render him "holy" (cf. Ps. 133:2). This action takes place in the context of extensive anointing rites involving the whole of the tabernacle and its contents. The effect is to incorporate Aaron into this larger whole, which is now recognizably and definitively holy, set apart from the realm of the common. There is more to be done, however, before Aaron is ready to perform his duties within the sanctuary.

The next phase in the ordination process (vv. 14–17) is the offering of sacrifices, the first of which is a bull for a sin offering (v. 14). All the elements cited here – the imposition of hands (v. 14), the anointing of the altar horns with the blood (v. 15), the pouring out of the rest of the blood at the altar base (v. 15), the burning of the fat, liver and kidneys (v. 16) – are attested in the descriptions of the sin offering in Leviticus 4. As previously noted there were two ways of disposing of the carcase of the sin offering; here the procedure is burning outside the camp (as in Lev. 4:12, 21; cf. 6:24–30).

14. The offering of a bull as a sin offering had already been prescribed in Exod. 29:10–14. The imposition of hands makes a connection between the offerer and the animal, thereby identifying it as destined for sacrifice (see on Lev. 4:1–5:13).

15. The altar to be anointed with blood must be the altar of burnt offering (see Lev. 4:7, 18). The anointing of the incense altar inside the tabernacle (Lev. 4:7) would occur only in rites involving priests already in office.

There are also important insights here about the function

of sin offerings, and the manipulation of the blood in partic-
ular. The action is for **purifying the altar** and that it may be
consecrated. The altar is protected from any contamination,
and its status ensured as "holy". Moreover, these are the
procedures and ideas which constitute **atonement** (see on
Lev. 4:22).

16. For the burning of the fat, liver and kidneys see Lev.
4:8–10.

17. The different methods of disposing of the remains of
the sin offering have been previously explained in terms of
the polarities in sacrifice, and the fact that priests in different
contexts can stand at both (see on Lev. 4:1–5:13). The proce-
dures here fit that explanation. The priests are offerers –
hence the imposition of hands (v. 14) – and the blood rites
are to protect the sanctuary from any contamination they
may bring. They cannot therefore receive (and eat) their
own sin offerings; the remains, like the altar ashes, must be
removed and disposed of outside the camp.

The importance of the sin offering at this point is that it
prepares for the burnt offering to follow in vv. 18–21. It is
vital that any contamination stemming from inadvertent
error be dealt with at the outset. It is also the case that the
newly anointed priest is to be granted access to the taber-
nacle. The altar close to the door has a particular significance
in this respect. The point of access must at all costs be
protected.

The next offering is a ram for a burnt offering. The main
elements of the burnt offering rite described in Lev. 1:3–9
are repeated here – the imposition of hands (v. 18), the
throwing of the blood (v. 19), the dissection of the animal (v.
20), the washing of entrails and legs (v. 21), and the burning
on the altar of the whole animal (v. 21).

18. The procedures follow the requirements set out in
Exod. 29:15–18. The imposition of hands by the offerer (the
verb is singular in Gk and Sam.) marks the victim as his own
and as set apart for sacrifice (see Lev. 1:4).

19. The throwing of the blood is discussed in relation to
Lev. 1:5. The basic presupposition is the unique status of the

blood as divine and life-bearing, a status which demands special handling.

20–21. The remaining procedures and terminological expressions are all integral to the account of the burnt offering given in Lev. 1:6–9.

The burnt offering occurs naturally enough at this point in the ordination rites. The newly vested and anointed priest, who has been protected by the sin offering from the consequences of any inadvertent error, now acknowledges and honours God in the gift of the ram of burnt offering. Like the sin offering this too is a necessary preliminary to the distinctive ordination rites which follow.

The next sacrifice and set of associated procedures is arguably central to the ordination rite. In all essentials the rites are those described in Exod. 29:15–34.

22. It is an ordination sacrifice, **the ram of ordination** ("investiture" – *NJB*), and as with all sacrifices begins with an imposition of hands by the offerer(s).

23. There are three quite distinctive features that mark this out as the ordination offering. Firstly, the bodily extremities of Aaron (the **lobe** of the ear, the right thumb, and the big toe of the right foot) are anointed with blood from the sacrifice. This is reminiscent of the way in which the extremities of altars (the "horns") are anointed in sin offerings (4:7, 25). The extremities, as there, are probably intended to signify the encompassing of the whole, and the function of the blood, to protect and purify, is probably similar. The **right** side is invariably the preferred side in biblical texts. Aaron has already been set apart as holy through the anointing with oil (vv. 10–12); as such he is part of the sanctuary effects, and like the altars must be protected.

24. Aaron's sons are anointed in the same way.

The procedures which follow have obvious affinities with the burnt and well-being offerings. The blood is thrown (**dashed**) (not "sprinkled" or "poured out" as in sin offerings), and the sacrifice is a **pleasing odour** and **offering by fire** (v. 28. cf. Lev. 3:5).

25. The offering of fat, liver and kidneys (v. 25, cf. Lev.

3:3–4), and the consumption of the flesh (cf. Lev. 7:15), make this a kind of well-being offering.

26–27. The second distinctive feature is the offering of the cereals and thigh as **tenuphah** (**elevation offering** – *NRSV*). In 7:30 only the breast is described as **tenuphah** (probably a "raised offering" or "elevation rite" – see on 7:30). In 7:32 the thigh is **terumah** (probably a gift made to the priest), and possibly a later development (see on 7:32). Here the cereal products and the thigh are elevated as **tenuphah**.

The cereals used mean that the ordination offering has affinities with the well-being offering for thanksgiving (7:12–14). The contents of **the basket of unleavened bread** are shown to include **one cake of unleavened bread** ("loaf of bread" – Exod. 29:23), **one cake of bread with oil**, and **one wafer** (v. 26, cf. 7:12).

28. The cereals and thigh are now burned. Clearly the priests cannot be recipients of God's share from offerings they themselves are making on their own account; hence the disposal of the offering by fire, along with the burnt offering. It is noteworthy that there is no reference to the thigh as something to be burned in Exod. 29:22–28. It is **tenuphah** in Exod. 29:27, but, like the breast, is set apart for the priests. At this point in the rites we have what appears to be the essence of the **ordination offering**.

29. A witness to priestly rights is maintained by the fact that Moses, who in effect functions as officiating priest, retains the **tenuphah** breast (v. 29, cf. 7:31). This recalls the rules about the disposal of well-being offerings in 7:30–31, as also do the allusions to **the right thigh** (vv. 25, 26 cf. 7:32–33).

30. The third distinctive feature is a further sprinkling of Aaron, his sons and their garments with blood from the altar, where presumably it had been placed after the killing of the animal in v. 23. This "sprinkling" is reminiscent of those sin offering rights where blood is taken within the tabernacle, and where the veil is treated thus (4:6, 17). Earlier in the ordination rites the altar is "sprinkled" with oil. It is hard to know what, in the light of v. 12, this further act of "consecration" achieves. The oil in v. 12 has already set Aaron apart; the blood in v. 23 protects and purifies him from any defilement.

It may be the case that the important thing here is the "conse-cration" of the garments Aaron wears; these too share the holiness of the sanctuary, and must be protected from risks of defilement. The account in Exod. 29:19–21 actually has this sprinkling of the garments (with oil as well as blood) in close association with the anointing of Aaron's extremities. Some textual displacement may therefore have occurred in Leviticus 8.

31. The eating of the flesh and the rest of the cereal produce is commanded (cf. the rules for the consumption of different kinds of well-being offering in 7:15–18).

32. Here, as with the thank offering (7:15), any left over from the day of the sacrifice is to be burned. A fuller account of these procedures is given in Exod. 29:31–34.

The processes of transition which the ordination rites entail are now complete, and the priest is ready to begin the seven-day period which will culminate in the inauguration of his ministry on the eighth day. The vesting (vv. 5–9, 13) is a preparation for the journey, the anointing by setting the priest apart begins the transition (vv. 10–12), the sin offering (vv. 14–17) and burnt offering (vv. 18–21) prepare the way for further movement by protecting the sanctuary from inad-vertent defilement, and by offering due recognition and honour to the deity. With the climactic ordination offering (vv. 22–32) the priest becomes thoroughly one with the sanc-tuary, its contents and environment, and therefore ready to begin his ministry. In undergoing the sanctuary rites of purification, and in receiving in his hands the **tenuphah** offering (though not yet offering it himself) the journey from the realm of the common to the realm of the holy is complete. The stage is set for the procedures which will actu-ally inaugurate his work.

The concluding verses (vv. 33–36) indicate briefly what is to take place during the next six days – days two to seven of the ordination ceremonies. The newly consecrated priests are not to leave the sanctuary (v. 33), because the work of **atone-ment** (v. 34) (see on 4:20) on their behalf must continue, and they must carry out the rites and procedures prescribed on

pain of death (vv. 34–35). As J. E. Hartley (*Leviticus*, 1992) observes, passages of time were an essential feature of rites of passage, and the greater the change the longer the period required.

33. On the phrase **to ordain you** see the discussion at the beginning of the chapter.

34. *RSV* suggests that the rites of day one must be repeated on each of these subsequent days. This view is adopted in older commentaries (e.g. A. T. Chapman and A. W. Streane, *The Book of Leviticus*, 1914; M. Noth, *Leviticus*, 1962/1965), but more recent commentaries and translations (e.g. *REB*, *NJB*, *NRSV*, *NIV*, *GNB*) take the verse to refer to what has taken place on day one.

35. *NRSV* interprets v. 35 as requiring a vigil. In Exod. 29:35–46 the requirements are indicated more precisely. Each day a sin offering (probably only one – see *REB*) is to be made (Exod. 29:36–39). This is apparently for the altar – to maintain its protection and purity. There are also morning and evening sacrifices, a continual burnt offering, consisting of a lamb, cereal produce, oil and wine (Exod. 29:40–41).

The description of the priest's role as **keeping Yahweh's charge** is typical of priestly writing. It is very common in the account of priestly and Levitical responsibilities regarding the tabernacle in the early chapters of Numbers (e.g. Num. 1:53; 3:7–8, 25, 28, 31–32, 36, 38; 4:27–28, 31–32; 8:26; 9:19, 23).

It is reasonable to suppose that within the perspectives of the story Moses is still carrying the sacrificial tasks. The main duty of Aaron and his sons at this stage is to remain in the sanctuary precincts. Not till the eighth day will they begin to perform priestly tasks. The rites of transition have thus far altered their status; they are now holy, along with the tabernacle and its contents. F. H. Gorman (*The Ideology of Ritual*, 1990, pp. 103–139) stresses the danger to which their position as mediators now exposes them. A passage of time must now elapse to prepare them for the functions they must undertake.

2. THE INAUGURATION OF THE CULT
(9:1–24)

With the ordination rites complete it is now possible, on the eighth day, for the priests themselves to take over their responsibilities, and thus for the cult itself to be fully inaugurated. The main textual units are:

9:1–7 – preparations for the offerings
9:8–11 – sin offering for Aaron
9:12–14 – burnt offering for Aaron
9:15–21 – the offerings of the people
9:22–24 – theophany.

In vv. 1–7 the requirements for the special eighth day rite are set out. Aaron's responsibility is to provide a bull calf for a **sin offering** and a ram for a **burnt offering** (v. 2). For their part the people are required to provide a goat for a **sin offering**, a calf and a lamb for **burnt offerings**, an ox and a ram for **well-being offerings**, and a **grain offering** (vv. 3–4).

2. The **bull calf** for Aaron's sin offering is not common in the priestly writing (normally a bull is used – 4:3; 8:2), though it does occur in a sacrificial context elsewhere (Mic. 6:6). The preference for an alternative may be explained in terms of the **bull calf**'s association with what were considered idolatrous rites (e.g. Exod. 32:4; Deut. 9:16; 1 Kgs 12:28; 2 Kgs 10:29; 17:16; Hos. 8:5; 13:2; Ps. 106:19; Neh. 9:18). The **ram** has already been specified as appropriate for a burnt offering (8:2), though it is also used in guilt offering rites (5:15, 16, 18; 6:6).

3. The **male goat** for the people is familiar in sin offering rites (4:23), though there it is for "the ruler", a sin offering for the whole people being a "young bull" (4:14).

The **calf** is again a "bull calf" as in v. 2.

The **lamb** is a feature of the daily burnt offering (Exod. 29:38–41) and an option as a sin offering for ordinary people (4:32). It was clearly a feature of the pre-exilic cult (Isa. 1:11), and was also prominent in Ezekiel's new order (Ezek. 46:4).

4. The use of the **ox** in well-being offerings is indicated in 4:10, but it is not often attested explicitly in the priestly

writing as a sacrificial animal (cf. e.g. 22:23, 27; Num. 15:11). Such usage is evident in older texts (e.g. Jdg. 6:25; 2 Sam. 6:13; Hos. 12:11; Deut. 17:1; 18:3).

A **ram** as a well-being offering is clearly permitted by 3:6–11. Elsewhere it is used as such in connection with Nazirite vows (Num. 6:14, 17). The ordination rites in 8:22–32 have affinities with the well-being offering, and they too use a ram.

Apart from the fact that it is **mixed with oil** (cf. 2:1, 4–7, 15, 16; 5:11; 6:15, 21; 7:10, 12; 8:2, 10, 12, 30) nothing is said here about the grain offering (v. 4).

5. On **congregation** see 4:13 and on **tent of meeting** see 1:1. That this is to be a day on which Yahweh makes a special appearance is indicated in vv. 4, 6 (see also vv. 22–24). The overriding purpose of these rites is said to be to **make atonement** (v. 7) for priest and people (see on 4:20) – i.e. to purify sanctuary, priest and people, and thereby to make amends for any inadvertent error.

6. On **the glory** see v. 23.

7. The first reference to **the people** may be better read with Gk as "your household" (J. Milgrom, *Leviticus 1–16*, 1991).

The first of the eighth-day rites is the sin offering for Aaron and the priests (vv. 8–11). The account contains essential elements of a sin offering, the smearing of blood on the altar horns, the pouring out of the rest at the altar base (v. 9 – 4:7, 18, 25, 30, 34), and the burning of fat, kidneys and liver on the altar (v. 10 – 4:8–9, 19, 26, 31, 35). The residue of the animal is burned outside the camp, in accordance with the requirements affecting sin offerings for priests and the congregation (v.11 – 4:12, 21, cf. 6:30).

The obvious elements not mentioned here are the imposition of the hand (4:4, 15, 24, 29, 33) and the sevenfold blood sprinkling in front of the veil (4:6, 17), which appears to be essential in a sin offering for priests, though not apparently for others where the flesh is eaten rather than burned (4:22–35; 6:26). It seems likely that these parts of the rite are "taken as read". The imposition of the hand on the sin offering of the first day is mentioned in 8:14. The fact that

the flesh was burned would certainly imply that blood had been taken **inside** the tent of meeting (4:7; 6:30), and the only likely purpose would be for the sprinkling ceremony. It is to be noted that in 10:16–20 Moses makes no objection to the way in which the flesh of this sin offering has been disposed of. This made "atonement in" (i.e. purified) the holy place. It could perhaps be omitted here (by way of reference rather than practice) because the prime interest is in the rites which atone for (purify) Aaron, as he takes up his full responsibilities.

The priority of the sin offering on many of these public cultic occasions has been noted and discussed by A. F. Rainey ("The Order of Sacrifice", 1970), who considers that these narrative texts, in their ordering of the various sacrifices, actually reflect Temple procedure. The purpose would presumably be to ensure that any inadvertent error causing or threatening contamination had been dealt with at the outset.

The next rite is the burnt offering for the priests (vv. 12–14). Here too the imposition of hands (cf. 1:4) is omitted. The legislation focuses instead on the main distinguishing features of the burnt offering, the throwing of blood (v. 12, cf.1:5, 11), the cutting up of the offering (v. 13, cf. 1:6–7, 12), and the burning of the whole animal (v. 13, cf. 1:9, 13, 17), after legs and entrails have been washed (v. 14, cf. 1:9, 13).

The terminology used is consistent with that contained in the accounts of the burnt offering in 1:1–17. Once the necessary precautions, embodied in the sin offering (vv. 8–11), have been taken, the time is right for Aaron and the priests to honour God and express their devotion and loyalty to him in the rites of the burnt offering.

The next phase in the eighth-day rites is the offering of sacrifices on behalf of the people (vv. 15–21). For the most part the various sacrifices are simply listed, without procedural detail. The sequence is a **sin offering** (v. 15), a **burnt offering** (v. 16), a **grain offering** (v. 17), and the **well-being offerings** (vv. 18–21), the breast and right thigh of which are **tenuphah** (v. 21) – i.e. a "raised offering" or "elevation rite" (**elevation offering** – *NRSV*) (see on 7:30. cf. 8:26–28).

15. As with the offering for the priests (vv. 9–14) the initial sin offering is probably of a precautionary nature (**like the first one**), while the burnt and grain offerings give honour and homage to the deity. The aftermath of this particular sin offering is described in 10:16–20. It suggests that in this instance there was no sprinkling of the blood, and that the flesh was burnt.

16. Aaron is said to have acted **according to regulation** (cf. 5:10) – "according to custom (tradition)" (N. H. Snaith, *Leviticus and Numbers*, 1967); "in the prescribed manner" (J. Milgrom, *Leviticus 1–16*, 1991). This presumably refers to the performance of the sacrificial rite rather than the disposal of the flesh which attracts Moses' anger (10:16–20).

17. Aaron is described as **taking a handful of it** ("filled his hand from it" – *RSV*) (i.e. the grain offering), a distinct expression which ultimately denotes ordination itself (see on 8:33). The idea is the same as in 2:2, but presumably this inaugural occasion warrants the language of ordination.

The phrase **in addition to the burnt offering of the morning** (v. 17) suggests that the daily offerings have already begun. They had been prescribed in Exod. 29:38–42, but this is the first indication in Leviticus that the system is operative. Modern commentators often suspect that the allusion is an editorial gloss.

18–19. The procedures of the well-being offering are described more fully, with an account of the handling of the blood and the burning of the fat. The well-being offering is probably intended to express the social solidarity between God and his people, and to which the shared meal bears witness. The fat belongs to the deity, the breast and right thigh to the priests, and the rest to the people.

20. The verb **laid** is singular in Gk, Sam., Syr, but Gk returns to the plural with **turned into smoke**.

21. There follows the elevation of the **tenuphah** breast and right thigh. The right thigh appears originally to have been a **terumah** offering (see on 7:32). J. Milgrom (*Leviticus 1–16*, 1991) suspects that the reference to the **thigh** is an interpolation, seeking to give it the status of an elevation offering.

The eighth-day rites are now virtually complete, and the ministry of Aaron and his sons has been fully inaugurated.

The eighth-day rites conclude with a priestly blessing (v. 22) and a theophany (vv. 23–24). The effect of the latter is to consume by fire the burnt offering and the fat of the peace offering without priestly action or intervention, despite the implication in vv. 16, 20 that the burning has already taken place.

22. The verbal content of a priestly blessing is contained in Num. 6:24–26. The "blessing" there entails divine protection, support, gracious provision and well-being. There is also a sense in which it places Yahweh's name upon his people (Num. 6:27). Here Aaron lifts his hands to pronounce the blessing. There is also apparently a second blessing (v. 23) in which Moses joins, and which takes place subsequently, after the two have re-entered the **tent of meeting**, and come out again. This double blessing may indicate some editorial intervention, particularly as the first seems to envisage the temple rather than the tent. Aaron's descent is suggestive of altar steps (cf. e.g. Ezek. 43:17, contrast Exod. 20:26).

The Deuteronomic historians see the blessing of the people as a royal role (1 Kgs 8:14, 55), though one evidently shared with the tribe of Levi (Deut. 10:8; 21:5; Josh. 8:33). The raising of the hands is a feature of oath-taking in God's name (Dan. 12:7), and a phrase with this meaning can be a synonym for "to swear" (Exod. 6:8; Num. 14:30).

23. Appearances of the divine **glory** ("dazzling light. . ." – *GNB*) are a familiar feature of the priestly tradition, occurring frequently in the context of Israel's disaffection (Exod. 16:10; Num. 14:10; 16:19, 42; 20:6). The word denotes a visible splendour, whether of wealth (e.g. Gen. 31:1), success (e.g. Gen. 45:13) or beauty (Isa. 35:2). In relation to Yahweh it is often used in connection with his royal majesty and authority (e.g. Num. 14:21; Isa. 6:1–4), and would appear to have its origins in the worship of the pre-exilic Temple (Isa. 6:4; Ezek. 10:4). Some texts associate the **glory** closely with the cloud (Exod. 16:10; Num. 16:42), the permanent sign, in the priestly writing, of Yahweh's presence in the wilderness

(Exod. 40:34–38; Num. 9:15–23; 10:11–12). The **glory**, by contrast, appears in critical episodes, when Israel's loyalty is in question as indicated above, immediately prior to the commands to build the Tabernacle (Exod. 24:16–17), at the completion of the Tabernacle (Exod. 40:35), and here after Aaron's ordination and the inauguration of the cult. Given the context we may conclude with J. Milgrom (*Leviticus 1–16*, 1991) that it appears as fire.

24. The notion of a spontaneous divine **fire** which consumes a sacrifice is familiar in a range of other texts (Jdg. 6:21; 1 Kgs 18:38). This same fire can be destructive of human life (Num. 11:1; 2 Kgs 1:10; Job 1:16). In the priestly writing it consumes the disobedient sons of Aaron (Lev. 10:2), and the rebel laymen who sought to offer incense (Num. 16:35). Exod. 24:17 confirms the view that for the priestly writers the glory of Yahweh has the appearance of devouring fire. The association of Yahweh with fire is well established in a variety of texts (e.g. Exod. 3:2; 19:18; Isa. 33:14; Mal. 3:2).

The verb which affirms that the people **shouted** can be rendered "to give a ringing cry" (BDB). It is often a cry of joy (e.g. Isa. 12:6; 24:14; 54:1; Jer. 31:7), but may also be a cry of lamentation (Lam. 2:19), or a summons (Prov. 1:20; 8:3). It is unusual in the priestly writing, and here in v. 24 it presumably has most affinities with the cry of joy (thus *NIV*; J. E. Hartley, *Leviticus*, 1992), but its close association with the theophany and the prostration suggests it recognizes and honours Yahweh's presence, and that it therefore also expresses awe and respect. The prostration, the comment that the people **fell on their faces**, is a common feature in priestly narratives (Num. 14:5; 16:4, 22, 45; 20:6; cf. Gen. 17:17; Josh. 7:10; 2 Kgs 19:14). This too can be a token of profound respect, and is sometimes used of obeisance made to human beings (Ruth 2:10; 1 Sam. 25:23; 2 Sam. 9:6; 1 Kgs 18:7). In Ezekiel, as here, it is a response to the divine glory, and a means by which God is honoured (Ezek. 1:28; 3:23; 11:13; 43:2–3; 44:4; cf. Dan. 8:17). It is common in other priestly stories for the prostration to be intercessory acts of self-abasement by Moses and sometimes Aaron in the face of Israel's disaffection and

Yahweh's impending wrath (Num. 14:5; 16:4, 22, 45; 20:6).

These dramatic events bring the eighth-day rites to an appropriate conclusion, and the cult is now fully inaugurated.

3. THE DEATHS OF NADAB AND ABIHU (10:1–20)

The dramatic climax to the eighth-day rites (9:22–24) is marred by the deaths of Aaron's sons, Nadab and Abihu. This tragedy is a potent reminder of Yahweh's holiness, and necessitates further precautions and clarifications with respect to priestly rights and responsibilities. The main textual units are:

10:1–3 – the deaths of Nadab and Abihu
10:4–7 – the aftermath, the disposal of their bodies
10:8–11 – priestly precautions and duties
10-:12–15 – priestly rights regarding the grain and well-being offerings
10:16–20 – priestly duties concerning the eating of sin offerings.

There is some reason for supposing that vv. 8–20 are a series of additions. In vv. 8–11 there is only a slight connection with the story of vv. 1–7 in the words **that you may not die** (v. 9); the precautions and duties discussed are not directly connected to the deaths of Nadab and Abihu. In vv. 12–15 there are no real links at all; the content belongs more naturally with 6:14–18. The narrative in vv. 16–20 has fairly superficial links with vv. 1–7 (vv. 16, 19b); its main purpose is to make points which belong to the themes of 6:24–30.

In vv. 1–3 the two older sons of Aaron make an unacceptable incense offering. The outcome is their destruction by the divine fire (cf. 9:24).

1. There has been some difference of opinion about the nature of the error. It was clearly in some way presumptuous. R. Gradwohl ("Das 'fremde feuer'", 1963) suspects that they

had no right to enter the inner sanctum; if they did have the right, then their failure was to neglect the precautions required in Lev. 16:12–13. N. Kiuchi (*The Purification Offering*, 1987, pp. 67–85) also makes connections with Leviticus 16, and sees aspects of the sin reflected in the commands of 16:2 and 10:9. Some have thought that the fire (or coals) for the offering came from the wrong place (i.e. it was unholy) (W. W. von Baudissin; *Die Geschichte*, 1889, M. Haran, "The Uses of Incense", 1960; J. Milgrom, *Leviticus 1–16*, 1991); some have suspected an hostility to incense offering as such (a possibility raised by M. Noth, *Leviticus*, 1962/1965). Others have suggested that the incense mixture was incorrect (Exod. 30:37–38), or infringed the requirements of Exod. 30:9 (B. A. Levine, *Leviticus*, 1989) for the latter). Another possibility is that the timing was wrong (A. T. Chapman and A. W. Streane, *The Book of Leviticus*, 1914; L. A. Snijders, "The Meaning of 'zār' in the OT", 1954). *GNB* reads "because the LORD had not commanded them to present it", which is where G. J. Wenham (*The Book of Leviticus*, 1979) puts the stress.

It is probably best to locate the crux in the words **unholy fire** ("illicit" – *REB*; "unauthorized" – *JB*; *NIV*) and **such as he (Yahweh) had not commanded**. If Nadab and Abihu had no right to make an incense offering, it is likely that the point would have been made explicitly, as indeed it is in comparable passages such as Num. 16:10b or 2 Chr. 26:18. Nor is it probable that incense offering in itself is the problem (the use of incense in Israel is discussed by K. Nielsen, *Incense in Ancient Israel*, 1986). The priestly literature prescribes it (Exod. 30:34–38), and in Num. 16:47 it performs a vital protective function. If timing were the problem it is reasonable to expect some explicit indication of what was wrong, and of what in this instance would have been right. Technical errors which bear to some extent on time and place are generously excused in vv. 16–20; there would appear to be something altogether more serious in vv. 1–3. Similar considerations make it unlikely that incense incorrectly composed was the point at issue. The objection in any case appears to relate more to the **fire** than to the incense.

This makes it distinctly possible, as argued by M. Haran

("The Uses of Incense", 1960) *et al*, that the fire was taken from the wrong place (i.e. not from the altar – cf. Lev. 16:12; Num. 17:11); in short, in terms of the distinctions made in 10:10 it was **common** fire. Here too, however, the mistakes in vv. 16–20, which in the event are overlooked, seem no less serious.

It may therefore be best to deduce that the fire is not simply common, but alien. The root **unholy** is sometimes used in the priestly writing of foreigners (Exod. 29:33; 30:33), or of persons who do not belong to Levitical or priestly families (Num. 1:51; 16:40), and it may be that fire kindled in a manner appropriate to other cults is in mind. The point would therefore be the difference between Yahweh's fire and that of other cults (G. Robinson (*The Prohibition of Strange Fire*, 1978), cf. also J. R. Porter (*Leviticus*, 1976)). As M. Aberbach and L. Smolar ("Aaron, Jeroboam and the Golden Calves", 1967) point out the phrase **such as he had not commanded them** is familiar in relation to other deities (Jer. 7:31; 19:5). J. C. H. Laughlin ("The 'Strange Fire' of Nadab and Abihu", 1976) proposes Zoroastrian practice.

2. The divine **fire** which **consumed** the brothers is that which also destroys the incense offerers in Num. 16:35. Judgements of this kind can be found elsewhere (e.g. Num. 11:1; 2 Kgs 1:10). Appearances of the fire may sometimes be marks of approval (Lev. 9:24; Jdg. 6:21; 1 Kgs 8:38).

3. Moses interprets the divine action to the effect that Yahweh has shown himself **holy** among the priests (**those who are near me** – the word denotes the "approach" of priestly ministry), and made clear his determination to be **glorified** ("given honour" – *REB*; "honoured" – *NIV*) among the people at large. The literary parallelism here suggests a liturgical background (see A. T. Chapman and A. W. Streane, *The Book of Leviticus*, 1914). Yahweh himself will act to protect the sanctity of the boundaries and to defend his honour. P. Segal ("The Divine Verdict", 1989) makes the point nevertheless that grace is at work here, averting wrath from Israel at large. *NEB* understood the silence of Aaron to indicate that he is dumbfounded ("silent" – *REB*).

The story is a dramatic illustration of the seriousness with

which the priestly boundaries must be observed. The risks are such that the boundaries are actually a vital system of security, on which the stability and well-being of priests and people alike depends. To cause them to be crossed or to introduce confusion is to threaten the stability and well-being of society at large.

In vv. 4–7 two of Aaron's cousins are called on to remove the corpses (vv. 4–5), while Aaron himself, along with his two remaining sons, is strictly warned by Moses not to observe any of the customary mourning procedures (v. 6). They are also under strict instructions to remain inside the tent of meeting (v. 7).

4. Mishael and **Elzaphan** are cited as sons of **Uzziel** (a son of Kohath) in the Levitical genealogy in Exod. 6:14–25. They play no further part in the biblical story. Eleazar and Ithamar could not, as newly consecrated priests, take on this responsibility.

5. The **tunics** are the priest's garments described in Exod. 28:4, 39 as being "checkered", and in Exod. 39:27 as **of fine linen** (cf. the references in 8:7, 13).

6. The orders given to Aaron and his sons correspond in broad terms with the demands of 21:1–15, though there an ordinary priest (not the one "exalted above his fellows") is allowed contact with his dead brother (vv. 2, 11). Similarly the prohibition about mourning is made of the "exalted" priest (21:10).

Loose hair is not commonly associated with mourning. Elsewhere the word root can denote lack of restraint (Exod. 32:25; Prov. 29:18). In priestly texts loosened locks are a feature of the rites associated with the woman suspected of adultery (Num. 5:18), and the leper whose condition has been diagnosed (Lev. 13:45). Rent garments (v. 6), by contrast, are familiar indications of grief and anguish, though a different verb is customary (e.g. Gen. 37:29; Num. 14:6; Josh. 7:6; Jdg. 11:35; 2 Sam. 1:11; 1 Kgs 21:27; 2 Kgs 5:7; Job 1:20; Isa. 37:1; Jer. 36:24; Joel 2:13).

The perceived danger is that divine **wrath** will descend upon the people. A similar formulation is used in Num.

16:22, where Moses and Aaron intercede for Israel in the context of Korah's rebellion. *NJB* understands the verse to mean that it is for Israel at large to mourn the deaths.

7. The requirement to remain within the tent of meeting is also demanded of the "exalted" priest in 21:12. The reason has to do with the **anointing oil** (cf. 21:12). The point once again has to do with distinctions and boundaries. The ordered priestly world must be sustained by means of visible actions and patterns of behaviour.

The demands made of Aaron, Eleazar and Ithamar in relation to the deaths of Nadab and Abihu (vv. 4–7) prompt the introduction of further restrictions and requirements regarding the priests. They are to abstain from alcohol when preparing to enter the tent of meeting (v. 9), and they are to discern and apply the distinctions that are fundamental to the priestly system (v. 10). A more general teaching responsibility with regard to Mosaic law is implied in v. 11.

9. Wine and **strong drink** ("other fermented drink" – *NIV*; "beer" – *GNB*; "ale" – J. Milgrom (*Leviticus 1–16*, 1991)) are also excluded from the Nazirite vow (Num. 6:3). The explanation for this may be related to the reasons for prohibiting leaven in sacred contexts (see 2:4–5). Perhaps the changes generated by the process of fermentation introduce confusions of substance which threaten the stability of the ordered priestly view of the world.

The **statute forever** is a familiar form in priestly texts for affirming the permanence of the principles set out (cf. 6:18, 22; 7:34; Exod. 29:28; 30:21; Num. 18:11, 19).

10. Here some important terminological distinctions are made; their significance is crucial for an understanding of the priestly system. The first distinction is between the **holy** and the **common** (profane – *REB*). This appears to differentiate a realm which is wholly and exclusively God's (the **holy**) from another in which human involvement and participation is expected (the **common**; "what is for general use" – *GNB*). J. Milgrom (*Leviticus 1–16*, 1991) notes that **common** occurs only here in the Pentateuch. A journey can be **common** (1 Sam. 21:5–6); so too can space (Ezek. 48:15).

Only those people, animals and objects which are specially consecrated (priests, offerings, sanctuary furniture) can have contact with the holy. The second distinction, between the **clean** and the **unclean**, operates within the realm of the **common**. On the one hand it makes clear what may freely be handled and used (the **clean**); on the other it indicates those kinds of contact which disturb the priestly order and which therefore constitute **the unclean**.

11. The priestly responsibility to **teach** (v. 11) is here defined essentially in terms of these distinctions and clarifications (cf. Hagg. 2:11–12). Elsewhere it apparently has a more general application (Deut. 33:10; Hos. 4:6; Mic. 3:11; Jer. 18:18; Ezek. 7:26). Other forms of guidance given by priests could be in the form of an oracle, secured by manipulative means (e.g. Num. 27:21), cultic proclamation (e.g. Deut. 27:14), or a legal verdict (e.g. Deut. 17:8–9).

In vv. 12–15 the connections with the overall context, the deaths of Nadab and Abihu (vv. 1–3), are very loose. The verses belong more readily with the disposal procedures described in 6:14–18; 7:28–36. There is, however, a distinction within the realm of the holy (the **most holy** – v. 12), and this may account for the passage being linked with vv. 8–11. It deals with the priestly consumption of those parts of the cereal and well-being offering which belong to them.

12. The first requirement is that the grain offering be consumed **beside the altar** (i.e. in a holy place – v. 13). In terms of v. 10 this is clearly within the realm of **the holy**.

13. The description of these benefits as a **due** (cf. vv. 14, 15) is in line with 7:34, 36 (contrast "portion" – 6:17). The word is that frequently translated as **statute** (e.g. v. 11).

14. By contrast the **tenuphah** breast and the **terumah** thigh may be consumed within the realm of the **common**, provided that the place itself is **clean**. It is clear that the latter is food for the priests' families (including females), while the former has a special character as **most holy** (v. 12), and is therefore wholly God's.

This distinction is in line with our supposition that grain offerings (along with burnt offerings) are essentially gift

rites, giving honour to God and expressing homage, while the well-being offerings are sharing rites, expressing social solidarity.

In vv. 16–20 the narrative mode of vv. 1–7 returns; the time is noted as the day of the deaths of Nadab and Abihu (v. 19 cf. vv. 1–3). The passage describes a confrontation between Moses on the one hand and Aaron and his surviving sons on the other, with respect to the disposal of the sin offering. In essence it returns to issues raised in 6:24–30, but, as with vv. 12–15, it is concerned with things which are **most holy** (v. 17), and therefore has a certain appropriateness here.

16. The circumstances that prompted the **sin offering** are not clarified, and it would not be unreasonable to suppose that Aaron and his sons are simply dealing with an occasional sin offering offered by a ruler, or by an individual lay person. Had they been taking action on their own account, or for the community at large, they should have offered, according to 4:3, 14, not a **goat**, but a young bull (see also 4:23, 28), and their burning of the remains would have been correct (4:12, 21). The choice of animal, however, is evidently not the cause of Moses' anger.

The overall context suggests that the sin offering in dispute is the special eighth-day offering of a goat by the people, and which is mentioned in 9:3, 15. Aaron's comments in v. 19 tend to support this supposition. The sin offering in dispute is therefore one peculiar to these rites of inauguration, and must be judged one of those where the priests represent the deity. In accordance with 6:24–30, they must therefore consume the flesh. It should be noted that the sin offering **for the people** in 9:15 was for the laity (contrast that for the priests in 9:8–11); it is therefore quite distinct from the offering for the **whole congregation** (inclusive of priests and laity) in 4:13–21.

17. Since such flesh is **most holy** it can only be consumed in a holy place (v. 17, see also v. 12).

In v. 17 there is some further insight into the function of the sin offering in general, and into the meaning of the disposal rites in particular. The priests are said **to remove the**

guilt ("to bear the iniquity of" – *RSV*) the congregation, and **to make atonement** for them. The latter phrase denotes primarily "purification", and is discussed in connection with 4:20. The idea of removing guilt/carrying iniquity has already been met in relation to the guilt offering (5:1, 17) and in connection with the eating of well-being offerings (7:18). It suggests accepting the consequences for some kind of error. The holiness of the priest is thus able to eliminate the sin of the offerer, and deal with its consequences. J. Milgrom (*Leviticus 1–16*, 1991), having urged that the sin offering absorbs the sin, suggests that the eating is indeed the means by which the sin is removed. We may still prefer the supposition that the blood rites are the primary means by which this is accomplished. This text wishes to stress that disposal by consumption (where specified) is not peripheral. It is integral to the total rite by which the priest deals with the iniquity of the sin.

18. Here Moses draws attention to another distinguishing feature of the two types of sin offering. In those for the priests and the congregation at large there are blood sprinklings in front of the veil of the sanctuary (4:6, 17). This rite is absent from the other sin offerings, and clearly from the offering under discussion here. The priests had observed Moses as he presented the sin offering (9:15), and the blood rites alone should have told them that the flesh must be eaten.

19. Aaron defends himself on the basis of the exceptional nature of the day's events. His point seems to be that his motives in refusing to eat were prompted by a proper regard for a divine holiness and power which had recently destroyed two of his sons, despite the faithful part they had played in the presentation of the sin and burnt offerings (9:9, 12). Enjoying the benefits of priestly duties in such circumstances might have been interpreted as an act of presumption. B. A. Levine (*Leviticus*, 1989) draws attention to Deut. 26:14 where mourners are understood to refrain from holy food.

20. This defence persuades Moses. J. E. Hartley (*Leviticus*, 1992) suggests that the incident illustrates priests in open debate about disputed issues regarding the interpretation and application of law. J. Milgrom (*Leviticus 1–16*, 1991; pp.

635–640) sees the issue as a borderline case in which Moses proceeds from a premise about how the blood has been used, and Aaron from a premise about the contamination the corpses of the dead priests would have generated.

The great rites of inauguration, whereby the priests are ordained and the cult formally instituted, are therefore complete. The eighth day was one of tragedy as well as triumph, a suitable reminder that priests, as well as people, are subject to the divine law, and must be meticulous in its observance.

THE MANUAL OF PURITY
(11:1–15:33)

The third major section of textual material can be described, like the first, as a manual. Its basic theme is the nature of "purity" and "contamination", and its primary concerns the distinctions between "clean" and "unclean". These issues were in 10:10, and this may account for the positioning of the work here. In the process the nature and effects of contamination in a wide variety of life situations are thoroughly explored. The manual may consist of a series of originally independent texts, each marked by new introductory words addressed to Moses, and in some instances Aaron. These units are as follows:

1. 11:1–47 – clean and unclean creatures
2. 12:1–8 – purification after childbirth
3. 13:1–59 – skin disease and contaminated garments: diagnosis
4. 14:1–32 – purification rituals for contamination
5. 14:33–57 – contamination in buildings: diagnosis and purification
6. 15:1–33 – bodily discharges: purification.

Within these individual texts there are often signs of further compositional complexity.

It is important to remember, in reading the Manual of Purity, that the language of uncleanness, pollution or contamination denotes a **ritual** condition; it is not essentially about what might be deemed dirty, offensive or unhealthy. The condition is certainly limiting, has risks attaching to it, and needs to be dealt with in the proper way, but, as perceived by the Manual of Purity, it is a facet of an overall conception of a culticly ordered world in which all aspects of human experience have their proper place and position. Though ethics

and ritual considerations do interact (see the Holiness Code), the Manual of Purity makes no ethical observations or conclusions about the conditions with which it deals.

A good deal of attention has been given to the distinction between clean and unclean creatures, and various models have been proposed by which the distinctions and differentiations can be understood. While it would be wrong to underestimate health awareness in ancient societies, it has proved difficult to identify such factors as determinative in the purity system, and most interpreters look to socio-religious explanations (e.g. B. A. Levine, *Leviticus*, 1989, pp. 243–248). Physical factors and the concept of anomaly are one such interpretative tool. Another is the nature/culture distinction, whereby nature signifies that which is outside human control, and therefore potentially dangerous. Further factors to consider are the blood prohibition and contact with death; predators will necessarily be reckoned unclean.

It seems desirable to look for an approach which does best justice to the system in its entirety, though it is overoptimistic to suppose that there is one key which can unlock its meaning. Different factors operate at stages in its emergence, and they are rarely mutually exclusive. Adopting the approach suggested in the General Introduction (see the sections on Holiness and Sacrifice), we may assume that the purity system embodies the ambiguities of living in an environment which is both hostile to survival and vital to survival. The system therefore **protects** and **affirms**. Sacrifice embodies the ambiguity, protecting life by providing food, while affirming its sanctity through the blood prohibition. Once the basic principles are in place it is of course open to priestly expertise to lay claim to control of the boundaries, and to develop further distinctions and differentiations based on physical and other characteristics.

A common factor in the Manual of Purity is the question of human control. Many creatures are wild. Likewise childbirth, skin diseases, contamination in objects and discharges all represent mysterious processes beyond human understanding and control – albeit in very different ways. In some instances central life symbols, such as semen and above all

the blood, are at issue. It is important therefore to protect the community, while at the same time acknowledging the divine life on which it depends.

Superimposed on these basic ideas, it may be suggested, is the priestly concept of order, wholeness and perfection, whereby physical anomaly becomes problematic. Hence the overtly physical skin diseases pose problems which other forms of illness apparently did not. A recent study by Mary Douglas ("The Forbidden Animals", 1993) suggests that "defect" or "anomaly" does not denote inferiority, but rather vulnerability; like the poor, for whom the prophets spoke, the forbidden non-predatorial creatures symbolize the weakness which calls forth divine compassion and which divine right-eousness defends. The strength of this proposal is that the priestly perspective is firmly monistic; there is no supernatural force of evil which generates uncleanness. Among the creatures it is not their repulsiveness which makes them prohibited. God made the unclean creatures, along with the clean, and saw that they were good. His only reservation has to do with the predators who are a part of the "violence" which calls forth the deluge (Gen. 6:11).

The possibility that, in the context of developed priestly theology, uncleanness symbolizes vulnerability, and not danger, deserves to be considered in relation to the other circumstances with which the Manual of Purity deals.

1. CLEAN AND UNCLEAN CREATURES
(11:1–47)

The first section in the Manual of Purity deals with living creatures. The main concern is to distinguish clean from unclean, and thereby make clear what may be eaten (the clean), though a subsidiary interest is the effect of contact with the carcases of certain creatures. These creatures belong of course to the realm of the "common" – see the distinctions made in 10:10. The textual units are easily identified:

11:1–8 – animals of the earth
11:9–12 – water creatures

11:13–19 – birds
11:20–23 – winged insects
11:24–28 – carcase contamination by animals
11:29–38 – contamination by swarming earth creatures
11:39–40 – carcase contamination by clean creatures
11:41–45 – swarming earth creatures
11:46–47 – summarizing distinctions and statements.

Moses and Aaron are required to address the nation at large in the second person plural (vv. 1–2), material we have designated statutes. There are elements which have the character of ritual (vv. 25, 28, 40), and also declarations about various conditions (vv. 24b, 26b, 27b, 31b, 32, 34, 35a, 36–38, 39a, 41). Among recent discussions of the literary structure of the chapter are those by D. P. Wright (*The Disposal of Impurity*, 1987, p. 201) and J. Milgrom (*Leviticus 1–16*, 1991, pp. 691–698). Milgrom's analysis sees the purification elements (vv. 24–28, 29–38) as imposed upon the diet rules. There is a parallel passage in Deut. 14:3–20, and the relationship between the two texts has been much discussed. J. Milgrom (*Leviticus 1–16*, 1991, pp. 698–704), for example, sees Deut. 14 as an abridgement of Lev. 11. A clear dependence in either direction is hard to establish, and variations on a common tradition is as plausible a solution as any.

It is easy to see why food should be a major point of interest. Eating is in part a process by which things are transformed, and their status within the scheme of things is thereby altered. More fundamental, however, is the question of death. The food under discussion here is that which must be killed.

The priestly view is that human beings were originally intended to be vegetarian (Gen. 1:29). In the aftermath of the flood a new order emerged in which meat-eating was permitted, provided the blood was excluded (Gen. 9:3–4). Prohibitions regarding the consumption of blood are familiar in the law codes (e.g. Deut. 12:23; Lev. 3:17; 17:10), and it is clear that the ban is ancient (1 Sam. 14:33). The blood belongs to God, and must be offered exclusively to him (Exod. 34:25). The effect of the diet regulations here is to set

further restrictions on the killing and eating of animals by human beings.

It is clear also that distinctions between clean and unclean food are ancient and fundamental assumptions in Old Testament texts. In Jdg. 13:4, 7, 14 they are associated with Nazirite vows, while the recognition that the flesh of pigs is abominable is reflected in Isa. 65:4, 66:17. The uncleanness of certain foods is evidently familiar to Hosea (9:3, 4). Food as an issue, including blood prohibitions, is prominent in the "priestly" prophecies of Ezekiel (4:13, 14; 33:25; 39:17). The risk of defilement by food is also an important theme in the early part of the book of Daniel (1:8).

In vv. 1–8 the **land animals** are discussed (v. 2). Physical criteria determine whether an animal is clean or unclean, and therefore permitted for food. A clean animal must be **cleft-footed** and one which **chews the cud** (v. 3). Four examples are provided of creatures which meet one requirement, but not the other (vv. 4–7). An unclean animal is not only precluded as food; contact with its carcase would render any one unclean (v. 8).

2. The word rendered **land animals** distinguishes the creatures in question from human beings (e.g. Exod. 8:17), birds and reptiles (e.g. Gen. 6:7) and fish (e.g. 1 Kgs 4:33). Some texts use the word more precisely to denote domestic animals over against those in the wild (e.g. Gen. 1:24–26; Lev. 19:19; 26:22; Num. 3:41, 45 – "cattle"). There are others where creatures of the wild seem to be intended (e.g. Deut. 28:26; 1 Sam. 17:44; Prov. 30:30; Isa. 18:6; Jer. 7:33; Mic. 5:8; Hab. 2:17), but not in the priestly writing.

3. The physical characteristics of clean animals are described by three root words or phrases, though probably only two essential characteristics are in mind. The first is the verb "to break in two" or "divide" (BDB), which is reflected in the phrase **divided hoofs**. The word is used as here in Deut. 14:6–8, but is more commonly used of hoofs in general, whether parted or not (e.g. Exod. 10:26; Isa. 5:28; Mic. 4:13; Jer. 47:3; Ezek. 26:11; 32:13; Zech. 11:16; Ps. 69:31). The second is the verb "to divide" or "cleave", and hence the phrase **cleft-footed**. It occurs in this sense in Deut. 14:6, 7,

but more usually has the meaning "to tear" or "to hurt" (Jdg. 14:6; 1 Sam. 24:8; Lam. 3:11). It may be that these two roots are simply alternative ways of indicating that the animals must have hoofs (see v. 26). The third root **chews the cud** employs a word which occurs only in accounts of clean/unclean creatures (cf. Deut. 14:6, 7).

4. Four unclean creatures which meet one of the criteria but not the other are then listed. The first three are ruminants (i.e. **those that chew the cud**), but they are not cleft-footed. Strictly speaking, neither rock badger nor hare are ruminants; they only appear to chew the cud. The **camel** is the first. It is frequently cited in the Hebrew Bible as property and as a means of transport (cf. J. A. Thompson, *IDB*:I, pp. 490–492), particularly among the ancestors (e.g. Gen. 12:16; 24:10, 61; 31:17).

5. The **rock badger** (coney – *NIV*) is the second. It belongs to the hyrax family (cf. W. S. McCullough, *IDB*:IV, p. 102), and is rarely mentioned elsewhere (Deut. 14:7; Ps. 104:18; Prov. 30:26).

6. The **hare** (rabbit – *GNB*; *NIV*) is the third. It is cited only here and in Deut. 14:7 (cf. W. S. McCullough, *IDB*:II, pp. 524–525).

7. The **pig** meets the hoof criterion, but not the eating requirement (for additional information cf. G. Henton Davies, *IDB*:IV, p. 469). The eating of pigs is prohibited in Deut. 14:8, as here, and further allusions to the unacceptability of eating or offering the flesh can be found in the later parts of Isaiah (65:4; 66:3, 17). In Ps. 80:13 it is identified as a creature of the wild (a boar), and in Prov. 11:22 a figurative usage occurs in relation to an indiscreet woman. Attitudes to the pig in the ancient near east were variable. There is evidence of its domestication, and of its use as food; there is evidence too of revulsion and of its use only in the worship of underworld deities (J. Milgrom, *Leviticus 1–16*, 1991). For Milgrom it is the association with these deities which lies behind the pig's proscription in Israel. The impurity of the pig in Hittite culture, and the section as a whole, is discussed by D. P. Wright (*The Disposal of Impurity*, 1987, pp. 105 n.48, 200–206). U. Hubner ("Schweine", 1989) is inclined to think

the pig prohibition relatively late, tracing it to the exilic/post-exilic period. In Deut. 14:3–8 a list of wild animals that meet the cleanness criteria is provided; these may therefore be eaten.

It is clear that the priests are making decisions here on the basis of physical criteria (M. Douglas, *Purity and Danger*, 1966). Considerations relating to the natural habitat of the animals, or their desirability as food, are not the overt point at issue. It is also clear that the creatures cited are borderline cases; they exhibit some of the requirements for cleanness, but not others. Since familiar domesticated animals, such as cattle, sheep and goats, are both ruminants and ungulates it seems to be the case that they provide the essential yardstick by which other animals are to be judged. As Deut. 14:5 makes explicit it is therefore possible for some wild creatures to be clean. It is also likely, as Douglas suggests, that a principle of order and notions of environmental appropriateness are operative factors, though as E. Firmage ("The Biblical Dietary Laws", 1990) has observed her stress on locomotion is not an operative principle with these creatures. In the context of the three environments (air, earth and water) those earth animals which best serve human need constitute the ordered ideal, the measure of wholeness by which others can be assessed. Creatures which do not correspond to those perceptions of appropriateness are experienced as anomalous, and are therefore unclean.

It is also worth observing that the creatures which provide the model of order and wholeness are herbivorous, and while it is true that behavioural characteristics are not the overt criteria, it is likely that the priestly system of order is built upon older fears about contact with blood and death. This would explain in v. 8 the concern about contact with carcases, and the rejection as food of animals which die naturally, or which are killed by other animals (Exod. 22:31; Deut. 14:21). Carnivorous creatures disturb human perceptions of the peaceful ideal environment (Isa. 11:6–9), and some are a danger to domesticated animals and to human life itself. In particular they pose a threat from nature to culture (M. P. Carroll, "One More Time", 1978). In this way the physical

characteristics of those creatures which least exhibit such behavioural tendencies become the criteria by which the whole (the clean) and the anomalous (the unclean) can be determined. The ecological and cultural factors which make an impact on the system are also explored by W. Houston (*Purity and Monotheism*, 1993); useful distinctions are made here between domestic animals which are members of the community, animals which because of their habits and behaviour are enemies, and ambiguous animals such as the dog and the pig.

Theories about anomaly on the one hand and nature/culture on the other are not necessarily incompatible. Both may well be facets of a dynamic and evolving purity system. As indicated in the introduction to the Manual of Purity, a recent study by Douglas ("The Forbidden Animals", 1993) indicates, from her perspective, a stress on the **behaviour** of the predators, and the **vulnerability** in different ways of many of the unclean.

Attention turns in vv. 9–12 to the water creatures – **all that are in the waters** – and once again physical criteria determine what is clean, and what therefore may be eaten. **Fins and scales** (v. 9) are the decisive characteristics. Forms of water life lacking them are therefore unclean, and once again contact with their carcases will pollute (vv. 10–12).

9. The criteria specified make it clear that fish are acceptable as food. **Fins** and **scales** are rare words. Both occur in the parallel passage (Deut. 14:9, 10), and the latter in 1 Sam. 17:5 (of armour) and Ezek. 29:4.

10. Here a particular type of water creature is identified; these are **the swarming creatures**. The verb means "to swarm" or "to teem" (BDB). As a noun it is used on several occasions by the priestly writers (cf. e.g. 5:2). In Gen. 1:20 it denotes, as here, aquatic creatures, but these forms of life can also swarm upon the land (Gen. 7:21; see also vv. 29–38 (where examples are cited); 41–44). Moreover, the same word is part of the phrase **winged insects** (vv. 20, 21, 23). Clearly such creatures do not belong to a particular environment. There are several possibilities about the word's precise connotation. It could

signify the capacity of these creatures to multiply and/or to move about in large numbers (cf. Gen. 9:7). The context of Ezek. 47:9 also suggests quantity (cf. Exod. 8:3–6; Ps. 105:30). In principle this might seem most probable in view of the textual support elsewhere. One difficulty, however, is uncertainty as to whether multiplication and numbers could really be thought to apply to some of the specific creatures cited in vv. 29–30. By this definition fish with fins and scales might also qualify. The animals in vv. 29–30 all have short legs and move in close proximity to the ground; the word, as applied to dry land, might therefore distinguish such creatures from the land animals in vv. 2–8. This, however, does not account for the swarmers that inhabit water and air. A further possibility is that the word has to do with the manner of locomotion – e.g. quick darting movements – though once again this would be equally true of creatures with fins and scales. Alternatively the point could be that these are creatures which creep or crawl (creepie-crawlies). Among the water creatures that might meet such a definition would be eels and reptiles such as the lizard. *REB* takes the word to mean "small creatures in shoals" (cf. "small water creatures" – *NJB*). The possibility that the swarming creature is by definition something that can be found in all three environments (albeit in different forms) is not to be discounted.

A further word to denote the unacceptability of the water creatures which fail to meet the criteria is **detestable** (cf. vv. 11, 12; cf. 7:21) ("abomination" – *RSV*). It continues to be used later in the chapter (vv. 13, 20, 23, 41, 42, 43, cf. also 20:25). In Deuteronomic and prophetic literature it is associated with alien cults (e.g. Deut. 7:26; 1 Kgs 11:5; 2 Kgs 23:13; Isa. 66:3; Jer. 4:1; Ezek. 5:11), and in Daniel there is the "abomination that makes desolate" (11:31; 12:11). A connection with food is probably intended in Zech. 9:7. The word appears to denote a special degree of abhorrence within the realm of the unclean. *NEB* rendered it "vermin"; *REB* prefers "prohibited".

Fins and scales constitute the means of locomotion felt to be appropriate for the water environment (M. Douglas, *Purity and Danger*, 1966). Creatures lacking them, and

particularly those that **swarm** with their "indeterminate form of movement", may be deemed anomalies which infringe the divine order. The presence of the swarmers in all three divinely ordained environments confirms this. Douglas's recent suggestion ("The Forbidden Animals", 1993) that lack of fins and scales might signify vulnerability is also to be noted. The nature/culture approach has no very evident significance here; eels or shellfish do not obviously intrude from another realm. This does not invalidate the relevance of the nature/culture distinction overall. The priestly system is one of divine order, evident in fixed environments, and specifying physical characteristics and forms of locomotion appropriate to those environments. It is arguable that this has been superimposed upon older concerns about the boundaries between nature and culture, and in this instance in such a way that they can no longer be easily discerned. It may be the case nevertheless, as Carroll ("One More Time", 1978) suggests, that the allusion to **scales** is significant. Carnivorous water creatures, such as the shark, have fins, but not scales, and, as with the beasts (vv. 1–8), it is plausible that flesh-eating, life-consuming, contact with death is an important element in the process by which some things are deemed unclean and/or abhorrent. F. S. Bodenheimer (*IDB*:II, pp.272–273) identifies the water creatures Israelites would have known, and identified as unclean. It is feasible that those from the sea, which had associations with chaos and disorder in ancient mythology, might have been deemed intruders from a realm beyond human control. The feeling that there are anarchic water creatures, not subject even to rulers of their own, is well expressed in Hab. 1:14. To catch them is cause for religious rites (Hab. 1:16).

In vv. 13–19 there is a list of flying creatures which must not be eaten. In this instance no defining physical characteristics are given, but most if not all appear to be carnivorous in one way or another. Some cannot be identified with certainty, but as B. A. Levine (*Leviticus*, 1989) observes there are basically five types – falcons, vultures/eagles, owls, ravens and marsh/sea birds. A discussion of the literary connections

between this passage and the corresponding list in Deut.
14:12–18 is provided by W. L. Moran ("The Literary
Connection", 1966).

13. The birds listed are assigned to that special category of
uncleanness – **detestable** (v. 13, cf. vv. 10, 11, 12). The word
birds can be used for all creatures of the air, including insects
(vv. 20, 21, 23; Deut. 14:19). More usually it clearly has the
narrower connation **birds** (e.g. Gen. 8:20; 1 Sam. 17:44; 2
Sam. 21:10; 1 Kgs 14:11; Ps. 78:27; Eccl. 10:20; Isa. 16:2; Jer.
5:27). Information about the birds listed in vv. 13–19 is
provided by W. S. McCullough (*IDB*:I, pp. 439–440; II, pp.
252–253, and under other appropriate headings). The
following brief observations are largely dependent on the
information he provides. The many *NEB* alternatives
(followed largely but not entirely by *REB*) are based on G. R.
Driver ("Birds in the OT", 1955), who believed that the list
was constructed in accordance with a fourfold system of clas-
sification – large broad-winged birds (vv. 13–14), the raven
group (v. 15), owls (vv. 16–18a), and water birds (v. 19).

The **eagle** (griffon-vulture – *REB*, J. E. Hartley (*Leviticus*,
1992); tawny vulture – *NJB*) was the largest of Palestinian
birds.

The **vulture** (griffon – *REB*; *NJB*; black vulture – J. Milgrom
(*Leviticus 1–16*, 1991); bearded vulture – J. E. Hartley
(*Leviticus*, 1992)) was perhaps one of the commonest birds of
prey.

The **osprey** (bearded vulture – *REB*, J. Milgrom (*Leviticus
1–16*, 1991); black vulture – *NIV*, J. E. Hartley (*Leviticus*,
1992)), a fish-eating bird, and a plausible identification, is
mentioned only here and in Deut. 14:12.

14. The **buzzard** (red kite – *NIV*; kite – J. Milgrom (*Leviticus
1–16*, 1991), J. E. Hartley (*Leviticus*, 1992)) is mentioned in
Isa. 34:15 as an habituee of deserted places; here too the
identification is plausible.

The **kite** (buzzard – *NJB*, J. E. Hartley (*Leviticus*, 1992);
black kite – *NIV*); falcon – J. Milgrom (*Leviticus 1–16*, 1991)),
a smaller bird of prey, is conjectural, but its sharp-eyed attrib-
utes (Job 28:7) make the identification appropriate.

15. The **raven** (crow – *REB*, J. E. Hartley (*Leviticus*, 1992))

probably represents the corvidae family (including e.g. crows and jackdaws), which in addition to its scavenging habits, is in part carnivorous (Job 38:41; Prov. 30:17). Feelings about the uncleanness of ravens did not inhibit the idea that Elijah was fed and sustained by them during a famine (1 Kgs 17:6).

16. The **ostrich** (v. 16) (desert owl – *REB*; horned owl – *NIV*; eagle owl – J. Milgrom (*Leviticus 1–16*, 1991), J. E. Hartley (*Leviticus*, 1992)) is a possible identification (cf. Job 39:13–18, Lam. 4:3). It is omnivorous, and may eat small mammals and birds.

The **night hawk** (or night jar) (short-eared owl – *REB*, J. Milgrom (*Leviticus 1–16*, 1991), J. E. Hartley (*Leviticus*, 1992); screech owl – *NJB*; *NIV*) is one of the more speculative translations in the list, the word occurring only here and in Deut. 14:15. A number of investigators prefer one of the owl family; this would retain the carnivorous element in the list.

The **sea gull** (long-eared owl – *REB*, J. Milgrom (*Leviticus 1–16*, 1991), J. E. Hartley (*Leviticus*, 1992)), another word found only in these lists (cf. Deut. 14:15), is plausible. As well as eating fish and young birds it is a scavenger.

The **hawk** is mentioned in Job 39:26; another bird of prey is suggested by the content and context.

17. The **little owl** (cf. Deut. 14:16) (tawny owl – *REB*, J. Milgrom (*Leviticus 1–16*, 1991); horned owl – *NJB*) is plausible, but attempts to identify a particular species here are speculative.

The **cormorant** (fisher-owl – *REB*, J. Milgrom (*Leviticus 1–16*, 1991)), a large fish-eating sea bird, is a reasonable proposal, but the word occurs only here and in Deut. 14:17.

The **great owl** (ibis – *RSV* follows Gk and Vg) (screech owl – *REB*, J. Milgrom (*Leviticus 1–16*, 1991); long-eared screech owl – J. E. Hartley (*Leviticus*, 1992); barn owl – *NJB*) is particularly problematic. The eating habits of ibis or owl would render them unclean in Israel.

18. The **water hen** (cf. Deut. 14:16) (little owl – *REB*; ibis – *NJB*; white owl – *NIV*, J. Milgrom (*Leviticus 1–16*, 1991); barn owl – J. E. Hartley (*Leviticus*, 1992)) is another translation prompted by Gk. Omnivorous eating habits make it a likely member of these lists.

The **desert owl** (horned owl – *REB*; scops owl – J. Milgrom (*Leviticus 1–16*, 1991), J. E. Hartley (*Leviticus*, 1992)) is preferable to *RSV*'s pelican – cf. Ps. 102:6, Isa. 34:11; Zeph. 2:14 where the bird is associated with the wilderness or ruins, neither of which would be the pelican's natural habitat.

The **carrion vulture** (cf. Deut. 14:17) (osprey – *REB*, J. Milgrom (*Leviticus 1–16*, 1991), *NIV*; white vulture – *NJB*; Egyptian vulture – J. E. Hartley (*Leviticus*, 1992)) has to be a tentative identification. Such birds were present in Palestine in biblical times and are to be expected in the lists.

19. The **stork** is another eater of fish and small mammals, and, in addition to Deut. 14:18, citations occur in Ps. 104:17 (nesting) and Jer. 8:7 (migration).

The **heron** (cormorant – *REB*) is mentioned only here and in Deut. 14:18. It is somewhat similar in appearance and habits to the stork.

The **hoopoe** (cf. Deut. 14:18) is taken by McCullough to be "reasonably certain" as an identification; he suggests that the bird's tendency to search for food in such places as dung hills is a possible explanation for its uncleanness. It will also eat small animals (E. Hunn, "The Abominations of Leviticus", 1979).

The **bat**, as a flying mammal, is understandably included in the list. It is not entirely clear why this fruit- and insect-eating creature should be considered unclean, but its habits as a nocturnal and cave-dwelling "bird" (Isa. 2:20) may have been difficult to discern, and perhaps it was therefore not to be risked.

Whatever the problems of identification in specific instances all the indications are that these flying creatures are unclean primarily because of their carnivorous or scavenging habits. Physical criteria, such as those offered in vv. 1–8 and vv. 9–12, are lacking here. M. Douglas (*Purity and Danger*, 1966) recognizes the problem this poses for her approach, but suspects that there was something deemed anomalous about the creatures in relation to their environments, and perhaps their capacity to swim and dive. This might be appropriate for some of those mentioned, though not all, if current identifications are reasonably accurate (E. Hunn,

"The Abominations of Leviticus", 1979). It seems better to suppose that older nature/culture criteria are operative here, and that flesh-eating birds (cf. Gen. 1:30; 9:3) are obscuring these fundamental distinctions (M. P. Carroll, "One More Time", 1978). Contact with death is essentially polluting, while scavenging carries obvious risks of contact with a variety of defilements, and the birds in question must therefore be avoided.

Explanations of a materialist kind supplement these observations. It is clear that carnivorous creatures (of land, sea or air) constitute competition for scarce resources. This would be an aspect of the threat from nature that they pose. The sense of the competitor as enemy, and therefore dangerous, and therefore polluting, and therefore not to be eaten, is a feasible sequence of reactive processes, arising partly from human material needs, and partly from cognitive system building.

In vv. 20–23 the theme is **winged insects** (20), all of which are unclean except the hoppers – those **with jointed legs above their feet** (v. 21). Locusts, crickets and grasshoppers are cited (v. 22) as examples of acceptable insects.

20. The phrase **winged insects** (v. 20) combines two of the key words already used in this chapter. These are the word which denotes the **swarming creatures** in v. 10, and that which designates the **birds** in v. 13. They belong to the detestable category of unclean creatures (see v. 10). The phrase **on all fours** is later used of animals (v. 27) and creatures that swarm on the earth (v. 41).

21. The **legs** indicate length, in contrast to those creatures who are so close to the earth that their legs cannot be seen. The word is familiar (e.g. Exod. 12:9; 29:17; Lev. 1:9, 13; 4:11; 8:21; 9:14). The legs also indicate a capacity **to leap** on the earth. The use of this word with this sense of to "spring" or "start up" (BDB) is infrequent; it occurs elsewhere in relation to the startling or shaking of human beings (Job 37:1; Hab. 3:6).

22. In v. 22 a few clean insects are indicated. A thorough account of the types of "locust" found in the Bible is given by

Y. Palmoni (*IDB*:III, pp.144–148; see also W. W. Frerichs (*IDB*:II, p. 470 on "grasshoppers"). As *GNB* suggests the insects in question are locusts, crickets or grasshoppers.

The first word **locust** (great locust – *REB*; migratory locust – *NJB*) is often used collectively, and may sometimes mean "grasshopper". Here it seems to be categorized in much the same way as the three distinct types that follow (**according to its kind**). A collective meaning may still be intended (the locust/grasshopper family in general), but a distinct type (as in Joel 1:4 – swarming locust) is a real possibility.

The **bald locust** (long-headed locust – *REB*; katydid – *NIV*) and the **cricket** (green locust – *REB*) occur only here, and may in fact belong to the grasshopper family, judging by Talmudic descriptions (see Palmoni).

The **grasshopper** (desert locust – *REB*) is cited elsewhere (Eccl. 12:5; Num. 13:33; Isa. 40:22), and can even be clearly a locust (2 Chr. 7:13). *NJB* simply transliterates the Hebrew in relation to the second, third and fourth species – solham, hargol and hagab locusts.

It is obvious that the locust and grasshopper families were not clearly distinguished. According to Frerichs "locust" should be used in the modern context "to designate only the gregarious phase of certain short-horned grasshoppers"; "grasshoppers" are either the long-horned variety or non-migrating short-horned insects.

At first sight the parallel passage in Deut. 14:19–20 seems to designate all winged insects unclean. The point is rather that winged creatures which swarm are unclean (v. 19). There are winged creatures, distinguishable from the birds (v. 11) which are clean (v. 20).

Physical characteristics are clearly a factor here in determining what is clean and what is not. Anomaly theory would point out that as creatures whose proper environment is the air insects are equipped, like the clean creatures of the land, with four feet. They are therefore anomalous. The locusts/grasshoppers of v. 22 are acceptable because, like clean birds, they can hop; if they simply crawled, like swarming creatures, they would be unclean. E. Firmage ("The Biblical Dietary Laws", 1990) expresses doubts,

pointing out among other things that "swarming" does not of itself determine uncleanness. The nature/culture factor is certainly applicable. The clean insects (locusts/grasshoppers) are those which remain within the natural realm. The rest are intruders into culture, by bite or sting, or by eating garments. If we could be certain that locusts threatening to agriculture are excluded in v. 22, this would obviously help the theory. The first type in v. 22 (**swarming locust**) is actually one of the highly destructive types cited in Joel 1:4 (locust – *RSV*); the other three (**cutting**, **hopping** and **destroying**) are not among the clean locusts here in v. 22. Some caution is clearly appropriate, but the idea that unclean creatures are those which compete with or hinder the human enterprise remains a plausible one.

The essential concern of vv. 24–28 is to indicate that contamination occurs when the carcases of unclean animals (of vv. 1–8) are handled. Washing rites of purification are required, and the transmitted unclean condition lasts until the evening. A tabular overview of this theme in the Manual of Purity is provided by P. P. Jensen (*Graded Holiness*, 1992, pp. 225–226). A clean animal must have **divided hoofs** (i.e. be an ungulate) as well as being **cleft-footed** (v. 26 cf. v. 3); one only of these characteristics is insufficient. Furthermore those that move **on their paws** (v. 27) are always unclean.

24. The idea that certain forms of pollution last until the evening (cf. vv. 25, 27, 28) is well established in priestly literature. Contact with the carcases of unclean creatures, as here, continues to be a concern (vv. 31, 32), but the dead bodies of clean creatures are similarly contaminating (vv. 39, 40). Other situations in the Manual of Purity having the same effects include entry into a house declared unclean (14:46), contact with a person who has a discharge and with objects with which he has come into contact (15:5, 6, 7, 8, 10, 11), emissions of semen (15:16, 17, 18; cf. Deut. 23:10–11), and contact with menstrual women and objects they have contacted (15:19, 21, 22, 23, 27). Eating the flesh of an animal which has died naturally or been killed by other animals has the same effects (17:15). Situations arising from contact with

dead people are also envisaged (Num. 19:19, 21, 22), and the preparation of the water for impurity will also have such effects (Num. 19:7, 8). Other legislation, exhibiting the same basic principles, affects the priests (22:6).

25. The washing of clothes, as an integral part of the purification process, is a requirement in many of these situations (vv. 25, 28; cf. v. 40; 14:47; 15:5, 6, 7, 8, 10, 11, 17, 21, 22, 27; 17:15; Num. 19:7, 8, 19, 21). Such washing is also necessary on other occasions – in connection with leprosy (13:6, 34; 14:8, 9), with aspects of the day of atonement rites (16:26, 28), with the consecration of Levites (Num. 8:7, 21), and with men of war (Num. 31:24). In many of these situations a washing of the body is also required (14:8, 9; 15:5, 6, 7, 8, 10, 11, 16, 18, 21, 22, 27; 16:26, 28; 17:15; 22:6; Num. 19:7, 8, 19; Deut. 23:11). The washing of clothes seems to be necessary here because the carcase is carried; contact with the body might be avoided in such situations, but not contact with the clothing. An extensive discussion of the rituals of washing bodies, washing clothes, and waiting till evening is conducted by D. P. Wright (*The Disposal of Impurity*, 1987, pp. 220–222, see also pp. 185–186 n.38, n.39). His contention that these various procedures constitute a single ritual unit seems likely. There is no strong evidence for supposing that each of the actions signifies something different; taken together (two or all three) they constitute what is required for a person to be restored.

26. The unclean animals are again identified in terms of their physical characteristics (v. 26; cf. vv. 2–8). D. P. Wright (*The Disposal of Impurity*, 1987, pp. 201, 205) takes the view that large land animals such as the horse are in mind here. The text seems to suggest that there can be animals which have **divided hoofs** and which are not **cleft-footed**, a situation not explicitly envisaged in vv. 2–8. In short, there are three physical characteristics, and an animal must satisfy all three if it is to be considered clean. It is also possible that the word rendered **divided hoofs** here (and v. 3) simply meant "hoof" to the writer – i.e. ungulates (see on v. 3 for other texts where this meaning seems clear). The required characteristics for clean animals would therefore be two; they must be

ruminant and cleft-footed ungulates. Contact with the carcases of creatures which do not meet these conditions renders a person unclean (but see also v. 39).

27. In v. 27 there is a further physical criterion for unclean animals. The carcases of those that **walk on their paws** contaminate in the same kind of way (vv. 27–28). The application of this word, which often means "palm of the hand", to animals is unusual. The human "hand" is often the point of reference, particularly in relation to the hands of the priests (Lev. 8:27; 9:17; 14:15, 16, 17, 18, 26, 27, 28). The word can also signify a "pan" or "vessel" (BDB) in priestly tradition – the dishes for incense in Exod. 25:29; 37:16; Num. 4:7; 7:14, etc. There are, however, a number of texts in which the word is explicitly linked to "feet", meaning the "palm" or "hollow" of the foot (Gen. 8:9 (of a dove); Deut. 11:24; Josh. 1:3; 2 Sam. 14:25; 1 Kgs 5:3; 2 Kgs 19:24; Job 2:7; Isa. 1:6; Ezek. 1:7 (of a calf); Mal. 4:3). The precise meaning here is difficult to assess. The animals are obviously four-footed, but that is clearly true of the clean animals in vv. 2–3. *REB* considers them to be "wild animals that walk on flat paws"; *NJB* describes them as "animals which walk on the flat of their paws". This is supported by D. P. Wright (*The Disposal of Impurity*, 1987, p. 205) who cites bears and dogs as good examples. J. R. Porter (*Leviticus*, 1976) suggests animals with front feet which look like hands (e.g. monkeys), and which might therefore be considered anomalous.

M. Douglas (*Purity and Danger*, 1966) takes this reference to creatures with "hands" to be applicable to those cited in vv. 29–30 (e.g. weasels, mice, lizards), and interprets the attitude shown in the light of her general theory about anomaly. The use of the "hands" in this instance constitutes a form of locomotion inappropriate to the creature's environment. M. P. Carroll ("One More Time", 1978) doubts whether an anomalous form of locomotion is the point at issue here. His contention, in accordance with his use of the nature/culture distinction, is that these creatures with "hands"/"paws" are probably wild carnivores such as the lion, bear and wolf. Certainly a fear about contact with death emerges in the passage, in its preoccupation with the polluting effects of

carcases. It seems very likely that the creatures with **paws** are wild, and therefore beyond the control of culture. Whether they also compete with humans in the struggle for resources is hard to determine. As has been suggested in the discussion of vv. 1–23 the theories of anomaly and nature/culture are not necessarily exclusive.

In vv. 29–38 a fourth major category of creature is introduced (taking the insects of vv. 20–23 along with the birds of vv. 13–19). These are the **creatures that swarm upon the earth**. Various examples are cited (vv. 29–30), and the probability is that all such creatures are unclean. H. P. Smith ("Animal Sources", 1911) thought there were religious reasons for these prohibitions, and A. Jirku ("Lev. 11:29–33", 1972) maintains that they all played a part in Canaanite cultic observance. As with the animals in vv. 24–28 the carcases convey uncleanness (v. 31). There follows an extended discussion of the ways in which such uncleanness can be transmitted (vv. 32–38).

29. The root word behind the word **swarm** has already been used of water creatures (v. 10) and of insects (v. 20). It is possible that it denotes a mode of locomotion (creeping and crawling); it certainly does describe a denizen of all three environments (see the discussion on v. 10).

The animals specified are discussed in detail by W. S. McCullough (*IDB*, appropriate volumes) and some of the following information is drawn from that source.

The **weasel** occurs only here in the Hebrew Bible. This is the identification favoured by the versions (also *NIV*); the mole or a species of rat are possibilities (mole-rat – BDB; *REB*; J. E. Hartley (*Leviticus*, 1992); mole – *NJB*, *GNB*; B. A. Levine (*Leviticus*, 1989); rat – J. Milgrom (*Leviticus 1–16*, 1991)).

The **mouse** is more familiar (1 Sam. 6:4, 5, 11, 18; Isa. 66:17), and may denote a variety of mouse-like rodents, including rats and voles (jerboa – *REB*; rat – *NJB*; *NIV*, *GNB*). Its capacity to cause damage is clear from 1 Sam. 6:5.

The **great lizard** (land crocodile – Gk; thorn-tailed lizard – *REB*; dabb lizard – J. E. Hartley (*Leviticus*, 1992)) is an identification supported by the versions, but as a creature the word occurs only here.

30. The **gecko**, another four-legged reptile, is most likely (cf. ferret or shrewmouse – BDB). The word has the same root as the verb "to cry, groan", and this may connect with the sounds a gecko makes.

The **land crocodile** (sand-gecko – *REB*; *NJB* transliterates koah; monitor lizard – *NIV*, J. E. Hartley (*Leviticus*, 1992); spotted lizard – J. Milgrom (*Leviticus 1–16*, 1991)) has a link with the word for "strength" or "power", and may therefore be the monitor, a carnivorous creature and the largest lizard known in Israel. Vg reads as chameleon and Syr as mole.

The **lizard** (wall-gecko – *REB*; *NJB* transliterates letaah; wall lizard – *NIV*) occurs only here (Prov. 30:28 has a different word). It is probably another type of reptile, one which can no longer be identified ("a kind of lizard" – BDB).

The **sand lizard** (great lizard – *REB*; chameleon – *NJB*; skink – *NIV*, J. Milgrom (*Leviticus 1–16*, 1991), J. E. Hartley (*Leviticus*, 1992)) poses problems of identification; some support for "sand lizard" (so-called because of its habitat) comes from the versions (cf. snail – *AV*).

The **chameleon** (tinshamet (transliterated) – *NJB*) is a small lizard-like creature, well known because of its colour changes. The **water hen** (v. 18) is a translation of the same word. The identification here clearly has to be tentative, with the versions offering very varied suggestions. The word may derive from the verb "to pant", and it could be that this connects with the sounds the chameleon makes, though McCullough is doubtful. The list in Deut. 14:3–20 does not mention any of these creatures, and does not deal with this particular category in general – i.e. the swarming earth creatures.

31. Contact with the carcases will cause uncleanness, which will last until **evening** (v. 31, see on v. 25).

Because many of these swarming things are relatively small their dead bodies might easily fall and come into contact with other objects. In vv. 32–38 a variety of such situations is envisaged. In brief, when the body falls upon artefacts in day to day use the objects concerned become contaminated.

32. The requirement for the restoration of most of the

items to a state of cleanness, and therefore to full use, is that they be put in water and be subject to the usual period of waiting (see on v. 25).

33. Any food or drink inside a vessel (possibly any vessel, and not simply the **earthen** type cited here) is unclean. The **earthen vessel** ("clay pot" – *GNB, NIV*) is a distinct type, and is mentioned on several occasions (6:28; 14:5, 50; 15:12; Num. 5:17). The **earthen vessel**, however, must be broken (v. 33) (cf. 6:28; 15:12) (see also v. 35).

34. The phrase relating to food "upon which water may come" (*RSV*) is taken by *NRSV* and many recent translations to mean water poured from such a vessel on to food.

35. The **oven** has already been cited in connection with cereal offerings (2:4; 7:9; cf. 26:26), and because it can be broken is presumably some kind of small fire-pot (BDB).

The word for **stove** ("cooking pot" – *NIV*) occurs only here in this exact form, and may denote some kind of cooking furnace able to support two pots (BDB); the root is familiar elsewhere, denoting various kinds of pots or basins. This also is made from a breakable substance.

The **oven** and **stove** (both made of clay) must be broken. The disposal of earthenware is discussed at length by D. P. Wright (*The Disposal of Impurity*, 1987, pp. 93–113). With assistance from Indian and Hittite evidence he accepts the view that the porous nature of earthenware would mean that contamination would penetrate and permeate the object to such a degree that customary forms of eradication would be ineffectual; hence the requirement that it be smashed. He proposes that the principle does not apply to other porous substances (e.g. wood, leather, cloth) for economic reasons. These are precisely the kind of organic artefact listed in v. 32.

36. Items not polluted are a **spring** or a **cistern** holding water. The **spring** is probably a natural water source, and the **cistern** (perhaps "well") one created by digging. Both are familiar in other biblical texts. Water as a sustainer of life has special power which protects it from contamination.

37. **Seed** ready to be sown is also safe from contamination. Like water it embodies the life force.

38. This does not obtain, however, if water has been

poured on the seed; in that instance the seed will be unclean.

The principle of anomaly is applicable here, in terms of a form of locomotion inappropriate to the environment. These are the creatures with "hands" (v. 27) which they use as front feet. Their essential characteristic – they are **swarming things** (v. 29) – links them to many of the creatures in the waters (v. 10) and in the air (v. 20); this denotes lack of wholeness, and introduces confusion into the divine ordering of the various environments.

Distinctions between nature and culture are also of interest here. It is significant that the items listed in vv. 32–35 are human artefacts, and the corpses of these creatures can therefore be seen as an intrusion from the realm of nature. Carroll ("One More Time", 1978) suspects that the creatures listed in vv. 29–30 are actually those which might be encountered in the home. If our suggestion that physical criteria (of the kind identified by Douglas) have been imposed upon older distinctions between nature and culture then identification of all the creatures in vv. 29–30 as those to be found in the home is not essential. There are creatures from the natural realm which intrude upon culture, and who therefore compete for the space that culture creates.

In vv. 39–40 the point is made that the carcase of all animals, including the carcase of an animal that can be eaten (v. 3), is unclean. In this respect the clean animal is no different from the unclean. The same waiting (till the evening) is necessary for those who touch the corpse (v. 39, cf. v. 24). Eating the carcase, or carrying it, will also require a washing of clothes (v. 40, cf. v. 28). In both instances the bathing of the body may be implied.

It must be the case that this stipulation is intended to deal with situations in which the animal has been improperly killed (D. P. Wright, *The Disposal of Impurity*, 1987, p. 185 n.38), or else has died naturally (cf. Lev. 7:24).

The verses confirm the impression that death, and everything which is in some way life-threatening, are key factors in establishing the pollution system.

In vv. 41–45 there is renewed discussion about creatures that **swarm upon the earth** (v. 41, cf. vv. 29–38). Whereas vv. 29–38 list eight such creatures which are unclean, vv. 41–45 declare all such to be unacceptable. In effect this passage rules out all small land animals as unfit to eat. This requirement is given a theological grounding in the holiness of Yahweh who has brought Israel out of Egypt (vv. 44–45).

41. The word **detestable** seems to denote a special degree of offensiveness (see on v. 10). There is also here an attempt to make clear the physical characteristics which define **creatures that swarm** (lacking in vv. 29–38).

42. Such a creature may go **on its belly**; this is probably intended to include all reptiles (cf. Gen. 3:14). The phrase **whatever moves on all fours** has already been used of animals in v. 27, where it could be a general term for all quadrupeds, clean and unclean alike. In relation to insects, however, only those going on all fours and which have a capacity to leap are clean (vv. 20–21). This suggests that short-legged quadrupeds, which move very close to the ground, are in mind here. Another indicator of a creature that swarms is **many feet** – i.e. more than four.

43. Here two risks are set side by side – to become **detestable** or **unclean**.

44. A final indicator is found in v. 44. The swarmers include everything that "crawls" (*RSV*) (**moves** – *NRSV*) upon the earth. This word makes its first appearance in the chapter at this point, but it is familiar elsewhere in priestly literature, and it commonly denotes a general category of creeping land creature over against other beasts and birds (e.g. Gen. 1:24; Lev. 20:25; cf. Deut. 4:18; 1 Kgs 4:33; Ps. 148:10; Ezek. 8:10; Hos. 2:18; Hab. 1:14). This seems to be the sense intended here. The word can, however, denote the movement of all land creatures (Gen. 1:28; 7:21; 8:19; 9:3) or night predators (Ps. 104:20). It can also be used of water creatures (v. 46; Gen. 1:21; Ps. 69:34; 104:25), suggesting that the mode of locomotion is a basic issue.

In vv. 44–45 the theology of holiness is expressed, using several of the turns of phrase which are characteristic of the Holiness Code in chapters 17–26. Yahweh's designation of

himself as Israel's God (vv. 44, 45) is such a phrase (18:30; 19:3,10, 25, 31, 34, 36; 20:7, 24; 23:22, 43; 24:22; 25:17, 38, 55; 26:1, 12, 13, 44). So too is the requirement that Israel **sanctify** herself and be **holy**, because Yahweh is **holy** (vv. 44, 45; cf.19:2; 20:7, 26). The deliverance from Egypt (v. 45) is also commonly recalled within this perspective (18:2; 19:34, 36; 22:33; 23:43; 25:38, 42, 55; 26:13, 45), and seems to be seen primarily as a great act of separation (20:24, 26).

The idea that swarming creatures are anomalous (see on vv. 29–38) continues to be tenable in the light of these further clarifications. M. Douglas (*Purity and Danger*, 1966) maintains that they exhibit an indeterminate form of movement which is not proper to any particular environment. As indicated above, to "crawl" is characteristic of creatures of the water or the land, and as such the swarmers cannot be properly classified within the divinely established environmental order. Swarming is itself a feature of both water (v. 10) and winged (v. 20) creatures.

While it is clear that physical criteria are basic to the distinctions which are being made in these verses, it is probable that nature/culture tensions are also applicable in the rejection of "swarming" land creatures (see on vv. 29–38). To the extent that such creatures may be found in the home they constitute an intrusion from the realm of nature, and compete for the space which culture creates. As creatures which move close to the ground it may be that they are at serious risk of contamination on their own account. Only carefully husbanded domestic creatures can be deemed clean. As creatures which "crawl" the swarmers seem to be without leadership, and as such represent the threat of chaos and anarchy.

The concluding verses (vv. 46–47) provide a simple summary of the content of the section as a whole.

46. The stipulations are described as **the law** (**torah**) (v. 46), in the same way as many of the directions given to the priests about sacrifices (6:9, 14; 7:1, 11, 37). The creatures are divided into four types – the land animals described in vv. 2–8, 26–27, the winged creatures of vv. 13–23 (the **birds**),

those that move ("crawl") in water as described in vv. 9–12, and finally those land creatures of vv. 29–38, 41–45 that swarm (**every creature that swarms upon the earth**).

47. The fundamental purpose of the **law** is to distinguish **clean** from **unclean** with a view to establishing what may and may not be eaten.

It is almost certainly mistaken to attempt to identify a single explanatory factor behind the various distinctions which operate in the chapter at large. The concept of anomaly probably has its place. Creatures which in terms of their appearance, characteristics, and possibly means of locomotion are felt to disturb what is deemed environmentally appropriate are unclean. From this perspective the creation ordinances of Genesis 1 establish the fundamental criteria. There three environments are established – the waters, the heavens and the dry land. The proper denizens of the waters are the "swarming creatures", while the winged creatures belong in the heavens (Gen. 1:20, 21). It is not surprising therefore that creatures which "swarm upon the earth" are problematic (vv. 29–38, 41, 45). The insects are problematic on two such counts. They are winged creatures which "swarm" (v. 20), and furthermore they go **upon all fours** (v. 20) like land animals. The proper denizens of the land are the **cattle** (probably signifying all domestic animals – Gen. 1:24), the creatures which crawl ("creeping things" – Gen. 1:24), and other animals ("wild animals" – Gen. 1:24).

Given this approach it is certainly possible to speculate about why some birds and water creatures are unclean. Many of the birds in vv. 13–19 are clearly flesh-eating, and it is feasible to suppose that they are felt to "invade" other environments (land and water) to secure their food. It is possible that water creatures without fins and scales are deemed intruders from the land; in Genesis 1 "creeping" things, according to the divine ordinance, belong to the land, but v. 46 makes it clear that they can also be found in the waters. Once the basic physical criteria have been established it is likely that further clarifications will become necessary, or even that exceptional concessions may be made. The

comments about animals that **walk on their paws** (v. 27) seem to be a clarification; the insects in v. 22 are perhaps a concession, rationalized on the basis of physical characteristics, to the hardships of life in desert places.

It seems likely, however, that anomaly does not account for all the distinctions, and it is quite possible that it is not the initial determinative factor at all. Not all proper denizens of the land are clean. The pig was probably deemed unclean before its anomalous characteristics were identified and affirmed. Here the basic physical criteria which denote that which is clean are those of the domesticated animals of the pastoralists (v. 3) – cattle, sheep and goats. This suggests that the nature/culture distinction is significant. That which human beings control and which helps them in the struggle for resources belongs to the realm of culture and is acceptable; that which remains untamed is therefore not fully controlled. It may also be life-threatening, and perhaps a competitor in the struggle for resources. The chaotic realm which threatens human survival is of course a strong element in ancient mythologies. Once the physical criteria (ruminants, ungulates) are established as fundamental they can of course be extended to include creatures of the wild which embody those characteristics (Deut. 14:5). It may be that some birds, winged insects and water creatures can also be conceived of as belonging to the threatening, competitive realm of nature. The small land creatures of vv. 29–30 may be those which "invade" the home, and which therefore intrude.

Another factor which cannot be ignored relates to blood and contact with death. Many creatures of the wild are carnivorous, and therefore ignore basic priestly requirements about life and blood (Gen. 9:4–5); indeed the primary creation ordinance was that all creatures should be herbivores (Gen. 1:29–30). It seems clear that many if not all of the birds in vv. 13–19 pose the same problem, and that some water creatures do too. Insects which sting or suck blood must be avoided for similar reasons. Animals can of course pose other contamination problems. Undomesticated land creatures cannot by definition be controlled, and

the defilements they have incurred cannot be known. From this perspective it is not surprising that the things that **swarm upon the earth** (vv. 29–38, 41–45) are deemed risky, and must be declared unclean. The importance of this element in the chapter at large is confirmed by the prominent and pervasive place given, not only to diet, but to contact with death (the carcase) (vv. 8, 11, 24, 25, 27, 28, 31–38, 39, 40).

E. Firmage ("The Biblical Dietary Laws", 1990) approaches the issue from another angle, the paradigmatic influence of sacrifice. What is fit for God's table (the domestic creatures and birds preferred by Israelites for food) provide a basic definition of what is clean. From this fundamental starting point the priests develop the system according to a variety of considerations, but in ways which laymen would readily understand and be able to apply. This too is helpful, though it illustrates the difficulty of distinguishing causes and effects. In a dynamic and developing purity system it seems likely that effects become new causes. W. Houston (*Purity and Monotheism*, 1993) provides an exhaustive survey of theories, and he too concludes that all suggest aspects which need to be taken into account. He stresses the influence of the sanctuary, and, like Firmage, what was acceptable for sacrifice, in the creation of the system. The function of the system as an affirmation of monotheism is also appropriately explored.

The fundamental defilement, however, is the carnivorous misuse of the blood. J. Milgrom ("The Biblical Diet Laws", 1963; *Leviticus 1–16*, 1991, pp. 704–742) has worked extensively to demonstrate that the social and anthropological phenomena at issue here also have ethical foundations. The life force is in the blood (cf. 17:11), and perhaps too in the running water, and the dry seed of vv. 36–38. To interfere with the life force, and in such a way that ignores the concessionary procedures of the sacrificial system, will constitute a defilement in which human beings must not participate.

2. PURIFICATION AFTER CHILDBIRTH
(12:1–8)

The second section in the Manual of Purity considers the purification rites that are necessary after childbirth. The section can be read as a single unit, but it consists of two parts. In vv. 1–5 the duration of the uncleanness is indicated; in vv. 6–8 the offerings which mark the end of the period are described.

There is no information elsewhere in the Bible about such rites of purification, though some evidence is available on the processes of birth. The Hebrew women in Egypt are noted for the speed (and ease?) with which they gave birth (Exod. 1:19), though the pains of childbirth are a common metaphor for trial and tribulation (e.g. Ps. 48:6; Isa. 13:8; 42:14; Jer. 6:24; 13:21; 22:23; 30:6; 48:41; 49:24; 50:43). The use of a birthstool and the presence of midwives is clear from Exod. 1:16 (cf. also Ruth 4:14; 1 Sam. 4:20 for attendant women). There is some indication that the newborn child was guided to the knees of the other parent (Gen. 50:23; cf. Gen. 30:3). Some of the procedures which immediately followed birth are indicated in Ezek. 16:4.

It is clear that the perspectives offered here in 12:1–8 must be understood within the context of priestly theology and its pollution system. It is particularly important to try to discover why such rites and procedures were considered essential.

The periods of uncleanness for a male child (v. 2) and a female child (v. 5) are indicated, and in both instances further periods of waiting are required (vv. 4, 5). At the end of the process a burnt offering and a sin offering are required, whether the child is male or female (vv. 6–8). A detailed discussion of the way in which human impurities are restricted is provided by D. P. Wright (*The Disposal of Impurity*, 1987, pp. 164–167, 220–224), and on the parturient in particular (pp. 195–196). Some comparative study is provided by J. Milgrom (*Leviticus 1–16*, 1991, pp. 763-765).

2. The period of uncleanness for a male child is **seven days**. This period of impurity is likened to that which obtains following menstruation (15:19–24).

The first period (one or two weeks) is a period of unclean-ness, comparable to that which obtains when the carcase of an animal is touched (11:24, 39). Anything the mother touches or is touched by would presumably become unclean. In this instance no rites mark the end of the period.

3. The requirement that males be circumcised is noted, a stipulation that in priestly tradition goes back to Abraham (Gen. 17:9–14). The rite is of obvious social significance for the life and structures of the community, and women are apparently excluded.

4. The further period of waiting is **thirty-three days** for a male.

The second period (thirty-three or sixty-six days) is a period in which the days of the mother's **purification are completed** ("for her blood to be purified" – *NJB*). The root used here is that which signifies the **clean** (10:10), and the meaning is presumably that the cleansing process continues. It continues to be an important idea in the Manual of Purity (13:7, 35; 14:2, 23, 32; 15:13; cf. Num. 6:9; Ezek. 44:26). In this phase the contagion of uncleanness would no longer be operative; the requirement is simply that she remain in the realm of the **common**, and avoid contact with the **holy** (see on 10:10).

A **holy thing** would include items and persons consecrated at holy places (cf. e.g. 1 Sam. 21:6; Jer. 11:15), and probably also any such which had been ceremonially cleansed.

The **sanctuary** is the overarching description of the sacred tent which Moses was commanded to construct (Exod. 25:8).

5. The period of uncleanness for a female child is **two weeks**. The further period of waiting is **sixty-six days**. The reason for the differences between male and female is hard to discern, particularly as the concluding offerings are the same (vv. 6–8). Some assume it simply denotes the cultic infe-riority of the woman (M. Noth, *Leviticus*, 1962/1965); D. I. Macht, ("A Scientific Appreciation", 1933) offered a theory based on the condition of the blood. More probably the longer period reflects a respect for (and fear of?) the power and mystery of female fertility (cf. B. A. Levine, *Leviticus*, 1989, pp. 249–250).

6. Two sacrifices conclude the process of restoration. A **lamb** is offered as a **burnt offering** (cf. 1:10–13), and a **pigeon** or **turtledove** as a **sin offering** (i.e. an offering for ceremonial purification). These birds are not specified as possible sin offerings in 4:1–35, but they are noted as possible guilt offerings by the poor (5:7–10).

7. An important indication is given here of the basic reason for the whole process of purification. It is that she may be clean **from her flow of blood**; hence the comparisons with menstruation (vv. 2, 5). The word **flow** can be rendered "spring" or "fountain" (BDB), and is freely used of running water (e.g. Ps. 36:9; Prov. 10:11; 13:14; 14:27; 16:22; 18:4; Jer. 2:13; 17:13). It is not the case that the processes of reproduction and birth are dirty and distasteful. It is rather that the life is in the blood (17:11), as in running water (11:36), and because of the sacredness of that life, particular steps must be taken when the blood flows at childbirth. These steps are a way of acknowledging the sanctity of life, and expressing a reverence for it. B. A. Levine (*Leviticus*, 1989, pp. 249–250) makes the suggestion that declaring the mother impure protects and shelters her from any dangers, a thought compatible with M. Douglas's ("The Forbidden Animals", 1993) recent proposal about unclean animals.

8. A concession to the poor is made here, allowing the lamb for the burnt offering to be replaced by a turtledove or young pigeon (cf. 1:14–17). The burnt offering is clearly appropriate as a gift rite, honouring God for the child he has given, and the sin offering performs its usual purificatory function, effecting **atonement** (vv. 7, 8; see on 4:20). These concluding rites suggest that children, whether male or female, are to be valued equally (vv. 6, 7); the sacrifices required are the same.

It is possible to read texts such as this as affirmations of patriarchy. Why should the flow of blood defile (v. 7), when blood is above all an agent of purification? Is not such law a product of male anxiety about natural processes in females which are beyond male control? Perhaps we can say that the text exemplifies very well some of the ambiguities to which attention

was drawn in the General Introduction. It can indeed be an agent of social control, but it reflects too, as suggested in the discussion of v. 7, a sensitivity to the mystery and sanctity of life forces, focused as usual in the blood, which are not fully understood, which are ultimately beyond human control, and which call for human recognition and respect.

3. SKIN DISEASE AND
CONTAMINATED GARMENTS: DIAGNOSIS
(13:1–59)

This section in the Manual of Purity deals with various skin diseases, and with contaminated garments. The phrase **leprous disease** (*NRSV*) is used to cover what must have been a wide variety of ailments and conditions; it is inherently unsatisfactory, not least because it occurs in objects as well as human beings. The problem of finding good translations for the word is discussed by J. Wilkinson ("Leprosy and Leviticus", 1978); he rejects words denoting "leprosy", and also *NEB*'s use of "malignant", preferring some such phrase as "unclean skin disease" or "defiling skin disease", or in v. 13 "disfiguring skin disease". J. E. Hartley (*Leviticus*, 1992) prefers "grievous skin disease", and J. Milgrom (*Leviticus 1–16*, 1991) "scale disease". For the purposes of clarity we retain *NRSV*'s **leprous disease**, while recognizing its limitations and tendency to mislead. G. J. Wenham (*The Book of Leviticus*, 1979) comments on modern definitions of different forms of skin disease; J. Milgrom (*Leviticus 1–16*, 1991, pp. 816–824) explores the nature of the condition, its rationale and causes.

The procedures that must be taken to identify and deal with **leprous disease** are discussed in detail. The textual units which make up the section can be identified as follows:

13:1–8 – suspicious skin eruptions
13:9–17 – diagnosing leprous disease
13:18–23 – boils in which leprous disease may develop
13:24–28 – burns in which leprous disease may develop
13:29–37 – itching diseases of the head and beard

13:38–39 – rashes or blisters
13:40–44 – falling hair
13:45–46 – the exclusion of those with leprous disease
13:47–59 – leprous disease in garments.

This is material conveyed exclusively to Moses and Aaron; there is no requirement that it be passed on immediately to the people. The basic form is typical of the ritual in the Manual of Offerings. Declaratory formulae are preserved at various points within the text, either about the **leprous disease** itself (vv. 8, 15, 22, 25, 27), or about a clean/unclean condition (vv. 13, 17, 36, 51). Elements of instruction, in the second person singular, seem to intrude in vv. 55, 57, 58. The role of the priest is emphasized throughout (vv. 3, 8, 11, 15, 17, 20, 22, 23, 25, 27, 28, 30, 34, 37, 44, 59).

The importance of **leprous disease** to pollution systems is easy to understand. The idea that holiness has to do with physical perfection implies boundaries, and this section deals with the problem of establishing these boundaries in relation to a variety of ailments and conditions. Issues of life and death, and the well-being of society at large, are all at stake in the process of determining exactly where the boundaries lie.

The condition described here as **leprous disease** is familiar enough in other parts of the Bible. In addition to its occurrence here in relation to human beings and garments it is a condition which can also be found in buildings (14:33–57). The consequences for priests (22:4) and others (Num. 5:1–4) with **leprous disease** (22:4) are explored elsewhere in priestly tradition. The belief that priests should take a major role in dealing with its effects is already established in Deuteronomic law (24:8–9), though it was apparently natural to look to a prophet to provide a cure (2 Kgs 5:3). The popular fear of it is clear from 2 Sam. 3:29, and its social effects (exclusion from the community) from the stories in Num. 12:1–15; 2 Kgs 7:3–15. Uzziah's attempt to take over priestly prerogatives leads to his being afflicted with **leprous disease**, and his removal from the sanctuary and permanent exclusion are described in 2 Chr. 26:20–21.

That the condition should occur in garments or houses (14:33–57) is not known in other texts. It is nevertheless a natural application of the pollution system and its principles, and a good example of priestly theology's pervasive interest in the whole of life.

In vv. 2–8 various diseases of the skin are considered, all of which require examination by a priest. It is the priest's task to make the diagnosis, and if **leprous disease** ("virulent skin disease" – *REB*; "dreaded skin disease" – *GNB*; "infectious skin disease" – *NIV*) is identified to pronounce the person examined unclean (v. 3). If there is no positive diagnosis at this stage further measures must be taken involving periods of confinement and further examinations (vv. 4–8). After these the priest will be in a position to declare that the condition is **leprous disease** (v. 8) or only **an eruption** (v. 6). Further discussion of the condition and the priestly concern to control it is provided by D. P. Wright (*The Disposal of Impurity*, 1987, pp. 75 n.1, 173–177, 208–212).

2. Here three skin conditions are identified.

The **swelling** is a word that can mean "exaltation" (e.g. Job 13:11 – "majesty") or "uprising" (e.g. Job 41:25 (BDB)), hence the supposition that this medical condition (which is found only here) is some kind of swelling in the skin (*REB* and J. Milgrom (*Leviticus 1–16*, 1991) take it to be "a discoloration of the skin"; *GNB*– "sore").

The **eruption** ("pustule" – *REB*; "boil" – *GNB*; "rash" – *NIV*; "scab" – BDB, *NJB*, J. Wilkinson,"Leprosy and Leviticus", 1977; J. Milgrom, *Leviticus 1–16*, 1991) is derived from the verb "to join" (e.g. 1 Sam. 2:36), but as a medical condition the word is rare.

The **spot** ("inflammation" – *REB*, *GNB*; "bright spot" – *NIV*; "inflamed patch" – J. Wilkinson, "Leprosy and Leviticus", 1977; "shiny mark" – J. Milgrom, *Leviticus 1–16*, 1991; "shiny patch" – J. E. Hartley, *Leviticus*, 1992) is related to the word "bright" (Job 37:21), and in medical terms is probably some kind of sore or scar (BDB). B. A. Levine (*Leviticus*, 1989) notes that it may be the disease vitiligo.

3. These three symptoms are possible indicators of **leprous**

disease, and they must be brought to the priests for examination. Together they constitute a **disease** (cf. also v. 2; "sore" – *REB*; "lesion" – J. E. Hartley, *Leviticus*, 1992), a word sometimes used to denote a "blow" (e.g. Deut. 17:8) or a "plague" (e.g. Exod. 11:1). It could be rendered an "affliction".

Details are then provided as to how the priest is to conduct his diagnosis. The decisive indicators of **leprous disease** are present if the hair on the **diseased area** has turned white, and if the disease is **deeper than the skin**. This means inevitably that the person being examined is **unclean** (see on 10:10).

4. Here further attention is given to a **spot**, though it is reasonable to suppose that the other two conditions are also in mind (the **eruption** is cited in v. 6). If the spot is found to be **white**, and if the two indicators of **leprous disease** are absent, then a period of confinement is necessary. It is usually assumed that this would be outside the settlement. This seven-day isolation is reminiscent of the action taken with regard to Miriam's "leprosy" (Num. 12:15).

5. On the seventh day a further examination takes place. If there is no deterioration (a spread) in the condition then a further seven-day confinement ensues.

6. The third examination will again be looking for any signs of deterioration, but also for indications that the **disease** has **abated** (become dim – *RSV*; "faded" – *GNB*, *NIV* ("dull" or "faint" – cf. e.g. Eli's eyes – 1 Sam. 3:2)). Once all these conditions are satisfied it can be assumed that the ailment is only an **eruption**, not **leprous disease**. A washing of the clothes is sufficient to render the person **clean** (cf. 11:25, 28, 40).

7–8. If subsequently the **eruption** spreads, a further examination is necessary, and **leprous disease** will be diagnosed (vv. 7–8).

In vv. 9–17 the basic text on **leprous disease** in vv. 1–8 seems to be expanded. The primary concern is to offer further information on the characteristics and treatment of the condition, once its presence has been confidently established (v. 9). The point may be that the return of an old outbreak of **leprous disease** is suspected (v. 11).

9. A person known to have **leprous disease** (or better to have had it) must be brought to the priest for an examination.

10. The priest's task is to look for various symptoms. One is a **white swelling** (cf. v. 2), the second is **hair** that has turned **white** (cf. v. 3), and the third, the significantly new element, is **quick raw flesh in the swelling** (v. 10). The word rendered **quick** by *NRSV* has to do with "preservation of life" (e.g. Gen. 45:5) and "sustenance" (Jdg. 6:4; 17:10) (BDB). It occurs again in v. 24, but nowhere else in relation to flesh. The rendering "quick" or "living" seems as appropriate as any. The word rendered **raw** occurs again in vv. 14, 15, 16 and in 1 Sam. 2:15 of raw flesh. This third and crucial element in the diagnosis can be understood as an **ulceration** (*REB*, cf. *NJB*; "full of pus" – *GNB*). Given the presence of these symptoms **chronic leprosy** (**leprous disease**) is certain, and no period of confinement is necessary.

11. The priest's concern is to discover whether this is a **chronic leprous disease**. The word **chronic** comes from the verb "to sleep". The sense here is of something that has "become inactive or stationary", or "grown old" (BDB) (cf. 26:10; Deut. 4:25).

12. In the discussion that follows there seems to be the recognition that not all **leprous disease** entails uncleanness (vv. 12–13), but the point is probably that the condition has not yet been certainly established. In other words **disease** here should be read as "possible **leprous disease**".

13. If the **disease** ("leprous disease") covers the whole of the body, the person is clean of the **disease** ("the affliction" – see v. 3). *RSV* helpfully distinguishes the two words as "leprosy" and "disease".

The phrase **it has all turned white** is probably to be read as a further indicator of chronic skin conditions which are not unclean.

14. The decisive symptom of uncleanness is the **raw flesh** (cf. v. 10); this really is **leprous disease**.

16–17. Even then the possibility is recognized that **raw flesh** may be a temporary phenomenon. Provided it turns **white**, and provided the priest is satisfied, the person concerned can be declared **clean**.

These verses make it clear that not all skin diseases are considered abhorrent. There is a very deliberate attempt to distinguish **leprous disease** from other conditions, and this probably implies a genuine awareness that some were more intractable than others. While there are doubtless risks in reading into the text a modern medical mentality, it is perfectly possible that some conditions were known to be particularly dangerous and contagious, and that priestly requirements constitute an attempt to control them.

In vv. 18–23 the diagnosis for **leprous disease** is taken one stage further. The possibility that the unclean condition may develop in a boil is confronted. The usual examination by a priest must take place (v. 20), and the possibility of a delayed diagnosis is allowed (v. 21). The usual priestly pronouncements are made (vv. 20, 22, 23).

18. The word rendered **boil** ("fester" – *REB*; "infected wound" – J. Wilkinson ("Leprosy and Leviticus", 1977)) is reasonably familiar (Deut. 28:27, 35; 2 Kgs 20:7; Job 2:7), and the condition can also occur in animals (Exod. 9:9, 10, 11). The situation envisaged is one in which to all intents and purposes the boil has healed.

19. The dangerous symptoms are **a white swelling** (as in v. 10) or **reddish-white spot**. The **spot** (possibly a scar) is as in v. 2. The idea of **reddish-white** as a colour is found only in relation to these skin conditions, and only in the Manual of Purity (cf. vv. 24, 43 and **reddish** in v. 49; 14:37).

20. The priest then has to decide whether the condition is **leprous disease**. The criteria he applies are twofold. The condition must first be more than skin deep (cf. v. 4). A different word, usually rendered "lower", is used for **deeper** here (thus *RV*), and *NJB* reads it as "a visible depression". The second criterion is that the hair must have turned **white** (cf. vv. 3, 10) (v. 20). These two tests are sufficient to decide that the condition is **leprous disease**.

21. If the two symptomatic criteria are absent, and if the **spot** has **abated** (is "dim" – *RSV*; "faded" – *REB, NIV*; "light in colour" – GNB) (see on v. 6), then a seven-day period of confinement occurs, as in vv. 4, 5.

22. A further examination is then to be assumed, and in

this instance the seven-day period is deemed sufficient (no possibility of further confinement is envisaged as is the case in v. 5). If the condition has spread then the person is **diseased**, and **leprous disease** must be assumed (as in v. 20).

23. If there is no spread (cf. vv. 5, 6), then the spot is only **the scar of the boil**, and the priest must declare the person **clean**. The word rendered **scar** here is rare; the root with the sense "to burn" or "to scorch" can be found in Prov. 16:27; Ezek. 20:47. For further discussion of this type of **leprous disease** see D. P. Wright (*The Disposal of Impurity*, 1987, pp. 210–212).

Here, as in vv. 9–17, there is an awareness that not all unusual skin conditions are abhorrent, and have to be identified as **leprous disease**.

In vv. 24–28 it becomes clear that **leprous disease** can also occur in burns. Once again there are preliminary symptoms which must be taken for examination to a priest (v. 24). He applies the same symptomatic criteria as in v. 20 (v. 25). If these symptoms are present the diagnosis is again **leprous disease** (v. 25), but if not, a seven-day period of confinement is required (v. 26). As in vv. 22–23 this is sufficient to establish certainty in the matter. The same principle, namely whether or not the condition has spread, is applied (vv. 27–28), and the appropriate judgement is made.

24. The **burn** (literally "burning fire") should probably be understood as the scar of a burn. The **raw flesh** is that which occurs in v. 10 ("ulcer" – *NJB*). The indicator that an examination is necessary is the appearance of a **spot** (cf. vv. 2, 19), which can be **reddish-white** (cf. v. 19) or **white**.

25. The priest's diagnostic criteria are essentially as in v. 20 – **hair** that turns **white**, and a condition that appears to be more than skin deep. The word **deeper** here is that used in v. 4, but the word for **deeper** used in v. 20, 21 does occur in v. 26, suggesting their interchangeability. If these two symptoms are present the condition can be declared to be **leprous disease**, and the person is **unclean**.

26. The absence of the symptoms, and signs of abatement (a "dim" mark – *RSV*) lead to a seven-day period of isolation, exactly as in v. 21.

27. Here a seventh-day re-examination is explicitly mentioned, with **spreading** (cf. v. 22) confirming that the condition is indeed **leprous disease**.

28. If there is no deterioration (cf. v. 23) then the condition can be deemed simply a **swelling** (cf. vv. 2, 10) from the burn. It is no more than the **scar** (cf. v. 23). For further discussion of this kind of **leprous disease** see D. P. Wright (*The Disposal of Impurity*, 1987, pp. 210–212).

As with boils (vv. 18–23) skin conditions associated with burns are not necessarily **leprous disease**, and therefore need not entail uncleanness.

In vv. 29–37 there is discussion of a **leprous disease** which might occur in connection with the head or beard (v. 29). In this instance no specific symptoms calling for an examination are cited. For the priest, however, there are important indicators which will lead to an immediate diagnosis (v. 30). Once again there are provisions for a seven-day confinement, and a subsequent examination (vv. 31–32), and also, as in vv. 2–8, for a further seven-day period (vv. 33–37), after which a definitive pronouncement about the condition will be given.

29. The word **beard** (v. 29) is probably intended to denote the "lower jaw" or "chin" (cf. 1 Sam. 17:35; Ezek. 5:1; thus *GNB, NIV*), hence presumably the appropriateness of an allusion to **woman**. No preliminary symptoms calling for a priestly examination are mentioned here (contrast vv. 18–19, 24); the condition is simply a **disease** (cf. v. 3) ("sore" – *REB, NJB*).

30. Two basic diagnostic criteria guide the priest. The condition must be **deeper** than the skin (the word used in vv. 3, 4, 25 (but not in vv. 20, 21, 26)), and the hair must be **yellow** and **thin**. The word **yellow** is very rare, and has connections with the verb "to gleam" (Ezra 8:27 – "bright"). It is probably intended to be the opposite of **black** in v. 31. The word **thin** is used of the cattle and ears of corn in Pharoah's dream (Gen. 41:3, 6). "Shrunken" or "withered" (or "sparse" – *REB*) would be appropriate in this context (cf. 21:20 where it denotes a "dwarf"). This **leprous disease** condition is described as an **itch** ("scale" – *REB*; "tinea" – *NJB*; "scaly rash"

– J. Wilkinson, "Leprosy and Leviticus", 1977; "scurfy patch" – J. E. Hartley, *Leviticus*, 1992). This word has the same root as the verb "to tear away" or "to pull". It occurs only in the Manual of Purity, and suggests "what one is inclined to scratch or tear away" (BDB) – hence **itch**.

31. If these two diagnostic criteria are absent, and if nevertheless there is no **black** hair (cf. Song 5:11) in the diseased place, then the usual seven-day period of confinement takes place (n.b. **black hair** is a sign that all is well – see v. 37).

32. The second examination repeats the procedures of the first, with the further requirement that the condition should not have spread (cf. vv. 8, 22, 27).

33. If all seems well the person must **shave**, but not including the affected part, and be confined for a further seven days. To **shave** has its place elsewhere in priestly rites. It occurs in connection with the defilements a Nazirite might incur (Num. 6:9) and with the termination of his vows (Num. 6:18). In 14:8, 9 it is an integral element in the purification rites for **leprous disease**. The process appears to carry away any impurities, and that would appear to be the purpose here. Sometimes there is the requirement that heads or beards be not shaved (21:5; Ezek. 44:20). In Deuteronomic law the heads of female captives must be shaved (Deut. 21:12). Enforced shaving of beards was humiliating (2 Sam. 10:4), while Samson's hair is the source of his strength (Jdg. 16:17). It seems probable that hair, like blood, saliva and semen, was thought to embody the life principle; in some ancient religions it could be an offering to the deity.

34. The third examination considers once again whether the condition has spread, and whether it is more than skin deep. If not the person can be declared **clean**. A distinct requirement here is the washing of clothes (cf. v. 6; and 11:25, 28, 40). Washing will deal with an **eruption** (v. 6), and, as here, with an **itch**, but not if they are also **leprous disease**.

35. As in vv. 7–8 account is taken of the possibility that, even after the cleansing rites, the condition might return.

36. This will necessitate a re-examination by the priest, who now need only certify a spread of the condition (there is no

need to search for **yellow** hair) to declare it **leprous disease**, and the person is **unclean**.

37. The priest may however be satisfied that, despite the return of the condition, the **itch** is under control, and **black hair** is growing normally, in which case the person can be pronounced **clean**. For further comment see D. P. Wright (*The Disposal of Impurity*, 1987, pp. 210–212).

These verses offer further proof that the priests were anxious to distinguish between different kinds of skin condition. For them **leprous disease** was a condition that was seriously **unclean**, and it required knowledge and skill to discern its presence.

In vv. 38–39 yet another skin condition is considered. It would appear to involve either rashes or blisters. Certain symptoms, suggestive of the condition and calling for priestly examination, are identified (v. 38). If a **rash** ("tetter" – *RSV*; "blemish" – *GNB*) is diagnosed, in the light of the priest's further investigation, then this is not a form of **leprous disease**, and the person can be declared **clean** (v. 39).

38. The symptoms are **white spots** (cf. vv. 3, 19, 24). These are rendered "inflamed patches" by *REB*.

39. The priest must determine whether the spots are **dull** (v. 39, **dim** in *RSV* vv. 6, 21, 26; "fading" – *REB*). If they are, then **rash** can be diagnosed. The word occurs only here, and it is hard to determine the correct modern term ("vitiligo" – *REB*; N. H. Snaith, *Leviticus and Numbers*, 1967). Clearly there is no risk of **leprous disease** in the condition.

In vv. 40–44 the discussion of **leprous disease** in human beings continues, dealing with what must happen when hair falls out (vv. 40–41), and various other symptoms develop (vv. 41–42). These appear to be preliminary indicators which call for a priestly examination (v. 43), but they are already identified as **leprous disease** (v. 42). The priest's task is to confirm the diagnosis, and if necessary declare the person **unclean** (vv. 43–44).

40. Baldness as such is a clean condition. The hair may fall from the top of the head ("scalp" – *NJB*; *NEB* takes it to be the

back of the head). The word **bald** is familiar in a variety of contexts (2 Kgs 2:23; Ezek. 29:18), and often in association with mourning (Lev. 21:5; Deut. 14:1), particularly in the prophets (Isa. 3:24; 15:2; Jer. 16:6; 47:5; 48:37; Ezek. 7:18; 27:31; Amos 8:10; Mic. 1:16).

41. The hair may also fall from the **forehead** and **temples**. The verb **loses** means "to make smooth" (BDB), and on several other occasions is used of hair (Ezra 9:3; Neh. 13:25; Isa. 50:6). The **forehead and temples** are one Hebrew word, which in general means "corner" or "side" (BDB); the "side" of the face is suggestive of **forehead and temples**. The phrase **baldness of the forehead** represents a single word and a different one from that used in v. 40. The word occurs only in this passage, and in v. 55 where it signifies **the front** – hence **baldness of the forehead**.

42. The signs of **leprous disease**, whether on head or forehead, are a **diseased spot** ("affliction" see v. 3) which is **reddish-white** (cf. vv. 19, 24 in relation to boils and burns).

43. The priest's task is clearly to confirm the condition. The **diseased** spot will exhibit **swelling** (cf. vv. 2, 10, 19, 28), and the condition will look like **leprous disease** does **in the skin of the body** (cf. v. 3).

44. In these circumstances **leprous disease** must be identified and pronounced.

Here once more there is the recognition that not all skin conditions are problematic, and that **leprous disease** is a specific ailment, which calls for a special knowledge and expertise with regard to its diagnosis.

The concluding verses on the subject of **leprous disease** in human beings follow in vv. 45–46. They indicate something of the life that the afflicted person must live. There are stipulations with regard to appearance (v. 45), and behaviour (v. 45), as well as requirements about social isolation (v. 46).

45. The first demand is that the person wears **torn clothes**. In 10:6; 21:10 this would appear to be a sign of mourning. The same is true of **dishevelled** hair (see generally on 10:6). The **upper lip** can be the hair above the lips – hence "moustache" (BDB) (2 Sam. 19:24). Other texts suggest that the

covering of the upper lip is another sign of mourning (Ezek. 24:17, 22; Mic. 3:7). The possibility is that covering the upper lip means the whole mouth must be covered (D. P. Wright, *The Disposal of Impurity*, 1987, p. 210). *GNB* and *NIV* read "the lower part of his face". The person concerned must proclaim his condition, presumably to any who might approach him.

46. The social isolation to which the victim is subjected (cf. Num. 5:2–3) is well reflected in Num. 12:14, and particularly in the story of the lepers who lived at the city gate in 2 Kgs 7:3–15.

A good deal of work has been done in an attempt to identify these various skin conditions in the light of modern medical knowledge, particularly **leprous disease** itself (see e.g. J. Wilkinson, "Leprosy and Leviticus", 1977, "Leprosy and Leviticus", 1978; D. P. Wright, *The Disposal of Impurity*, 1987, p. 75 n.1). Much in this area is necessarily speculative. It is perhaps more important to understand the place of such conditions within the priestly pollution system.

The final unit in this section (vv. 47–59) deals with the outbreak of **leprous disease** in garments. These can exhibit suspicious symptoms in the same way as human beings (vv. 48–49), and the same processes of priestly examination and seven-day confinement may be necessary (vv. 50–51). Any such garment which has **leprous disease** must be burned (vv. 52, 55, 57). Washings (vv. 54, 58) and the possible removal of the affected part (v. 56) are sufficient where the presence of **leprous disease** has not been demonstrated.

REB understands **leprous disease** in garments to be **mould** (cf. J. Wilkinson, "Leprosy and Leviticus", 1978). Some kind of fungus is in mind (D. P. Wright, *The Disposal of Impurity*, 1987, p. 90 n.11). Three types of garment are identified, those made of wool, linen or skin (vv. 47–48). These must include virtually all the garments that would have been worn in ancient Israel (n.b. the prohibition of garments made from both wool and linen (19:19; Deut. 22:11)).

48. Wool was the tribute Mesha of Moab had to pay to

Israel (2 Kgs 3:4), highly valued (Hos. 2:5, cf. Jdg. 6:37; Prov. 31:13), and a commercial product (Ezek. 27:18). Testimony to its usefulness as clothing is evident in Ezek. 34:3; 44:17.

Linen, derived from flax, is also well attested, though a variety of Hebrew words describe it. The one used here is often translatable as "flax" (Exod. 9:31; Josh. 2:6; Jdg. 15:14; Prov. 31:13; Ezek. 40:3; Hos. 2:5). Its use to denote garments, as here, is evident in Deut. 22:11; Isa. 19:9; Jer. 13:1; Ezek. 44:17, 18), and the usage appears to be general rather than specific.

The **warp or woof** signify the two directions (lengthwise and crosswise respectively) of the threads on the loom. Used in this sense the words occur only in this passage. *NJB* renders the phrase "fabric or covering". It is difficult to see how the warp might be infected and not the woof (N. H. Snaith, *Leviticus and Numbers*, 1967).

The word **skin** is commonly used of human flesh, as in this chapter (e.g. v. 2), but it is also regularly used of animal hides. As clothing it is attested in Gen. 3:21; 2 Kgs 1:8. Here in v. 48 any article made from skin (garment or not) must be taken into account (cf. 11:32; Num. 31:20). Elsewhere in the priestly writing the covering of the tabernacle is one of the most important uses for animal skin (e.g. Exod. 25:5).

49. The indicators which demand a priestly examination are the appearance of **greenish** or **reddish** (cf. **reddish-white** – vv. 19, 24, 42, 43 and **reddish** in 14:37) marks in the garment (v. 49). **Greenish** is perhaps "pale green" (BDB) (cf. 14:37). In Ps. 68:13 the word is associated with the way gold shines. The text seems to identify this condition as **leprous disease** from the outset.

50. The priest presumably confirms this, and automatically isolates the garment for a seven-day period.

51. The crucial examination then takes place, and the decisive diagnostic criterion is whether there is any spread in the condition; if there is then **leprous disease** is confirmed, and the garment or skin must be declared **unclean**. The description of **leprous disease** as **spreading** ("malignant" – *RSV*) (vv. 51, 52) is a new feature in the chapter at large. The root is rare, and has something to do with "causing pain"

(Ezek. 28:24). J. Wilkinson ("Leprosy and Leviticus", 1978) prefers "rotting mould" or "corrosive growth" (cf. *NEB*) to "malignant" (cf 14:44) (Sam. reads "obstinate" in these P contexts). N. H. Snaith (*Leviticus and Numbers*, 1967) favours "persistent, incurable", as in Gk and Vg.

52. In this situation there is only one thing to do; the article in question must be burned. A spreading **leprous disease** for *REB* is a "rotting mould"; for *NJB* it is "contagious disease".

53–54. If, on the other hand, the condition has not spread in the garment or skin then it is washed, and a further seven-day period of isolation takes place.

55. The further examination which then takes place is final and definitive. It must be assumed that if there is any spread in the condition then **leprous disease** will be identified, and the item burned (as in vv. 51–52). Even if there is no development of the condition, if there is no **changed colour** then **leprous disease** must be identified. The word used here is "eye", and "changed appearance" is perhaps satisfactory (cf. Num. 11:7; 1 Sam. 16:7) (thus *REB*; *NJB*; *NIV*). There can be no concessions in such circumstances; the whole of the garment or skin must be burned.

The word rendered **leprous spot** has connections with the root "pit", and suggests the idea of "boring/eating out" (BDB).

The word **inside** ("back" – *RSV*) is precisely that used to denote "bald head" in vv. 42, 43, while **outside** ("front" – *RSV*) is the "bald forehead" of vv. 42, 43. *REB* takes the sense to be right side or the wrong (*NJB* – "through and through").

56. It is only if the mark has **abated** (become "dim" – *RSV*) (cf. vv. 6, 21, 28, 39) that something can be done to save the article. The affected spot must be torn out, and repairs would presumably be effected.

57. A recurrence of the condition would mean that the whole garment/skin would have to be burned. The verb translated **spreading** is that which hitherto in this chapter has been translated "break out" (vv. 12, 20, 25, 39, 42; cf. 14:43; cf. Exod. 9:9, 10). For further discussion of infected fabrics see D. P. Wright (*The Disposal of Impurity*, 1987, pp. 90–91, 215).

The idea that **leprous disease** can infect garments and articles made of skin is a natural application of the ideas about **leprous disease** in human beings. Here again there is the recognition that not all conditions are **leprous disease**, and while a **leprous disease** diagnosis necessarily entails the loss of property, steps can be taken to preserve items where the condition is absent.

4. PURIFICATION RITUALS FOR CONTAMINATION (14:1–32)

This section outlines the rites that are required for the purification and restoration of a person who has been cured of **leprous disease**. While these rites have obvious points of contact with the rituals described earlier in the book and elsewhere in the priestly writing, they also exhibit several distinctive features. There are two main textual units:

14:1–20 – basic purification rites
14:21–32 – alternative eighth-day offerings for the poor.

The text consists entirely of ritual. It is passed on by Yahweh exclusively to Moses. The literary history of the text seems reasonably straightforward, with the basic ritual in vv. 2–20, and concessions on behalf of the poor as a likely accretion in vv. 21–32. Accretions of this kind are found elsewhere (e.g. 5:7–10, 11–13); the priests were sympathetic to those unable to make the customary offerings for economic reasons. Such concessions did of course serve priestly interests, insofar as they made it possible for all people, whatever their economic status, to be brought within the scope of the priestly system.

Rites of restoration were obviously a key element in the process whereby the priestly system of social stability was established.

In vv. 1–20 the rites that are required when **leprous disease** in a human being has been healed are described. They divide into three basic phases:

1) After the priest has certified the cure (v. 3), there are procedures involving two living birds (vv. 4–7), followed by washing and shaving (v. 8).
2) The person can now re-enter the camp, but must remain outside his/her tent for a further seven days (v. 8), after which further shavings and washings take place (v. 9).
3) On the eighth day, special offerings take place. Most of the emphasis is placed on the **guilt offering** (vv. 12–14), and anointing rites with oil (vv. 12, 15–18); both lamb and oil are **tenuphah – an elevation offering** (v. 12). There is also a **sin offering** (v. 19), a **burnt offering** (vv. 19, 20), and a **grain offering** (vv. 10, 20).

2. These rites are described as **ritual** (**torah**), the word customarily used of information which the priests in particular would need to know (6:9, 14, 25; 7:1, 11, 37; 11:46; 13:59). The matter is brought to the attention of the priest.

3. The priest then goes out of the camp to make the examination, and to certify the cure.

4. The **two birds** must be **living** and **clean** (for birds which would be excluded see 11:13–19). For offerings using birds see 1:14–17; 5:7–10; 5:11–13; 12:6, 8. The word for **birds** is general, and can include birds of prey (Ezek. 39:4), so that the insistence that they be **clean** is important. They would probably be wild, nevertheless, to avoid any risk of the return of the one to be released (J. Milgrom, *Leviticus 1–16*, 1991).

The three other items required for these rites (v. 4) have not been previously encountered in Leviticus. The only other text in which they occur as key elements in purification rites is Num. 19:6, where they are cast into the burning carcase of the red heifer. The purpose there is to prepare the ashes which are to be used in the "water for impurity", which in turn will be used in the purification of a person who has come into contact with a corpse. These items may reflect ancient apotropaic beliefs and practice, but they no longer have this significance for priestly thought.

Cedarwood is familiar elsewhere as an important building material (e.g. 2 Sam. 7, 2, 7; 1 Kgs 5:8, 10; 6:10; 9:11; Isa. 9:10; Jer. 22:14, 15). Further information is supplied by J. C. Trever

(*IDB*:I, pp. 545–546). The reason for its use in these rites is obscure.

Crimson yarn is familiar within the priestly writing as a material used in the making of curtains and veil for the tabernacle, and of the priestly ephod (e.g. Exod. 25:4; 26:1, 31; 28:5). It is also an element in the cloth that covers the sacred objects on journeys (Num. 4:8). Other texts associating the word with clothing are 2 Sam. 1:24; Prov. 31:21; Jer. 4:30. In some texts its purpose seems to be to denote the colour of thread (Gen. 38:28, 30; Josh. 2:18; Song 4:3). The usual view is that in essence the word signifies a dye, derived from insects (C. L. Wickwire, *IDB*:IV, pp. 233–234). It was highly valued, as many of the texts suggest, and hence perhaps its use in this ritual. In practice the item used here would presumably be a small piece of fabric coloured with the dye (*REB* – "scarlet thread"). The colour probably symbolizes the power of blood (J. Milgrom, *Leviticus 1–16*, 1991).

The third item is **hyssop**, a herb of some kind ("marjoram" – *REB*) (J. C. Trever, *IDB*:II, pp. 669–670), which was also used in Passover rites as a means of sprinkling blood on doorposts (Exod. 12:22, cf. also 1 Kgs 4:33). In Ps. 51:7 it is associated with cleansing, and this may provide some reason for its use here. The ultimate explanation for this use of wood, fabric and plant life in a rite of purification (here and in Num. 19:6) is hard to uncover. It may be that ancient apotropaic beliefs and practice lie behind the custom (J. R. Porter, *Leviticus*, 1976); if so, such beliefs are no longer a significant factor for priestly thought in Leviticus.

5. The rite begins with the killing of one of the birds in an **earthen vessel** (see on 11:33) over **fresh water** (see on 11:36) ("running" – *RSV*).

6. One of the purposes of the vessel is to retain the blood of the bird. Fresh or running water is clean (cf. 11:36), and may also signify the life force (literally "living" water). Four items are then dipped in the blood of the dead bird – the cedarwood, the scarlet stuff, the hyssop and the living bird. This "dipping" has previously been associated with the sin offering (4:6; 9:9; cf. also Num. 19:18).

7. There follows a sevenfold sprinkling of the person to be

cleansed, using the blood of the dead bird. This procedure is strongly reminiscent of the sin offering rites of purification (4:6, 17) – cf. also the use of oil in 8:11, 30. It seems likely that the wood, the fabric and the plant are used to sprinkle the blood on the person (cf. the use of hyssop in Exod. 12:22), no further account of them being given. The person can now be pronounced **clean**, and the living bird is released. The purpose of this release is not made clear (cf. the goat in 16:10). In some sense it seems to dispose of or carry away the impurity associated with the **leprous disease** (D. Davies, "An Interpretation of Sacrifice", 1977). That it has been dipped in the blood of the dead bird may suggest that it has been cleansed from such impurity, and will not transmit it elsewhere. For further discussion see D. P. Wright (*The Disposal of Impurity*, 1987, pp. 75–86, and in general pp. 212–215).

8. There follow the customary washing rites, of clothes (cf. 11:25, 28, 40; 13:6, 34), and of the person (cf. 8:6), and a shaving of the hair (cf. 13:33).

The person can now be admitted to the camp, a move from the realm of the **unclean** to the realm of the **common** (see on 10:10), but the procedures are not yet complete, and a further seven days outside the tent is required.

9. At the end of that period a further shaving of all hair takes place, along with the washing of clothes and of the person. The transitional phase is now complete, and the stage is set for the eighth-day rites (phase three), which mark the full and final restoration of the person to normal life in the community.

10. The sacrifices to be offered on the eighth day are three lambs, two of them male, and the third a female a year old. They are to be offered as a **guilt offering** (v. 14), a **sin offering** (v. 19), and a **burnt offering** (v. 20). The female lamb will presumably be for the **sin offering** (4:32; 5:6; cf. v. 12; 1:10; 5:15, 18). In addition to these there is to be a **grain offering** (v. 10), consisting of **three-tenths of an ephah of choice flour mixed with oil** (cf. 2:1, 2, 4) ("wheaten flour" – *NJB*) and a **log of oil**. The measure of flour (**three-tenths**) is prescribed in the priestly writing for the major feasts (Num. 15:9; 28:12, 20,

28; 29:3, 9, 14) – n.b. the one-tenth prescribed in 5:11 (to accompany certain sin offerings) and 6:20 (for Aaron's ordination offering) (cf. also Num. 5:15; 28:5). The **log** occurs only in these purification rites (vv. 12, 15, 21, 24), and is a liquid measure of some kind. *GNB* suggests "a third of a litre" (cf. S. Rattray in J. Milgrom, *Leviticus 1–16*, 1991, pp. 890–901 for a detailed study of biblical capacity measures; the priestly log is set at 0.3 litres).

11. The usual presentation **at the entrance of the tent of meeting** takes place (cf. on 1:3). The first sacrifice is of one of the male lambs as a **guilt offering** (see on 5:14–6:7; 7:1–10), and the text clearly attaches particular importance to the ensuing rites (vv. 12–18). B. A. Levine (*Leviticus*, 1989) notes that in Egypt and Mesopotamia certain priests were specially trained for purificatory work, which may be reflected in the phrase "The priest who cleanses. . ."

12. The **log** of oil accompanies the guilt offering, and both are then presented as **tenuphah** (**an elevation offering**) before Yahweh. This naturally raises the question as to why **leprous disease** alone among the conditions described in chapters 11–15 requires a **guilt offering**, particularly as 5:14–6:7 suggest that restitution or reparation are integral to that particular sacrifice. Is it to compensate for loss to the people and to God during the sufferer's exclusion (N. H. Snaith, *Leviticus and Numbers*, 1967), for the loss perhaps of sacrifices and tithes (G. J. Wenham, *The Book of Leviticus*, 1979), or for any unwitting sacrilege which may have caused the condition (J. Milgrom, *Leviticus 1–16*, 1991), or for damage to the image of God the disease has caused (J. E. Hartley, *Leviticus*, 1992)? Another possibility is that the priestly examination causes or threatens damage to the priest, who, like the Nazirite (cf. Num. 6:12), is sacred property. The offering, which will become the priest's (v. 13), is therefore compensation. For the idea of a sacrifice as **tenuphah** see on 7:30 (cf. 8:27, 29; 9:21; 10:15; 23:11, 12, 20; Exod. 29:24, 26, 27; Num. 5:25; 6:20; 18:11, 18). This "raised offering" (B. A. Levine) or rite of dedication (J. Milgrom) certainly confirms that the animal belongs to the priest.

13. The sacrificial procedures for a **guilt offering** are

described in the barest detail in 5:14–6:7, and two points about it are made explicitly here in v. 13. The slaughter of the animal is conducted at the place where the sin and burnt offerings are killed, and the guilt offering, as **most holy** (see on 2:3, 10; 6:17, 24, 29; 7:6; 10:12, 17), belongs to the priest.

14. There then follow four acts of "anointing", conducted by the priest:

1) Blood from the **guilt offering** is smeared on the **right ear**, on the **thumb of the right hand**, and on the big toe of the **right foot** of the person who is to be cleansed. This is obviously reminiscent of the ordination rites in 8:23–24. The **right** side was apparently favoured (the reason is unclear); the extremities are probably intended to signify an anointing and purification of the whole person.

16. 2) Some of the oil is sprinkled **seven times before Yahweh**. Sevenfold sprinklings of blood before Yahweh are familiar in some sin offerings (4:6, 17), and the use of oil in this way is again a feature of the ordination rites, though in this situation it is the altar (8:11) and the priests and their garments which receive the sprinkling (8:30 – number of times not specified). In this context the anointing presumably protects the sanctuary from any conceivable form of defilement.

17. 3) More of the oil is then applied to the person (v. 17), in exactly the same way as is the blood in v. 14. This is another purification procedure signifying the cleansing of the whole person.

18. 4) The rest of the oil is then poured on to the person's head (cf. 8:12) as a final act of purification.

19. Once these procedures have been completed the priest makes **atonement** (v. 18b) (see on 4:20), an action associated particularly with the **sin offering**. This is the essential purification offering. In public rites it is often made before others, in this instance before the **burnt offering** (vv. 19b, 20), and the **grain offering** (v. 20).

20. Once the purification procedures are complete (the anointings and the sin offering) the two gift sacrifices (burnt (v. 19b) and grain offerings) express the cleansed person's homage and devotion to the deity. Gk and Sam. make it clear

that these two sacrifices are offered "before Yahweh". Taken
as a whole the eighth-day rites are clearly purification proce-
dures, hence the stress on **atonement** as the essence of what
has taken place.

This passage offers a good illustration of the processes of
transition which were necessary within the priestly scheme if
the ordered world which it aims to present was to be
sustained. The recovery of social status for the person
concerned is stressed by F. H. Gorman (*The Ideology of Ritual,*
1990, pp. 152–179).

In vv. 21–32 there are alternative eighth-day rites for the
cleansing of someone with **leprous disease** who is unable to
afford the lambs required in vv. 10–20. The concession
involves only one **male lamb** (for the **guilt offering**) (v. 21),
with two **turtledoves** or **pigeons** (v. 22) for the **sin offering** and
the **burnt offering**. There is also a smaller quantity of **choice
flour** (v. 21) for the **grain offering** (only one-tenth instead of
three). Otherwise the procedures are as in vv. 10–20.

21. Concessions to the poor are also to be found in 5:7–10,
11–13. The word **poor** is widely used of those without signifi-
cant economic resources, and often in opposition to the rich
or the great (Exod. 30:15; Ruth 3:10; Prov. 10:15; 19:4; 22:16;
28:11; Jer. 5:4–5). It can also denote those who are weak or
insignificant (Jdg. 6:15; 2 Sam. 3:1). There is some stress in
the passage on what the person **can afford** (cf. also vv. 22, 30,
32). The phrase used here means literally "one's hand has
reached" ("able to get" – *RV*), and is found elsewhere in the
priestly writing in relation to wealth and poverty (cf. 5:11;
25:26, 47; 27:8; Num. 6:21).

The **tenuphah** lamb as a **guilt offering** follows the require-
ments of vv. 12–13. It is noteworthy that this, like the sin
offering, is an act of **atonement** (cf. v. 19). So too is the
pouring of oil on the head (v. 29).

The measure **one-tenth of an ephah** is a reduction of what
was required in v. 10 (three-tenths). It is also found in the sin
offering concessions made in 5:11 and in Aaron's ordination
offering (6:20) (cf. Num. 5:15; 15:4; 28:5, 21, 29; 29:4, 10,
15).

The **log of oil** is as stipulated in v. 10.

22. **Turtledoves** and pigeons are familiar as burnt offerings (1:14) or sin offerings (5:7; 12:8) (cf. also 15:14, 29; Num. 6:10).

The ensuing procedures are as in vv. 10–20, with an appearance at the **tent of meeting** (v. 23/v. 11), the **tenuphah** of the lamb and **log of oil** (v. 24/v. 12), the killing of the lamb and the anointing with blood (v. 25/vv. 13–14), the sprinkling of oil (vv. 26–27/vv. 15–16), the anointing with oil (v. 28/v. 17), the pouring of oil on the head (v. 29/v. 18), and the three offerings (vv. 30–31/vv. 19–20).

30. In the Hebrew the phrase **such as he can afford** is repeated in v. 31.

5. CONTAMINATION IN BUILDINGS:
DIAGNOSIS AND PURIFICATION
(14:33–57)

This section is in effect a supplement to 14:1–20. It deals with outbreaks of **leprous disease** in buildings. The diagnostic procedures are set out in detail (vv. 33–48), and the rites for purification are prescribed (vv. 49–53). The concluding verses (vv. 54–57) relate to chapters 13–14 as a whole. There is further discussion by D. P. Wright (*The Disposal of Impurity*, 1987, pp. 76–77, 87–89, 206–208), and comment on Mesopotamian and Hittite practice by J. Milgrom (*Leviticus 1–16*, 1991).

Milgrom (*Leviticus 1–16*, 1991, pp. 886–887) sees reasons for associating the section with the Holiness Code, among them God's first person intervention and the interest in Canaan and "possession" (v. 34). This is certainly plausible (cf. comparable evidence for Holiness editing in 11:44–45), and compatible with our view that the Manual of Purity is a pre-exilic compilation.

33. Both Moses and Aaron are recipients of these commands (cf. 13:1).

34. The buildings under discussion are those Israel will occupy in **the land of Canaan**. Israel's destination is cited for

the first time here in Leviticus (cf. also 18:3; 25:38), and it is understood as given by Yahweh for a **possession**. This word is frequent in priestly tradition for landed property (e.g. 25:10, 13, 24, 25, 27, 28, 32, 33, 34, 41, 45, 46; 27:16, 22, 24, 28; Gen. 17:8; 23:4, 9, 20; 36:43; 47:11; 48:4; 49:30; 50:13; Num. 27:4, 7; 32:5, 22, 29, 32; 35:2, 8, 28; Deut. 32:49; Josh. 21:12, 39; 22:4, 9, 19). According to S. Rattray (cited by J. Milgrom, *Leviticus 1–16*, 1991) the word denotes property received from a sovereign, not inherited property.

The idea that Yahweh would be responsible for putting such a condition as **leprous disease** into a building ("fungous infection" – *REB*, J. Milgrom (*Leviticus 1–16*, 1991); "spreading mildew" – *GNB*, *NIV*) is typical of priestly stress on Yahweh's sole sovereignty (cf. e.g. Exod. 14:8). The word "affliction" (see 13:3) is part of the phrase here. J. E. Hartley (*Leviticus*, 1992) reads it as a "grievous growth" or "fungus". N. H. Snaith (*Leviticus and Numbers*, 1967) notes dry rot or mural salt as possible causes of **leprous disease** in houses, but doubtless various other conditions were viewed suspiciously and regarded as such.

35. The responsibility for initiating the diagnostic procedure is placed firmly in the hands of the house owner, who must inform the priest of the seeming presence of **some sort of disease**.

36. The priest's first step is to order the emptying of the house prior to his arrival. This seems to be a concession to the owner with regard to the rest of his property inside the house. It seems that the contents of the house will only be **unclean** if declared to be so by the priest. The owner is therefore given the opportunity to remove other items of property, prior to the priest's arrival. This is a further indication of a degree of flexibility within the priestly system, and a willingness to make economic considerations and concessions where this was deemed appropriate.

37. The symptoms of **leprous disease** in a house are the same as those for **leprous disease** in human beings or in garments, and so too in general are the procedures for dealing with it. The condition is a **disease** ("affliction" – see 13:3), and the priest must look for **greenish or reddish spots**

in the walls of the building (13:49; cf. 13:19, 24, 42, 43). The Hebrew text also mentions a "hollow" or "depression" (BDB) in the wall, a word which occurs only here, though it has affinities with the priestly word for "dish" (Exod. 25:29; 37:17; Num. 7:13). The condition must also be more than surface deep (v. 37) (the word used in 13:20, 21, 26 and often rendered "lower").

38. Where such symptoms are present the priest must shut the house for **seven days**, the equivalent of the period of isolation in e.g. 13:4.

39. The second examination (on the seventh day) will be concerned only to determine whether the condition has spread; if it has then **leprous disease** can confidently be identified, without any further period of waiting (cf. 13:51).

40. The action to be taken, under the supervision of the priest, is the removal of the affected stones to an **unclean place** outside the city (contrast the clean place outside the camp in 4:12; 6:11) (D. P. Wright, *The Disposal of Impurity*, 1987, pp. 232–243).

41. The rest of the house must be **scraped** inside (plural verb in Sam., Gk, Syr, Tg), and the **plaster** ("daub" – *NEB*) removed to the **unclean place** (v. 41). The verb "to scrape" occurs only here, but the same root is used of some kind of tool in Isa. 44:13. The word **plaster** is that commonly used for "dust" or "dry earth" (BDB).

42. The stones infected with **leprous disease** can then be replaced by fresh stones and new plaster. The verb **plaster** ("over-spread", "over-lay", "coat", "besmear" (BDB)) (plural in Sam., Gk, Syr) is relatively infrequent, occurring only here and in a few texts in Ezekiel and the Chronicles (Ezek. 13:10, 11, 12, 14, 15; 22:28; 1 Chr. 29:4).

43. As with human beings and garments there is the possibility that the condition will recur (cf. 13:7, 57).

44. If it does the priest must make a further examination, and confirm that the **leprous disease** has spread ("broken out again" – Sam. (also in v. 48)). The **leprous disease** here is described as **spreading** ("malignant" – *RSV*) (see on 13:51, 52) (a "corrosive growth" – *REB*). B. A. Levine (*Leviticus*, 1989) identifies it as "malignant, acute...".

45. In these circumstances there can be no concessions to the owner of the house; the whole building must be dismantled, and the pieces removed to an **unclean place**. It seems likely that the priest is intended to supervise this process (as in v. 40) (there is a plural verb in Sam., Gk, Syr).

46–47. The possibility is envisaged that people will enter the house during the seven-day period of isolation, and continue to use it. In this situation conditions of uncleanness will ensue. The person concerned will be unclean **until the evening** (v. 46, cf. 11:24, 25, 28, 31, 32, 39, 40, 41), while anyone who **lies down** or who **eats** there must **wash his clothes** (v. 47, cf. 11:25, 28, 40; 13:6, 34, 54, 58; 14:8, 9). Gk adds "and he shall be unclean until the evening".

If the action taken in vv. 40–42 is successful, and there is no recurrence of the condition, then a series of purification procedures are required (vv. 49–53). In general they are the same as those prescribed for the first phase of the purification of a person with **leprous disease** (vv. 4–7).

49. The text reads literally "he shall take for the sin of the house". The requirements are **two birds**, with **cedarwood**, **crimson yarn** and **hyssop** (Gk notes that the birds must be "clean", cf. v. 4). It is doubtless assumed that they must be clean; the only difference here is the proposal that they be "small" (*RSV* – not *NRSV*).

50. The killing of one of the birds **in an earthen vessel** over **fresh water** is as in v. 5.

51. For the dipping of the three items and the living bird in the blood see v. 6.

The sevenfold sprinkling of the house corresponds with that of the person in v. 7.

52. This completes the process of cleansing (cf. v. 7).

53. The living bird is now set free (cf. v. 7).

The other two phases, a waiting period of transition (vv. 8–9), and eighth-day sacrificial rites (vv. 10–20), are not considered necessary here; these first phase procedures are sufficient to make **atonement** (see on 4:20).

The remaining verses (vv. 54–57) are a typical concluding

summary (cf. 7:37–38; 11:46–47; 13:59), and they evidently relate to the content (in whole or in part) of 13:1–59; 14:1–53. It seems likely that these summaries give some clues as to the textual elements in Leviticus, and to the processes by which the book has been constructed. Since 13:47–58 (on garments) has its own concluding summary in 13:59, it may originally have been an independent element which has subsequently been incorporated into the larger whole as demarcated by 14:54–57. These textual elements are described as **ritual** (**torah**) (vv. 54, 57; cf. 6:9, 14, 25; 7:1, 11, 37; 11:46; 13:59).

This section brings to an end the discussion of **leprous disease**. One way to interpret the concerns of chapters 13–14 is to relate them to an understanding of holiness as wholeness (M. Douglas, *Purity and Danger*, 1966). A person with **leprous disease** is as problematic as a blemished animal offered for sacrifice, and all measures must be taken to protect the realm of the sacred from such defilement. For the same reasons an infected house is a danger to the community. These concerns are very much those of priestly theology.

At another, and perhaps older, level such blemishes may be understood as an intrusion; they occur unexpectedly and indiscriminately (M. P. Carroll, "One More Time", 1978). As such, steps must be taken to bring them within the control of culture, or at least to limit the damage to social well-being that they may inflict.

6. BODILY DISCHARGES: PURIFICATION
(15:1–33)

This final section of the Manual of Purity deals with bodily discharges of various kinds. The effects and implications of such conditions are dealt with in each case, and appropriate purification procedures are prescribed. The basic textual units are as follows:

15:1–15 – male discharges
15:16–18 – emissions of semen

15:19–24 – menstrual discharges
15:25–30 – abnormal female discharges
15:31–33 – concluding warning and summarizing statement.

These regulations are transmitted to Moses and Aaron (v. 1),
and it is required that they be passed on to the people (v. 2).
(Gk has a singular verb in v. 2). They are essentially laws, with
a summarizing statute (second person plural) near the end
(v. 31). The statute is seemingly addressed to Moses and
Aaron rather than to the people at large.

The importance of these conditions to pollution systems is
not immediately apparent. Basic fears about loss of the life
force (blood and semen) are a likely factor, along with feel-
ings of unease about these vital fluids being in the wrong
place, and therefore infringing principles of order. It is likely,
if holiness has something to do with physical perfection, that
a number of these conditions infringe the boundaries such a
perception implies. Those conditions involving the flow of
semen or blood clearly deal with substances in which the life
force was believed to reside (cf. e.g. Gen. 24:2–3). It has been
suggested that the cyclical nature of the menstrual flow may
have been linked in some cultures to lunar phenomena, and
to the gift of fertility; hence perhaps the problem posed by
irregularities (vv. 25–30). If such perceptions were ever held
in Israel they no longer influence priestly thinking.

Sexual intercourse at such a time was forbidden (18:19, cf.
Ezek. 22:10). In the light of the life the blood carries steps
must be taken to acknowledge it as a gift which God has
given. The life force must never be treated lightly or thought-
lessly. An element which unites all the conditions is the fact
that they represent processes not fully understood and
beyond human control, and as such they are potentially life-
threatening. The nature/culture conflict is therefore
perhaps part of the background to the discussion.

There is little biblical evidence elsewhere casting much
light on the significance of these procedures. The example
of Onan, in relation to a discharge of semen (Gen. 38:9), has
to be understood in the context of Levirate marriage, while
Deuteronomic law prescribes a period of exclusion from the

camp in the case of inadvertent discharges (Deut. 23:10–11). There are references to menstruation elsewhere (e.g. Gen. 31:35), and 2 Sam. 11:4 makes it clear that purification was not merely a preoccupation of the priestly writing. In general, however, these texts offer little help by way of understanding the motivations and concerns which underlie these laws about discharges.

The concluding verses (vv. 32–33) relate to the content of this section, and suggest that the regulations of vv. 1–31 as a whole were originally an independent element prior to their incorporation into the Manual of Purity.

In vv. 1–15 discharges from the flesh are discussed. Various conditions are in mind, though there is little stress on the diagnosis. Most emphasis is placed on the polluting effects of such conditions, and the steps that must be taken to deal with them. A detailed discussion of the condition is given by D. P. Wright (*The Disposal of Impurity*, 1987, pp. 181–189).

2. The word used for **discharge** comes from the verb "to flow, gush" (BDB). It does not commonly occur with the kind of meaning it has here, but its association with **leprous disease** as an abhorrent condition is well attested in 2 Sam. 3:29 (cf. 22:4; Num. 5:2). Many suspect gonorrhoea is in mind, but the condition need not be limited to that. B. A. Levine (*Leviticus*, 1989) suggests infections of the urinary tract and of internal organs.

3. The words "the law" (*RSV*) come from Gk. The overall point seems to be that the state of uncleanness persists, whether or not the discharge itself has ceased; the same steps must be taken.

The word **flows** is rare. In Job 6:6 it occurs as "slime", and in 1 Sam. 21:13 as "spittle".

The verb **stopped** is used only here in this kind of context; it generally has the sense of "to seal". BDB suggests that this relates specifically to an emission of semen.

NRSV has **member** in preference to "body" (*RSV*) (Heb. "flesh"; "penis" – *GNB*). There is a longer text in v. 3b in Gk and Sam. (supported by *11Q* (see J. Milgrom, *Leviticus 1–16*, 1991, p. 909); these readings support the supposition that

member is correct. The point might be that the discharge inhibits the flow of semen. *NJB* reads **whether his body allows the discharge to flow or whether it retains it**

The following verses (vv. 4–12) are largely concerned with the polluting effects of contact with such a person.

4. Pollution is transmitted to a **bed**, and to anything on which the person **sits**.

5. The pollution can then be transmitted to anyone who touches the **bed**. A person who becomes unclean through this process of transmission must then undergo the three familiar purification procedures, a washing of his clothes, of his body, and a period of waiting **until the evening** (cf. vv. 6, 7, 8, 10, 11) (cf. 11:24, 25, 27, 28, 31, 32, 39, 40; 13:6, 34, 54, 58; 14:8, 9).

6. Pollution also affects anyone who sits where the person who has the discharge has sat.

7. It is not surprising, therefore, that person-to-person contact with the one who has the discharge has the same effect, in this instance when someone touches the body of the person who has the discharge (cf. v. 11).

8. Spittle is a further means by which the pollution of the discharge can be passed to another. This might be accidental, but usually a gesture of contempt would be involved (Num. 12:14; Deut. 25:9; Job 30:10; Isa. 50:6).

9. Here attention turns again to items on which the person with the discharge has sat (cf. v. 10). One item specified is a **saddle**, a rare word the root of which is the verb "to ride" (cf. Song 3:10).

10. The impression is again given that the washing procedures are particularly for those who have carried such items (cf. 11:24–25).

11. Person-to-person contact is addressed again, in this case when the person with the discharge touches someone else. The transmission does not occur, however, if the person with the discharge has rinsed (cf. v. 12; 6:28) his hands.

12. Here directions are given concerning contact with an **earthen vessel** (cf. 11:33) or a **vessel of wood** (cf. 11:32 – "article"). The requirement that the former be broken is

familiar (see on 6:28; 11:33), as is the application of water to items made of wood (11:32).

The concluding verses (vv. 13–15) deal with the cleansing of the person with the **discharge**. The procedures are less demanding than in the case of **leprous disease** (cf. 14:1–20). There are no initial (phase one) bird rites; the person, though unclean, has not been banished from the realm of the **common** (see on 10:10). In Num. 5:2–3 it is required that the person with a discharge be excluded from the camp (along with the person with **leprous disease**, and one contaminated by a corpse). Num. 19:11–22 does not make this assumption about corpse contamination, just as these verses here do not make it concerning a discharge. D. P. Wright (*The Disposal of Impurity*, 1987, pp. 172–173) sees a contrast between camp conditions, reflected in Num. 5:2–3, and those of settled life, reflected here and in Num. 19:11–22. A theology of divine presence within the camp· is strongly affirmed in Num. 5:3, and this may reflect a distinction noted in priestly theology (presence and separation) in the Introduction.

13. The seven-day period of waiting begins the process of purification, and it is concluded with the familiar washing rites (cf. 14:8–9) (n.b. the stress here on **fresh** water (cf. 11:36), though this is lacking in some Gk mss.).

15. There is no **guilt offering** (cf. 14:12) on the eighth day. There is, however, a **sin offering** and a **burnt offering** to effect the necessary **atonement** (see on 4:20), but these are the inexpensive bird offerings (**turtledoves** or pigeons – v. 14), which in the case of **leprous disease** the poor are entitled to make (see 14:30–31).

In vv. 16–18 there is discussion of **an emission of semen**, one which presumably has nothing to do with any sort of **discharge** (vv. 1–15). The effects of pollution in these circumstances, and the steps to be taken, are closely combined (discussed further by D. P. Wright, *The Disposal of Impurity*, 1987, p. 196).

16. The circumstances do render a man **unclean**, and

familiar washing and waiting procedures are required. The expression **an emission of semen** is peculiar to the priestly writing, though the verb ("to lie down"), which is part of the expression, is commonly used of sexual relations (e.g. vv. 18, 33; Gen. 26:10; 30:15, 16; 34:2, 7; 35:22; 39:7, 12, 14; Exod. 22:16; Num. 5:19; Deut. 22:22; 1 Sam. 2:22; 2 Sam. 11:4, 11; 12:11, 24; 13:14). The full expression used here occurs again in 19:20 and Num. 5:13 where *NRSV* renders it "to have intercourse with". No such assumption is necessary here; an involuntary emission, independent of intercourse, is perhaps hinted at in v. 17.

17. As in vv. 1–12 pollution is transmitted to whatever garment the semen touches, whether of **cloth** or **skin** (cf. 13:47–48). In this instance the item must be washed, and remain unclean until the evening. This is clearly a less serious case of contamination than those in which **leprous disease** is identified or suspected (cf. 13:47–58).

18. Here an emission in the context of sexual intercourse is considered and pronounced unclean. If copulation has occurred this is strange, because to be fruitful and multiply is a basic requirement of the priestly creation ordinance (Gen. 1:28). G. J. Wenham ("Why Does Sexual Intercourse Defile?", 1983) concludes that semen, like blood in 12:1–8, is a life liquid, and that its loss is therefore polluting. People must recover the loss and be restored under these circumstances. R. Whitekettle ("Leviticus 15:18 Reconsidered", 1991) draws attention to the functional ambiguity of the penis, as producer of both life and waste. B. A. Levine (*Leviticus*, 1989) detects in this stipulation an Israelite reaction against polytheistic mythologies of divine mating which celebrated fertility.

Abstinence was required on occasions of special obligation (Exod. 19:15; 1 Sam. 21:4), and comparative material reveals the same kind of insistence in other ancient cultures (J. Milgrom, *Leviticus 1–16*, 1991). It remains possible that this was so, not because sex itself was polluting, but because there were risks of pollution should the semen go astray. There is the possibility therefore that the emission of v. 18 is premature. The context, sexual intercourse, requires that both persons must wash and wait (i.e. **until the evening**).

These emissions are clearly not a form of **discharge** (the word is not used), but the general context makes it appropriate that they be considered here. The semen as a life force has the power to pollute, when it comes into contact with items thought to be inappropriate for it. In other words there is a system of order which has been disturbed, and steps must be taken to remedy the situation.

Attention turns in vv. 19–24 to menstruation and its effects. The notion that menstruation rendered a person cultically unclean was widespread (cf. the discussion by J. Milgrom (*Leviticus 1–16*, 1991, pp. 948–953)). Like the emissions of vv. 16–18, however, it is accepted as "normal" in the sense that **atonement** (v. 15) is not an issue here. Early marriages and the demands of constant child-bearing may well have meant that menstruation was a less significant factor in the lives of women than it is today.

The impurity lasts for seven days (v. 19, cf. 14:8), and there are the usual processes of transmission if any contact occurs, whether with persons (vv. 19, 21, 22, 23, 24) or objects (v. 20). D. P. Wright (*The Disposal of Impurity*, 1987) provides further discussion on the menstruant (pp. 181–192).

19. This condition is considered to be a **discharge**; the use of this word in relation to menstruation occurs only here and in vv. 25–30. The phrase **regular discharge** (v. 19) contrasts with **many days, not at the time of her impurity** in v. 25.

The word **impurity** (cf. vv. 20, 24) is rendered "menstruation" in 12:2, and it has this significance in a number of other texts (vv. 25, 26, 33; 18:19; Ezek. 18:6; 22:10; 36:17). It can also denote the "water of impurity" for use after contact with a corpse (Num. 19:9, 13, 20, 21; 31:23); more general applications are also possible (Ezra 9:11; 2 Chr. 29:5; Lam. 1:17; Ezek. 7:19; Zech. 13:1).

The verb **touches** (cf. vv. 21, 22, 23) renders the same root commonly used earlier in the Manual of Purity to signify **disease**, and particularly with the possibility of **leprous disease** (e.g. 13:2, 47; 14:34).

The waiting **till evening** for purification to take place is familiar (e.g. vv. 5, 6, 7, 8, 10, 11; 11:24, 25, 27, 28, 32, 40).

20. The transmission of impurity to anything upon which the woman lies or sits is to be expected (cf. vv. 4, 6, 9). The further transmission of impurity to any person who touches these objects (vv. 21, 22, 23) is also consistent with the principles applicable to discharges in general (see vv. 5, 6, 10, 11).

21. The three purification procedures (washing of body, clothes and waiting) are required (cf. v. 22), and probably also, by implication, in v. 23 (see v. 7).

24. A final situation envisaged relates to a man who has sexual relations with a woman who is menstruating. On the phrase **lies with her** see v. 18. Such an action is severely condemned in 18:19; Ezek. 18:6; 22:10, but the concern here is only with the ritual effects. The man becomes **unclean** for seven days, and will transmit this uncleanness to **every bed** he uses during that period. In short, the man's ritual predicament becomes that of the woman herself, and the full consequences outlined in vv. 19–23 are probably to be understood.

In vv. 25–30 abnormal flows of blood are the point at issue – **for many days, not at the time of her impurity** (v. 25). Interest focuses once again on the way in which this condition transmits impurity (vv. 26–27), and on the procedures to be taken when the condition clears or is cured (vv. 28–30). Here sacrifice and **atonement** are required (v. 30). The predicament is discussed further by D. P. Wright (*The Disposal of Impurity*, 1987, pp. 172–173, 193–195; cf. also pp. 181–192).

25. In v. 25a the point seems to be that this is a flow of blood which occurs unexpectedly, and not at the normal period – i.e. **the time of her impurity** (the seven days cited in v. 19).

In v. 25b the point is that the menstrual flow persists, a condition which will extend the seven-day period of impurity. Either situation entails a **discharge of blood for many days**.

26. The effects of such a condition are as expected. Any bed on which the woman lies, or any chair on which she sits, becomes **unclean** (cf. v. 20).

27. Uncleanness will be transmitted to those who come into contact with the bed or chair (cf. vv. 21–23), and the three rites of purification apply – clothes washing, body washing, and a waiting until evening (cf. v. 21).

The abnormality of these conditions is emphasized by the special rites that must take place once the condition has ceased (vv. 28–30).

28. In the first instance a seven-day period of waiting must take place, and this renders the woman **clean** (contrast the longer periods required after childbirth (12:4–5)).

29–30. The rites on the eighth day are a **sin offering** and a **burnt offering**, consisting of **turtledoves** or **pigeons**. In performing these rites for her the priest makes **atonement** for the condition (see on 4:20). These eighth-day rites are precisely the same as those required in connection with any **discharge** (see 15:14–15). J. R. Wegner ("Leviticus", 1992) draws attention to the fact that the woman, unlike the man (v. 14), does not appear "before Yahweh"; hence the absence of washing (v. 13). Her access to God is seemingly less direct, and her status secondary.

These verses confirm the impression that abnormality, anything contrary to what is perceived to be the natural order of things, posed pollution problems, and that the pollution system (the steps to be taken) are intended to safeguard that order and restore it.

The concluding verses (vv. 31–33) contain a theological assessment of uncleanness and its significance for the life of the community (v. 31), in addition to a summarizing statement (vv. 32–33).

31. The theology is one of divine presence (see General Introduction). God is associated closely with the **tabernacle** at the centre of the camp, and **uncleanness** in any form threatens to defile it. The verb **keep separate** is a form of the verb "to dedicate" or "to consecrate" (BDB), with the sense "to consecrate from their uncleanness" ("set apart from their impurity" – Milgrom). This is an unusual turn of phrase, and it is possible, with Sam. and Gk, to read the verb "to warn" – "thus you shall warn the people of Israel about their uncleanness" (cf. Ezek. 3:18; 33:8, 9) (thus *REB*, *NJB*). That, however, is also an unusual turn of phrase for the priestly writing, and it may be better to read the Heb.

The description of the holy place as **tabernacle** has only

been encountered on one previous occasion in Leviticus (8:10, cf. also 17:4; 26:11). It is extensively used in the narrative detailing its construction (e.g. Exod. 25:9; 26:1), and derives from the verb "to settle" or "to dwell", hence "dwelling place". The word naturally expresses the priestly theology of divine presence within the camp – **in their midst**. This verse contains important witness to the fact that uncleanness in all its forms threatens the holy place; the diagnoses and procedures required all have a fundamental interest in protecting the holiness of the sanctuary from the dangers of defilement (cf. 20:3; Num. 19:13, 20).

32. This summarizing statement clearly relates to the content of vv. 1–30. As with many such statements the procedures required are described as **ritual** (**torah**) (cf. 6:9, 14, 25; 7:1, 11, 37; 11:46; 13:59; 14:54, 57).

33. Most of the terminology used here is drawn from the regulations earlier in the chapter. An exception is the description of a woman as **in the infirmity of her period**, an expression which apparently covers both conditions previously described (i.e. vv. 19–24, 25–30).

The association of **infirmity** with menstruation also occurs in 12:2; 20:18, but it often has a wider frame of reference regarding illness (e.g. Deut. 7:15; 28:60; Job 6:7; Ps. 41:3; Lam. 1:13; 5:17), and can sometimes be rendered faint of "heart" or "spirit" (Isa. 1:5; Jer. 8:18; Lam.1:22).

This chapter makes it clear that the priests did distinguish between "normal" and "abnormal" conditions; only for the latter were sacrifice and **atonement** required (vv. 15, 30). This relates readily to priestly thinking about wholeness and blemish within their concept of order. Here too, however, there appear to be older concerns about mysterious life forces, not fully understood, and not fully under human control. They must be acknowledged and respected; only so can they become part of the life of the community, rather than agents of damage and destruction.

THE DAY OF ATONEMENT
(16:1–34)

This section picks up the narrative thread from chapters eight to ten. In v. 1 there is reference to **the death of the two sons of Aaron** (cf. 10:1–3). The interest in sin which 16:1–34 exhibits follows naturally from the events and laws of 10:1–20 as a whole. The concluding comment that Moses **did** as he had been commanded (v. 34) is characteristic of the priestly narrative tradition. The insertion of the Manual of Purity may have been prompted by the feeling that it amply illustrated the concerns of 10:10–11, and that the Day of Atonement rites were a fitting conclusion to its interest in uncleanness and purification (see especially v. 16). The basic textual units here in 16:1–34 are as follows:

16:1–5 – Aaron's entry into the holy place
16:6–10 – the rites of atonement in outline
16:11–22 – the rites of atonement (further detail)
16:23–28 – concluding rites and procedures
16:29–34 – day of atonement statutes.

The directives are delivered to Moses (v. 1), who in turn must pass them on to Aaron (v. 2). It has often been suspected that the text is composite (M. Noth, *Leviticus*, 1962/1965; N. H. Snaith, *Leviticus and Numbers*, 1967). There might be two versions of the central rites (vv. 6–10; vv. 11–22). It could be that vv. 6–10 constitute the original nucleus, and vv. 11–22 an expansion, but if the scapegoat rites (v. 8) are a later addition to the procedures, the earliest nucleus may perhaps be the sin offerings of vv. 11, 14–16. J. Milgrom (*Leviticus 1–16*, 1991, pp. 1059–1065) sees vv. 2–28 as a unitary source, incorporated subsequently into his view of the priestly document. Our view would stress the role of the priestly narrators in incorporating earlier ritual material, and in vv. 29–34 in aligning it with

concerns in the Holiness Code such as the calendar of feasts (23:4–44) and the situation of the alien (e.g.17:8).

The history of the day of atonement as an occasion in the Israelite calendar is obscure. It is attested elsewhere only in relatively late priestly texts (cf. 23:26–32; 25:9; Exod. 30:10; Num. 29:7–11), but the older critical assumption that it was therefore of exilic origin is oversimple. According to Ezek. 45:18–20 there were two days associated with temple cleansing, and the second of these (on the first day of the seventh month) corresponds most closely to the dating of the day of atonement (v. 29). The procedures described briefly in Ezek. 45:19 have some affinities with those outlined in vv. 11–14. Some connection between the rites described in Ezek. 45:18–20 and those set out here seems probable, though in the former there is no scapegoat, and no atonement for the people at large. It also seems likely that the day developed in scope and importance. What had originally been rites of purification for the sanctuary, and therefore a prime concern and preoccupation of the priests alone, became eventually a major occasion of penitence and purification for all. It is reasonable to suppose that the interest in penitence and fasting, which exile and its outcome provoked (cf. e.g. Ezra 9:6–15; Neh. 9:6–37), was a factor in this process. Elements such as the scapegoat rites (vv. 8, 21–22), ancient in themselves, were incorporated in ways which can no longer be traced.

In vv. 1–5 an account is given of the circumstances under which Aaron may enter the holiest place, **inside the curtain** (v. 2), and indicate the sacrificial offerings he must bring when he does so (v. 3), and the garments he must wear (v. 4). It concludes with the offerings he must receive from the people at large.

1. The deaths of Nadab and Abihu recorded occur in 10:1–3. In Gk there is also a reference to the **unholy fire** they offered (cf. Num. 3:4).

2. There is then a warning to Aaron that his entry to **the sanctuary inside the curtain** can only occur on the day of atonement, and under the circumstances to be outlined.

The **sanctuary** sometimes denotes the tabernacle and its courts in the priestly writing (e.g. Num. 3:28), but in 10:4, 7, 18 it is more narrowly defined as the tabernacle itself or the place where holy food must be eaten. Sometimes the word is used to distinguish the outer part of the tabernacle from the inner (i.e. the "most holy" place) (e.g. Exod. 26:33; 28:29). Here, as also in 4:6, it is used of the inner part of the tabernacle, as defined by **inside the curtain**. This "veil" (*RSV*) is the curtain separating the two parts of the tabernacle (cf. 4:6; 24:3; Exod. 26:31; 35:12; 39:34; 40:21; Num. 4:5).

The **mercy seat** (from the same root word as **atonement**) is the cover which was placed on top of the ark (hence "cover" – *REB*; "lid" – *GNB*; "atonement cover" – *NIV*). The reference to the cover is omitted in Tg. Its manufacture is commanded in Exod. 25:17–22, and further references occur in Exod. 26:34; 30:6; 31:7; 35:12; 37:6–9; 39:35; 40:20; Num. 7:89; 1 Chr. 28:11). Its function as "cover" and its connection with "atonement" (the same root word seems to be used) suggest a protective purificatory role. M. Görg ("Eine neue Deutung", 1977) suggests an Egyptian origin, and connections, not with "atonement", but with "the sole of the foot", denoting the ark's function as Yahweh's footstool.

The construction of **the ark** is commanded and described in Exod. 25:10–22; 37:1–9. Its description as "ark of the covenant" is traceable in the main to Deuteronomic literature; a description favoured by the priestly writers is "ark of the testimony" (e.g. Exod. 25:22; Num. 4:5; 7:89; Josh. 4:16).

The **cloud** above the **mercy seat** is designated as a place where Yahweh will **appear** (cf. Num. 7:89 for the location). The theophany **cloud** in the priestly writing may appear in the wilderness (Exod. 16:10) or on the mountain (Exod. 24:15, 16), in both cases in association with the divine "glory". After the construction of the tabernacle the cloud covers the tent and fills it, moving on only when it is time for Israel to resume the journey (Exod. 40:34–38; Num. 9:15–22; 10:11–12, 34; Num. 16:42). This special association of **cloud** with the **mercy seat** occurs only in this chapter; in v. 13 the **cloud** is linked to the incense that Aaron must bring.

3. The preparations which must be made are then

described. Aaron is to enter the **holy place** with a **sin offering** and a **burnt offering**. The **young bull** is the animal specified for a priest's sin offering in 4:3, cf. 4:14 (simply a **bull** in 8:2, 14, 17, and a different word **calf** in 9:2).

The **ram** as **burnt offering** occurs in the ordination ceremonies in 8:18; 9:2.

4. Aaron must then clothe himself with holy vestments. These are the **linen tunic** (cf. 8:7), the **linen undergarments**, the **linen sash** (cf. 8:7), and the **linen turban** (cf. 8:9). The **breeches** ("shorts" – *REB*; *GNB*) are not mentioned in the ordination ceremonies, as described in Leviticus, but do occur in 6:3; Exod. 28:42; 39:28. There is no reference here to the ephod (8:7) or the breastpiece (8:8). B. A. Levine (*Leviticus*, 1989) suggests that the unadorned garments symbolize an abject state appropriate for a situation of confession and expiation. The washing procedures recall the preliminaries in the ordination rites (8:6).

5. The final act of preparation is to receive from the people animals for a **sin offering** and a **burnt offering**. This makes it clear that the offerings in v. 3 are for Aaron himself.

The description of Israel as a **congregation** (i.e. an assembly of people meeting by appointment; "community" – *REB*, *NJB*, *GNB*, *NIV*) is very common in the priestly writing, particularly in narrative, but less so in Leviticus, with its predominantly legal content (4:13, 15; 8:3, 5; 9:5; 10:17; 19:2; 24:14, 16). It is to be noted that a number of these texts occur, as here, in those parts of the book which are arguably narrative (8:3, 5; 9:5; 10:17; 24:14, 16).

The animals for the **sin offering** are **two male goats**. The rites are discussed at length by N. Kiuchi (*The Purification Offering*, 1987, pp. 143–159). This is the animal specified for the sin offering of the ruler in 4:23. As in that text two words are used to describe the animal, the one denoting a mature male, and the other that it must be from among the domesticated goats. The goat is also the people's sin offering for the eighth-day ordination rites (9:3, 15; 10:16). The presentation of **two** is a new feature, and one in fact will not be sacrificed (vv. 8, 21).

On the **ram** as **burnt offering** see v. 3. In the eighth-day ordination rites the ram is a well-being offering (9:4, 18).

It seems best to see vv. 6–10 as an overview of key elements in the forthcoming rites – note the way in which v. 11 duplicates v. 6. The elements involved are the **sin offering** for the priests (v. 6, cf. v. 3), and the use to which the two goats are to be put (vv. 7–10, cf. v. 5). One is to be a **sin offering** (v. 9), as indicated in v. 5, and the other is to be released into the wilderness **to Azazel** (v. 10).

6. Aaron's first task is to **make atonement** (see on 4:20) for himself and his family. The animal is the **bull** described more precisely as **young** in v. 3. The primary point is that Aaron is purifying and protecting the holy place from any defilement which he and the other priests might bring.

7. The two **goats** are cited without the qualification in v. 5 that they must be domestic. These are to be set before Yahweh at the entrance of the **tent of meeting** (see on 1:1).

8. Aaron is then required to **cast lots** over the two animals. This is the only reference to such a practice in sacrificial contexts, but P does envisage it in connection with the allocation of land (Num. 26:55; 33:54; 34:13; 36:2; Josh. 19:1; 21:4). Elsewhere lot-casting serves many purposes, including decisions about war (e.g. Jdg. 20:9), and about guilt (e.g. Jon. 1:7), and in the assigning of temple duties (e.g.1 Chr. 24:5).

The purpose of the lot-casting is to decide which goat shall be **for Yahweh** and which **for Azazel**. The turn of phrase suggests strongly that **Azazel** is to be understood as a deity or spirit distinct from Yahweh (D. P. Wright, *The Disposal of Impurity*, 1987, pp. 21–25; B. A. Levine, *Leviticus*, 1989; J. Milgrom, *Leviticus 1–16*, 1991), and that some very ancient religious rite is enshrined within the day of atonement procedures. B. A. Levine (*Leviticus*, 1989, pp. 250–253) stresses the magical perceptions which he believes are presupposed. J. Milgrom (*Leviticus 1–16*, 1991, pp. 1071–1079) provides evidence of comparable rites in the ancient near east. It is possible, as with Gk, to make a connection with the verb "to depart", and to read the word as "the goat that departs" (i.e. scapegoat). Another possibility is to find some reference within the word to the place to which the goat is to be sent. Connections of this kind have been suggested with the Arabic for "be rugged", denoting perhaps a steep cliff (G. R.

Driver, "Three Technical Terms", 1956) or a remote desert location. In line with this theory *NEB* reads "for the precipice" (*REB*, *GNB* prefer "for Azazel", and *NIV* "for the scapegoat"). G. J. Wenham (*The Book of Leviticus*, 1979) and J. E. Hartley (*Leviticus*, 1992) offer further explorations of these alternative theories. The juxtaposition of **Yahweh** and **Azazel** favours the supposition that the latter was originally a deity or desert demon, though, as Wright points out, he no longer has any active reality in the priestly rite. The function of the scapegoat will emerge as the rite unfolds.

9. The goat which is **for Yahweh** is to be a **sin offering** in the usual way (cf. v. 15).

10. The goat for **Azazel** must also be **presented** before Yahweh (the verb is "made to stand" – thus *REB*), and be a means by which **atonement** is made. In both respects this is a good indication that for the priestly writers there is no rivalry between Yahweh and Azazel, and that the latter is a cultic "survival". The fact that the goat is to be despatched **into the wilderness** is indicated for the first time (v. 10).

In vv. 11–22 there is a full account of the central rites for the day of atonement. The sin offering for Aaron himself and the priests is described in vv. 11–14. The sin offering for the people follows in vv. 15–19, and the scapegoat rites in vv. 20–22. These three central elements constitute the necessary procedures by which the holy place is protected and purified from all forms of defilement.

11. The **sin offering** for the priests is the first of the central elements (vv. 11–14). The content of v. 6 is repeated, with no significant addition or modification. Gk makes it clear that the offering is for Aaron's house, as well as himself. The **bull** has been described more specifically in v. 3 as **young**. The ram for a **burnt offering**, also mentioned in v. 3, is offered later in the day (v. 24).

12. The sin offering is accompanied in this instance by **crushed sweet incense**. There is no reference to this in sin offering rites of 4:1–35 (though there is an anointing of the incense altar in 4:7), nor is there in the ordination sin offerings of 8:14–17; 9:8–11.

The **censer** (v. 12) is the same kind of object as that used by Nadab and Abihu in 10:1. It must be **full of coals of fire from the altar** (contrast the probable error of Nadab and Abihu).

The **incense** (see on 10:1) must have two characteristics. It must be **sweet** ("fragrant" – *REB*, *NIV*; "aromatic" – *NJB*; "fine" – *GNB*) (better "spiced" or "made with spices"). The making of it is described in Exod. 30:34–38, and other references occur in 4:7; Num. 4:16; 2 Chr. 2:4; 13:11. **Two handfuls** are specified (contrast the single handful of flour and oil in offerings – 2:2; 5:12; 6:15; 9:17; Num. 5:26). The incense must also be **crushed** (v. 12) ("finely ground" – *NJB*). This is that which is to be specially set aside in Exod. 30:36 as "most holy". The word also occurs with the sense of "small" or "fine" in relation to manna (Exod. 16:14) and hair (13:30).

Aaron is then commanded to bring the censer with its coals and the two handfuls of incense **inside the curtain**, that is, inside the inner part of the sanctuary (see on 4:6). This entry into the inner sanctum distinguishes the day of atonement rites from all others. In some sin offering rites there is a sprinkling of the curtain (4:7, 17), but this is the only occasion on which Aaron enters the holiest place (cf. v. 2).

13. The incense generates the **cloud**, the focus of God's presence and self-revelation (see on v. 2). The **cloud** in turn covers the **mercy seat** (the cover to the ark – see on v. 2), here designated simply as **the covenant** (see on v. 2). This abbreviated reference to the "ark of the testimony" is common elsewhere in the priestly writing (Exod. 16:34; 27:21; 30:6, 36; Num. 17:4, 10). The **covenant** (or "testimony" – *RSV*, *NIV*; "the Tokens" – *REB*) is strictly the stone tablets the ark contains (Exod. 31:18; 40:20), and is derived from the earlier narrative tradition (Exod. 32:15; 34:29). It can be related to the tabernacle in general (Exod. 38:21; Num. 1:50, 53; 9:15; 10:11) or the curtain (24:3).

The sin offering for Aaron concludes with a sprinkling of the blood on the **mercy seat**. The verb **sprinkle** is familiar in sin offering rites (4:6, 17; 5:9), and in other purification rites (14:7, 51; Num. 8:7; 19:4, 18, 19; 19:21). Similar procedures involve the use of oil (8:11, 30; 14:16, 27). To **sprinkle seven times** is also common (4:6, 17; 8:11; 14:7, 16, 27, 51; Num.

19:4). The **mercy seat** is sprinkled **on the front of** (literally "on the face of") and **before** (which suggests "in front of"). These are the procedures, involving the ark and its cover, which distinguish day of atonement rites from those on other occasions (e.g. 4:1–12 where the curtain receives the sprinkled blood (4:6)). The holiest place is thus protected and cleansed from any priestly defilements that threaten it.

15. The second central element in the day's events is the sin offering for the people (vv. 15–19). Once the **goat** has been slaughtered (v. 15) its blood must be handled in exactly the same way as that of the bull in Aaron's sin offering. Gk makes it clear that this is only some of the blood; there are other purposes to which the blood must also be put in vv. 17–19.

16. The **mercy seat** is sprinkled **on the front of** and **before**. It is made very clear that this, as with vv. 11–14, is an **atonement for the holy place** (i.e. the "holy of holies" in this instance). The sanctuary and all it contains are the beneficiaries of these rites, purified and protected from all that might defile.

The **sins** that threaten are described as **uncleannesses** (the conditions discussed in chapters 11–15) and **transgressions** ("acts of rebellion" – *REB*, cf. *NIV*). The latter word (cf. also v. 21) occurs only here in the priestly writing, and is rare in the Pentateuch at large (Exod. 23:21; 34:7; Num. 14:18). It is not uncommon in the prophets, and is used on a number of occasions by Ezekiel (14:11; 18:22, 28, 30, 31; 21:24; 33:10, 12; 37:23; 39:24). The verb can be rendered "rebel" (BDB), and for the priestly writers it probably denotes the most serious sins.

In v. 16b the point is made that the same must be done for **the tent of meeting** (see on 1:1). This clearly distinguishes the term from the holy of holies, and it should be understood to denote the holy place where the altar of incense and the table are to be found. This is a uniquely limited frame of reference within the priestly writing for the **tent of meeting**. Exactly how the blood is to be manipulated in this instance is not made clear. Some sprinkling or anointing of the holy objects is to be understood. Once again it is clear that this

atoning action is **for** the sanctuary and all it contains; the danger to it arises from the fact that it is **in the midst** of Israel's **uncleannesses**.

17. The point is further enforced with the requirement that no one is to enter the tent until this work of atonement is complete, namely all the rites described in vv. 11–16. The preposition **for** signifies "on their account" (i.e. the priests and the people).

The description of Israel as an **assembly** (v. 17) is not frequent in Leviticus (see v. 33; 4:13, 14, 21). In the present form of the priestly writing it is in effect a synonym for **congregation** (see v. 5). It may originally have denoted Israel gathered together for cultic purposes (cf. Deut. 5:22; 9:10; 10:4; 18:16; Ps. 107:32; Jer. 26:17; 44:15; Joel 2:16.

18. From the holy place Aaron moves out into the court of the tabernacle and makes **atonement** for the **altar** there, literally "upon it" (i.e. the altar of burnt offering). The procedures are indicated clearly here. In the first place he must smear some of the blood on the horns of the altar, its extremities symbolizing the whole (see on 4:7, 18, 25, 30, 34). This is a familiar feature of the sin offering, though in the case of priests (4:7) or congregation (4:18) the altar anointed is the incense altar in the holy place. The blood to be used for this anointing is to be from both the bull (Aaron's sin offering) and the goat (that of the people).

19. The second thing he must do is to **sprinkle** blood **seven times** on the altar (see v. 14). The purpose of these rites comes through with clarity here. The holy things (in this instance the altar) are to be made clean and made holy (see on 10:10) (**cleanse it and hallow it**). The danger is the **uncleannesses** of Israel (cf. v. 16), the states and conditions which have been discussed at length in chapters 11–15. It may be assumed that this process of "cleansing" and "hallowing" has a protective as well as a purifying function. Known risks would have been dealt with at the time, and these annual rites probably offer safeguards for the forthcoming year. They also doubtless cover risks which have been undetected and conditions undiagnosed.

20. The third central element is the sending out of the

other goat into the wilderness (vv. 20–22). When the rites of atonement for the sanctuary are complete the **live goat** must be presented to Yahweh. As in v. 16 **holy place** denotes "the holy of holies", and **tent of meeting** signifies "the holy place".

21. There follows an imposition of hands by Aaron, a familiar feature of the animal offerings (1:4; 3:2; 4:4) which identifies the offerer (in this instance **the people of Israel**) with the animal offered.

Aaron must then **confess** over the goat. This is a form of the verb "to throw" or "to cast" (BDB), and has already been encountered in connection with the guilt offering (5:5). It is used of the formal confessions of sin in Ezra 10:1; Neh. 9:3; Dan. 9:4, and with **iniquity** or **sin** (as here) in 26:40; Num. 5:7. The word **iniquities** (unlike **transgressions** and **sins**) was not used earlier in v. 16. It is obviously important because this is what the goat is said to carry away (v. 22). Elsewhere in Leviticus it is often what an offender has to "bear" (i.e. the consequences of an offence) (5:1, 17; 7:18; 17:16; 19:8; 20:17, 19; 22:16; cf. Num. 5:31; 14:34; 18:23), and it is something the priest bears in sin offerings (10:17; cf. the father in Num. 30:15). In the Holiness Code it is punished by Yahweh (18:25; 26:39, 40), and amends can be made for it (26:41, 43). It seems to denote "guilt incurred" , and is translated that way by *NRSV* in Exod. 28:38. In Num. 5:15 it can be "brought to remembrance". The concept seems to cover all types of offence from those committed in ignorance (5:17) to deliberate and wilful sin (Num. 15:31).

The **sins** (**transgressions** and **iniquities**) thus confessed are **put . . . upon the head of the goat**. Some kind of transference seems to be implied here, though this too is probably a purificatory rite. Just as the blood of the sin offerings carries away any defilements incurred by (or threatening) the sanctuary so the scapegoat carries away the **iniquities** of Israel (v. 22) – i.e. those she has incurred and which threaten her status as the holy people.

22. The destination of the goat is **the wilderness** (v. 22), and specifically **a barren region**, a phrase which occurs only here. The underlying verb means "to cut" or "to divide" (BDB), and the sense seems to be "to a place cut off", and

from which it cannot realistically return. A man has been deputed to be responsible for ensuring that this happens (v. 21); a priest would not be allowed to risk the defilements that would ensue from a journey into the wilderness. On the similarities and differences between this and the bird rites in 14:2–7, 48–53 see D. P. Wright (*The Disposal of Impurity*, 1987, pp. 78–80).

D. P. Wright (*The Disposal of Impurity*, 1987, pp. 15–74) also offers a detailed discussion of the scapegoat rite in general, making comparisons with parallel procedures in Hittite and Mesopotamian sources. His main conclusion is that there are significant conceptual differences. It is precisely because Azazel is not an angry deity that notions of substitution and propitiation must be excluded from the biblical rite; the goat simply carries away sin to a place where the sin can no longer damage the community. Other distinctive features are the infrequency and limited nature of such procedures in the priestly writing. There is only this annual rite, and it deals only with ritual sin. It is perfectly possible of course, as Wright recognizes, that appeasement in some form, perhaps of a fierce deity, was at the centre of the original Azazel rite.

In vv. 23–28 the concluding washing procedures are described, along with the burnt offerings. Aaron must remove the garments he wore when he went into the holy of holies, and leave them in the **tent of meeting** (i.e. the holy place in this chapter) (v. 23). After he has washed he offers the two burnt offerings (v. 24) (for himself and the people), and then burns the fat of the sin offering (v. 25). The man who took charge of the goat for Azazel must also wash before he can be readmitted to the camp (v. 26). The carcases of the two sin offerings are to be removed altogether from the camp, and burned (v. 27); the person responsible must wash before he can return to the camp.

23. Aaron returns from the court (v. 18) to the **tent of meeting** (the holy place), and removes the linen garments he has been wearing (v. 4), leaving them there. This is both a preliminary to the washing (v. 24), and more particularly a recognition of the holiness of the garments themselves. The

very high degree of holiness attaching to them, by virtue of his entry into **the holy place** (i.e. the holy of holies), must be protected, and this can only be done by not allowing them to move beyond **the tent of meeting** (i.e. the holy place). It is unclear as to where precisely Aaron is to leave the clothes; B. A. Levine (*Leviticus*, 1989) suggests a special screened area outside the tent itself.

24. The requirement that Aaron (or the priests) should wash at the end of a rite is unusual; washing is customarily a purification rite for those who have become unclean (11:25, 28, 40; 13:6; 14:8, 9; 15:6, 7, 8, 10, 11, 13, 16, 18, 21, 22, 27), or else for priests a preliminary to important rites (v. 4; 8:6), thereby ensuring that they are clean. Must it be assumed that Aaron has incurred some defilement or is at risk of having done so? If so, the most likely source of such defilement would be the act of confession and the contact with the live goat (v. 21). D. P. Wright (*The Disposal of Impurity*, 1987, p. 218) suggests that there cannot be any defilement attaching to the priest (any more than there is when he eats the sin offering). This washing would therefore have affinities with those in v. 4 and 8:6, and would mark a transition between major parts of the rite. The place where he washes must be **holy** – i.e. within the courtyard of the tabernacle. Clothed once again, in appropriate garments, Aaron is ready to make the two burnt offerings in honour of God. The generalized statement that this makes **atonement** is part of a tendency within the priestly writing to make all sacrificial rites purificatory (see on 4:20). Gk makes it clear that Aaron offers for his household as well as for himself and for the people.

25. Aaron must now burn **the fat of the sin offering** on the altar. This refers presumably to the fat of both of the sin offerings (vv. 11, 15). The burning of the fat is a key feature of the sin offering (4:8–10, 19, 26, 31, 35; 8:16; 9:10), and its separation from the blood rites here is unusual. The effect is to highlight the blood rites as the central atoning elements.

26. The man to whom the goat for **Azazel** (Gk – "determined for release") had been committed is necessarily unclean through his contact with the sin-bearing animal.

Two washings, of body and clothes, are required before he can come into the camp again (see v. 24). The customary requirement that the person waits until the evening is absent here (as also in v. 28); perhaps in both instances it is irrelevant since the persons involved will not be going back to the sanctuary or partaking in sacrifices (D. P. Wright, *The Disposal of Impurity*, 1987, pp. 217–218).

27. The carcases of the sin offerings must be disposed of in the way described in 4:11–12, 21 (sin offerings for priests and congregation – D. P. Wright (*The Disposal of Impurity*, 1987, pp. 134–135, 243)), and not as prescribed in 6:26; 10:17–18. This is clearly the kind of sin offering in which blood has been brought into what 10:18 calls **the inner part of the sanctuary** (i.e. the holy place, and in this instance the holy of holies), and not simply confined to the altar of burnt offering (4:25, 30, 34). The priest cannot eat this sin offering, because it is an offering for himself, specifically for him and his family in vv. 6–10, and for himself as member of the congregation in vv. 15–19.

28. There is the further requirement that the person who disposes of the carcases must wash body and clothes – a clear indication that the flesh of the animals carries away pollution. In 4:12, 21 it seems to be the task of the priest; here the person is not clearly designated, though it cannot be Aaron and the implication seems to be that it could be a layman (a priest would probably be specified).

The concluding verses offer general regulations about the observance of the day of atonement, the obligations attaching to it (vv. 29, 31, 32), and its effects (vv. 30, 33, 34).

29. The fixing of the day in the calendar is a **statute . . . for ever** (cf. also vv. 31, 34). This phrase has already been encountered in 3:17; 7:36; 10:9, and will recur in 17:7; 23:14, 21, 31, 41; 24:3. Elsewhere it is found in Exod. 27:21; 28:43; 29:9; Num. 18:23; 19:10, 21). A masculine form, with no obvious difference of meaning, is found in similar priestly contexts (6:18, 22; 7:34; 10:15; 24:9; Exod. 29:28; 30:21; Num. 18:11, 19). The phrase probably belongs to the latest layers of the priestly writing, identifying stipulations which

carry a very weighty degree of obligation, or which are now
being fixed for all time.

The dating of the day of atonement (**in the seventh month,
on the tenth day of the month**) agrees with the calendar in
the Holiness Code (23:27) and with Num. 29:7. The account
of the day as one on which **you shall deny yourselves** is also
found there ("fast" – *REB, NJB, GNB*). It suggests being
"bowed down"/"humbled", probably by fasting (cf. Ps. 35:13;
Isa. 58:3, 5). Elsewhere it can be used in fulfilment of an oath
(Num. 30:13).

In addition to fasting there must be abstention from work
on the day of atonement. These requirements are applicable
to the **alien** as well as the **citizen**. The former denotes tempo-
rary visitors or resident aliens, and the applicability of laws to
both groups (**citizen** and **alien**) is often made explicit in
priestly laws (Exod. 12:19, 48, 49; Num. 9:14; 15:14, 29, 30).
These situations deal with Passover observance, with offer-
ings by fire, and with sin (deliberate or otherwise). A variety
of laws in the Holiness Code also exhibit this feature (17:15;
18:26; 19:34; 24:16, 22). It may originate there or perhaps in
Deuteronomic circles (Josh. 8:33). Laws which seem to apply
only to the **citizen** have to do with the feast of booths (23:42).
The rights of the **alien** (i.e. those without rights of inheri-
tance) are extensively set out in laws of all ages, and include a
share in sabbath rest (Exod. 20:10), food forbidden to
Israelites (Deut. 14:21), prosperity (25:47), and future
success (Deut. 28:43). Most law collections warn against
exploiting the **alien** (19:33; Exod. 22:21; 23:9; Deut. 24:17;
27:19) and encourage kindness towards such people (19:10,
34; 23:22; Deut. 10:18, 19; 14:29; 24:19, 20, 21; 26:12, 13). J.
Milgrom ("Religious Conversion", 1982) offers further
comment on the legal status of the **alien**.

30. The purpose and effect of **atonement** is once again
made clear. It is to **cleanse** (render **clean** – see on 10:10) – i.e.
to purify. The stress here is not on the purification that is
accomplished for the sanctuary (though that is a crucial part
of the day's rites (vv. 11–19), but on the purification of Israel
herself (effected in vv. 20–22). Israel, like the sanctuary, is
holy.

31. The nature of the day is further defined. Its affinity to the **sabbath**, implicit in v. 29, is here made explicit. The phrase **of complete rest** ("solemn rest" – *RSV*) comes from the same root as **sabbath**, the repetition emphasizing the importance of the occasion – "a sabbath of sabbatic observance" (BDB) (cf. 23:32). The weekly sabbath can be described in these terms (23:3; Exod. 16:23; 31:15; 35:2), and so also can the sabbatical year (25:4). The Holiness Code sometimes uses the phrase on its own, of the feast of trumpets (23:24), and of the first and last days of the feast of booths (23:39).

32. The importance of the occasion is emphasized by further summarizing statements. The duly **anointed and consecrated** priest (see on 8:30) must make the **atonement**, wearing the **holy vestments** (see on v. 4). The expression "to fill the hand" is rendered **consecrated** here (see on 8:33) ("installed to officiate" – *NJB*).

33. The full range of what is accomplished on the day is indicated – purification for the **sanctuary** (see on 12:4), the **tent of meeting**, the **altar**, the **priests**, and the **people**.

34. The **everlasting statute** (v. 34) is the same phrase as **statute . . . for ever** in v. 29. The concluding phrase, indicating Moses' obedience in *NRSV*, connects the rites with the priestly narrative tradition, as does v. 1 at the beginning. It is probably better read as "and he (Aaron) did as Yahweh commanded Moses" (J. Milgrom, *Leviticus 1–16*, 1991) (cf. "And as Yahweh ordered Moses, so it was done" – *NJB*). In any event Moses faithfully passes on to Aaron the requirements for the day of atonement, and the assumption is that when the appropriate day arrived (v. 29) the first day of atonement was observed.

The main purpose of the rites is to ensure that the tabernacle, now in place (Exod. 40:1–37), along with its newly inaugurated cult (Lev. 8–9), is kept from any defilement or impurity. The statutes in vv. 29–34, reflecting perhaps a development in atonement theology, make it clear that the people are also purified (v. 30). On a broader front the rites can also be seen as the process by which the priestly understanding of

cosmic and social order is affirmed and ensured for the
forthcoming year. Helpful comments along these lines, and
on the significance of space and time in the rites, is offered by
F. H. Gorman (*The Ideology of Ritual*, 1990, pp. 61–102). He
sees them as procedures by which creation is "newly created",
defilements are done away with, chaos is banished once again
to the wilderness, and Yahweh's continuing presence is
ensured.

THE HOLINESS CODE
(17:1–26:46)

This major block of textual material is in one sense less homogenous than the Manual of Offerings or the Manual of Purity. A greater diversity of materials covering a miscellany of topics are found here. On the other hand the editorial influences, which have enabled scholars to identify these texts as the Holiness Code, give to the block as a whole a degree of cohesion. The relationship of the Code to the rest of the book and to the priestly writing as a whole is debatable; the influence of the editors who collected these chapters is discernible elsewhere in Leviticus (see General Introduction: Sources and Component Parts).

The main characteristics of the editing are as follows:

1) Historical allusions to Israel's experience in Egypt (18:3; 19:34, 36; 23:43; 25:38, 42, 55; 26:13, 45).
2) The description of laws as "ordinances", "statutes", "charge", "commandments", "covenant", something to be "kept", "walked in", and "performed" (18:4, 26, 30; 19:19, 37; 20:8, 22; 22:31; 25:18; 26:3, 14, 15, 21, 23, 27, 42, 43, 46). It is this kind of language which provides the Holiness Code with its major affinities with Deuteronomy.
3) Yahweh's self-designation – "I am Yahweh. . . (your God)" (18:5, 6, 21, 30; 19:3, 10, 12, 14, 16, 18, 25, 28, 30, 31, 32, 34, 36, 37; 20:7, 8, 24; 21:15, 23; 22:2, 3, 8, 9, 16, 30, 31, 32, 33; 23:22, 43; 24:22; 25:17, 38, 55; 26:1, 2, 13, 44, 45).
4) Yahweh depicted as the one who sanctifies (or separates) (20:8, 24, 26; 21:15, 23; 22:9, 16, 32), and who demands holiness (19:2; 20:7, 26; 21:6; 22:32). As W. Zimmerli shows ("'Heiligkeit'", 1980) the holiness consists in the first instance of Yahweh's delivering act of separation.

Within this editorial framework there appear to be ten or eleven textual units (the regulations about offerings in 22:17–33 could be separated from the rules about priests – see General Introduction: Content):

1. 17:1–16 – restrictions on slaughter, sacrifice and food
2. 18:1–30 – prohibited sexual relations
3. 19:1–37 – miscellaneous cultic and ethical requirements
4. 20:1–27 – penalties for various offences
5. 21:1–22:33 – rules concerning the priesthood/regula-tions about offerings
6. 23:1–44 – feasts and observances
7. 24:1–9 – the sanctuary light and the bread
8. 24:10–23 – blasphemy and various penalties
9. 25:1–55 – the sabbath year and the jubilee year
10. 26:1–46 – discourse – promises and warnings.

As will become clear the texts often exhibit signs of Holiness editing, or of supplementation from priestly sources.

Whether these ten texts (together with the Holiness editing) ever constituted an **independent** legal code is not easy to determine (see General Introduction). The working hypothesis that we have proposed is that the basic material came from priestly archives, was subject to the editing that gives the Holiness Code its distinctive features, and was subse-quently inserted into the priestly narrative tradition. A part of the Manual of Purity was also subject to the Holiness editing (most clearly in 11:44–45). This would also account for the other "H" material Milgrom has located outside the confines of 17:1–26:46, though he adopts a substantially different hypothesis about the Holiness School and its rela-tionship to the priestly writing (which we have identified as essentially the narrative tradition). We must also reckon in places with priestly editing, supplementary material added after the incorporation of the bulk of the Code into the priestly narrative. This distinction between the original mate-rial, the "preaching" of the Holiness editing, and the priestly supplementation is clearly depicted by W. Thiel ("Erwägungen", 1969).

It remains true nevertheless that the bulk of the Holiness editing is to be located in 17:1–26:46. This is not surprising, because it helps to bind together the shorter more miscellaneous collections in 17:1–25:55 and gives them a cohesion comparable to that of the Manuals of Offerings and Purity. It also helps to prepare the way for the climactic and definitive statement of theological perspective in 26:1–46. Evidence from 26:27–45 suggests strongly that this work was undertaken during the exile, and in that event the two Manuals are either in essence pre-exilic, or else exilic distillations of pre-exilic practice.

That we should think of a Holiness "school" seems very probable. A detailed study by A. Cholewinski (*Heiligkeitsgesetz,* 1976) has detected several stages in the redaction of the code, and whether or not the reconstruction is accepted the evidence of unevenness is substantial. Connections with Deuteronomy are also real; for Cholewinski the Holiness school is critically engaged with tendencies in Deuteronomy and the Josianic reform which it deemed destructive of ancient religious tradition. Further comparative work of a literary and theological nature is conducted by G. Bettenzoli ("Deuteronomium", 1984).

The relationship of the Holiness Code to Ezekiel 40–48 is also hard to determine (see General Introduction). Both appear to be closely parallel, but distinct, attempts to interpret the significance of priestly tradition in the light of historical experience and future expectation. Ezekiel has its roots in prophetic circles, and envisions a restored Temple and cult. In some respects it is conservative, anticipating a form of royal cult, and preserving the distinction between Zadokite and Levite priests; its commitment to a new future under God is real and sustained. The hopes and expectations of the Holiness Code are more restrained, though it remains confident that God will remember his covenant if the community is penitent and humbled (26:40–42), and makes the distinctive suggestion that the holy land, during the exile, is enjoying its sabbath rest (26:43).

1. RESTRICTIONS ON SLAUGHTER,
SACRIFICE AND FOOD
(17:1–16)

The first body of texts within the Holiness Code deals with
cultic matters relating to the slaughter of animals, sacrifice
and food. Some aspects of the content have already been
dealt with in earlier parts of Leviticus. There are three textual
units:

17:1–9 – restrictions on slaughter and sacrifice
17:10–14 – consumption of blood prohibited
17:15–16 – carcases and contamination.

Though this section lacks the more obvious features of the
Holiness editing, it nevertheless exhibits some of the charac-
teristics of the texts which now form the Holiness Code.
There is a more marked tendency for Yahweh to speak in the
first person (vv. 10, 11, 12, 14), and for explanations or moti-
vations to be offered (vv. 5, 7, 11–12, 14). In particular, the
section is angled towards the identification of offences and
the articulation of penalties (vv. 3–4, 8–9, 10, 14, 16), and it
has an explicit interest in the reform of non-Yahwistic reli-
gious practice (v. 7). The indication of penalties is essentially
of a piece with the kind of material we have identified as
judgements. Elements of law (familiar in the two Manuals)
are preserved in vv. 6, 13, 15.

There is a common interest within these three units which
justifies the suspicion that the section was in some form a
single text when it was taken up and adapted by the editors.
Background issues which were important to the Manual of
Offerings and the Manual of Purity continue to be important
here, particularly those concerned with blood and death.

The first section (vv. 1–9) insists that domestic animals, when
killed, must be offered to Yahweh at the tent of meeting (vv.
3–4). This is the case whether they are killed inside or outside
the camp. The stated aim is to ensure that sacrifices are
offered to Yahweh, and not to goat-demons ("satyrs" – *RSV*)
(vv. 5–7). Such sacrifices are to be well-being offerings (vv.

5–6). There is the further demand that offerings and sacrifices of all kinds must be brought to the tent of meeting and offered to Yahweh (vv. 8–9).

2. Moses is required to pass on the forthcoming information to the priests and to the people at large. The basic format of the verses is familiar enough, but the idea of laws to be passed on to both priests and people at the same time is new. Where Aaron is a recipient through Moses it is normally of information of special interest to priests (6:8–9, 24–25; 8:31; 9:2; 10:12; 16:2). There are also occasions when Aaron is addressed directly by God, alongside Moses, as recipient of special information (13:1; 14:33), and others when, with Moses, he is commissioned as communicator to the people (11:1–2; 15:1–2). Here Aaron and people appear to stand together as recipients of God's words through Moses. It would be unwise to read too much into this difference; the basic format associates these verses with the work of the book's editors, the priestly narrators.

This is confirmed by the particular phrase **This is what Yahweh has commanded**, a distinctive feature of the priestly narrative (8:5; 9:6; Exod. 16:32; 35:4).

3. It seems likely that the earliest element is a law stipulating that all slaughter of domestic animals be deemed sacred. This might be a practicality prior to the Josianic reform when there were local sanctuaries. If so there appears to be some relaxation of the law in Deut. 12:20–27. Priests might also have deemed it desirable and practicable in the circumstances which immediately ensue after the return from exile (J. R. Porter, *Leviticus*, 1976). Alternatively it is possible to suppose that **slaughters** here has a specifically sacrificial purpose in mind, and perhaps in particular the well-being offering (J. E. Hartley, *Leviticus*, 1992).

The phrase **house of Israel** does occur elsewhere in the priestly writing (cf. also vv. 8,10; 10:6; 22:18; Exod. 16:31; 40:38; Num. 20:29), but in all but two of these instances (10:6; Num. 20:29) there is strong textual witness in favour of "people of Israel". Here in v. 3 Gk and one Heb. ms. support "people". Gk has in addition a reference to aliens (as in v. 8).

The word **slaughters** is that customarily used in Leviticus to

denote the killing of all kinds of sacrificial offering (e.g. 1:5; 3:2; 4:4; 14:13).

The word **ox** is that used in 4:10; 9:4, 18 where it is associated with well-being offerings (cf. also 22:23, 27; Num. 15:11 where it is rendered **bull**).

The word **lamb** is associated with a variety of offerings (1:10; 3:7; 4:35; 22:19, 27; Num. 18:17). A variant spelling of this word is found in the priestly writing (e.g. 4:32; 12:6; 14:10; Num. 7:15; 29:2).

The **goat** has similar sacrificial connections (1:10; 3:12; 4:23, 28; 5:6; 22:19). The point is made very clearly that the same principles apply, whether the killing takes place inside or outside the camp.

4. The essential requirement is that when all such animals are killed they must be brought to **the entrance of the tent of meeting**, and presented as an **offering** to Yahweh. This general word is sometimes rendered "gift" by *RSV*, as here (1:10; Num. 6:14), and can also be used of offerings of silver (Num. 7:13), gold or jewellery (Num. 31:50).

Sam. and Gk have substantial additional material, indicating that the offering must be a burnt offering or well-being offering to Yahweh, and a "pleasing odour" (see vv. 6, 8).

The description of Yahweh's dwelling place as **tabernacle** occurs infrequently in Leviticus (8:10; 15:31; 26:11), though it is very common in the priestly narrative (thus 8:10 and cf. e.g. Exod. 25:9; 40:38; Num. 1:50; 31:47). In 26:11 the word is used somewhat differently (see 26:11), while the reference in 15:31 is easily an editorial addition. The same could easily be the case here in 17:4; the reference to the **tabernacle** is not strictly necessary, but it does help to clarify what is required from the perspectives of the priestly narrative.

The phrase **guilty of bloodshed** is derived from the verb "to think" or "to account" (BDB), with the sense that blood is "imputed to" the person. It has already occurred in 7:18 where it is rendered "credited". The word also occurs in Num. 18:27, 30 as "reckoned" (cf. Ps. 106:31; Prov. 27:14). The point seems to be that failure to offer the animal to Yahweh is to be thought of in the same terms as the shedding of human blood (Gen. 9:6) – **he has shed blood**.

The penalty, that the man must be **cut off from the people**, is familiar in priestly laws (see the discussion on 7:20). Though the death penalty cannot be ruled out (thus BDB) some kind of exclusion from the community seems more probable ("outlawed" – *NJB*). A plausible view is that adopted by J. Milgrom who sees this kind of penalty as one which God himself will inflict (*Leviticus 1–16*, 1991, pp. 457–460). The offence is against God and will be dealt with by him; there is no intention that a legal execution should take place. It may involve an early death, no descendants, or no after-life (see Milgrom).

5. Here the kernel of vv. 3–4 is interpreted. The words **outside the camp** (v. 3) are further enforced; the focus is clearly on that which **they offer in the open field** (literally "upon the face of the field"). It is also clear that such slaughter has sacral significance; the word rendered **sacrifices** is the one which contributes to the word **well-being offering** (see the discussion in Lev. 3:1–17). If we were to adopt the view that the "sacrifice" and the "peace" were originally independent rites, the former essentially a private family occasion and the latter a sanctuary rite under priestly supervision, this text constitutes evidence of the process by which the two were brought together as the **well-being offering**. In any event there is a clear concern that all sacrifice be brought under the control of the sanctuary, and an insistence that all slaughter in the open field intended as sacrifice should be a **well-being offering**. The text must be assuming that the slaughter under discussion is of animals appropriate for sacrifice (i.e. domestic animals of the kind cited in v. 3). It would be incorrect to maintain, as with earlier source critics, that this text necessarily presupposes the **centralization** of worship; it does provide evidence of worship becoming subject to priestly supervision and control.

6. Two key features of the **well-being offering** rites are cited here – the manipulation of the blood, and the burning of the fat. *RSV*'s "sprinkle" is the same word as *RSV*'s "throw" in 3:2; *NRSV* is consistent in producing **dash**.

The text does seem to imply that the blood is to be dashed

"on" the altar, not round about (3:2); it is hard to say how important the difference may be.

The burning of the fat as a **pleasing odour** also corresponds with the essential elements in 3:3–5.

In general vv. 5–6 seem to represent the viewpoint of the Manual of Offerings; vv. 7–8 (see below) bring the burnt offering within the scope of this legislation.

7. The ostensible motive for priestly control over the "sacrifice" is made clear. Steps must be taken to ensure that no more sacrifices are offered to alien deities or beings. The rare word **goat-demons** ("satyr" – *RSV*, "demon" – BDB; "demons" – *REB*; "goat idols" – *NIV*) occurs in Isa. 13:21, 34:14 as a denizen of deserted places, and is hardly distinguishable from the wild creatures. Goats may have had some special association with these demons or deities (cf. Azazel in 16:8) (see D. P. Wright (*The Disposal of Impurity*, 1987, pp. 21–30)). Connotations of apostasy seem to be present in 2 Chr. 11:15, and possibly also in 2 Kgs 23:8 where *NRSV*, following MT reads **gates** (the Heb. could be pointed to read **satyrs**).

The phrase **to whom they prostitute themselves** is a feature of the Holiness editing in these chapters. It is used in 20:5 of apostasy (to Molech), and in 20:6 in relation to **mediums and wizards** (cf. Num. 15:39 – a passage sometimes associated with the Holiness Code). This figurative use of "harlotry" is also a feature of literature often deemed Deuteronomistic (Exod. 34:15–16; Deut. 31:16; Jdg. 2:17; 8:27, 33) (cf. also Ezek. 6:9; 16:15, 16, 17, 41; 20:30; 23:3, 19). The idea has some currency in earlier prophets, and might originate with Hosea (1:2; 2:5; 4:12, 15; 9:1; cf. also Isa. 57:3; Jer. 2:20; 3:1; 5:7). Literal meanings are widespread, and occur in the Holiness Code in 19:29; 21:7, 9, 14.

On the phrase **statute forever** see on 16:34, and for **generations** cf. 3:17; 7:36; 10:9.

8. The concluding verses reaffirm the points that all sacrifices must be offered (Heb. – "made") to Yahweh and at the tent of meeting (vv. 3–4).

An additional point is that the same principles apply to **aliens** (see on 16:29).

A further additional point is that the obligations discussed

include the **burnt offering** as well as the "sacrifice" or **well-being offering**.

9. The point that offenders will be **cut off** (cf. v. 4) is repeated. *REB* reads the form of the expression as **cut off from his father's kin**.

Taking the passage as a whole the following editorial structure is feasible:

1) The legal core in parts of vv. 3–4.
2) The Holiness editing in vv. 5–7.
3) The priestly editing in vv. 1–2, parts of vv. 3, 4, vv. 8–9.

In vv. 10–14 there are stringent prohibitions regarding the consumption of blood. Natives and aliens alike will be **cut off** if they ignore these prohibitions (vv. 10, 12). Whereas vv. 1–9 deal with the slaughter of domestic animals, here in v. 13 the case of clean creatures killed for food during hunting is raised. The blood must be poured out, presumably in the open field (v. 5), and covered with dust. Explanations are offered in vv. 11, 14, to the effect that life is in the blood, and that the blood is given to make atonement. The importance of the blood prohibition has already been raised in relation to both the Manual of Offerings and the Manual of Purity. The issue has been discussed in 7:26–27.

10. On the phrase **house of Israel** see v. 3, and on **aliens who reside** see v. 8. Yahweh's words, expressed in the first person singular, are a good indication of Holiness editing, for which the blood prohibition, cast in terms of "eating", is clearly of cardinal importance.

The expression **I will set my face against** occurs also in 20:3 (worship of Molech), 20:6 (in relation to **mediums and wizards**) and 26:17 (cf. Ezek. 14:8; 15:7). On being **cut off from the people** see v. 4.

11. The explanatory words here are clearly crucial to an understanding of the priestly system of sacrifice and atonement, but there are significant problems for translators in the syntax and the language (examined in detail by J. E. Hartley (*Leviticus*, 1992)). The following explanation interprets the text of the *NRSV*.

The blood is the animating life force (the **nephesh**) within the flesh, and by implication must be honoured and respected as the divine principle within all living creatures (cf. Gen. 9:4). This perception is not peculiar to the priestly writing – see Deut. 12:23 ("for the blood is the life"; see also Jer. 2:34 for an association of blood and **nephesh**). The flesh may be eaten, permission granted in the wake of the flood (Gen. 9:3), but the life (the blood) signifies the divine principle in a special way, and cannot be exploited to serve human ends.

The blood is also marked out as sacred by virtue of its function within the sacrificial system. It is that which effects **atonement** upon the altar **for your lives**. The word **for** might denote "in place of", suggesting a substitutionary element (B. A. Levine, *Leviticus*, 1989), or "on behalf of" (J. Milgrom, "Sin-Offering", 1971). In either event it would seem desirable to read **atonement** as "ransom" rather than "purification" (thus also H. Brichto, "On Slaughter", 1976; B. J. Schwartz, "The Prohibitions", 1991). "Purification", it may be argued, serves better to denote what is accomplished in sin offerings where the sanctuary and items within it seem to be the primary or only objects of atonement. On the other hand, as N. Zohar ("Repentance", 1988) proposes (see the introductory discussion of Lev. 4:1–35), it is not impossible to see people as the objects of purification. In that event the blood on the altar might be understood to make purification **upon** your lives (not **for**), just as it does upon sacred objects (cf. e.g. Lev. 16:16). The basic point, however, is inescapable. The blood is sacrosanct, and therefore unavailable for human use, because of its crucial functions within the cult.

B. J. Schwartz ("The Prohibitions", 1991) makes the suggestion that, taking priestly writings as a whole, there are several quite distinctive features within these verses, among them the allusion to "eating" blood, and the idea that **given** means "placed" on the altar by God. Such features, if acknowledged, can readily be attributed to earlier priestly views or to distinctive perceptions within the Holiness school.

It is precisely because the blood embodies **nephesh** (the animating life force) that it is able to purify or ransom

nephesh (the lives of individuals and the community as a whole). The role of the blood as the purifying or ransoming agent is quite clear here, and it is its life-embodying power that makes it uniquely effective in this respect.

12. Here Yahweh reaffirms the basic prohibition, and repeats his insistence that it is applicable to **aliens** as well as to native Israelites.

13. The blood prohibition is applied to other creatures (i.e. non-domestic animals) which may be killed for food. Some of these are listed in Deut. 14:5.

The root "to hunt" occurs only here in the priestly corpus; a figurative use is found in Ezek. 13:18, 20, 21.

The requirement to **pour out its blood** is established in Deut. 12:16, 24; 15:23 ("like water"). In both instances this rite recognizes the significance of the blood, while acknowledging the impracticality of insisting that all such slaughter should involve the tent of meeting. The word used (**pour out**) ("drain out" – *REB*; *NIV*) is actually that used for the blood that is "poured out" at the base of the altar in the sin offering (4:7, 18, 25, 30, 34; Exod. 29:12). Its use here agrees with that in Deut. 12:16, 24; 15:23, and is one indicator of affinities between the Holiness Code and Deuteronomy.

The requirement that the blood be covered with **earth** is not found in Deuteronomic texts, but is a feature of Ezek. 24:7. The action presumably protects the blood from any subsequent defilement.

14. Despite the paragraphing in *NRSV* this verse is best read along with vv. 10–13. It reiterates, and may offer further explanation, of the key principles set out in vv. 10–13, namely the blood prohibition, and the pronouncement that offenders will be **cut off**.

The Heb. text at the beginning of the verse poses some problems, and English translations tend to follow Gk. In effect, this says nothing new, namely that the blood is the life principle in every creature. The Heb. reads "for the life of all flesh, its blood is in its life" or "for the life of all flesh is in its blood, it is in its life". Gk omits the second "life". The text as it stands is obviously awkward and unclear, but it may be wishing to make the point that not only is the life principle in

the blood (already established in v. 11), but also that it is wholly so – i.e. the blood is the **sole** constituent of the life principle (the life is the blood, the blood is the life).

Here again it is possible to propose an editorial structure for the passage:

1) The core in v. 13, a new stipulation requiring that the blood of animals killed in hunting be poured out, and covered with dust.
2) The Holiness editing in vv. 10–12, 14, characterized by Yahweh's speech in the first person singular, a reaffirmation of the crucial blood prohibition, and explanations about its importance.

J. Milgrom ("Sin-Offering", 1971) is right to stress an anxiety about the exercise of uncontrolled human power over the animal world; these rites both limit the power and deal with the anxiety. The function of sacrifice as a channelling of these concerns is discussed in the General Introduction: Sacrifice.

The concluding verses in this section deal with carcases and contamination. They insist that anyone, native or alien, who eats from the carcase of an animal (presumably any creature) must observe the familiar washing procedures (of clothes and body), and wait until the evening when the purification process will be complete (v. 15). Failure to comply means that offenders will **bear their guilt** (v. 16).

15. The essential principles set out here have been well established earlier in the book. In the Manual of Purity the fact that contact with a carcase is contaminating is made clear in 11:24–25, 27–28, 39, and the possibility that such flesh might be eaten is raised in 11:40. The further points made here are that this is applicable whether the animal has died naturally or violently, and that both **a citizen or an alien** must observe the rites of purification.

A further rule, preserved in the Manual of Offerings (7:24), is that the fat of such animals must not be eaten (cf. also 5:2 where the uncleanness which ensues from contact is

clear). The same expressions **dies of itself** (the word is "carcase" or "corpse" – BDB) and **torn by beasts** are employed (cf. 7:24; 11:39, 40; 22:8; Deut. 14:21; Ezek. 4:14; 44:31). Furthermore, should the animal be one of those suitable for offerings, then an offender would be **cut off** (7:25).

The washing procedures and the waiting are also familiar in the Manual of Purity, covering a wide variety of states and conditions (13:6, 34, 54; 14:8, 9; 15:5, 6, 7, 8, 10, 11, 13, 18, 21, 22, 23, 27). The bathing of the body is not mentioned in the parallel passage in 11:40, though it may be implied.

16. Those who neglect the purification rites will **bear their guilt** (v. 16) (see on 5:1) – i.e. they must be held responsible for their failure and can expect God to act against them in some undefined way.

The content of the verses (vv. 15–16) suggests that they are drawn from an independent collection of priestly rules (independent from those that make up the Manual of Purity). There is no obvious indication that Holiness editing has sought to develop or explain them, though it is feasible that the incorporation of the alien belongs to some stage in the editorial processes.

2. PROHIBITED SEXUAL RELATIONS
(18:1–30)

The second section within the Holiness Code deals primarily with sexual relations and matters of kinship. Four textual units can be distinguished:

18:1–5 – exhortation calling for loyalty to Yahweh's laws
18:6–18 – sexual prohibitions and the family
18:19–23 – other sexual prohibitions
18:24–30 – exhortation calling for loyalty to Yahweh's laws.

The presence of Holiness editing is very marked in this section, particularly in the two exhortations which surround the prohibitions. There is a reminder of life in Egypt (v. 2), and anticipation of life in Canaan (vv. 3, 24, 25, 28). There is an overriding insistence on loyalty to Yahweh's laws,

characteristically described here as **ordinances and statutes** (vv. 3, 4, 5) or **my charge** (v. 30). Yahweh frequently identifies himself (vv. 4, 5, 6, 30), and speaks in the first person singular (vv. 3, 24, 25, 30).

Embedded within these editorial exhortations are the laws, framed as categorical or apodictic prohibitions. The hearers are addressed in the second person singular in all the laws of vv. 7–23, and this doubtless demarcates the text taken up by the Holiness editors. Their preferred form of address is the second person plural which is consistently used in the exhortations of vv. 1–5, 24–30, and in v. 6 which constitutes the editors' introduction to the forthcoming prohibitions. A detailed view of the redaction of the chapter, and of the social background to these laws is provided by S. F. Bigger ("The Family Laws", 1979).

Most of the prohibitions concern relationships considered incestuous (vv. 6–18). It is surprising at first sight that a daughter is absent from the list. Some have thought the omission accidental (J. R. Porter, *Leviticus*, 1976), but it can be explained by the belief that the daughter's biological function belongs already to the father (J. R. Wegner, "Leviticus", 1992). This does not mean that incest with daughters was practised. The point is simply that sexual activity involved the appropriation of another man's property; to cite the daughter in such a context was unnecessary.

There are several examples of incest in biblical narrative (Gen. 19:30–38; 35:22; 49:4; 2 Sam. 13:1–14). Abhorrence of the practice is clearly expressed in Ezek. 22:10–11. As C. R. Taber points out (*IDB*:Supp.Vol., p. 819) the basis of the list about incest is social rather than genetic (e.g. wives of kin are prohibited, but not a first cousin); an explanation he favours is that competition between related men for the same woman would disrupt the stability and well-being of the extended family. J. R. Porter (*Leviticus*, 1976) also stresses social peace and harmony as the prime motive. B. A. Levine (*Leviticus*, 1989, p. 254), while recognizing "natural" feelings against incest, points out that the marriages prohibited are those which would threaten patrilineage; the family's future as a socio-economic unit was at risk if inbreeding was too close.

Penalties for incest are not specified in the laws, though a curse is pronounced in Deut. 27:20, 22–23).

The remaining prohibitions in the chapter are of a more varied kind (vv. 19–23), and include an isolated command forbidding the offering of children to Molech (v. 21). The sexual practices forbidden relate to sex during menstruation (v. 19, cf. 15:24), adultery (v. 20), homosexuality (v. 22) and bestiality (v. 23). Adultery is condemned in the Decalogue (cf. Exod. 20:14; Deut. 5:18), and in 20:10; Deut. 22:22–24 the death penalty is prescribed. The seriousness of the offence lies in the infringement of the husband's rights. The wife is his property, and the children she bears must be his. A rite intended to determine whether a woman has committed adultery or not is described in Num. 5:11–31. It seems then the laws emerge from preconceptions about the security and well-being of the social group, and the subordination of women.

Bestiality and homosexuality carry the death penalty in 20:13, 15–16; Exod. 22:19; Deut. 27:21, and homosexual practice is described in biblical narrative (Gen. 19:5; Jdg. 19:22–25), though in both instances abuse of hospitality is at least part of what is at stake. There is evidence that these practices were not taboos in other religious cultures (n.b. e.g. the male prostitutes in 1 Kgs 14:24). It seems likely nevertheless that for Israel the prohibitions are not simply reactive; there were after all many aspects of culture and religious practice which Israel readily shared with her neighbours. It seems clear that for Israel a sense of order is profoundly disturbed. The differentiation of entities and an awareness of boundaries is vital to both accounts of creation (Gen. 1:1–2:25), and as the Manual of Purity makes clear the pollution system as a whole is based on this sense of each entity in its proper place. It is in the breaking of the boundaries that pollution occurs, and there is little doubt that in these cases (man/beast or man/man) (lesbianism is not an issue) the boundaries are infringed. The laws in Lev. 19:17, 19; Deut. 22:5, 9–11 exhibit the same kind of abhorrence of what are felt to be unnatural mixtures. A further factor of some significance is the matter of wasted semen (cf. N. Gottwald, *The Hebrew Bible*, 1985, p.

477). The social importance of the seed-bearing fluid is
evident in a different context in the story of Onan. (Gen.
38:1–11). The future security of the family (and the tribe and
nation) resides within it; to waste it is to risk that future. It
seems quite possible that the prohibition of sex during
menstruation arises from the belief that conception would
not occur at such a time. Such taboos are therefore likely in
cultures which, for one reason or another, felt themselves
threatened.

One further factor which must be thoroughly understood
if these laws are to be appreciated is that the family was the
fundamental network of social and economic security. The
need for wider provision is recognized in those laws which
seek to protect and provide for the poor (e.g. Deut. 15:1–3;
23:19–20; 24:10–21). Laws in the Holiness Code seek to deal
with poverty by strengthening the rights of the person in the
context of family and tribal rights (25:10, 25–28, 35–41).

In vv. 1–5 there are exhortations introducing the Code's laws
on sexual relationships and kinship. They insist that Israel's
practice must be clearly differentiated from custom in Egypt
and Canaan (v. 3). An obedient commitment to Yahweh's
laws is the source of life (v. 5).

1. Yahweh repeatedly identifies himself as Israel's God (cf.
4, 5).

3. He declares his intention to bring the people into the
land of Canaan. This orientation towards the land is strong in
the Holiness editing (vv. 24; 19:9, 23–25, 33; 20:22; 23:22;
25:2, 9, 18, 38; 26:34–39, 43).

B. A. Levine (*Leviticus*, 1989) notes that there is some
evidence for homosexuality and bestiality in Canaanite
culture, but not for incest. These introductory exhortations
embody the preoccupations of the editors.

4. The words used to describe the distinctive practice of
Yahwism are **statutes** and **ordinances** (cf. v. 5), and to obey is
to **follow**, **observe** or **keep** them. Egypt too has its **statutes** (v.
3). The use of these words in close combinations is a distinc-
tive feature of the Holiness editing, and is one of its key
affinities with Deuteronomy.

The word **statute** ("something prescribed" – BDB) in its feminine form, as here, has already occurred in 3:17; 7:36; 10:9; 16:29, 31, 34; 17:7 (the masculine occurs in 6:18, 22; 7:34; 10:11, 15). The only previous use of the plural, however, is in 10:11. In the Holiness Code the plural recurs in vv. 26; 19:19, 37; 20:8, 22; 25:18; 26:3, 15, 43, 46, and in vv. 26; 19:37; 20:22; 25:18; 26:15, 43, 46 in combination with **ordinances** (with **commandments** in 26:3 and **laws** in 26:46). Originally it denotes "the recording and promulgation of the law" (B. A. Levine, *Leviticus*, 1989).

This linking of **statutes** and **ordinances** (so that they are in effect synonymous) is evident in Deuteronomy (4:1, 5, 8, 14, 45; 5:1, 31; 6:1, 20; 7:11; 11:32; 12:1; 26:16, 17), though the masculine plural of "statute" is employed in these instances. A feminine does, however, occur in 11:1 in association with "ordinance"; a more frequent linkage of the feminine in Deuteronomy is with **commandments** (Deut. 6:2; 28:15; 30:10, 16), a linkage also made in a number of instances with the masculine plural (Deut. 4:40; 5:31; 6:1; 7:11; 26:17; 27:10).

The word **ordinances** ("judgement" – BDB) has already been used in its singular form in 5:10; 9:16 (cf. also 24:22; Num. 9:14; 15:16, 24; 29:6, 18, 21, 24, 27, 30, 33, 37). The plural, denoting God's laws, occurs here for the first time, but continues to feature prominently in the Holiness Code (vv. 26; 19:15, 35, 37; 20:22; 25:18; 26:15, 43, 46), and, as already observed, in Deuteronomy. Its first point of reference are the norms "that govern the judicial process" (B. A. Levine, *Leviticus*, 1989).

The use of the verb "to walk" (**follow** – *NRSV*) with reference to the observance of laws (cf. v. 3; cf. also 26:3) is familiar in Deuteronomy (e.g. 8:6; 10:12; 11:22; 28:9), and particularly in Ezekiel in connection with ordinances and statutes (Ezek. 5:6, 7; 11:20; 18:9, 17; 20:13, 16, 19, 21).

The same can be said in general terms of the verb "to keep" (cf. v. 5; cf. also 26:3) (e.g. Deut. 4:6; 5:1, 10, 29; 7:12; 29:8; Ezek. 11:20; 17:14; 20:18). It also has special connections with observance of the sabbath (19:3, 30; 26:2; Exod. 31:13, 14, 16; Deut. 5:12).

These verses are uniform in style, and constitute the Holiness editing which introduces the list of prohibitions in vv. 6–18.

In vv. 6–18 there is a list of family relationships within which marriage or sexual intercourse is forbidden. The person addressed is the man (in the second person singular); the women with whom he must not relate are specified. No penalties are prescribed (but see 20:19–21).

6. This is an introduction to the list from the Holiness editor. The second person plural is used to address the hearers, and the familiar self-designation **I am Yahweh** indicates the real speaker.

The phrase **near of kin** (vv. 6, 12, 13, 17) is used elsewhere in the Holiness Code of blood relations (20:19; 21:2; 25:49) and also in Num. 27:11.

The phrase **uncover nakedness** (cf. Deut. 22:30 and the discussion by A. Phillips ("Uncovering the Father's Skirt", 1980)) is a euphemism for sexual relations. It would appear that "to see" "nakedness" has the same meaning (20:17), though it may also indicate the witnessing of such acts (Gen. 9:22, 23). The noun is often accompanied by some sense of shame (Gen. 9:22, 23; Isa. 47:3; Ezek. 16:37; Hos. 2:9).

The list taken up by the editor contains twelve prohibited relationships: mother (v. 7); stepmother (v. 8); sister (v. 9); granddaughter (v. 10); half-sister (v. 11); aunt through father (v. 12); aunt through mother (v. 13); uncle's wife (v. 14); daughter-in-law (v. 15); sister-in-law (v. 16); two closely-related women (v. 17); the sister of a wife (v. 18).

There is no clearly explicit explanation for the prohibitions, but at various points there are hints as to what motivates them.

7–8. The first two cite **father** as well as **mother** (v. 7) or mother-in-law (v. 8). A relationship with a parent strikes at the heart of the order and stability of the family network. It seems very probable that the preoccupation with order (each in its own place), which underlies the Manual of Purity, is also operative here. The family network, as the fundamental social unit, has boundaries which must not be transgressed.

9. The prohibition makes it clear that this network is real and operative, irrespective of place and circumstance of birth; the sister **born abroad** (literally "outside": "elsewhere" – *NJB*: "in another home" – *REB*) has the same status as one **born at home**.

10. The question of boundaries is evident again (cf. v. 16). Relations with a granddaughter would be a confusion of entities (it is **your own nakedness**) (*REB* understands it to mean "to bring shame upon yourself"; *NIV* –"dishonour"; *GNB* – "disgrace"), suggesting that the point in v. 8 is not simply a matter of a father's property rights, but again a confusion of role and status, and a transgression of boundaries. The same point is suggested in relation to a sister-in-law (v. 16); she is **your brother's nakedness**. The integrity of role and status within the family network is preserved by these taboos of abstinence.

11–17. The **sister**, the **aunt**, and other closely-related women (**father's flesh** or **mother's flesh**) (vv. 12, 13, 17) are identified, and their place within the family network acknowledged. This in turn strengthens and stabilizes the network, and the social system in general.

In v. 17 there appears to be confirmation of this interpretation. The identity and integrity of other family networks must be maintained; to take two closely-related women from another family would introduce confusions which threaten the sense of place in the scheme of things. This particular action is described as **depravity** (*REB* – "lewdness"; *NJB, GNB* – "incest"), a word which often has the sense of "plans" or "devices", possibly with neutral connotations (Job 17:11), but usually in a strongly negative sense (cf. e.g. 19:29; 20:14; Jdg. 20:6; Ps. 119:150; Prov. 24:9; Isa. 32:7; Ezek. 16:58; 23:48, 49).

As M. Noth (*Leviticus*, 1962/1965) observes, there is no contradiction between v. 16 and the principle of Levirate marriage (Deut. 25:5–10), which presupposes the death of the brother.

18. The likelihood that there were pragmatic factors in this ordering process is suggested here. Any action that engendered rivalries was deemed dangerous to the stability and well-being of the family network. Problems of rivalry within

family contexts are attested in a number of narratives (e.g. Gen. 16:4–6; 30:31–35; 1 Sam. 1:6). *NJB*'s "harem" does not fully express the element of rivalry in the Hebrew. A. Tosato ("The Law of Leviticus 18:18", 1984) has suggested that the law is concerned, not with incest, but with polygamy and divorce, the interpretation given it at Qumran.

The possibility that economic factors were at stake in this preoccupation with the identity and integrity of the family network is also worth serious consideration. In a context in which women were of monetary value to a family, and in which virginity was esteemed and doubtless enhanced the value (cf. e.g. Deut. 22:13–21, 28–29), some at least of the relationships prohibited here might well reduce a family's assets and threaten its economic well-being.

It seems clear that this set of second person singular prohibitions has been taken up by the Holiness editor from priestly sources, and given a brief introduction (v. 6).

In vv. 19–23 there are five further prohibitions. Four deal with sexual relations (as in vv. 6–18), while the other considers child sacrifice in relation to the worship of Molech (v. 21).

This list, like that in vv. 7–18, is framed in the second person singular.

19. The first prohibition forbids sexual relations during menstruation, an issue addressed in the Manual of Purity (15:24). That text does not exactly prohibit such relations, but makes it clear that a condition of uncleanness will ensue. Here in v. 19 the context (adultery (v. 20) and apostasy (v. 21)) suggests that sex during menstruation could be viewed as a serious offence, and later in the Holiness Code (20:18) the **cut off** penalty is pronounced.

20. The second prohibition forbids adultery. *RSV* and *NIV* take **kinsman's wife** to be "neighbour". This word ("associate", "fellow", "relation" – BDB) is common in Leviticus (6:2), and especially in the Holiness Code (19:11, 15, 17; 24:19; 25:14, 15, 17). Elsewhere it is found only in Zech. 13:7. It is sometimes rendered simply as **one another** (19:11; 25:17) (*REB* reads "fellow-countryman", *GNB* – "another man").

The phrase **have sexual relations** links the noun "copulation" with the verb "to give" (as also in v. 23; 20:15; Num. 5:20), and also includes the word "seed" or "semen" (in 19:20 "copulation" and "seed" are linked).

The concluding comment that this will **defile** (i.e. "make you unclean") shows how the Holiness Code has incorporated adultery into the priestly system of thought.

21. The prohibition about child sacrifice may seem out of place in this series on sexual relations. There are, however, clear verbal connections in Hebrew between v. 21 and v. 20. The phrase **give any of your offspring** picks up the words "to give" and "seed" in v. 20. To give seed **to Molech** is as serious as to give seed in an adulterous relationship.

The phrase **to sacrifice them** ("to devote them by fire" – *RSV*; "to be used in the worship of" – *GNB*) is a rendering of the causative form of the verb "to pass over/through" (Gk reads simply "to serve Molech", *REB* – "surrender"), and it is often assumed that children offered to Molech are being caused to pass through fire. The justification for this assumption is to be found in 2 Kgs 23:10. There is other testimony to the sacrificial "passing through fire" of children in Deut. 18:10; 2 Kgs 16:3; 17:17; 21:6; Ezek. 20:31. N. H. Snaith (*Leviticus and Numbers*, 1966) pointed out that the Hebrew here has nothing to say about "burning" or "fire"; he thought that the children would be passed between two large fires, and thus be devoted to the deity, perhaps as temple prostitutes. J. Day (*Molech*, 1989), by contrast, sees no reason for doubting that sacrifice and death were involved. Other texts which attack the offering of children to other deities are Jer. 32:35 (with reference to Molech); Ezek. 16:21; 20:26; 23:37.

According to 1 Kgs 11:7 **Molech** was an Ammonite deity, for whom Solomon built a sanctuary to the east of Jerusalem, though the Hinnom Valley (2 Kgs 23:10; Jer. 32:35), which had later associations with this deity, was to the south-west of the city. The consonants in the name are those for "king", and the vowels those for "shame", which has suggested to some that **Molech** is a deliberate recasting of the name. The word is probably therefore a title ("king") for the Ammonite god (not a proper name), and may well be reflected in Amos

1:15. A god with the name or title "Muluk" has been identi-
fied among the Mari tablets from north-west Mesopotamia (J.
Gray, *IDB*:III, pp. 422–423). An alternative form of the title is
Milcom in 1 Kgs 11:5, 33; Jer. 49:1, 3; Zeph. 1:5. Jephthah
appears to identify the national god of the Ammonites as
"Chemosh" (Jdg. 11:24), who also clearly has connections
with Moab (1 Kgs 11:7). Gray concludes that "Chemosh"
(Moab) and "Milcom" (Ammon) are local titles of a god
whose proper name was Athtar, and who was probably an
astral deity. The suggestion has been made (O. Eissfeldt, *The
OT: An Introduction*, 1965, p. 70 n.1 for references) that **to
Molech** actually means "as a votive offering", but this is based
on relatively late Punic inscriptions (G. C. Heider, *The Cult of
Molek*, 1985; J. Day, *Molech*, 1989). Both Heider and Day point
to evidence of a deity bearing the name, and to be associated
with a cult of the dead. Heider suspects, with Eissfeldt, that
the cult was licit in Israel until Josiah's time. The Josianic
reformation destroyed the cults of the Hinnom Valley (2 Kgs
23:10), and also those to the east of Jerusalem (2 Kgs 23:13),
but the perils they posed are sufficiently recent to concern
the Holiness editors, as here in v. 21 and in 20:2.

To sacrifice children to Molech would be to **profane the
name of your God**. This idea that the name of God can be
profaned (i.e. "polluted") is common in the Holiness Code
(19:12; 20:3; 21:6; 22:2, 32). It is also familiar in Ezekiel
(20:39; 36:20–23), and in other prophets (Jer. 34:16; Amos
2:7; Mal. 1:12). These texts, taken together, make it clear that
a wide range of social and cultic infringements of the divine
will constitute profanation of the divine name.

22. The fourth prohibition precludes sexual relations
between men. The sensitivity to difference and the fear of
confusion (each in its proper place), along with anxiety
about wasted semen, are probably major factors here.

Such acts are described here as an **abomination** (cf. also
20:13) (*NJB* – "hateful thing"). This is a quite different word
from that used extensively in the Manual of Purity (11:10–13,
20, 23, 41, 42). It appears to be a feature of the Holiness
editing (vv. 22, 26, 27, 29), and is extremely common in
Ezekiel (e.g. 5:9, 11; 6:9, 11; 7:3, 4, 8, 9, 20; 8:6, 9, 13, 15, 17;

9:4; 11:18, 21; 12:16), and to a lesser extent in Deuteronomy (e.g. 7:25, 26; 12:31; 13:14; 17:1, 4; 18:9, 12; 20:18). In Deut. 14:3, in contrast to the Manual of Purity, it is used of prohibited food. The word is also well known to the wisdom tradition (e.g. Prov. 3:32; 6:16; 8:7; 11:1, 20, 22; 13:19; 15:8, 9, 26; 16:5, 12; 17:15), where it generally has some kind of ethical content (e.g. 6:16–19). It often refers to religious or social praxis which is alien to a particular group (cf. e.g. Gen. 43:32; 46:34; Exod. 8:26), and is therefore popular in Deuteronomy and Ezekiel as a means for condemning the religious practice of other peoples. This is probably a significant part of what the Holiness editor has in mind here. It is worth observing that the use of this text as an argument against homosexual relations today would necessitate, in the interests of hermeneutical consistency, a similar attitude to the issues raised in e.g. Deut. 14:3–8; 22:5 where **abomination** is also identified.

23. Here **animal** is the word used in 1:2 and rendered **livestock** by *NRSV* (cf. also Gen. 1:24), though as 11:2 makes clear the term can be used of any four-legged animal. For a man to engage in such activity would be to **defile yourself with it**, to render yourself unclean. Though this sounds comparable to the conditions discussed in the Manual of Purity it merits death (20:15).

The expression used in relation to a woman reads literally "to stand before a beast to lie down". The use of "lie down" for copulation occurs in 19:19 and 20:16 (the death penalty), but the use of the verb "to stand" is peculiar ("submit herself to intercourse with" – *REB*).

The action of a woman with a beast is also described as **perversion**. This is the word translated by *RSV* as "incest" in 20:12. It has connections with the verb "to mingle" or "to mix", and in sacrificial terminology has an entirely positive connotation (cf. e.g. 2:4; 14:10, 21; 23:13. Here it clearly embodies the confusions and violations of order which priestly theology fears (*REB/NJB* – "a violation of nature"). A wide-ranging consideration of forbidden mixtures as a threat to cosmic order is provided by C. Houtman ("Another Look", 1984).

Evidence for bestiality in other ancient near eastern cultures is set out by J. E. Hartley (*Leviticus*, 1992).

In summary, the Holiness editor has taken up a series of five prohibitions from priestly sources. His own influence is evident in Yahweh's self-identification (v. 21), and perhaps also in the declaratory pronouncements about **abomination** and **perversion** (vv. 22, 23).

The last part of this section (vv. 24–30), like the first (vv. 1–5), contains exhortations by the Holiness editor. This is indicated by the return to the second person plural mode of address, and by familiar words and phrases. The verses are primarily a warning against the practice of Canaanite **abominations**. These not only **defile**; they will lead to expulsion from the land (vv. 25, 28).

24. The concept **defile yourselves** embodies the familiar notion of **uncleanness** (see on 10:10). All the actions described and prohibited in vv. 6–23 render people unclean. The universalizing tendency in the Holiness editing is very clear in the idea that the peoples of Canaan also became unclean in doing these things. The stress in this priestly pattern of thought is that Israel's occupation of the land is not so much, as in Deuteronomy, a gracious gift, or a fulfilment of a promise to the ancestors, but the result of Yahweh's revulsion at the habits and praxis of the Canaanites.

25. This line of thought is pursued in a typically priestly mode. Canaanite defilement is transmitted to the land (v. 25), which in turn is **punished** (or "visited") by God for its **iniquity** (see on 5:1). The outcome is that the land **vomited out** the Canaanites. This expression recurs in v. 28 and again in 20:22 (cf. Job 20:15; Prov. 23:8; 25:16; Jonah 2:10).

26. The reference to **statutes and ordinances** (v. 26) recalls the motifs of vv. 3–5, and **abominations** recalls v. 22, though all the practices prohibited in vv. 6–23 are clearly interpreted as such. Both **citizen** and **alien** (see 16:29) are required to obey.

27. That these **abominations** were common among the Canaanites, that the land became **defiled**, and that even Israel might be **vomited out** are points which are reiterated (cf. also v. 28; cf. vv. 24–25).

29. Particular persons who commit the **abominations** can expect to be **cut off** (see on 17:4).

30. Here another term for obedience to Yahweh's laws is employed – **keep my charge** (*NJB* – "rules"). The root for the word **charge** is the same as that for the verb **keep**. It can even be used of a "guard" or place of imprisonment (2 Sam. 20:3), but in connection with Yahweh's commands it is found in D (Deut. 11:1) and in Deuteronomistic texts (Gen. 26:5; Josh. 22:3; 1 Kgs 2:3). It occurs in Mal. 3:14, and elsewhere in the priestly writing in Num. 9:19, 23.

The word **abominations** includes the word frequently translated as **statutes** elsewhere in the chapter – "abominable statutes".

There is every indication that vv. 24–30 are entirely the work of the Holiness editor, providing, along with vv. 1–5, a framework for the prohibition collections in vv. 6–23. The section ends with the familiar self–identification by Yahweh.

3. MISCELLANEOUS CULTIC AND ETHICAL REQUIREMENTS (19:1–37)

The third section within the Holiness Code could be described as a community code. It covers a range of topics, including social, ethical and cultic obligations. The bulk of the chapter is a complex of laws which have much in common with aspects of Deuteronomic law. In addition there is priestly law, ritual of the kind found in the Manual of Offerings (vv. 5–8), and the familiar signs of Holiness editing, which, as in 18:1–30, are prominent at the beginning and end of the chapter. To one of the "Deuteronomic" laws elements of priestly ritual have been appended (vv. 20–22). The text can be handled as follows:

19:1–10 – Decalogue principles and poor laws
19:11–18 – Decalogue principles and social justice
19:19–25 – laws on farming
19:26–31 – cultic practice
19:32–34 – respect for the old and the alien
19:35–37 – commercial practice.

The Holiness editing in this chapter is easily identified. The demand that Israel **be holy** as Yahweh is holy (v. 2), reminiscences of Egypt (v. 36), and the references to **statutes** and/or **ordinances** (vv. 19, 37) are the most obvious. Yahweh's persistent concern to identify himself (vv. 2, 3, 4, 10, 12, 14, 16, 18, 25, 28, 30, 31, 32, 34, 36, 37) is also a prominent feature of the chapter, one which also helps to separate the various elements within the "Deuteronomic laws".

To represent the laws in the base text as "Deuteronomic" is not intended to prejudge the question of their age or origin. It indicates simply that the base text has much in common with laws found in Deuteronomy. It seems likely in principle that they emerge from similar sources as those from which Deuteronomy is constructed. Whether or not the Holiness editor is working with a text of Deuteronomy is hard to judge; in vv. 20–22 there does appear to be a deliberate modification of law contained in Deuteronomy, but no conclusions can be safely drawn about literary dependence.

Some elements within the "Deuteronomic" laws are framed in the second person plural (vv. 3–4, 9a, 11–12, 15a, 23–28, 30–31, 33–34a, 35–36a), and the remainder (apart from the casuistic laws in v. 20) in the second person singular (vv. 9b–10, 13–14, 15b–19, 29, 32, 34b). They are largely apodictic or categorical.

The series of singular laws covers the following topics:

1) gleanings for the poor (vv. 9b–10) (cf. Deut. 24:19–22)
2) the prompt payment of wages (v. 13) (cf. Deut. 24:14–15)
3) respect and care for the deaf and blind (v. 14) (cf. Deut. 27:18)
4) equality/impartiality in law (v. 15b) (cf. Deut. 16:19)
5) slander and false witness (v. 16) (cf. Deut. 19:16)
6) love and respect for the neighbour (vv. 17–18) (cf. Deut. 22:1–4).
7) avoidance of mixtures (v. 19) (cf. Deut. 22:9–11)
8) sale of daughters as prostitutes (v. 29) (cf. Deut. 23:17)
9) respect for age and fear of God (v. 32) (cf. Deut. 4:10)
10) love for aliens (vv. 33a, 34b) (cf. Deut. 10:19, 23:7).

The law on mourning rites (v. 27b) (cf. Deut. 14:1) is possibly an eleventh (it is framed in the plural in Gk and Sam.).

These ten laws might have been the original collection taken up by the Holiness editor. They probably do not come directly from Deuteronomy – the selection appears to be too random to justify any supposition that there is deliberate adaptation of Deuteronomy here, and respect for age lacks an obvious parallel in Deuteronomy – but the connections are close enough to suggest that they come from the same milieu as Deuteronomy's laws. Some connections with wisdom are evident – slander (5) (cf. e.g. Prov. 11:3; 20:19), respect for age (9) (cf. e.g. Prov. 16:31), and fear of God (10) (cf. e.g. Prov 1:7).

The one casuistic law in the chapter (v. 20) does represent what would appear to be a clarification of Deuteronomic law. Sexual relations with a betrothed slave are not a capital offence (as might be supposed from Deut. 22:23–24), but a guilt offering would be required (vv. 21–22).

The apodictic laws in the plural appear to be an accretion – vv. 9a, 15a simply set the scene for the singular laws in vv. 9b–10 and v. 15b respectively. The themes covered are as follows:

1) honouring of parents (v. 3a)
2) the keeping of sabbath (v. 3b) (cf. v. 30)
3) prohibition of images (v. 4)
4) prohibition of theft (v. 11a)
5) prohibition of false witness (v. 11b)
6) honouring Yahweh's name (v. 12).

It is easy to see that these take up key themes from the Decalogue (Exod. 20:1–17; Deut. 5:1–21). The remaining laws set in the plural deal with:

7) fruit trees (vv. 23–25) (cf. Deut. 20:5–6, 19–20)
8) consumption of blood prohibited (v. 26a) (cf. Deut. 12:23)
9) divination and witchcraft prohibited (v. 26b) (cf. Deut. 18:10)

10) alien mourning rites prohibited (vv. 27–28) (cf. Deut. 14:1)
11) the keeping of sabbath (v. 30) (cf. v. 3b)
12) prohibition of necromancy (v. 31) (cf. Deut. 18:11)
13) care for the alien (vv. 33b–34a) (cf. Deut. 19:32–34)
14) just weights and measures (vv. 35–36a) (cf. Deut. 25:13, 15).

Here too connections with Deuteronomy are apparent, both through the Decalogue, and through the other themes for which legislation is framed. On the other hand the connections do not appear to be close enough to warrant any supposition that the Holiness Code is deliberately adapting, clarifying or developing Deuteronomic law (or vice versa), or to establish literary dependence in one direction or the other. The laws have probably been recast in the second person plural, and merged by the Holiness editor with the singular collection. They were probably not originally a unit – note the repetition of a sabbath law (vv. 3b, 30) – and it may be the case that the original collection ((7)–(14)) was subsequently provided with a prologue of Decalogue stipulations ((1)–(6)).

An overview of the whole chapter would therefore suggest:

A. A series of ten statutes, framed in the second person singular (vv. 9b–10, 13–14, 15b–19, 29, 32, 34b).
B. A series of eight statutes, framed originally in the second person singular (vv. 23–28, 30–31, 33–34a, 35–36a) but provided subsequently with a prologue (vv. 3–4, 11–12), and recast in the second person plural.
C. The merging of these two collections by the Holiness editor, with an overall prologue and epilogue (vv. 1–2, 36b–37), minor editing (vv. 3b–4b, 9a, 10b, 12b, 14b, 15a, 16b, 18b, 25b, 28b, 30b, 31b, 32b, 34b), a clarification (vv. 20–22), and the incorporation of a short element of priestly ritual (vv. 5–8).

Since A. Alt's ground-breaking study ("The Origins of

Israelite Law", 1934) the *Sitz-im-Leben* of Israel's apodictic law has often been deemed to be both cultic and also specifically Israelite. More recently it has proved impossible to sustain the supposition that the forms of apodictic law are peculiarly Israelite (cf. e.g. I. Rapaport, "The Origins of Hebrew Law", 1941; S. Gevirtz, "West-Semitic Curses", 1961; R. Kilian, *Literarkritische*, 1963; J. G. Williams, "Concerning One of the Apodictic Formulas", 1964), and theories about Israelite covenant festivals as the creative force behind such law are less popular than once they were. Alt's beliefs about a cultic context for the proclamation of such law remains nevertheless compelling. The list of curses in Deut. 27:15-26 has a cultic form, appears to be Shechemite in origin, and embodies many of the themes dealt with here in Leviticus 18-19. Identifying a context in which material was preserved and propagated is not necessarily to identify its origins. The most that can probably be said with confidence about Israel's apodictic law is that it enshrines long-standing beliefs and social practices, whose roots belong in the pre-monarchic village life of the clans and tribes.

The variations between singular and plural forms of apodictic law are as apparent in Deuteronomy as in the Holiness Code. It is generally easier to argue that the plural forms are secondary, and it seems feasible that they represent a **literary** tendency whereby laws are adapted in the consciousness that they constitute a "book" to be addressed to all Israel. In short, they may be part of the process whereby the Torah is created.

In vv. 1-10 there is introductory material to the chapter as a whole by the Holiness editor (vv. 1-2), and some basic laws drawn from the Decalogue tradition (vv. 3-4). These are a preliminary to the laws providing for the poor in vv. 9-10. Inserted between is material about the disposal of well-being offerings (vv. 5-8).

The Holiness editing contains the key theme of the Holiness Code as a whole – the demand that Israel be **holy** because Yahweh himself is **holy** (v. 2) (cf. 11:44, 45; 20:7, 26; 21:6; 22:32). B. A. Levine (*Leviticus*, 1989, p. 256) considers the question of what it might mean to call God holy, and

concludes that it signifies that he "acts in holy ways". Further evidence of the editing is Yahweh's self-identification (vv. 3, 4, 10).

The laws drawn from Decalogue tradition deal with the honouring of parents (v. 3a, cf. Exod. 20:12; Deut. 5:16), the keeping of the sabbath (v. 3b, cf. Exod. 20:8–11; Deut. 5:12–15), and the rejection of images (v. 4, cf. Exod. 20:4–6; Deut. 5:8–10). There is no particular connection between these and the poor laws in vv. 9–10, but a similar approach (Decalogue + other laws) is adopted in the next set of verses (vv. 11–18).

3. Respect for parents (v. 3a) is a fundamental feature of Israelite law. In addition to the Decalogue texts the Book of the Covenant prescribes penalties for offences against father or mother (Exod. 21:15, 17). The verb used here – **revere** – is a verb often rendered "to fear" (contrast "to honour" in Exod. 20:12; Deut. 5:16). It is often used of God, and in these contexts "stand in awe of" expresses the fundamental idea. Respect for parents is much encouraged in Israel's wisdom literature (e.g. Prov. 1:8; 6:20; 10:1; 17:25; 23:22; 29:3). The prevalence of this theme in Israel's traditions is probably a witness to its origins in the family and clan life of the villages prior to the monarchy.

Sabbath observance (v. 3b) is also widely and strongly attested. In addition to the requirements of the Decalogue it is demanded in the Book of the Covenant (Exod. 23:12), and in the Ritual Decalogue (Exod. 34:21). There is also narrative witness (2 Kgs 4:23; 11:5, 9), and testimony in the pre-exilic prophets (Isa. 1:13; Hos. 2:11). It came to particular prominence in P (Gen. 2:2; Exod. 16:22–30; 31:12–17; 35:2–3; Num. 15:32–36), and it was evidently an observance by which the Babylonian exiles were able to identify and set themselves apart within their environment. Failures to observe the sabbath are important in Ezekiel's critique (20:13, 21, 24; 22:8, 26, 38), and in the Deuteronomic editing of Jeremiah (17:21–27). Sabbath issues continued to be prominent in post-exilic writing (Neh. 10:31, 33; 13:15–22; Isa. 56:2–6; 58:13; 66:23). Here too pre-monarchic origins in agricultural communities can reasonably be proposed. The

association of sabbath with new moon in earlier texts (e.g. Amos 8:5; Isa. 1:11–13; Hos. 2:11; 2 Kgs 4:23) has led some to suppose that as a seventh-day observance it may be no earlier than the sixth century BCE (e.g. R. B. Coote and D. R. Ord, *In the Beginning*, 1991); originally it may have been monthly, marking the full moon. B. A. Levine (*Leviticus*, 1989, pp. 261–263) contests this view.

The phrase **keep my sabbaths** is typical of priestly terminology (19:30; 26:2; Exod. 31:13).

4. The third Decalogue principle affirmed here is the prohibition of images. This principle is strongly affirmed in Exod. 20:23 (arguably the beginning of the Book of the Covenant), as well as in the Decalogue. It is also given dramatic expression in the story of the golden calf (Exod. 32:1–35). Its centrality in the speeches and laws of Deuteronomy, along with the rejection of alien deities, is well known (cf. e.g. 4:12, 16–18, 25; 9:16; 27:15). Iconoclastic tendencies in early narratives are evident in Jdg. 6:25–27, while among the pre-exilic prophets Hosea (8:4; 11:2; 13:2) is an eloquent opponent of idols. In the exilic period a polemic against images as merely human artefacts is common (e.g. Isa. 44:9–20; Jer. 10:1–10; cf. Isa. 2:8).

The verb used to denote apostasy here is **turn**. It can be used in many contexts; its use, as here, in connection with alien deities is evident also in Deut. 31:18, 20; Hos. 3:1.

Two words are used to describe images. The first – **idols** – is a word used to denote that which is "worthless" (e.g. Job 13:4; Jer. 14:14; Zech. 11:17). In connection with deities it can be found in 26:1; 1 Chr. 16:26; Ps. 96:5; 97:7; Isa. 2:8, 18, 20; 10:10, 11; 19:1, 3; 31:7; Ezek. 30:13; Hab. 2:18). (It should be noted that a number of other words are often translated as "idol" in English versions.) Images of metal – **cast** – are also cited here. This word is widely used in association with other deities. In addition to the calf (Exod. 32:4, 8; Deut. 9:16; Ps. 106:19; Neh. 9:18) allusions to molten gods can be found in e.g. Exod. 34:17; Num. 33:52; Deut. 27:15; Jdg. 17:3, 4; 18:14; 1 Kgs 14:9; 2 Kgs 17:16; Isa. 30:22; 42:17; Hos. 13:2; Nah. 1:14; Hab. 2:18. This attestation is widespread, and also ancient (n.b. the Ritual Decalogue (Exod. 34:17), the Shechemite

rite (Deut. 27:15), and the early narratives (Jdg. 17:3, 4·
18:14)). There is evidently a deeply rooted suspicion abou
metallic representations of deity, gold, silver and bronze
being commonly used for this purpose. The suspicion prob-
ably goes back to the circumstances under which Israel came
into being, and constitutes an alternative to prevailing reli
gious practice and the socio-political structures it represents.

The section on well-being offerings (vv. 5–8) seems on the
face of it to disrupt the passage. The reason for its insertion,
whether by the Holiness editor or by a subsequent scribe,
may have been prompted by the thought of what constitutes
acceptable worship in v. 4. In priestly thought it is not suffi-
cient to shun alien deities and their forms; Yahweh has his
own statutes and ordinances which must be carefully
observed. There is a similar passage in the Manual of
Offerings (7:15–18), but that dealt with specific types of well-
being offering, namely the thank offering (v. 15), the votive
offering, and the free-will offering (v. 16). Here in vv. 5–8 the
concern is with well-being offerings in general; no precise
distinctions are made. Permission to eat some of the sacrifice
a day later is granted (v. 6a), as with the votive and free-will
offerings (7:16) but not the thank offering (7:15). Otherwise
the requirements are essentially the same.

5. Much of the language of these verses is familiar – for
well-being offerings see on 3:1–17, and for **acceptable** see on
1:4.

6. The burning of any that remains till the third day is as
with the votive and free-will offerings in 7:17.

7. The eating of any part of the offering on the third day is
abomination ("rotten food" – *NJB*; "tainted" – *REB*; "impure"
– *NIV*; "ritually unclean" – *GNB*) and the offering is not
accepted (cf. 7:18).

8. The offender will **be subject to punishment** (more liter-
ally "bear his iniquity" (cf. 7:18)). Here in v. 8, however,
further explanations and clarifications are offered. The
offender has **profaned what is holy.** Profanation of the name
of Yahweh has already been encountered in 18:21 (cf. other
references cited there). The idea can be applied more widely,
as here to sacrifices (cf. 22:15), to a daughter (v. 29), to

priests and their families (21:9, 15), to sacred places (21:12, 23), and to Yahweh's charge (22:9). In short, within Leviticus it is a distinguishing feature of the laws collected in the Holiness Code. Elsewhere in the priestly writing profanation of sabbath (Exod. 31:14) and of sacrifices (Num. 18:32) is attested. The idea is also common in Ezekiel (e.g. 7:21; 13:19; 20:13; 22:8; 23:38; 24:21; 28:7; 36:20; 44:7), and with a very similar range of reference. A further clarification offered here is that the offender will be **cut off from the people** (see on 7:20 and 17:4).

9. The "Deuteronomic" elements in this section are the laws providing for the poor (vv. 9–10) (cf. Deut. 24:19–22). The Holiness editor begins in the second person plural with an introductory phrase – **when you reap the harvest of your land** (v. 9a). The words **reap** and **harvest** come from the same root word (cf. 23:10, 22; Deut. 24:19). The **edges** of the **field** must always be left. The **edges** can denote "corners" or "borders" (RSV) (cf. vv. 27, 21:5; 23:22, and in the priestly writing e.g. 13:41; Exod. 25:26; 26:20; 27:9, 12; 37:13). The words **gather** and **gleanings** also belong to the same root. This word can be used of a wide range of gathering activities; this specific meaning in relation to harvests is found in e.g. 23:22; Ruth 2:2, 3, etc.; Isa. 17:5; 27:12.

10. With respect to vineyards it is required that they should not be stripped **bare**, and that **fallen grapes** should not be gathered. The verb **stripped bare** is another word for "to glean" (BDB); it is used in Deut. 24:21 which may suggest that a second harvesting process is what the law wishes to prohibit. In some texts it is used figuratively of decimating an enemy (Jdg. 20:45; Jer. 6:9.

The **fallen grapes** is a rare word of doubtful meaning. The root is rendered **sing idle songs** by NRSV in Amos 6:5.

These parts of the harvest, from field and vineyard, are to be left for **the poor** and the **alien** (cf. 16:29; 17:8, 12). The word **poor** is widely used in laws to denote those who are in economic need (23:22, Exod. 22:25; Deut. 15:11; 24:12, 14, 15), and also in wisdom literature (Prov. 14:21; 15:15; 31:20; Eccl. 6:8). The poor are also recognized as without influence; the rich and the powerful are often their oppressors. The

prophets in particular were alert to this (e.g. Isa. 3:14; 10:2; 32:7; 58:7; Jer. 22:16; Ezek. 16:49; 18:12; 22:29; Amos 8:4; Zech. 7:10; 11:7). So too were the wisdom writers (Job 24:4; 29:12; 34:28; 36:6; Prov. 22:22; 30:14; 31:9). It is not surprising that Israel herself could be thought of as **poor** (sometimes "afflicted" in *RSV*) in the face of powerful nations who often exploited her (Isa. 14:32; 26:6; 41:17; 49:13; 51:21; 54:11; Hab. 3:14). The numerous allusions in psalms to **the poor** (sometimes "afflicted" – *RSV*) fit very well into one or more of these ranges of meaning (e.g. Pss. 9:18; 10:2; 12:5; 14:6; 22:26; 25:16; 34:6; 35:10; 37:14; 40:17; 68:10; 69:29; 70:5; 72:2; 74:19; 82:3; 86:1; 88:15; 102 (*superscription*); 109:16; 140:12. The word is sometimes translated as "humble" or "lowly" by *RSV*. It is not at all clear that in Ps. 18:27, for example, this translation is justified. Elsewhere in Isa. 66:2, for example, it does parallel "contrite in spirit" and again in Zeph. 3:12 it denotes what appears to be a desirable attitude or frame of mind (cf. also Prov. 16:19; Zech. 9:9). Even in these texts it is unwise to think of a "spirituality of poverty"; to be "humble" or "lowly" is to eschew the attitudes and activities of the rich and powerful.

Though the theme of vv. 9–10 is essentially the same as that of the law in Deut. 24:19–22 there are many differences in detail. In Deuteronomy it is a forgotten sheaf, not the grain on the edges, which is for the poor, who are there identified as sojourner, fatherless and widow. The question of olive trees is not considered here, and the matter of fallen grapes is not mentioned there. It seems best to envisage some legal stipulations to which both the Holiness Code and Deuteronomy had access, and which they developed independently.

In summary the passage consists of instruction cast in the singular (laws providing for the poor) (vv. 9b–10), statutes cast in the plural (some Decalogue laws) (vv. 3–4), an introduction by the Holiness editor (vv. 1–2), and some further Holiness editing identifying Yahweh (vv. 3b, 4b, 10b), and introducing the law for the poor (v. 9a).

As in vv. 1–10 the laws of vv. 11–18 begin with some

Decalogue principles (vv. 11–12). These function as a kind of prologue to a set of laws cast primarily in the second person singular (vv. 13–14, 15b–18). There is a plural introduction to one of these elements (v. 15a) (cf. v. 9a). The general themes are social justice and love of neighbour.

The Holiness editing is most obvious in the refrains which identify Yahweh (vv. 12, 14, 16, 18). The laws drawn from Decalogue tradition are different from those cited in vv. 3–4, but here again there are three of them. The issues addressed are theft (v. 11a, cf. Exod. 20:15; Deut. 5:19), false witness (v. 11b, cf. Exod. 20:16; Deut. 5:20), and reverence for Yahweh's name (v. 12, cf. Exod. 20:7; Deut. 5:11).

11. Laws which recognize property rights (v. 11a) are common enough in Israelite codes. Laws about slaves (e.g. Exod. 21:1–11, 20–21, 26–27; Deut. 15:12–18) and family (e.g. Exod. 21:22–25; 22:16–17; Deut. 22:13–30) are property laws, though the distinct status as human beings of the persons involved is invariably recognized. Livestock (e.g. Exod. 21:28–22:1, 4), buildings (e.g. Exod. 22:2–3), land (e.g. Exod. 22:5–6), money and other goods (e.g. Exod. 22:7–15) also constitute property, and must be protected by law from theft. These rights to property were deemed, of course, to be God-given; they were never absolute human rights. The desire to extend holdings, by financial or other forms of power, was resisted by law-givers (e.g. 25:8–17) and prophets (e.g. 1 Kgs 21:1–24; Isa. 5:8–10; Ezek. 45:7–8).

The law about false witness (v. 11b) also concerns itself with those who **deal falsely** – i.e. acts of deception. The root word is employed in 6:2, 3.

The verb **lie** is also widely used of deceit in all its forms. This is the word employed in Exod. 20:16 (the Decalogue), though the textual witness in the parallel law in Deut. 5:20 is not uniform. Since the prophets sought to defend the weak on the basis of traditional custom (1 Kgs 21:1–24) it seems likely that the prohibition of theft, and probably Decalogue principles as a whole, are traceable to the pre-monarchic period.

12. The requirement that **you shall not swear falsely by my name** could be understood as a continuation of the false

witness motif in v. 11b ("with intent to deceive" – *REB*). An interpretation of the Decalogue command (Exod. 20:7) is found in Lev. 24:10–22.

The verb **swear** is widely used in connection with the making of oaths. In the priestly writing it is used in association with the root underlying **falsely** in 6:3, 5, and here property appears to be the point. In 5:4 it is used of rash oaths about future actions, in Josh. 9:20 of a promise, and in Num. 30:3 of a vow that a woman might make. All the indications are therefore that v. 12 is concerned not with false testimony against a neighbour, but with promises that are not kept or oaths which are not true. A good example of the latter would be "the oath of the curse", something pronounced against oneself, as recorded in Num. 5:19, 21. Wherever such words are uttered in Yahweh's name then his honour is at stake, and if they prove false then this is one obvious way in which his name is taken in vain (Exod. 20:7; Deut. 5:11).

On the word **profaning** see 19:8. Heb. reads "your God" as a second person singular, indicating perhaps editorial introduction of the notion of "profanation" in this context, but Gk reads a plural.

13. There follow in vv. 13–14 some "Deuteronomic" elements on the theme of social justice. The **neighbour** in legal texts is any fellow Israelite (cf. vv. 16, 18; 20:10; Exod. 20:16, 17; 21:14 ("another" – *NRSV*); 22:7, 8, 9, 10, 11, 14, 26; Deut. 15:2), though elsewhere the word can be used of companions or friends (e.g. Gen. 38:12; 1 Sam. 30:26).

The first requirement is that **you shall not defraud** ("oppress" – *RSV*) him. The verb here is often used of extortion (see on 6:2), and often also in relation to the poor and weak (Amos 4:1; Deut. 24:14; Prov. 14:31; 22:16; 28:3; Eccl. 4:1; Jer. 7:6; Ezek. 22:29; Zech. 7:10).

The second requirement is that you do not **steal** ("rob" him – *RSV*) (see again 6:2, 4) – i.e. plunder or in other ways take possession of that which is his (cf. Ps. 62:10; Eccl. 5:8; Isa. 61:8; Ezek. 18:18; 22:29).

The insistence on prompt payment of wages (v. 13b) gives concrete form to these general requirements (cf. the Deuteronomic law in Deut. 24:14–15). The **labourer** ("hired

servant" – *RSV*) is the day labourer, someone of low social status, who has presumably lost his own land holding or is unable to subsist on what he has. Soldiers might also be thought of in the same terms (Jer. 46:21). The day labourer is cited on several occasions in H (22:10; 25:6, 40, 50, 53), and it is clear that he can easily be exploited (Mal. 3:5), and that his work was hard (Job 7:1, 2; 14:6). This status is the alternative to slavery, which in the Holiness Code is not permitted for Israelites (25:40); it is expected that a hiring contract would last for a year and be renewable (26:53, cf. also Isa. 16:14; 21:16). In Exod. 12:45 it seems to be assumed that such a servant would be a foreigner. In Deut. 15:18 the wages of a **labourer** would apparently be twice the cost of keeping a slave.

The **wages** to which he is entitled is a relatively infrequent word, and one which is often used figuratively in terms of rewards or recompense (e.g. Ps. 109:20; Prov. 10:16; Isa. 40:10; 49:4; 61:8; 62:11; Ezek. 29:20).

The theme of the law is the same as that in Deut. 24:14–15, but the linguistic detail is considerably different. The points of contact are "defraud" and "labourer". In Deuteronomy payment must be paid before the sun goes down (cf. Exod. 22:26), and there is a generally fuller form of exhortation. Once again it seems likely that Deuteronomy and the Holiness Code are handling legal precedents independently.

14. Here the legislative concern is with the disabled people, and specifically the **deaf** and the **blind**.

The verb to be **deaf** can also mean to be "silent" or "dumb" (hence *NJB*). With the sense of those who do not hear it is often used of those who refuse to hear. It does occur elsewhere as a physical disability and often in association with the **blind** (e.g. Exod. 4:11; Isa. 29:18; 35:5; 42:18; 43:8), but it is arguable that in some at least of these references the meaning is figurative. A parallel in Deuteronomy can be found in Deut. 27:18, which calls down a curse on those who for some reason misdirect a blind man.

The **blind** is a word with a similar range of literal and figurative meanings (e.g. 2 Sam. 5:6, 8; Job 29:15; Isa. 29:18; 35:5; 42:16, 18, 19; Jer. 31:8).

The **stumbling block** is usually used in a figurative sense (cf. e.g. Ps. 119:165; Isa. 57:14; Jer. 6:21; Ezek. 3:20). The priestly tradition is well known for the value it attaches to physical perfection as an expression of holiness (cf. e.g. 21:16–24); it is therefore instructive to note the protective concern of the law here in v. 14 for those with physical blemishes.

The requirement that Israel should **fear** God occurs again in v. 32 and in 25:17, 36, 43. It is not typical of the priestly writing, but is common in the early narrative tradition, particularly perhaps in the Elohist (Gen. 22:12; 42:18; Exod. 1:17; 9:30; 14:31; 18:21) and also in Deuteronomy (Deut. 4:10; 6:24; 8:6; 10:12, etc.).

15. The next element is introduced by a phrase in the second person plural – **you shall not render an unjust judgement** (but Sam. reads it as a singular). It is an appropriate general statement which will be clarified in the laws that follow.

The word **unjust** is found again in v. 35, and also in Deut. 32:4; Job 34:10; Ps. 7:3; 53:1; 82:2; Prov. 29:27; Jer. 2:5; Ezek. 3:20; 18:24; 28:15; 33:13). It is sometimes rendered as "wrong" or "iniquity". The root word translated **judgement** here is rendered as **ordinances** in 18:4.

(1) The first clarification in the singular series which follows is the insistence on strict impartiality in the administration of the law.

There are to be no special favours whether for the **poor** (cf. Exod. 23:3) or the **great**. The word for **poor** is different from that used in v. 10; it is the word used in 14:21 where the sense is clearly those deprived of economic resources (see on 14:21). The word **great** is commonly used of prominent, powerful and often wealthy people (Exod. 11:3; 1 Sam. 25:2 (**rich** in *NRSV*); 2 Sam. 3:38; 5:10; 7:9; 19:32 (**wealthy** – *NRSV*); 2 Kgs 4:8 (**wealthy** – *NRSV*); 5:1; 10:6, 11; 18:19, 28; Est. 9:4; Job 1:3; Prov. 18:16; 25:6; Eccl. 9:14; Jer. 5:5; 27:7; Jon. 3:7 (**nobles** – *NRSV*); Mic. 7:3; Nah. 3:10).

The word **partial** means literally "you shall not lift up the face of. . .", a phrase which is commonly used of some sign of favour. Its use in the sense required here in v. 15 – of showing

unwarranted partiality towards – can also be found in Deut. 10:17; Job 13:8, 10; 32:21; 34:19; Ps. 82:2; Prov. 6:35; 18:5.

The word **defer** can be used in a positive sense, as in v. 32 of the honour to be paid to the elderly; the negative sense used here is also found in Exod. 23:3 in relation to the poor. As Job 34:19 and Exod. 23:3 show, **partial** and **defer** are interchangeable with reference to the poor or the great.

Judgement of the **neighbour** must be with **justice** ("strict fairness" – *REB*; "righteousness" – *RSV*; "fairly" – *NIV*). The word **neighbour** is different from that used in v. 13, and much less common, except in Leviticus. It has already occurred in v. 11 and 6:2; 18:20, and is found again in vv. 17, 24:19; 25:14, 15, 17 (cf. also Zech. 13:7). It is rendered "associate", "fellow", "relation" by BDB. The word **justice** is used very extensively to denote what is fair, and is integral to the character of Yahweh himself (e.g. Job 36:3; Ps. 85:10; 89:14; 97:2; 119:142; Isa. 42:6; 45:13, 19; Jer. 11:20; Hos. 2:19). The concern here is the administration of justice, a particular sphere where it is widely required and expected (Deut. 1:16; 16:18, 20; Ps. 58:1; 94:15; Prov. 8:15; 25:5; 31:9; Eccl. 5:8; Isa. 32:1).

16. (2) The second clarification deals with slander. The concern perhaps is with the "tale-bearer" or "informer" (BDB). The word is not common. It occurs in Jer. 6:28; 9:4; Ezek. 22:9 in the sense of one who is evil and who seeks personal advantage (e.g. to supplant). In Prov. 11:13; 20:19 it might denote those who are merely indiscreet. Here the general context suggests a serious issue of malicious libel or defamation of character. *REB* takes **your people** to mean "your father's kin" (cf. also v. 18).

In v. 16b the phrase is literally **to profit by** ("stand against" – *RSV*) **the blood of your neighbour** (**neighbour** as in v. 13). The phrase **to profit by** with the sense of "to oppose" is attested in Jdg. 6:31; 2 Chr. 26:18; Ezr. 10:15; Isa. 50:8. In association with **blood** it occurs only here in v. 16. The overall sense of the verse seems to be that malicious slander which threatens the life of a neighbour is strictly prohibited (*REB* – "on a capital charge"; cf. *GNB*).

Though the themes of vv. 15b–16 are easy to locate in

Deuteronomy, there is little to suggest any specific literary dependence between Deuteronomy and the Holiness Code (cf. e.g. Deut. 16:19; 19:16).

17. (3) A third clarification deals in part with attitudes of heart and mind (vv. 17–18). There is a requirement in v. 17a that **you shall not hate in your heart anyone of your kin**, and in v. 18b that **you shall love your neighbour as yourself**. These basic principles are enshrined in earlier legislation (e.g. Exod. 23:4–5), and also in Deut. 22:1–4.

The effects of **hate** are identified in other laws – e.g. in relation to homicide (Deut. 19:4, 6, 11) and marriage (Deut. 22:13, 16; 24:3). The word **anyone** ("brother" – *RSV*) does have the familiar meaning of two born of the same mother (e.g. Gen. 4:2; 27:6; 44:20), but can also have the very much wider sense of "neighbour" or of belonging to the same people (e.g. Exod. 2:11; 4:18; Deut. 15:2; Jdg. 14:3; Neh. 5:1; Isa. 66:20).

The word **heart** relates not merely to emotions, but also to the inner being – "mind" and "will" (BDB). It is the seat of an immense range of human experiences – mental, emotional and moral.

Between the general requirements prohibiting hate and encouraging love are more specific indications of what observance of the general principles would mean. In situations where there is disagreement or conflict of interest you may **reprove your neighbour** (**neighbour** as in v. 15) (v. 17b). The word **reprove** ("reason with" – *RSV*) seems appropriate (BDB) (**rebuke** – *RV*; "reprove. . . frankly" – *REB* (cf. **reprove. . . firmly** – *NIV, NJB*). It is used of Abraham's complaint in Gen. 21:25, and is commonly used of reproofs or rebukes in wisdom literature (e.g. Prov. 9:8; 28:23; Job 40:2 "argues" – *NRSV*) (cf. also Jer. 2:19).

The idea that the consequence of hatred might be that **you incur guilt** occurs only in the Holiness Code and the priestly writing (e.g. 20:20; 22:9; 24:15; Exod. 28:43; Num. 18:22, 32). It appears to mean the same as to **be subject to punishment** (see 5:1, 17; 7:18; 10:17; 16:22; 17:16; 19:8; 20:17, 19; 22:16). *REBn* suggests "and for that you will bear no blame".

18. There is the further clarification about "love" and

"hate" in the warning against taking **vengeance**. BDB understands this to mean the entertaining of vengeful feelings, given the contrasting parallelism with love in v. 19b. This presupposes that love is about feelings. It is certainly customary for **vengeance** to describe actions of some kind.

The prohibition about bearing a **grudge** is more probably the word for feelings of resentment. The verb means "to keep" (BDB), and the sense probably has to do with the continuing retention of anger – cf. its use in Ps. 103:9; Jer. 3:5, 12; Nah. 1:2.

The **neighbour** (v. 18b) is as in v. 13; to **love** your **neighbour as yourself** is a commitment to the well-being and best interests of the other person. In v. 34 it includes the **alien** (cf. Deut. 10:18, 19). The word **love** carries a wide range of meanings, including the love of a man for a woman (e.g. Gen. 24:67; Deut. 21:15), or the love between friends (e.g. 1 Sam. 16:21), or the devotion a slave might exhibit to a master (Exod. 21:5).

In summary, the passage consists of statutes on social justice (vv. 13, 14, 15b, 16) and love of neighbour (vv. 17–18), with an introduction consisting of some Decalogue laws (vv. 11–12a), and further H editing (vv. 12b, 15a) which includes Yahweh's self-identification (vv. 12b, 14b, 16b, 18).

In vv. 19–25 attention turns for the most part to the use of land and to farming. In vv. 20–22, however, there is an element of family law. There is not, as in vv. 1–10 and vv. 11–18, an introduction of Decalogue principles, but there is in v. 19a a general statement about the keeping of Yahweh's **statutes**. The form of the laws is mixed. The first set (v. 19) is framed in the second person singular, and the last set (vv. 23–25) in the second person plural. The family law, by contrast, is conditional and essentially casuistic in form (v. 20), but the familiar ritual law form appears in vv. 21–22 to describe the required **guilt offering**.

The Holiness editing is modest in scope, being most evident in the general statement about Yahweh's statutes (v. 19a), and in the familiar refrain identifying Yahweh as lawgiver (v. 25b).

19. On the keeping of **statutes** see 18:3, 4 (Gk has **law**). The singular laws prohibiting "mixtures" have a clear affinity with Deut. 22:9–11. The texts, however, are clearly independent. The only common ground relates to the wearing of garments. Otherwise the points at issue are different – here the breeding of cattle and sowing in fields (Gk adds "vineyards" here in v. 19), and there sowing in vineyards, and ploughing with an ox and ass. In Deut. 22:5 the "mixing" of male and female garments is also raised.

The word **animals** usually denotes domestic animals (1:2).

The translation **breed** is from a verb meaning "to lie stretched out" or "lie down" (BDB). In the Holiness Code it invariably refers to copulation (18:23; 20:16).

The phrase **with a different kind** means literally "two kinds", and occurs only in these laws about mixtures (cf. **two kinds of seed** here and in Deut. 22:9, and **two different materials** here). The word **materials** is another point of contact with the law in Deuteronomy (22:11), and occurs only in these laws ("yarn" – *REB*; "fabric" – *NJB*; "clothing" – *NIV* (cf. *GNB*)).

This hostility to the mixing of different things probably reflects ideas about order, the notion that each has its proper place, and fear about confusion. As the Manual of Purity reveals, this is integral to the priestly understanding of holiness; it also probably underlies the laws about prohibited sexual relations (see on 18:22–23). This may partly explain why the text which follows (vv. 20–22) deals with another sexual prohibition.

20. The central element in this section (vv. 20–22) deals with an issue raised in Deut. 22:23–27, the seduction of a betrothed woman. In Deuteronomy it is clear that this is a capital offence (Deut. 22:24), though if relations take place in the open country the woman is deemed not guilty and is acquitted (Deut. 22:25–27). The basic point is that betrothal in effect constitutes marriage. The clarification introduced here in v. 20 deals with cases of this kind, but in particular those in which the woman is a slave. In these instances the offence does not merit death. Instead an **inquiry** is conducted, presumably to establish the facts, and the man will be required to make a **guilt offering** (vv. 21–22).

The phrase **has sexual relations** is that used in 15:18.

The phrase **a woman who is a slave** denotes customarily a "maid" or "maid servant" (BDB), belonging possibly to a master (e.g. Gen. 29:24; Ruth 2:13), but more usually to a mistress (e.g. Gen. 16:1; 29:24; Ps. 123:2; Prov. 30:23; Isa. 24:2). The laws in Exod. 21:7–11; 22:16–17 provide earlier legal material on these subjects.

The phrase **designated for another man** ("betrothed" – *RSV*) occurs only here ("acquire" – BDB); in this social context "acquired as a concubine" may be implied (*GNB*). A betrothal intending marriage would probably already have led to the woman's freedom. *REB* takes the situation to be one in which the man is the owner, and in which the girl has been "assigned" (given as concubine?) to another man without having been given her freedom. *NJB* takes the view that the man is not the owner, the girl being the "concubine slave" of another man.

The phrase **but not ransomed** denotes the price that would be paid, normally by a relative, to gain a slave's freedom. The phrase can be used figuratively, of, for example, deliverance from exile. In legislative contexts a sum of money, not always specified, is usually in mind (e.g. 27:27, 29; Exod. 13:13, 15; 21:8; 34:20; Num. 3:46, 48, 49, 51; 18:15, 16, 17).

The word **freedom** is often used of release from slavery (e.g. Exod. 21:2, 5, 26, 27; Deut. 15:12, 13, 18; Job 3:19; Jer. 34:9, 10, 11, 14, 16), though it can denote freedom from taxes or other obligations (e.g 1 Sam. 17:25).

The word **inquiry** is taken by BDB to denote "punishment after examination" ("she shall be scourged" – *AV*; "they shall be punished" – *RV*). It seems preferable, with *RVn* and *NRSV*, to take the root to be the verb "to inquire" or "to seek". The absence of a death penalty (a singular in Sam. – i.e. the man) makes it clear that the status of the woman as slave means that the offence is against property rather than life; in short it is not adultery.

21. The details about the **guilt offering** (vv. 21–22) which the man is apparently required to offer is reminiscent of material from the Manual of Offerings (5:18–19) and the Manual of Purity (14:12–13). As J. Milgrom ("The Betrothed

Slave Girl", 1977) points out, the man has offended God and recompense must be made.

On the **guilt offering** see 5:14–19. On the **entrance of the tent of meeting** see 1:3.

22. The animal to be offered is a **ram** as in 5:18. On **atonement** and **forgiven** see 4:20.

The **guilt offering** is in part an act of restitution or compensation (see 5:14–16), and it is probably intended that the offender should make payment to the slave owner. Here the emphasis is only on the offender's act of restitution to God.

23. The final element in the section returns to questions relating to agriculture and the land (vv. 23–25). The laws are cast in the second person plural. Gk adds that it is the land which Yahweh gives you.

The fruit of freshly planted trees must not be eaten for three years. The phrase **regard. . . as forbidden** means literally "uncircumcised", and the tree must be treated as such. This description of a tree in these terms is unique, but figurative use of the word is attested elsewhere (e.g. 26:41; Exod. 6:12, 30; Jer. 6:10; 9:25; Ezek. 44:7, 9).

24. The fruit in the fourth year belongs to Yahweh, as a kind of first fruits (v. 24). The "uncircumcised" condition ceases after the three-year period and in the fourth the fruit is **set apart** ("holy" – *RSV*) **for rejoicing** in Yahweh ("an offering of praise" – *RSV*). The root word in this latter phrase is common enough, but the particular form here ("rejoicing", "praise" – BDB) is rare (cf. Jdg. 9:27).

It seems likely that underlying these laws there are more ancient rites relating to the fertility of the land. J. R. Porter (*Leviticus*, 1976) refers to the custom of leaving crops for the spirit of the ground. Ancient vintage festivals are attested in Jdg. 9:27; 21:21.

25. In the fifth year the fruit may be eaten freely. Laws about fallow land occur in 25:1–7. The expectation that the trees will increase their yield is probably part of the older beliefs. One word used in this phrase ("product" – BDB) is commonly used in laws about yields from the earth (e.g. 23:39; 25:3, 7, 15, 16; Exod. 23:10). The priestly theology of

"circumcision" and "holiness" seems to have transformed the content of these older rites. On the priestly attitude to first fruits see 2:14–16.

There is no direct literary dependence between these laws about trees and those in Deuteronomy. In Deut. 20:19–20 the context is quite different, what may or should not be done when an enemy city is put under siege. The common ground is the conviction that ultimately the land and its produce is God's, and must be respected and reverenced as such.

In summary the passage consists of singular instruction (laws about "mixtures") (v. 19b) and plural statutes (laws about fruit trees) (vv. 23–25). In between is an element of casuistic law on sexual relations with a slave (v. 20) and the ritual law of the guilt offering which is required subsequently (vv. 21–22). The Holiness editor introduces the section with a brief general statement about keeping Yahweh's statutes (v. 19).

The following verses (vv. 26–31) deal with various aspects of cultic practice, including witchcraft (v. 26), mourning (vv. 27–28), prostitution (v. 29), and necromancy (v. 31). Apart from the laws about cutting the edges of the beard (v. 27b) and prostitution (v. 29), framed in the second person singular (v. 27b is actually a plural in Sam. and Gk), all these laws belong to the plural stratum in the text. They do not begin with Decalogue principles (as do the laws in vv. 1–10, 11–18), but like vv. 19–25 they begin with a principle fundamental to the Holiness Code – the prohibition of blood consumption (see 17:10–14). A Decalogue principle is articulated in v. 30. Holiness editing is also evident in Yahweh's self-identification (vv. 28b, 30b, 31b).

Ancestor cults, seeking access to the dead, were widespread in the ancient world. They were resisted by prophets (e.g. Isa. 8:19) as well as by law-makers.

26. The blood prohibition does not have the word "flesh" (*RSV*) – hence *NRSV*'s **anything**. Gk has, in place of blood, "you shall not eat upon the mountains", a phrase reminiscent of some in Ezekiel (e.g. 18:6, 11, 15; 22:9).

The word **augury** means divination of some kind, and specifically the observation of signs or omens (cf. e.g. Gen.

30:27; 44:5, 15; 1 Kgs 20:33. It is prohibited in Deuteronomy as it is in the Holiness Code (Deut. 18:10; cf. 2 Kgs 17:17; 21:6).

The word rendered **witchcraft** is understood by BDB to mean "practise soothsaying" (thus *REB*; "magic" – *NJB*; "sorcery" – *NIV*). It denotes perhaps the words that the diviner speaks in response to enquiries (cf. Jdg. 9:37), in which case **witchcraft** is not the best rendering. The practice is prohibited in Deut. 18:10; 2 Kgs 21:6, and attacked by prophets (Isa. 2:6; 57:3 ("sorceress" – *NRSV*); Jer. 27:9; Mic. 5:12 ("soothsayers" – *NRSV*).

27. The expression **round off the hair on your temples** occurs only here, and probably denotes a mourning rite. The word "corner", "side" or "edge" is part of the expression, as in v. 27b and in 13:41. In Jer. 9:26; 25:23; 49:32 those who cut the corners of their hair are seen as alien.

The word **mar** seems to mean "go to ruin" (BDB), and is widely used in contexts where destruction or spoliation are in mind (e.g. Deut. 20:19, 20; Jdg. 6:4; Jer. 6:5; Mal. 3:11). It does therefore suggest some deliberate kind of cutting of the beard, rather than its neglect. *REB* has "shave the edge of your beards" in v. 27b. (*NJB*, *NIV* are similar; *GNB* has "trim your beard").

28. Another prohibited mourning rite is **gashes in your flesh** (see also 21:5, cf. Zech. 12:3).

The word for **the dead** customarily denotes a "person" or "living being" (BDB), but its use in relation to the deceased without the word "dead", as here, is not uncommon in the priestly writing and in the Holiness Code (21:1; 22:4; Num. 5:2; 6:11; 9:6, 7, 10; 19:11, 13; cf. Hag. 2:13).

The phrase **tattoo any marks** occurs only here, and a literal meaning would seem to be "a writing of incision or imprintment". A **tattoo** is a reasonable supposition (thus *REB*, *NJB*, *NIV*).

These mourning rites are comparable with those described in Deut. 14:1, but there are no obvious signs of literary dependence. The verb "cut yourselves" (Deut. 14:1) and the phrase "baldness on your foreheads" (Deut. 14:1) are both quite different from those used here.

29. The word **profane** is that used in v. 8 of holy things (see v. 8). A woman could **profane** herself in this way (21:9), and a priest might **profane** his children by marrying a woman who is not a virgin (21:14–15). It is widely assumed that **making her a prostitute** would entail her involvement in alien religious rites. A close association between prostitution and apostasy is common (see on 17:7; cf. e.g. Exod. 34:16; Hos. 4:10, 18; 5:3), and fornication might also be so described (Deut. 22:21). Payments were made to prostitutes, as is clear from the story in Gen. 38:15–17, and this may have been motive enough for a father to take the action envisaged here. On **depravity** see 18:17.

30. The sabbath law repeats that in v. 3b, and a requirement is added to the effect that you **reverence my sanctuary**. The idea that **reverence** is to be paid to the sanctuary occurs again in 26:2.

31. Here two further sources of guidance are prohibited. The **medium** is one who practises necromancy (cf. 20:6, 27; 1 Sam. 28:3, 9; 2 Kgs 21:6; 23:24; Isa. 8:19; 19:3), and in all these texts the **medium** is linked closely with the **wizard** – better understood as the medium's "familiar spirit" (BDB). Both roles are also prohibited by Deuteronomy (18:11). In 20:27 both can apparently be put to death. *REB* understands the words as "ghosts" and "spirits" respectively, and *NJB* as "spirits of the dead" and "magicians". *NIV* has "mediums" and "spiritists", while *GNB* prefers simply "people who consult the spirits of the dead".

The word **defiled** is the root in the Manual of Purity which commonly denotes uncleanness.

In summary this section consists primarily of statutes in the plural, into which singular statutes have been inserted (v. 29 and perhaps v. 27b). This may have been the work of the Holiness editor, who provides the introduction v. 26a and Yahweh's self-identification (vv. 28b, 30b, 31b).

The following verses (vv. 32–34) foster respect for the elderly (v. 32) and the **alien** (vv. 33–34). The laws about the elderly (v. 32), and elements of the law about strangers (vv. 33a, 34b)

are cast in the second person singular (Sam. and Gk have v. 33a as a plural). There appear to be elaborations of the latter cast in the plural form (vv. 33b–34a). There is no generalized introduction to the section, or any Decalogue principles. The influence of the Holiness editor is evident in Yahweh's self-identification (vv. 32b, 34b) and in the appeal to Israelites to remember their own status as **aliens in the land of Egypt** (v. 34b) (cf. vv. 36; 18:2; 22:33; 23:43; 25:38, 42, 55; 26:45; Deut. 5:15). It is possible that the plural adaptations of the aliens law are also to be traced to the Holiness editor.

32. The aged ("hoary head" – *RSV*) (v. 32) is a word widely used to denote grey hairs and old age in general (e.g. Gen. 15:15; 25:8; 42:38; 44:29; Deut. 32:25; Jdg. 8:32; Ruth 4:15; 1 Kgs 2:6, 9; Ps. 71:18; Prov. 16:31; 20:29; Isa. 46:4).

There are also a number of texts where **rise before** is a mark of respect (e.g. Gen. 19:1; 31:35; Job 29:8; Isa. 49:7), followed possibly by an act of prostration or worship (Gen. 23:7; Exod. 33:10; 1 Sam. 20:41; 25:41).

The verb **defer** ("honour" – *RSV*) (v. 32) is the same as that used negatively with the sense of deferring to the great in v. 15. This suggests that acts of deference or positive discrimination in favour of the elderly are appropriate.

The requirement that **you shall fear your God** means to stand in awe of him, and to honour his commandments (see on v. 14).

33. For the word **alien** see on 16:29 (cf. also 17:10, 12, 13, 15).

The phrase **oppress** (or "maltreat" – BDB; "molest" – *NJB*) is widely used of different kinds of exploitation (cf. 25:14, 17; Exod. 22:21; Deut. 24:17; Jer. 22:3; Ezek. 18:7, 12, 16; 22:7, 29; 45:8; 46:18).

34. The **citizen** (see on 16:29) is the Israelite, in contrast to the alien; the requirement that they be treated equally, with the same rights and obligations, is common in the laws (e.g. in the Holiness Code 17:8, 10, 12, 13, 15; 18:26; 20:2; 22:18; 24:16, 22, and in the priestly writing 16:29; Exod. 12:19, 48, 49; Num. 9:14; 15:14, 15, 16, 26, 29, 30; 19:10; 35:15).

On **love** see v. 18.

The recollection that Israel was an **alien** in Egypt is attested

elsewhere in several Pentateuchal texts (Gen. 15:13; Exod. 22:21; 23:9; Deut. 10:19; 23:7).

Though there are affinities with Deuteronomy – e.g. interest in the fear of God (e.g. Deut. 4:10), respect for the alien, and the recollection that this was Israel's status in Egypt – these affinities are not exclusive to Deuteronomy and the Holiness Code, and there is no obvious indication of literary dependence.

In summary, the section consists of second person singular statutes about respect for old age (v. 32) and for the alien (vv. 33a, 34b), the latter receiving some supplementation in the form of plural forms (vv. 33b, 34a). The Holiness editor is possibly responsible for the supplementation, along with the more obvious indications of his work in vv. 32b, 34b.

The last verses of the chapter deal with various issues in commercial practice (vv. 35–36a), and then provide concluding observations for the section as a whole. They are cast entirely in the second person plural, and the commercial content is concerned primarily with just weights and measures. The influence of the Holiness editor is apparent in Yahweh's identification of himself as Israel's deliverer from Egypt (vv. 36b, 37b), and in the general requirement that his **statutes** and **ordinances** be observed.

35. The word **cheat** can be rendered "injustice" or "unrighteousness" (BDB). It is widely used, with a very general frame of reference. It is associated here with **mishpat** (**judgement, ordinances** in 18:4; "administering justice" – *NJB*), and the rest of the verse – **measuring length, weight or quantity** indicates what is in mind.

The word **measuring length** might denote a liquid measure in Job 28:25, but there is enough attestation, particularly within the priestly writing, to suggest that **length** is in mind here (e.g. Exod. 26:2, 8; 36:9, 15; Josh. 3:4; Ezek. 40:3, 5; 42:15; 48:30, 33; Zech. 2:1).

The word **weight** is widely attested in narrative, and easy to identify (e.g. Gen. 24:22; Num. 7:13; Josh. 7:21; Jdg. 8:26; 1 Sam. 17:5; 2 Sam. 12:30; 1 Kgs 7:47; 10:14).

The word **quantity** is rare, and can denote "measures" of water (Ezek. 4:11, 16); here any measure of capacity can be assumed.

36. The **balances** might be used for a kind of commercial dealing; in Jer. 32:10 they are used for weighing money.

The **weights** is a word that usually means "stone" (e.g. Prov. 27:3), but is common enough in the sense required here (cf. e.g. Deut. 25:13; 2 Sam. 14:26; Prov. 11:1; 16:11; 20:10, 23; Mic. 6:11; Zech. 5:8).

The **ephah** (lacking in Gk) is a grain measure (see on 5:11; cf. 6:13; Exod. 16:36; Num. 5:15; 28:5; Jdg. 6:19; Ruth 2:17; 1 Sam. 1:24; 17:17), and perhaps about twenty litres in capacity. The possibility of injustice or fraud in relation to the measure is clear in Deut. 25:14; Prov. 20:10; Isa. 5:10; Amos 8:5; Mic. 6:10).

The **hin** is a liquid measure of some kind (perhaps about four litres), often used in connection with offerings. The liquid might be water (e.g. Ezek. 4:11), oil (e.g. Exod. 29:40; 30:24; Num. 15:4, 6, 9; 28:5) or wine (e.g. 23:18; Exod. 29:40; Num. 15:5, 7, 10; 28:14). As the text here makes clear the measure was also in use in day-to-day commercial dealing.

All of these items – **balances**, **weights**, **ephah** and **hin** – must be **honest** ("just" – *RSV* (see on v. 15)). Truthfulness and consistency are clearly the underlying requirements; the stability of the commercial life of the community depends upon it.

On Yahweh as deliverer from Egypt see on 11:45 and cf. 22:33; 23:43; 25:38, 42, 55; 26:13, 45).

37. On the observance ("keeping") of **statutes** and **ordinances** see on 18:3, 4.

The comparable text in Deuteronomy is 25:13–16. Some of the same words occur there – e.g. **weights**, **ephah** (rendered "measure" there), **honest**, but in general the texts appear to be independent of one another, with more exhortation and clarification in Deuteronomy.

These concluding laws on just weights and measures are cast in the second person plural, and the Holiness editor has added some characteristic comments of his own.

4. PENALTIES FOR VARIOUS OFFENCES
(20:1–27)

The fourth main section in the Holiness Code is a catalogue of offences and penalties. All the offences have already been identified in chapters 18 or 19; the appropriate penalties are here set out. The text can be divided into the following units:

20:1–7, 27 – cultic misdemeanours
20:8–21 – family/sexual misdemeanours
20:22–26 – concluding exhortations.

The Holiness editing is easily seen in the exhortations in vv. 7–8, where Yahweh identifies himself (v. 7b) and requires that Israel **be holy** (v. 7a) and **keep** his **statutes** (v. 8a). Israel must **consecrate** herself (v. 7a, cf. 11:44), because Yahweh sanctifies her (v. 8b). The whole of the concluding exhortation (vv. 22–26) is also the work of the editor. The most obvious indicators are the familiar requirement to **keep . . . statutes and . . . ordinances** (v. 22a), the risk that the land will **vomit you out** (v. 22b, cf. 18:28), and the warning about the **practices** ("statutes") of the nations at present occupying the land (v. 23a, cf. 18:4). Yahweh continues to identify himself in these verses (vv. 24b, 26), as the one who has separated Israel from the nations (vv. 24b, 26), and who requires that the people be **holy** (v. 26).

The offences are dealt with at varying length and in varying degrees of detail. This may mean that they have been drawn from various sources by the Holiness editors, and perhaps elaborated. The catalogue itself is cast primarily in **casuistic** form, with the discussion introduced by such phrases as **any of the people** (v. 2) or **if . . .** (vv. 4, 6, 10, 12, 13, 14, 15, 16, 17, 18, 20, 21) or **all who** (v. 9). The apodictic form (second person singular) in v. 19 is exceptional. A tendency here and there for Yahweh to break in to the first person singular (vv. 3, 5, 6) may reflect the influence of the editor. Most of the Holiness editing is, as usual, cast in the second person plural.

The Molech cult is at the centre of attention in vv. 1–5; it has already been identified in 18:21, and its background

discussed there. In vv. 6, 27 mediums and wizards are discussed (see 19:31). Verse 27 appears to be an appendix, making it clear that offenders are liable to the death penalty.

The family offences (vv. 8–21) begin with a Decalogue principle - respect for parents (see 19:3), and continue with an extensive list of prohibited sexual relationships (see 18:6–18).

A variety of penalties are envisaged in the section. They range from death (vv. 9, 10, 11, 12 (probably), 13, 15, 16), by stoning (v. 2) or by burning (v. 14), to being **cut off** from the community (vv. 5, 6, 17, 18, 19 (probably)) and childlessness (vv. 20, 21). Phrases such as **their blood is upon them** (vv. 9, 11, 12, 13, 16), and **subject to punishment** (vv. 17, 19, 20) are not separate penalties, but statements whereby guilt is affirmed, and which vary depending upon the seriousness of the offence.

In vv. 1–7, 27 are set out the penalties attaching to the practice of the Molech cult (vv. 1–5, see 18:21), and of any resort to **mediums and wizards** (vv. 6, 27, see 19:31). The Holiness editing is evident in the concluding exhortation (v. 7), and probably also in Yahweh's words **I myself will set my face against . . .** (vv. 3, 5, 6).

2. The prohibitions regarding the cult affect natives and **aliens** (see on 16:29) alike, and the penalty is death by stoning. Other offences which explicitly require this penalty in the Holiness Code are being a **medium** or **wizard** (v. 27), and blasphemy (24:15–16). Elsewhere in the priestly writing sabbath-breaking leads to death by stoning (Num. 15:32–36). In D any form of apostasy is to be dealt with in this way (Deut. 13:10; 17:5), along with filial disobedience (21:21), prostitution (22:21) and adultery (22:24). Appropriation of the spoils of war also leads to stoning (Josh. 7:25). In other instances where the manner of death is unspecified, stoning is probably to be assumed (e.g. Exod. 21:29). Stoning was also a form of popular protest (1 Sam. 30:6; 1 Kgs 12:18).

The point is made that **the people of the land** carry out the sentence. In later times this phrase became a term of abuse for those who are ignorant or slack in religious matters, but

that is clearly not the case here. It has often been suggested that originally it denoted not "people in general", but a specific class – e.g. provincial landowners, or citizens who have a voice (B. A. Levine, *Leviticus*, 1989). They appear to have influence in the political affairs of the southern kingdom (e.g. 2 Kgs 11:12, 18–20; 21:24; 23:30, 35; 25:19 (2 Kgs 24:14 is an exception)) and are sometimes cited by Jeremiah and Ezekiel in close association with other leader figures (Jer. 1:18; 34:19; 37:2; 44:21; Ezek. 7:27; 22:25–29). In post-exilic times the phrase becomes a way of distinguishing returning exiles ("the people of Judah") from their opponents, those who remained in the land (Ezra 4:4; 10:2, 11; Neh. 10:30–31), and hence the tendency for the phrase to become one of disparagement. Here in the Holiness Code, an exilic text, the question of political power and property rights may be less important; the intention perhaps was to signify any male who was a full member of the community in the vicinity. *NEB* rendered the phrase "the common people", and G. J. Wenham (*The Book of Leviticus*, 1979) "ordinary citizens". *NJB* reads "the people of the country". N. H. Snaith (*Leviticus and Numbers*, 1967) suggests that it must mean "all the people".

Stoning would normally, but not always (Deut. 22:21), take place outside the city (24:14; Deut. 22:24; 1 Kgs 21:13). For further information about stoning procedures see 24:14 and Deut. 17:1–7.

3. The seriousness of the offence is emphasized; Yahweh himself indicates his intention to take action against the offender. On the phrase **set my face against** see 17:10, and on **cut. . . off from the people** see on 7:20; 17:4. The association of **cut off** here with Yahweh's personal action lends support to the view that in essence it denotes a penalty Yahweh himself will inflict, independently of human legal procedures.

The offence is serious because it involves **defiling** (making "unclean"– see on 10:10) Yahweh's **sanctuary**, and **profaning** Yahweh's name (see on 19:8, 12).

4. The phrase **close their eyes to** includes the verb "to conceal", and suggests a deliberate action; the general sense

here is clearly "to disregard" (cf. Isa. 1:15; Ezek. 22:26) (*REB* – "connive at"; *GNB* – "ignores").

5. Here Yahweh repeats his intention to take action on his own account (see v. 3, but with a different verb for **set**), insisting in addition that the man's **family** will also be **cut off**, along with others who may be involved. The sense of social solidarity which requires that his family be considered involved in a man's offence is well illustrated in the story of Achan (Josh. 7:24–26).

On the phrase **prostituting themselves** (used figuratively here) see on 19:29.

6. The same hostility is exhibited against those who resort to **mediums** and **wizards** (necromancy in general – see on 19:31). Yahweh will **set. . . face against** (as in v. 3) any who engage in such practice. Direct divine intervention will effect the penalty – **cut them off from the people** (see 7:20; 17:4).

27. It is possible that v. 27 has been displaced. In any event it addresses the question of the fate of **mediums** and **wizards** themselves (as opposed to those who resort to them in v. 6), and insists that they be put to death by stoning (see on v. 2).

The text seems to suppose, since both can be put to death, that the two titles represent two kinds of necromancy (*NJB* – "necromancer or magician"; *NIV* – "medium or spiritist"). *REB* makes a distinction between the dead who are summoned – "ghosts or spirits". The phrase **their blood is upon them** is used on a number of occasions in this chapter (vv. 9, 11, 12, 13, 16) – cf. the concept of "blood guilt" in 17:4. The idea is similar to the notion that some offences cause a person to be **subject to punishment** (vv. 17, 19, 20). It is an affirmation of guilt. For a person's **blood** to be **upon** him/her is a consequence of the most serious offences; the penalty in this chapter is invariably death.

7. This is a generalizing summary by the Holiness editor. The language is already familiar.

On **consecrate yourselves therefore, and be holy** (missing in Sam. and Gk) see on 11:44.

For **I am Yahweh your God** see 18:1, 30; 19:3, 10, 25, 31, 34, 36.

In vv. 8–21 there is a list of penalties relating to offences which in the main (but not entirely) take place within the family. Apart from the offence of cursing parents (v. 9) the list deals entirely with unacceptable sexual relationships (vv. 10–21). As in vv. 1–7 the penalties relate to offences already identified earlier (cf. 18:6–18; 19:3). The Holiness editing is most apparent in the introduction in v. 8.

8. On the necessity that Israel **keep** and **observe** Yahweh's **statutes** see 18:4. For God's self-description as the one who sanctifies you (literally "makes you holy") cf. 21:15, 23; 22:9, 16, 32.

9. To **curse** ("revile" – *REB*) a parent obviously infringes the requirement in 19:3a. The root word is that used in 19:4 in relation to the deaf, and it recurs in 24:11, 14, 15, 23. It is used in relation to the dishonouring of parents in the Book of the Covenant (Exod. 21:17), where death again is prescribed. Deuteronomy prefers to speak of anyone who **dishonours** parents (Deut. 27:16), and calls down a "curse" (a different word) on those who do so. The seriousness of the offence is indicated by the fact that offenders' **blood is upon them** (see on v. 27). The manner of death is not specified, but stoning seems likely.

10. The catalogue of sexual offences begins with **adultery** (v. 10) (for the repetition in the Heb. text see *NRSV*n) (cf.18:20). This is the word used in the Decalogue (Exod. 20:14; Deut. 5:17). Elsewhere its root is most frequently found in wisdom (e.g. Job 24:15; Prov. 6:32) and prophetic literature (e.g. Jer. 3:9; 5:7; 7:9; 23:14; Ezek. 16:38; 23:45; Hos. 4:2). The manner of death is not specified (cf. Deut. 22:22), but stoning again seems likely (cf. Deut. 22:23–24).

The list of prohibited relationships within the family (vv. 11–21) can be compared to that in 18:7–18 and 18:19–23: mother/stepmother (v. 11); daughter-in-law (v. 12); homosexuality (v. 13); two closely-related women (v. 14); bestiality (vv. 15, 16); sister/half-sister (v. 17); menstrual woman (v. 18); aunt (v. 19); uncle's wife (v. 20); sister-in-law (v. 21).

It will be apparent that in all essentials the same ground is covered as in 18:7–23, the exception being the lack of

explicit reference here to relations with a granddaughter (cf. 18:10).

Some of the terminology in the catalogue that follows (vv. 11–21) is the same as that used in 18:7–18 – e.g. **uncovered**, **nakedness**.

11. The phrase **lies with**, meaning sexual intercourse, is employed in the Manual of Purity (15:24).

The offences which demand a death penalty, and for which there is usually the declaration **their blood is upon them** (cf. vv. 12, 13, 16 – see on vv. 9, 27), are the first five in the list above.

12. The list does contain occasional explanations. Relationships with a daughter-in-law are **perversion** ("incest" – *RSV*; *GNB*) ("violation of nature" – *REB/NJB*). This word is actually that used in 18:23 of bestiality. It denotes "confusion" (BDB), the mixing of distinct entities and the dislocation of a particular sense of order. It seems likely that the word would fit all these offences; the reason for explicitness in v. 12 is perhaps to put the nature of this particular relationship (with a daughter-in-law) beyond doubt.

13. Homosexual acts are described as **abomination**, as in 18:22 ("hateful thing" – *NJB*; "detestable" – *NIV*; "disgusting" – *GNB*).

14. The taking of a wife and her mother is **depravity** ("lewdness" – *REB*; "incest" – *NJB*; "wicked" – *NIV*; "disgraceful" – *GNB*). This is the word used in 18:17 and 19:29.

These words (**depravity, abomination, perversion**) clearly carry distinct meanings (see on 18:17, 22, 23), but together they constitute very serious infringements of the divine order, as conceived by the priestly legislators, and call for the death penalty.

The manner of execution is specified only in relation to the two women (**a wife and her mother**), where it is required that the offenders be **burned to death**. In the other cases stoning is perhaps to be assumed. Death by burning occurs again in 21:9 – the case of a priest's daughter who becomes a prostitute (cf. also Gen. 38:24) – but is otherwise not attested. Why this particular form of death was associated

with prostitution, and with this particular offence involving **a wife and her mother** is unclear. Burning has cultic overtones (cf. Deut. 13:16; Josh. 7:25), and is a means by which impurity is eliminated (Num. 31:21–23).

The other five offences in the catalogue (vv. 17–21) envisage penalties enacted directly by God himself. Much of the terminology is already familiar.

17. To **see . . . nakedness** means the same as to have **uncovered** it (cf. vv. 18, 19, 20, 21 – see on 18:7).

Relationships with a sister are described as **disgrace** ("infamous disgrace" – *REB*). The Hebrew word is rarely used with this sense (cf. Prov. 14:34 – "reproach"); usually the root means "steadfast love". N. H. Snaith (*Leviticus and Numbers,* 1967) suggested that some such idea as "eager zeal" or "desire" could have taken on both positive and negative connotations. *GNB* understands it to mean that they are to be "publicly disgraced".

The penalty is that the offenders will be **cut off** (cf. v. 18) – see on 7:20; 17:4). *NJB*'s "executed in public" would be unique and seems unlikely. *GNB* takes it to mean "driven out of the community", and B. A. Levine (*Leviticus,* 1989) "excommunicated".

It is also asserted that offenders are **subject to punishment** (*RSV* – "bear. . . iniquity") (cf. v. 19, see on 5:17). *REB* reads "be held responsible").

18. The word **sickness** (of menstruation) was used in 15:33, and **flow** occurs in 12:7 (the blood following childbirth).

NJB here prefers "outlawed" for **cut off**.

19. Relationships of this kind are said to **lay bare one's own flesh** (see on 18:6).

20. Here it is clear that sex with a woman can be an offence against the man to whom she belongs – the uncle's **nakedness** is **uncovered** (see on 18:7–8).

The phrase **subject to punishment** is literally "to bear sin" (absent in Gk), rather than "iniquity" (the usual word). The matter is in the hands of God, but the legislators are confident that God will take action of some kind. The conviction

that these "penalties" are God's responsibility is confirmed
by what is specified here and in v. 21 – **they shall die/be child-
less**. The word means literally "stripped" (BDB). *REB* reads
the word as **proscribed**, and understands **die** in v. 20 as **put to
death**; that childlessness is in mind is strongly suggested by
Gen. 15:2; Jer. 22:30 (thus *NIV, GNB*). To be childless in
ancient Israel was serious, not only because it was a social
stigma (cf. e.g. 1 Sam. 1:6) or because children perpetuate
the family name, but also because they constitute a source of
security in old age. Since children are signs of divine blessing
(Pss. 113:9; 127:3–5), childlessness here means blessing with-
drawn.

21. Taking a sister-in-law is described as **impurity**, an
unusual word in this context. In the Manual of Purity it is
used of menstruation (12:2; 15:19, 20, 24, 25, 26, 33), and
again in 18:19. It is also used in the phrase "the water for
cleansing" (Num. 19:9, 13, 20, 21).

It seems clear that the offences in vv. 17–21 are deemed
less serious than those in vv. 11–16; the confidence that
judgement is in the hands of God and that he will act accord-
ingly is nevertheless real.

The concluding verses (vv. 22–26) contain for the most part
some general observations and exhortations from the
Holiness editor. In v. 25 there are some more specific
comments about clean and unclean creatures which recall
the Manual of Purity (11:1–47 and particularly 11:41–45).
Familiar indications of the work of the Holiness editor are
present throughout.

22. It is important to **keep** and **observe** Yahweh's **statutes**
and **ordinances** (see on 18:4).

On the danger that the land will find Israel repulsive and
vomit you out see on 18:25, 28.

23. The importance of not following the **practices** (i.e.
"statutes") **of the nations** has already been stressed in 18:3,
30.

That Yahweh is expelling (**driving out**) these nations
before Israel is another key editorial theme (see on 18:24).

The thought that Yahweh **abhorred** them (v. 23b) ("feel a

loathing" or "dread" – BDB) is new, and occurs only here in the Holiness Code. It is found in some measure in the early narrative tradition (JE) (Num. 21:5; 22:3; Exod. 1:12) and in the priestly writing at Gen. 27:46 (rendered weakly as "weary" by *NRSV*) (cf. also 1 Kgs 11:25; Prov. 3:11; Isa. 7:6).

24. The idea that Israel is to **inherit** the land (v. 24) is also new, but the word recurs in 25:46. The idea is very common in Deuteronomy, though sometimes expressed by a different word. The root used here does occur in Deut. 2:31; 16:20, and also provides the word **possess**. This translation is very common in D (*RSV*) (e.g. Deut. 1:8, 21, 39; 2:24, 31; 3:12, 18, 20; 4:1, 5, 14, 22, 46, 47; 5:31, 33).

The idea that Yahweh **will give** the land (cf. also 23:10; 25:2, 38) is another close connection with Deuteronomy (e.g. 1:8, 20, 25, 35, 36, 39; 2:12; 3:18; 4:1, 21, 38, 40; 5:16, 31).

The familiar description of the land as **flowing with milk and honey** is found in the early narrative (Exod. 3:8, 17; 33:3; Num. 13:27; 16:13, 14), in the priestly writing (Exod. 13:5; Num. 14:8) and in Deuteronomy (6:3; 11:9; 26:9, 15; 27:3; 31:20) (cf. also Josh. 5:6; Jer. 11:5; 32:22; Ezek. 20:6, 15). It was evidently common ground in both priestly and Deuteronomistic circles.

Yahweh's identification of himself as Israel's God, and the description of the exodus as an act of separation are characteristic of the Holiness Code. The latter is a distinctively priestly interpretation of Israel's origins (it recurs in v. 26), and provides theological support for priestly understandings about the importance of holiness. The word continues to be used in the priestly writing for the way in which clerical groups are "separated" from Israel at large (Num. 8:14), and in post-exilic literature for Israel's separateness from the people of the land (e.g. Ezra 6:21; 9:1; 10:11; Neh. 9:2; 10:28; 13:3).

25. Here there are clear echoes of 11:47. The verb **to make a distinction** is constructed from the same root as **separated** (v. 24) (see 10:10; 11:47).

For **animal** see 11:46, and for **clean** and **unclean** see 10:10; 11:47.

For the root behind **bring abomination on yourselves** see 11:10, and for **teems** see 11:44, 46 ("moves").

26. The concluding requirements are that Israel be **holy** because Yahweh is **holy** (see on 10:10 and cf. 19:2; 22:32) (the reference to Yahweh's holiness is absent in Sam.), and because of the act of separation which Yahweh has accomplished (see v. 24).

27. For comment see after v. 6.

5. RULES CONCERNING PRIESTHOOD/REGULATIONS ABOUT OFFERINGS
(21:1–22:33)

This large section deals essentially with the priesthood (21:1–22:16) and with offerings (22:17–33). It can be divided into the following:

21:1–15 – priests and their families
21:16–24 – physical requirements for the priesthood
22:1–16 – priests and holy food
22:17–25 – blemished offerings
22:26–30 – newborn animals as offerings
22:31–33 – concluding exhortation.

The Holiness editing is most obvious in the concluding exhortation (22:31–33). Here Yahweh names himself (vv. 31, 33), and particularly as the one who sanctifies Israel (v. 32, cf. 20:8), and as the deliverer from Egypt (v. 33, cf. 19:36). Israel's obligation to **keep** his **commandments** (v. 31, cf. 18:4–5), and the dangers of profaning that which is holy (v. 32, cf. 19:8, 12) are both key themes in the Holiness Code. Aspects of these editorial interests are evident earlier in the section, particularly Yahweh's self-identification (21:12; 22:2, 3, 8, 30) as the one who sanctifies priests and Israel (21:8, 15, 23; 22:9, 16).

The material about priests is cast mainly in the third person, singular or plural, but parts of the laws about offerings are framed as statutes (22:19, 20, 22, 24, 25, 29, 30) (second person plural). Here, as usual, editorial accretions are likely.

Background to the history of the priesthood has been

discussed in connection with Leviticus 8–10, and to the offerings in connection with Leviticus 1–7. The priest who is **exalted above his fellows** is not yet designated "high priest" (cf. e.g. Num. 35:25), but the office and function is clearly emerging. The prophet Malachi is a useful source of external information on blemished offerings (1:6–2:9). The main function of the texts in this section here in the Holiness Code is to apply holiness principles and ideology to the priesthood as an institution and to the offerings Israelites bring.

In 21:1–15 the first part deals with priests in general (vv. 1–9) and the second with the high priest, he who is **exalted above his fellows** (vv. 10–15). The main requirements impose limitations on a priest's contact with the dead (vv. 1–4), on his involvement in mourning rites (vv. 5–6), and in relation to the women he may marry (v. 7). These limitations are more strict in relation to the high priest (vv. 10–15). Their aim is to ensure that the priests are **holy** both to God (v. 7) and Israel (v. 8).

1. The persons addressed here are the priests themselves, a pattern which is the norm for the section as a whole (21:16; 22:2, 18; cf. 6:8–9). On the priests as **sons of Aaron** see on 1:5 and the introduction to Leviticus 8–10.

The word **defile** comes from the root usually rendered "unclean".

The phrase **for a dead person** embodies the word which often means "soul" or "living being" (BDB). It is not uncommon in the priestly writing and the Holiness Code as a word for the deceased (see 19:28; 22:4; Num. 5:2; 6:11; 9:10; cf. Hagg. 2:10).

2. As the Manual of Purity makes clear, contact with death is a primary source of uncleanness (cf. e.g. 11:8, 11, 24, 25, 27, 32, 35, 39, 40), and the priest must avoid it. Exceptions are to be found among **his relatives**. The word here ("flesh" – BDB) has already occurred in 18:6, 12, 13, 17; 20:19; cf. also 25:49; Num. 27:11). These relatives are so much part of his own physical being that their "flesh" is his. They include **mother, father, son, daughter** and **sister**.

3. The sister can be an exception only if she is unmarried and

a **virgin** (v. 3). In Israelite law virginity clearly had monetary value to a family (Exod. 22:16), but was also a matter of reputation (Deut. 22:19). As far as the Holiness Code is concerned a woman who ceases to be a virgin belongs elsewhere, and can no longer be considered closely linked to her brother (cf. Gen. 2:24). G. J. Wenham (*The Book of Leviticus*, 1979) reads **virgin** as a young woman of marriageable age ("teenage").

4. There are particular difficulties with the meaning of **as a husband**. The word can be used of owners (e.g. Exod. 21:28), of inhabitants (e.g. Josh. 24:11), of rulers (Isa. 16:8), and in a wide variety of contexts of relationship. *RV* understands the point to be that the priest as a **chief man** must not open himself to situations of defilement. The word is well attested with the sense "husband", not least in legal texts (Exod. 21:3, 22; Deut. 22:22; 24:4), and it is reasonable to suppose that that is its meaning here. If so, the sense remains problematic. *REB* and *NJB* assume that a priest must not defile himself for a female relative who has married (N. H. Snaith, *Leviticus and Numbers*, 1967). *GNB* and *NIV* understand any relative by marriage (M. Noth's (*Leviticus*, 1962/1965) translation suggests a woman who has married into the priest's family). The point may be that he must not defile himself on behalf of any members of the family into which he marries (J. E. Hartley, *Leviticus*, 1992). B. A. Levine (*Leviticus*, 1989) notes that all relatives for whom a priest can allow himself to become impure are consanguineal relatives; a wife is not, and the point may simply be that she is in mind. This would mean that the "one flesh" of Gen. 2:24 was not an absolute, at least with respect to priests.

Whatever the action envisaged it would lead the priest to **profane himself**. This word is widely used in the Holiness Code – in relation to the pollution arising from sexual misdemeanours (19:29; 21:9, 15), or affecting sacred places (21:12, 23), or sacred things (19:8; 22:9, 15). In particular, the name of God may be profaned (18:21; 19:12; 20:3; 21:6; 22:2, 32).

5. Here attention turns explicitly to mourning rites, though it is possible that v. 2 has such rites in mind, and that the defilements in vv. 1–4 are therefore primarily those that would arise from participation in the rites.

The phrase **make bald spots** uses the same root word as **bald** in 13:40. The practice is forbidden for everyone (not simply priests) in Deut. 14:1. The word is widely attested in connection with mourning rites in prophetic literature (e.g. Isa. 3:24; 15:2; Jer. 47:5; 48:37; Ezek. 7:18; 27:31; Amos 8:10; Mic. 1:16). Gk adds that these tonsures are for the dead.

The phrase **shave off the edges of their beards** echoes the prohibition in 19:27b, and **make any gashes in their flesh** that in 19:28. The verb **shave off** does not occur in 19:27, but has been used in the Manual of Purity (13:33; 14:8, 9). Participation in such rites is clearly deemed to defile through contact with death.

6. Here the positive aspect is stressed – priests are to be **holy to their God**. On profanation (here in relation to God's name) see v. 4. Explanations are forthcoming in the rest of the verse, and this may denote a contribution of the Holiness editor.

On **the offerings by fire** (possibly food offerings of meat) see on 1:9.

The phrase **food of their God** is extensively used in this section as a description of what the priests must offer (cf. vv. 8, 17, 21, 22; 22:13, 25). As 22:25 suggests, the phrase includes food in general, all food that can be legitimately offered to God and in which the priest and his family may share (22:13), and not simply that made from cereal products (cf. also Num. 28:2).

7. These concerns about protecting the holiness of the priests affect the question of marriage. Three categories of woman are precluded as wives.

The **prostitute** would be one known to have committed acts of fornication; the word might also carry overtones of religious apostasy – cf. its use in 17:7; 19:29; 20:5.

The **woman who has been defiled** (the root word as in v. 4) is perhaps one who has been forced into sexual relations against her will (cf. Deut. 22:25–27) (cf. N. H. Snaith, *Leviticus and Numbers*, 1967). M. Zipor ("Restrictions on Marriage", 1987) thinks it best to see the expression as a repetition of the point made about prostitutes; the priests must not marry women "profaned by prostitution" (cf. *NIV*, B. A.

Levine, *Leviticus*, 1989). J. E. Hartley (*Leviticus*, 1992) identifies this second category as the woman who has participated in alien cult practices.

The third category, a woman **divorced from her husband**, employs a verb meaning "to drive out" or "to cast out". It occurs elsewhere in this section (21:14; 22:13), and also in connection with marriage and divorce in Num. 30:10; Ezek. 44:22.

The idea that the woman the priest marries must be a virgin is explicit in Ezek. 44:22, and in relation to the high priest in 21:13. An Israelite law on divorce (using different legal terminology) can be found in Deut. 24:1–4.

8. That the priests are also **holy to you** as well as **holy to their God** (v. 6) is a good indication of their role as bridge between God and people.

On the **food of your God** see v. 6.

9. A particular obligation is placed upon the **daughter** of a priest. She must not **profane** herself (see v. 4) through **prostitution** (see v. 7; cf. 19:29); such an action would **profane** the priest her father (his "name" in Gk). There is no attempt to explain why a daughter is singled out in this way; anxiety about cultic prostitution may be one reason. The penalty is death by burning (see 20:14).

10. Attention turns to the priest **who is exalted above his fellows**. This phrase occurs for the first time here. It is not used of Aaron in the ordination rites in chapters 8–10, and it is clear there that all priests receive **the anointing oil** and wear special **vestments** (8:30). Those rites do, however, depict Aaron as in some sense "chief", and the **anointing oil** is in the first instance his (cf. 8:12; Num. 35:25; Ps. 133:2). There are obviously **vestments** which are uniquely Aaron's (cf. 8:7–9). The title given here **the priest who is exalted** is sometimes rendered **high priest** (e.g. Num. 35:25, 28; Zech. 3:8).

The word **consecrated** (better "ordained") renders the literal expression "to fill the hand" (see on 8:33).

Two mourning rites are precluded for the high priest (presumably in addition to those described in v. 5). The first involves letting dishevelled **hair** ("letting the hair of his head hang loose" – *RSV*). This would entail removing the turban (8:9; cf. the leper in 13:45).

The second forbids the high priest to **tear his vestments**. Both of these commands had already been given to Aaron in the context of the deaths of Nadab and Abihu (see on 10:6).

11. The requirements concerning contact with death are clearly more stringent with regard to the high priest. Not even for **father** or **mother** is he allowed to **defile** himself (i.e. make himself unclean).

12. The demand that he remain in the sanctuary because the anointing oil is upon him recalls the words of Moses to Aaron in 10:7.

On **profane** see v. 4.

The word **consecration** is rare in the context of priestly ordination. It comes from the root which provides the word **crown** in 8:9. In Num. 6:1–21 it is used specifically of Nazirite consecration.

13. The requirements are also more stringent with respect to marriage. In addition to the three excluded categories of woman cited in v. 7 the high priest must marry **a wife in her virginity** (see v. 3). Gk understands it to mean "from among his people".

14. This clearly excludes a further category, the **widow** (cf. Ezek. 44:22 where widows are forbidden to Levitical priests in general). These stipulations here and in v. 7 bear witness to the separateness of the hereditary priesthood, and are intended to leave no room for doubt about its credentials as such (for further discussion see J. R. Wegner ("Leviticus", 1992, pp. 41–42)). M. Zipor's ("Restrictions on Marriage", 1987) proposal about the **woman who has been defiled** would be applicable here too (see v. 7).

15. The risk cited here is that the high priest will **profane his offspring** ("dishonour his descendents" – *REB*).

In summary the passage distinguishes between the holiness of the priests, and that of the priest who is **exalted**, with more stringent requirements and exclusions regarding the latter. The switch to the third person plural in vv. 5, 7 (the mourning rites) may denote an accretion within these priestly sources. This material has been expanded and explained by the Holiness editor (vv. 6b, 8, 12b, 15).

In 21:16–24 certain physical requirements are set out concerning those who are going to function as priests. All blemishes render a man of priestly family unfit to take part in priestly service. A list of such blemishes is provided (vv. 18–20). These conditions do not prevent him, as a member of a priestly family, from receiving priestly income (v. 22).

17. This is special information for the priests – **say to Aaron**. On **generations** see 3:17 (*REB*, *GNB* reads "for all time").

The word **blemish** (*NJB* – "infirmity") is widely used in laws of defects which would exclude an animal as an offering (cf. e.g. 22:20, 21, 25; Num. 19:2; Deut. 15:21; 17:1). It is used later of injuries that might be inflicted on a human being (24:19, 20). Other texts which use the word of human disfigurements are 2 Sam. 14:25, Song 4:7, Dan. 1:4. Figurative usage occurs in Deut. 32:5; Job 11:15; 31:7; Prov. 9:7.

On the phrase **to offer the food of his God**, as a description of the essence of priestly service, see v. 6.

18. The list of blemishes includes the **blind** (see on 19:14) and the **lame**. A saying excluding such people seems to have been preserved in 2 Sam. 5:6, 8. Other texts which make this close link are Deut. 15:21 (of animals); Job 29:15; Isa. 35:5, 6; Jer. 31:8; Mal. 1:8 (of animals).

Two other conditions are cited in v. 18. The phrase **mutilated face** is speculative (*REB* – "stunted"; *NJB*, *GNB*, *NIV* – "disfigured"); according to BDB it comes from a verb "to slit". It is possible that "a limb too short" is intended, to contrast with the phrase that follows (B. A. Levine, *Leviticus*, 1989).

The phrase **a limb too long** is also rare (*REB* – "overgrown"; *NJB*, *GNB*, *NIV* – "deformed") (but see 22:23 and cf. the use of the root in Isa. 28:20 with the sense "stretch oneself").

19. Two other blemishes are a **broken hand** or **foot**. The word **broken** comes from the verb "to break" (*REB* – "deformed"; *GNB*, *NIV* – "crippled"). It occurs later in relation to fractured limbs (24:20). These are presumably conditions which would only temporarily preclude a priest from serving.

20. A further six conditions are specified.

A **hunchback** (*REB* – "misshapen brows") is a speculative but plausible translation (the word occurs only here).

Dwarf ("rickets" – *NJB*) is also uncertain; the root occurs in 13:30; 16:12 of something "thin" or "small" ("a withered member" – J. E. Hartley, *Leviticus*, 1992).

The word **blemish**, used here in relation to sight, is difficult ("confusion", "obscurity" – BDB; *REB* – "film over his eye or a discharge from it"; *NJB* – "ophthalmia"; *GNB* – "eye disease"; *NIV* – "eye defect"). The root is similar to that rendered "perversion" in 18:23; 20:12 (better "confusion").

The **itching disease** (*REB/NJB* – "scab") is paralleled in the law about animal offerings (22:22; cf. also Deut. 28:27).

The **scabs** (*REB* – "eruption"; *NJB* – "running sores") (some kind of eruptive disease – BDB) also occur in the animal law (22:22).

NIV reads these two conditions as "festering or running sores" and *GNB* as "skin disease". B. A. Levine (*Leviticus*, 1989) comments on the *JPS* translation of "boil–scar" and "scurvy". J. E. Hartley (*Leviticus*, 1992) prefers "festering rash" and "lichen".

The phrase **crushed testicles** comes from two words. The word **crushed** (*REB* – "ruptured"; *NIV* – "damaged") is speculative, but the second root occurs in Jer. 5:8 ("lusty") and suggests genitalia. *NJB*, *GNB* take the phrase to mean that he is a eunuch.

21. The basic requirements are repeated; any **blemish** precludes a priest from rendering the **offerings by fire** and the **food of his God** (see v. 6).

22. This does not mean, however, that he is not entitled to **eat the food of his God** (the reference to food is absent in Sam.) – i.e. to receive priestly income by partaking of those parts of the offerings which belong to priests.

The distinction between priestly food which is **most holy** and that which is simply **holy** came to the fore in 10:12, 17. That which is **most holy** must be eaten in a holy place (10:13).

The Manual of Offerings gives various indications of what priests were entitled to from the offerings (cf. e.g. 2:3, 10; 6:16–18, 26, 29; 7:6, 8, 9–10, 31–35).

23. The important thing is that the priest with a defect must not approach the **curtain** or the **altar** – to engage, that

is, in the acts of atonement that take place there. On the **curtain** see 4:6 (cf.16:2, 15).

On **profane** see v. 4.

The plural **sanctuaries** is surprising in a priestly text (Gk reads "the sanctuary of his God"); the meaning may be "my holy things". Alternatively we may have a survival from pre-Josianic times (cf. J. R. Porter, *Leviticus*, 1976). On Yahweh as the one who sanctifies (makes holy) see on 20:8 and cf. v. 4.

It is important to note that although priests with these defects are forbidden to engage in acts of atonement, they may nevertheless enter the sanctuary and eat the most holy food (i.e. food which can only be eaten in the sanctuary (see further D. P. Wright, *The Disposal of Impurity*, 1987, p. 165 n.5).

24. Contrary to vv. 16–17, it appears that these laws are promulgated, not only to Aaron and his family, but to all Israel. This is perhaps an accretion, reflecting the process by which material which was originally of a limited frame of reference becomes understood as **torah** for all Israel.

In 22:1–16 the question of holy food, raised in 21:22, is addressed more directly, and in considerable detail. The main concern is that priests who for any reason are unclean should not profane holy things. Steps required for avoiding such an eventuality are indicated.

2. The passage is addressed to **Aaron and his sons**, and begins with the solemn warning that they **deal carefully** with the **sacred donations** which the people offer.

These **sacred donations** ("holy things" – *RSV*) do indeed include those parts of the sacrifices and offerings to which the priests have a right. The warning is a precaution, the point being that they must not take advantage of that right lightly, and unaware of the risks of contamination to which the sacred donations are exposed.

The word **deal carefully** ("keep away from" – *RSV*) might be rendered "separate themselves from" (thus *RV*), the root being that which provides the word "Nazirite" (see Num. 6:2). The use of the word as here – "hold sacredly aloof from" (BDB) – is unusual (cf. Lev. 15:31). *REB* reads "be scrupulous". *NJB* prefers "they must be consecrated through the

holy offerings. . .". Both *GNB* and *NIV* read "treat with respect".

The risk is that the priests will **profane** Yahweh's name (see on 19:8, 12).

3. On **generations** see 3:17.

The risk of **uncleanness** is the point at issue. If a priest were to contaminate **sacred donations** then he would be **cut off** (see on 17:4).

4. The text then turns to some of the kinds of uncleanness that would have this effect. For **leprous disease** see 13:2. For **suffers a discharge** see 15:2. The conditions for cleansing, which seem to presuppose those indicated in the Manual of Purity, must be met before a priest can partake of the **sacred donations** – those offerings to which he is entitled. The other kinds of uncleanness specified arise out of contact:
– with death (v. 4). This would be through contact with any thing (or person) that was itself contaminated through contact with a corpse or carcase (see on 5:2–3; cf. 11:8, 24, 27, 36, 38, 39–40). On **corpse** see 21:1.
– with a man who has had an emission of semen (v. 4, see on 15:16–18).

5. – with a **swarming thing** (cf. 11:10, 29, 41–43).
– with anyone who is unclean for any reason (the last phrase in v. 5b seems aimed at all conceivable unclean conditions).

6. Here the measures necessary for cleansing a priest who becomes unclean are indicated. The two basic requirements – a period of waiting until the evening, and the bathing of the body – are familiar from the Manual of Purity.

For the **evening** see 11:24, 25, 27, 28, 31, 32, 40.

The bathing of the body (rather than simply clothes) occurs in connection with leprous disease (14:8, 9), discharges (15:5, 6, 7, 8, 10, 11, 13), and emissions (15:16, 18, 27). See also 16:24; 17:15–16.

7. Here **evening** is defined precisely – **when the sun sets**.

8. A further situation of defilement is specified – the uncleanness of an animal which "dies of itself" (*RSV*) or is **torn by wild animals** (see 7:24; 17:15). For a priest to eat such flesh would make him **unclean**.

9. The insistence that the priests **keep my charge** (v. 9) is

common as a description of their responsibilities (cf. e.g. 8:35; Ezek. 44:8, 16; 48:11; Zech. 3:7). In Numbers it is also used of Levitical duties (e.g. Num. 1:53; 3:32; 31:30, 47).

On **incur guilt** ("bear sin" – *RSV*) see 5:17; 20:20, and on **profaned** see 21:4. On Yahweh as sanctifier cf. vv. 32; 20:8; 21:15.

In the next part (vv. 10–16) consideration is given as to whether anyone else can eat a **sacred donation**.

10. The word **lay person** ("outsider" – *RSV*) (vv. 10, 12, 13) used in relation to priestly families is common in the priestly writing (e.g. Exod. 29:33; 30:33; Num. 1:51; 3:10, 38; 18:4, 7). It can be widely used in other contexts in connection with whatever is "strange" or "foreign". The verses following help to determine who is and who is not an outsider, particularly with regard to dubious cases.

Among the persons excluded are **a bound. . . servant of the priest**. ("sojourner of the priest's" – *RSV*). The word is uncommon, occurring mostly in the priestly writing and the Holiness Code, and should be distinguished from "the alien who resides" (see on 16:29). Its precise significance is uncertain. *NJB* reads **guest**. For its use elsewhere see 25:6, 23, 40, 45, 47; Gen. 23:4; Exod. 12:45; Num. 35:15; Ps. 39:12. The person is presumably resident in the priestly household, and probably on a temporary basis.

Another excluded person is the priest's **hired servant** (see on 19:13). These people ("guest" and "hired servant") are not full members of the priest's household, and therefore not entitled to eat the **sacred donations**.

11. On the other hand a slave, acquired by purchase, is a full member of the household, and can eat priests' food. Furthermore, anyone born in the priest's house, including presumably anyone born to the slave, **may eat of his food**. *REB* reads "slaves born in his household". The phrase rendered **acquires. . . by purchase** tends to be used of the acquisition of land, livestock, or possessions in general (Gen. 31:18; 34:23; 36:6; Josh. 14:4; Ps. 105:21; Ezek. 38:12, 13).

12. Turning again to excluded persons the daughter of a

priest who marries a **layman** (see on v. 10) no longer has a right to priestly food.

The word **offering** here is **terumah** (see on 7:14).

13. This exclusion no longer operates if the daughter is **widowed** or **divorced** (see on 21:7, 14), and provided she is childless. If she returns to her father's house then once again she is entitled to priestly food. It is to be assumed that if she has a child then she and the child are the responsibility of the other family.

14. Here attention turns to the consumption of **sacred donations unintentionally**. The Manual of Offerings shows interest in various kinds of inadvertent offence (see on 5:15, and cf. 5:2–4, 17). Here the requirement is full compensation with respect to the value of what has been eaten, with the addition of one-fifth. This is fully in accordance with 5:16.

15. There follow concluding warnings of a general nature. The priests must not **profane** (see on 21:4) the **sacred donations** which the people **offer** (the **terumah** root as in v. 12).

16. On the bearing of **guilt** ("iniquity and guilt" – *RSV*) see on 5:1 and 5:2. *NRSV, NJB, NIV* see an allusion to guilt/reparation offering here.

In summary, we have here further materials from priestly sources, and which for the most part appear to be largely untouched by the Holiness editor. Obvious signs of the latter are present in vv. 2, 3, 8, 9, 16, in Yahweh's identification of himself.

The question of blemished offerings is raised in 22:17–25. Animals affected in this way are excluded, and some indication is given of the conditions which constitute a blemish (vv. 22–25).

18. The subject matter is obviously of direct importance to both priests and people. Gk has **congregation** instead of **people**. On the phrase **house of Israel** see 17:3. Gk has **of the people of Israel** at this point.

On **aliens** see 16:29 (this is not the word used in v. 10).

On **presents an offering** see 1:2.

The phrase **in payment of a vow** is the votive offering of 7:16; the **free-will offering** is also cited in 7:16. The key

difference is that this text (v. 18) reckons with the possibility that these offerings could be a **burnt offering**. In 7:11–18 (as also here in v. 21) the context is the **well-being offering**.

Since the **burnt offering** was wholly given to God it is obviously appropriate that the question of blemishes be confronted, but as v. 21 makes clear there is to be no diminution of standards, whichever kind of offering is envisaged.

19. The terminology is reminiscent of that contained in the Manual of Offerings. For **acceptable** and **a male without blemish** see 1:3. Detailed instructions for the offering of **cattle, sheep** or **goats** are contained in 1:3–13.

20. The word **blemish** is that used in relation to priests in 21:16–24 (the word in v. 19 and 1:3 is different and denotes "perfection").

21. The word **fulfilment** in relation to vows has not previously been used, and may denote a special kind of votive offering (cf. Num. 15:3, 8). Details for the presentation of **well-being offerings** from **herd** or **flock** are given in 3:1–18.

The word **perfect** (v. 21) is rendered **without blemish** in v. 19 by *RSV*.

In vv. 22–25 a list of conditions that constitute a **blemish** is provided. This parallels to some extent the blemishes that may affect priests in 21:16–24.

22. For **blind** see 21:18.

The word **injured** ("lame" – *NJB*) comes from the verb "to break" (cf. 6:28; 11:33; 15:12), and probably denotes a fractured limb (cf. Exod. 12:46; Num. 9:12). The word "broken" in 21:19 comes from the same root.

The word **maimed** comes from the verb "to cut" or "to sharpen" (BDB); it is uncommon with the sort of sense required here (the word rendered "mutilated face" in 21:18 is similar but not the same), and "mutilation" is a reasonable inference.

The phrase **having a discharge** (v. 22) comes from a word meaning "running"/"suppurating" (BDB) ("running sore" – *REB, GNB*; "ulcerous" – *NJB*). It is not that customarily used in the Manual of Purity (e.g. 15:2).

On **itch** (allergic condition?) see 21:20.

For **scabs** see 21:20.

On **offerings by fire** see 1:9.

23. The **ox** and **lamb** are presumably representative of all animals that might be offered.

For **too long** see 21:18.

This law (v. 23) allows an exception in the case of **free-will offerings**. Slightly deformed animals (a part too long or too short) can be offered. The requirements for a votive offering, however, are more stringent, and no exception in relation to "blemishes" can be allowed. This is a good example of priestly decision-making with regard to border-line cases. B. A. Levine (*Leviticus*, 1989) suggests that the entirely voluntary nature of the free-will offering gave scope in the minds of the legislators for some relaxation of the customary requirement.

24. The law about **testicles** parallels that in 21:20. The word is not actually used here, but is to be assumed.

The word **bruised** ("pressed" or "squeezed" – BDB) is rare (cf. 1 Sam. 26:7; Ezek. 23:3).

The word **crushed** is used in a variety of contexts with this sense (e.g. Num. 14:45; Deut. 1:44; 9:21).

The word **torn** also occurs in a range of contexts; it can be used, for example, of the "tearing away" or "pulling off" of a ring (cf. e.g. Jer. 22:24).

The word **cut** is well attested, and is as common as any with this meaning (cf. e.g. its use in Exod. 4:25).

The phrase **do within your land** ("sacrifice" – *RSV*) adds nothing to the meaning, but shows the orientation of the Holiness Code towards Canaan and its occupation (cf. e.g. 18:3, 28; 19:9–10, 23–25, 33–34; 20:2, 4, 22–24; 23:10, 22, 39–43; 25:2–55; 26:34–45). It is intended to contrast with practice in other lands (J. E. Hartley, *Leviticus*, 1992).

25. A final "blemish" of a different kind are **animals from a foreigner** (literally "foreignness"). The word occurs only here in the Holiness Code, but there are several references in the priestly writing (Gen. 17:12, 27; Exod. 12:43) (cf. also Isa. 56:3, 6; 60:10; 61:5; 62:8; Ezek. 44:7, 9). Such animals are presumably unacceptable because they do not have origins in the holy land among the holy people, and because there

are defilement risks stemming from their origins which the Israelite owner may not be aware of.

On **food to your God** see 21:6.

It is possible of course that v. 25b is seeking to explain why such creatures obtained from foreigners are not acceptable. *REB* may be understanding it thus with its reading "their deformity is inherent in them" (cf. *GNB*).

It seems more likely that v. 25a is an insertion, and that v. 25b is a summarizing explanation which has reference to vv. 22–24. In fact, **mutilated** (v. 25b) ("corruption" – BDB) is a rare and difficult word. It seems to have connections with the verb "to go to ruin". In Isa. 52:14 it denotes a disfigurement of the face (BDB).

In summary, the passage addresses priests and people as a whole, and is framed essentially as statutes (second person plural). This is probably imposed upon the original core of material, evidence of which survives in the singular formations (v. 23b) (Sam. has a plural here) and in "whosoever . . ." clauses (vv. 18, 21). All the material evidently comes from bodies of priestly expertise relating to the sacrificial system.

The last major textual unit in this section (vv. 26–30) deals with other issues affecting the acceptability of animals as sacrifices. A newly born sheep, goat or bull is not ready for offering until the eighth day (v. 27). The mother and young cannot be killed on the same day (v. 29). The concluding law indicates that a **thanksgiving offering** must be eaten on the day it is offered (vv. 29–30).

26. These commands are delivered only to Moses.

For **acceptable** see 1:3, and for **offering by fire** see 1:9.

27. No reasons are indicated as to why the **eighth day** marks the point of acceptability. From a practical point of view the sacrifice clearly needs to be something of substance, and the sanctity of the seven-day cycle is of course well established in Israel.

28. No reasons are given as to why both mother and young may not be slaughtered on the same day. There may be economic factors behind the law, relating to the continuing

well-being of the flocks and herds, which have subsequently become institutionalized in this prohibition.

29. The law about a **thanksgiving offering** seems out of place here, and may be an addition. Offerings of this kind, apparently **well-being offerings**, are cited in the Manual of Offerings (see 7:12–15).

30. The requirement that it be eaten on the same day adds nothing to the law in 7:15. The only difference is that this is framed in the second person plural whereas 7:12–15 is cast in the third person singular.

The concluding verses in the section are generalized exhortations with all the marks of the Holiness editor.

31. The word **commandments** serves the same purpose as **statutes** and **ordinances** in 18:4, 26; 19:19, 37; 20:8, 22; 25:18; 26:15, 43, 46, a general term for the detailed laws which the Holiness Code contains. It occurs again in 26:3, 14, 15, and, like **statutes** and **ordinances**, is a point of contact between the Holiness Code and Deuteronomy (e.g.4:2, 40; 5:10, 29, 31; 6:1, 2, 17, 25). It also occurs elsewhere in the priestly writing. In the Manual of Offerings it constitutes the verb "commanded" (*RSV*) in 4:2, 13, 22, 27; 5:17. As **commandments** it is found in the appendix to the book in 27:34, and later in the priestly writing in Num. 15:22, 31, 39, 40; 36:13.

The idea that Israel should **keep** and **observe** Yahweh's laws is already well established (18:4, 26, 30; 19:19; 19:37; 20:8, 22 – see also 25:18; 26:14, 15).

Yahweh's self-designation at the end of the verse is absent in Sam. and Gk.

32. The warning that Israel must not **profane** Yahweh's **name** is also typical (see 19:12; 20:3; 21:6; 22:2), along with the concern that Yahweh be **sanctified** within Israel because his purpose is to **sanctify** her (see 19:2; 20:7, 8, 26; 21:8, 23; 22:9).

33. The final reference to Yahweh as deliverer from Egypt is also a familiar element within the Holiness editing (18:3; 19:36; 23:43; 25:38, 42, 55; 26:45).

6. FEASTS AND OBSERVANCES
(23:1–44)

This section lists the feasts and other major observances that
are required. Its closest parallel is the longer list found later
in the priestly writing (Num. 28:1–29:40). The section divides
fairly easily as follows, using the words "Yahweh said to Moses
. . ." as indicators:

23:1–8 – sabbaths/Passover and unleavened bread
23:9–22 – first fruits/weeks
23:23–25 – trumpets
23:26–32 – Day of Atonement
23:33–44 – booths.

It may be that vv. 37–38 constitute a first conclusion to the
section, in which case vv. 39–43 are a supplement on the Feast
of Booths, and v. 44 is the second conclusion.

The Holiness editing in the chapter is restrained, or at
least less obvious than elsewhere. There is the familiar self-
introduction by Yahweh in vv. 22, 43, and the reference to
Yahweh as deliverer of Israel from Egypt in v. 43 (cf. 19:36;
22:33). The concept of the land as "gift" (v. 10) is probably
also to be traced to the Holiness Code (cf. 20:22; 25:38).
These features apart the more obvious signs of Holiness
editing are absent from the chapter.

The textual material is cast primarily as statutes in the
second person plural; the text itself requires that the set
feasts be "proclaimed" (v. 2). The presence of Yahweh as
speaker in the first person singular is also apparent (v. 2 – **my
appointed festivals**). Both of these features are likely to
represent later rather than earlier stages in the development
of the text. There is in v. 22 an isolated law framed essentially
in the singular which seems to belong rather with 19:9–10
than with the list of feasts.

There are reasons for thinking that the precise calendrical
data (in vv. 5–8, 23–36) comes perhaps from the practice of
the Jerusalem Temple, whereas vv. 9–21 and the original
parts of vv. 39–43 presuppose earlier custom whereby feasts
were determined according to the progress of the harvest (J.

R. Porter, *Leviticus*, 1976). This distinction corresponds with what N. H. Snaith (*Leviticus and Numbers*, 1967) called the "agricultural" and "ecclesiastical" elements of the chapter. Our view of the redaction of the book (see General Introduction) would suggest that the Holiness Code embodied the earlier material and that the calendrical datings represent the norms observed in the second Temple. The latter would be from the priestly editors whose work was detected in 17:1–9 and perhaps in 19:5–8, and who introduced into the Holiness Code norms from the priestly writing about an Aaronic priesthood (17:1; 21:1, 17, 24; 22:2, 17). They may also be responsible for terminology such as **holy convocations** (v. 2), though the interpretation of the festivals in terms of sabbath law can be attributed to the Holiness editors, for whom sabbath was a vital institution (19:3).

The emergence of the festal calendar was a long and complicated process (cf. e.g. E. Auerbach, "Die Feste", 1958; B. A. Levine, *Leviticus*, 1989, pp. 261–268; J. E. Hartley, *Leviticus*, 1992, pp. 376–383). The detail of the calendars is conveniently set out in tabular form by P. P. Jensen (*Graded Holiness*, 1992, pp. 227–231). Some of the earliest evidence comes from the Book of the Covenant (to be dated perhaps to the early period of the monarchy). This collection of laws lists three annual feasts which all males are required to attend (Exod. 23:14–17). These are the feast of unleavened bread (seven days in the month Abib), the feast of harvest (the first fruits at the beginning of the harvesting process), and the feast of ingathering (marking the end of the harvest and the end of the year). It seems clear that these celebrations underlie the feasts listed here in the Holiness Code – unleavened bread in vv. 1–9, harvest in vv. 9–22, and ingathering in vv. 33–44. Other elements of the feasts here are attested in the Book of the Covenant – "my sacrifice" (Exod. 23:18) may be the Passover lamb, and first fruits (Exod. 23:19), but these appear to be distinguished from the three evidently agricultural feasts. There is certainly a pre-priestly Passover tradition, usually assigned to the Yahwist (Exod. 12:21–27).

The Ritual Decalogue (Exod. 34:17–26) is also ancient, and attests the principle of three annual feasts which all males must attend – unleavened bread (Exod. 34:18), to be observed as in the Book of the Covenant, and linked closely with the first fruits of the womb (Exod. 34:19–20), the feast of weeks (Exod. 34:22) (obviously the equivalent of harvest in the Book of the Covenant), and ingathering (Exod. 34:22) (to be observed as in the Book of the Covenant). Here too "my sacrifice" occurs, in close association in this case with the feast of Passover (Exod. 34:25), as also does **first fruits** (Exod. 34:26). As in the Book of the Covenant these cultic events seem to be quite separate from the three public feasts. Passover does qualify, however, as a "feast".

The laws in Deuteronomy represent a clear development of these older festal arrangements. The most obvious changes are:

1) the linking of Passover and unleavened bread to constitute the first of the three great public feasts (Deut. 16:1–8)
2) the fixing of the feast of weeks at a point seven weeks after the first harvest cuttings (Deut. 16:9–12)
3) the renaming of ingathering, now the feast of booths, and the specifying of seven days as the period within which it is to be observed (Deut. 16:13–15).

The laws here in the Holiness Code are not necessarily a further evolution of festal law – their age may be similar to that of those in Deuteronomy – but they do offer more detail, and attest further linkages. The most obvious points of extra information are:

1) clarity about what "the appointed time" is for Passover/unleavened bread – i.e. beginning on the **fourteenth day** of the first month (Abib) (v. 5).
2) more detail about the feast of weeks, making it clear that the seven-week period is preceded by the offering of first fruits (vv. 9–14), and with more information about the offerings for the feast itself (vv. 15–21).

3) clarity about precisely when the feast of booths is to be observed – i.e. on **the fifteenth day of this seventh month** (v. 33).

In addition to these developments and clarifications there is the first evidence here of **trumpets** (**trumpet blasts** – *NRSV*) as one of the appointed feasts (vv. 23–25), provided here with its own fixed day, and the **day of atonement** (vv. 26–32, cf.16:1–34). **Sabbath** is also included as an integral element in the calendar (v. 3). While much of the sabbath legislation belongs to the priestly writing there is enough older attestation to establish the antiquity of the observance (Exod. 20:8–11; 23:12; 34:21; Deut. 5:12–15; 2 Kgs 4:23).

The later priestly laws in Num. 28:1–29:40 provide precise detail about the offerings required on these various occasions, for Passover/unleavened bread (Num. 28:16–25), for weeks (Num. 28:26–31), for trumpets (Num. 29:1–6), for the day of atonement (Num. 29:7–11), and for booths (Num. 29:17–38). Its main addition is the legislation for offerings on the first day of each month (Num. 28:11–15), an observance with its roots in the new moon feast (2 Kgs 4:23).

Outside the law codes there are very general references to feasts as occasions of rejoicing (e.g. Isa. 29:1; 30:29; Amos 5:21), but only very limited hints about their development. The association of sabbath with the new moon may indicate, as some think, that sabbath was originally connected to the lunar cycle, though the two systems of counting are not of course compatible (the lunar cycle is not exactly twenty-eight days). B. A. Levine (*Leviticus*, 1989, p. 261) contests any connection with the lunar cycle, seeing sabbath as entirely innovative within Israel. In the texts of course sabbath is consistently a period of rest from work every seventh day. The offering of the first fruits is discussed in Deut. 26:1–11 and in Lev. 2:14–16.

Much obscurity continues to surround the history of the three pilgrim feasts. Passover was presumably a shepherd's rite, belonging to a nomadic community (it is discussed, for example, by M. Haran ("The Passover Sacrifice", 1972) and O. Keel ("Erwägungen zum Sitz", 1972)). Keel thinks its

roots may perhaps be traced to the change of grass in early summer. J. W. McKay ("The Date of Passover", 1972) suspects that it was connected with the spring equinox rather than, as is sometimes supposed, the lunar cycle.

Unleavened bread is probably agricultural and Canaanite in origin (the Canaanite background is disputed by J. Halbe ("Erwägungen zu ursprung", 1975)), celebrating the first fruits of the winter barley crop. The connections between Passover and unleavened bread have been explored, for example, by H. G. May ("The Relation of the Passover", 1936) H. J. Kraus ("Zur Geschichte", 1958) and B. N. Wambaq ("Les Massôt", 1980)). Whether the link is established by the Josianic reformation, or at an earlier period, is uncertain.

That weeks and booths also belong to the agricultural cycle seems certain, and they are probably Canaanite in origin. The former was probably a harvest (grain) celebration, marking the end of the wheat harvest, and the latter a vintage festival (the harvest of grapes and olives), though it also came to be associated with the "threshing floor" as well as the "wine press" (cf. Deut. 16:13; Jdg. 21:19; 1 Kgs 8:2) (it is discussed by G. W. MacRae ("The Meaning and Evolution", 1960)). Israelite tradition makes a close connection between booths and the wandering in the wilderness (vv. 42–43).

Trumpets of course is a "first of the month/new moon festival", the only one prescribed here in the Holiness Code. Its particular significance lies in the fact that it marks the seventh month (Tishri), just as sabbath marks the seventh day. The sacredness of "seven" is widely attested in Israelite and other much older semitic literature; explanations are inevitably speculative (e.g. astrology and the seven planets, the lunar cycle). On the background to the day of atonement see 16:1–34.

This first part of the festal calendar (vv. 1–8) contains information about the sabbath (v. 3), and about the feast of Passover/unleavened bread (vv. 5–8). It is introduced as a word from Yahweh to Moses (v. 1). It is arguable that vv. 1–3 (containing the material about sabbath) have been added as a prologue to some other element within the chapter.

Certainly v. 4 has all the marks of an introduction to a list of feasts.

2. The phrase **appointed festivals** ("solemn festivals" – *NJB*) is used several times in this chapter (vv. 4, 37, 44) as a description of the observances under discussion. The word is used extensively, of appointed places as well as times. It is commonly used in the priestly writing to denote sacred times (Gen. 1:14; Exod. 13:10; Num. 10:10; 15:3; 29:39), but also in older sources (Exod. 23:15; 34:18; Deut. 31:10). Prophets also speak of these sacred seasons (e.g. Isa. 1:14; 33:20; Ezek. 36:38; 44:24; 45:17; 46:9; Hos. 9:5; 12:10; Zech. 8:19).

These feasts are also to be proclaimed as **holy convocations** (cf. vv. 3, 4, 7, 8, 21, 24, 27, 35, 36, 37) ("sacred assemblies" – *REB*, *NJB*; "religious festivals" – *GNB*). The phrase is used in the priestly writing in relation to sabbath (e.g. Exod. 12:16), and to the other feasts and observances (Num. 28:18, 25, 26; 29:1, 7, 12). In an earlier text such occasions ("the calling of assemblies") are severely criticized by Isaiah (Isa. 1:13). Later witness outside the laws can be found in Neh. 8:8 (where the word appears to mean the reading (lection)); Isa. 4:5 ("assemblies").

3. The reference to **sabbath** is not the first in the Holiness Code (see 19:3), but the phrase **a sabbath of complete rest** is distinctive (literally "a sabbath of sabbatic observance" – BDB; "solemn rest" – *RSV*). It has already occurred in the priestly writing in connection with the day of atonement (see on 16:31), and does so again in v. 32. It is also applied later in this chapter to trumpets (v. 24) and booths (v. 39).

The last phrase in v. 3 indicates that sabbath observance honours Yahweh – **it is a sabbath to Yahweh**.

For the phrase **throughout your settlements** see 3:17; 7:26; 13:46 (cf. Exod. 12:20; 35:3; Num. 35:29 elsewhere in the priestly writing). It recurs in this chapter (vv. 14, 17, 21, 31). It helps stress the pervasive character of sabbath observance, in houses and in the community at large, and not simply at the sanctuary (B. A. Levine, *Leviticus*, 1989).

4. There appears to be a new introductory sentence here, marking the beginning of a list in which **Passover** is the first feast to be cited (v. 5).

5. The circumstances under which **Passover** became fixed, to the fourteenth of the first month (Abib), are not known. The first month began at some point from the middle of March to the middle of April, being determined by the lunar year, though there are evidences of a fifty-two week year at Qumran (see the discussion by G. J. Wenham, *The Book of Leviticus*, 1979, p. 302).

The phrase **at twilight** means literally "between the two evenings". This is usually taken to mean between sunset and darkness ("between dusk and dark" – *REB*; "twilight" – *NIV*; "sunset" – *GNB*), and it is a distinctive feature of the priestly writing (Exod. 12:6; 16:12; 29:39, 41; 30:8; Num. 9:3, 5, 11; 28:4, 8). B. A. Levine (*Leviticus*, 1989) shows that the phrase could be understood as a longer period of time, beginning at noon, as in Jewish tradition.

The traditions recording the institution of **Passover**, and marking the deliverance from Egypt, are to be found in Exod. 12:1–51.

6. These same traditions attest a linkage between **Passover** and **unleavened bread**, the latter beginning on the fifteenth day, and lasting for a further seven days. **Unleavened bread** is a distinct kind of **festival** ("pilgrim feast" – *REB*) – i.e. one of those which older law collections insist all males must attend.

7. It appears that **holy convocation** (see v. 2) denotes a special day in which abstinence from work is required. The phrase **at your occupations** ("laborious" – *RSV*) (see also vv. 8, 21, 25, 35, 36; Num. 28:15, 25, 26; 29:1, 12, 35) indicates a sensitivity to the problem of defining what precisely constitutes "work". *REB* (as *NRSV, NIV, GNB*) understands it to mean "daily" work – i.e. the normal commitments of the working day. *NJB* understands it to mean "heavy" work.

8. Offerings by fire (see on 1:9) are required on each of these seven days (for further detail see Num. 28:16–25).

The concluding day is again a **holy convocation** on which there must be **no work at your occupation**.

The stress that these are Yahweh's observances (vv. 1, 4, 5), and that they are **to** him (vv. 3, 6, 8) (in his honour, and in recognition of his goodness to Israel) is pervasive.

Verses 9–22 deal with the offering of the **first fruits** (vv. 9–14) and the feast of **weeks** (vv. 15–22). It is possible that originally vv. 10–14 constituted a variant from a particular sanctuary for the feast of unleavened bread (J. R. Porter, *Leviticus*, 1976). The section concludes with an isolated piece reminding harvesters that the **edges** and **the gleanings** must be left for **the poor and the alien** (v. 22; cf.19:9–10).

10. Like vv. 1–9 these laws are addressed to Israel at large.

For the idea of the land as God's gift, a belief of the Holiness editors, see 20:24.

For the **harvest** see 19:9 and cf. vv. 22; 25:5.

The word **sheaf** (v. 10) recurs in vv. 11, 12, 15, and is found also in Deut. 24:19; Ruth 2:7, 15. In Exod. 16:16, 22, 36 the word is rendered "omer", a measure.

For the word **first fruits** see 2:12, and for further detail about the cultic procedures see 2:14–16 and Deut. 26:1–5. In the oldest law codes no obvious chronological or other connections are made between the offering of the first fruits and the three pilgrim feasts (Exod. 23:19; 34:26).

11. The task of the priest is to **raise** ("wave") the sheaf before Yahweh. This is the **tenuphah** root (see on 7:30). In Deut. 26:1–5 the priest receives the first fruits in a basket and is required to "set it down" before the altar.

For **that you may find acceptance** see 1:3.

The reference to the day after **sabbath** is confusing. It could mean the first day of unleavened bread, or the sabbath which fell during the seven days of unleavened bread, or perhaps the "sabbath" (i.e. a day of rest) with which the feast of unleavened bread concludes (v. 8). B. A. Levine's (*Leviticus*, 1989) discussion of the issue suggests a gloss, aiming to ensure that the counting of seven weeks begins on the day after the sabbath (cf. also v. 15). The first fruits might be the first cuttings from the barley harvest, which would normally be ready in April.

12. The first fruits are accompanied by a **burnt offering** (v. 12). This is to be a lamb a year old. For the details of the rite cf 1:10–13, though in that text the age of the animal is not specified. The model here is that of the daily burnt offering

(cf. Exod. 29:38–42) – i.e. lambs a year old accompanied by a **grain offering** (v. 13).

13. The content of the grain offering is **two-tenths of an ephah of choice flour mixed with oil**. The quantity of flour is equal to that which would be offered (morning and evening) in the daily burnt offering (Exod. 29:40, 41). The quantity is **one-tenth** in the ordination offering (7:20) and in the poor person's **guilt offering** (14:21).

On **offered by fire** and **a pleasing odour** see 1:9.

The libation is **one-fourth of a hin** (cf. Exod. 29:40; Num. 15:5; 28:14). Larger quantities were sometimes used (Num. 15:7, 10; 28:14). The **drink offering** is attested in an early text (Gen. 35:14), but is found customarily in priestly or related literature, and often in close association with the burnt offering (see e.g. vv. 18, 37; Exod. 29:40; Num. 15:5, 7, 10, 24; 28:7, 9; 29:6, 18).

14. Abstinence from particular grain products is required **until that very day** (presumably abstinence relates to the preceding feast of unleavened bread). These products are **bread** and **parched** or **fresh** grain. **Parched grain** is referred to in a number of narrative texts (Ruth 2:14; 1 Sam. 17:17; 25:18; 2 Sam. 17:28) where it appears to be a familiar food.

The word **fresh** is more problematic. The word means "garden" (BDB), and apparently also "fruit" or the growth from a garden (2 Kgs 2:42). The word also occurs in 2:14 (rendered "fresh" by *RSV*). *REB* takes it to mean "fully ripened", *NIV* "new grain", and *GNB* "new corn".

The phrase **until that very day** ("same day" – *RSV*) is common in this chapter (vv. 21, 28, 29, 30; cf. also in the priestly writing Gen. 7:13; 17:23, 26; Exod. 12:17, 41, 51; Deut. 32:48). For the concluding phrases in the verse – **statute forever, generations, all your settlements** see e.g. 3:17; 6:18; 7:36; 16:29, 34; 17:7).

15. The rest of the passage deals with the feast of weeks itself, an event which here in the Holiness Code can be dated precisely. **Seven weeks** (**fifty days** (v. 16) to be precise) are to be counted from the day when the **first fruits** are offered (i.e. the day when **the sheaf of the elevation offering** was brought (see v. 11)).

16. The day is marked firstly by **an offering of new grain**.

17. The essential components of this offering are **two loaves of bread**, which like the first fruits are **tenuphah** (**an elevation offering** – see on 7:30).

Precise directions are given about their composition – they consist of **two-tenths of an ephah** (see 5:11; 6:20; 19:36), though **ephah** here is assumed by *NRSV*. They are to be of **choice flour** (see on 2:1) and **baked with leaven**. For **baked** see 6:17; 7:9 and for **leaven** see 2:11.

This offering is also apparently a **first fruits**, marking presumably the first cuttings of the wheat harvest.

18. This central element in the feast of weeks is accompanied by three animal sacrifices (cf. also v. 19).

As a **burnt offering** there are to be **seven lambs a year old** (see v. 12), one **young bull** and two **rams**. The **bull** seems to have been common as a burnt offering (see e.g. Num. 7:15; Jdg. 6:25; Ps. 50:9; 51:19; 1 Kgs 18:23). For the **ram** as burnt offering see e.g. 9:2; 16:3, 5; Num. 15:6, 11; Ezek. 46:4).

The **grain offering** and **drink offerings** which accompany the burnt offering are probably modelled on those which accompany the daily burnt offering (Exod. 29:40). On the **drink offering** see v. 13.

For **offering by fire** and **pleasing odour** see 1:9.

19. The second animal sacrifice is a **sin offering**, consisting of one **male goat** (see 4:23) (Gk has a third person plural subject).

The third is a **well-being offering**, consisting of two **male lambs** (see 3:7). Gk adds "with the bread of the first fruits" at the end of v. 19.

The impression is given that these sacrifices are accompaniments to the central element, the offering of **new grain** (v. 16). They too are to be an **elevation** offering (**tenuphah**) (see vv. 12, 15, 17).

20. One key characteristic of such offerings is that they are **for the priest** (see 7:34).

21. For **proclamation** and **convocation** see v. 2, and for **same day** see v. 14.

For **work at your occupations** see v. 8.

For v. 21b see v. 14b.

22. It seems clear that thought about the harvest feasts has prompted the editor to include the law concerning harvesting and the poor. In all essentials the text repeats the principles of 19:9–10 (see discussion there). The comment about vineyards in 19:10a is missing, but otherwise the text is effectively the same.

In summary, this passage (vv. 9–21) contains the requirements for first fruits and the feast of weeks as understood by the Holiness editor. The material is essentially coherent, and uniform, and was presumably drawn from priestly sources. It is cast as statutes in the second person plural. The editor was prompted by thoughts of the harvest to add at the end (v. 22) the harvest law which provides for the poor. It appears to be a shortened version of the law in 19:9–10.

A short passage (vv. 23–25) deals with the feast of trumpets (**trumpet blasts** – *NRSV*), which takes place on the first day of the seventh month. The information provided about the event is minimal.

23. As with all the laws in this section the instructions are given to Moses, and spoken by him to the people at large (cf. v. 24).

24. This occasion is to be a **day of complete rest** ("solemn" – *RSV*). This phrase expresses the word which normally occurs in close association with "sabbath" (see on 16:31, and cf. vv. 3, 32; 25:4). It is unusual for it to occur on its own (cf. also v. 39 where it does so in connection with the feast of booths).

The word **commemorated** ("memorial") carries with it connotations of "remembrance". It is quite common in priestly texts (Exod. 12:14; 28:12, 29; 30:16; Num. 5:15, 18; 10:10; 17:5; 31:54), and has a varied frame of reference. It also occurs in earlier parts of the Pentateuch (Exod. 13:9; 17:14), and a variety of other biblical texts (e.g. Josh. 4:7; Eccl. 1:11; Isa. 57:8). The text of Num. 10:10 has some affinities with v. 24 here in that it uses the word (translated "reminder" by *NRSV*) in association with the blowing of trumpets over sacrifices. The prime concern of the passage Num. 10:1–10 is the sounding of trumpets as an "alarm" in the

context of war. Here, however, the sounding of trumpets at **appointed festivals** (presumably all), and at the beginnings of months, is explicitly provided for.

The **trumpet blasts** could be rendered "shouts". *REB* calls the event a day of "acclamation". The customary words for "trumpets" are absent. The "shout" could be a war cry or alarm (e.g. Josh. 6:5; Jer. 20:16; Ezek. 21:27; Amos 1:14; 2:2; Zeph. 1:16), and although this sense is preserved in some priestly texts (e.g. Num. 10:5, 6; 31:6), there is also a cultic function for the "shout" or "sound-making" (cf. 25:9; 29:1). The religious "shout" of joy is attested in other texts (e.g. 1 Sam. 4:5, 6; 2 Sam. 6:15; Job 33:26; Ps. 150:5 (where it is associated with the clashing of cymbals)). The word means the "making of sounds" and **trumpet** is a very reasonable supposition in the light of Num. 10:1–10.

For **a holy convocation** see v. 2.

25. For **at your occupations** see v. 8.

The sacrifices are simply described as **an offering by fire** (see on 1:9). *BHS* speculates as to whether Gk read the Hebrew for **burnt offering** at this point, and *JB* renders it as such ("burnt for Yahweh" – *NJB*). There is more detail about the offerings in Num. 29:1–6.

In summary, the passage has been drawn by the Holiness editor from priestly sources; there is little indication of his own influence. The priests of the second Temple would again be responsible for the dating (v. 24).

The next part of the calendar (vv. 26–32) deals with the day of atonement. It parallels the material in 16:1–34, where a much fuller account of the events of the day is given.

27. The usual command to Moses to speak to Israel is absent here in v. 27 (cf. vv. 2, 10, 24, 34), though it is doubtless to be assumed (it is present in Syr).

For the fixing of the day on the **tenth** of the **seventh month** (v. 27) see 16:29; Num. 29:7–11.

For **atonement** see 4:20; for **holy convocation** see v. 2.

The phrase **you shall deny yourselves** (cf. vv. 29, 32) (i.e. by fasting) is the same as that used in 16:29, 31 (cf. also Num. 29:7; Ps. 35:13; Isa. 58:3, 5).

For **offering by fire** see 1:9.

28. For **entire** day see v. 14 (**very day**).

29. For **cut off from the people** see on 17:4.

There is considerable stress on the seriousness of the occasion, and the importance of abstaining from all work. Yahweh himself will take action against those who fail to fast.

30. The word **destroy** (v. 30) ("root out" – *REB*; "eliminate" – *NJB*; "put him to death" – *GNB*) is not common in the priestly writing, and the use of the first person singular may indicate the intervention of the Holiness editor.

31. For **a statute forever. . . in all your settlements** see vv. 14, 21.

32. For the phrase **a sabbath of complete rest** see v. 24. In v. 32b the point is made that the fast begins on the evening of the **ninth** day of the month. The final clause seems to indicate that this obtains on any occasion of sabbath rest.

B. A. Levine (*Leviticus*, 1989) raises the possibility that the phrase **from evening to evening** denotes a distinctive feature of the day of atonement rites, and not something applicable to the festivals as a whole.

In summary, this material has been drawn by the Holiness editor from priestly festal material. His own influence is not prominent, but the intervention of the first person pronoun in v. 30, threatening destruction for those who work, is probably his. The specific dates (vv. 27, 32) may be attributed to subsequent priestly scribes whose work reflects the practice of the second Temple.

The final part of the chapter (vv. 33–44) deals with the last of the feasts – the **festival of booths**. The calendrical concerns of the priests of the second Temple are again evident in vv. 33–36, 39. In vv. 37–38 they go on to affirm that each festival has its own sacrifices (to be legislated for in Num. 28:1–29:40), and that the festivals are not to be confused with ordinary sabbaths and other occasions of giving to Yahweh.

The remainder (vv. 39–43) contains some calendrical material, but also substantial information about the feast of booths which was integral to the Holiness Code (vv. 40–43).

34. Yahweh's commands are given to Moses, who in turn is

required to communicate them to Israel. The **festival of booths** is fixed for the **fifteenth** day of the seventh month (as in Num. 29:12). This occasion, like the feast of unleavened bread (v. 6), is to last for **seven days** (v. 34). The word **festival** makes it clear that this is one of the obligatory pilgrim feasts (cf. Exod. 23:14).

35. The first day is to be a time of **holy convocation** (see v. 2), which requires that there be no **work at your occupations** (see v. 8).

36. Offerings will be made on each of the seven days, described here vaguely as **offerings by fire** (see on 1:9), and the eighth day is another **holy convocation** (read as "closing ceremony" by *REB*, "closing assembly" by *NIV*, "a day for worship" by *GNB*). A much fuller account of the daily offerings occurs in Num. 29:12–38.

The phrase **solemn assembly** renders a word used infrequently in the laws. It does occur in Num. 29:35 in connection with the festival of booths (cf. Neh. 8:18), and in Deut. 16:8 with the last day of unleavened bread. It also occurs in relation to Solomon's dedication of the altar (2 Chr. 7:9). Outside the laws the word tends to denote "sacred assemblies" in a general way (e.g. 2 Kgs 10:20; Isa. 1:13; Joel 1:14; 2:15; Amos 5:21).

37. The first conclusion identifies the festivals described as **appointed** (see v. 2), and times of **holy convocation** (see v. 2). They are summed up as primarily occasions for **offerings by fire** (see on 1:9), and these in turn are listed as **burnt offerings**, **grain offerings**, **sacrifices** (see on 3:1), and **drink offerings**. These are singular in Heb., except for the drink offerings. Gk renders them as plurals, omits any reference to **grain offerings**, and makes the **sacrifices** and **drink offerings** those that belong to the **burnt offerings**.

The phrase **each on its proper day** means literally "each day's affair in its day" (BDB). It is not characteristic of the priestly writing, but does occur in some texts from the early narrative tradition (Exod. 5:13, 19; 16:4), in the Deuteronomistic history (1 Kgs 8:59; 2 Kgs 25:30), and in some later texts (e.g. 1 Chr. 16:37; 2 Chr. 8:14; 31:16; Ezra 3:4; Neh. 11:23; 12:47; Dan. 1:5).

38. These occasions are then described as additional to other rites and observances. The customary **sabbaths** (the weekly ones) are cited. So too are **your gifts**. This word occurs here for the first time in Leviticus. As an offering to Yahweh it is attested in Exod. 28:38; Num. 18:29; Deut. 16:17; Ps. 68:18, and to other gods in Ezek. 20:26, 31, 39. In other contexts it can be a gift to a human being (Gen. 25:6; 2 Chr. 21:3; Est. 9:22; Ezek. 46:16) and even a bribe (Prov. 15:27; Eccl. 7:7).

For the **votive offerings** and for the **free-will offerings** see 7:16; 22:18, 21, 23.

39. The text of vv. 39–44 contains additional information about the **festival of booths**. The date is repeated (cf. v. 34), and the point that the original intention was to mark the end of the harvest is made clear (v. 39a) – **when you have gathered in the produce of your land**. The word **gathered** is frequently used in laws in relation to the fruit of the earth (e.g. 25:3, 20; Exod. 23:10, 16; Deut. 11:14; 16:13; 28:38); the same is true of **produce** (e.g. 19:25; 25:3, 7, 15, 16; Exod. 23:10). Both words have a wider frame of reference.

The phrase **keep the festival** embodies the concept of "pilgrimage" (see v. 34).

For the phrase **complete rest** (v. 39) see v. 24.

40. The significantly new information occurs here; it is required that on the first day branches of various trees are to be cut. The intention is that shelters (or booths) are to be made, and that the pilgrims will dwell in them for the duration of the feast (v. 42).

The phrase **the fruit of . . . trees** probably means "fruit-bearing trees" (i.e. the branches and foliage of such trees) (cf. e.g. Gen. 1:11; Exod. 10:15; Ps. 148:9; Ezek. 36:30). *REB* reads as "the fruit of citrus trees", and *NJB*, *NIV* as "choice fruit", *GNB* as "best fruit".

The word **majestic** ("goodly" – *RSV*) is often indicative of "splendour" or "dignity"; its use in relation to trees is rare.

The word **branches** is often used of the palm of the hand or the sole of the foot. The point is probably that the branches plus their foliage should be shaped like large hands.

Palm trees are cited only occasionally in the Pentateuch

(Exod. 15:27; Num. 33:9; Deut. 34:3) (cf. also Josh. 1:12; Jdg. 1:16; 3:13; Song 7:8).

The word **boughs** is uncommon (cf. e.g. Ps. 80:11; Ezek. 17:8, 23; 31:3; 36:8; Mal. 3:19). **Leafy** might be better rendered "with interwoven foliage" (BDB) (cf. its use in Neh. 8:15; Ezek. 6:13; 20:28).

For **willows of the brook** ("poplar" – BDB) see Job 40:22. It appears to be a proper name in Isa. 15:7.

The indication that this is an occasion for joy – **you shall rejoice before Yahweh** – is a new note in the Holiness Code (and also in the priestly writing), though it is common in Deuteronomy (e.g. 12:7, 12, 18; 14:26; 16:11, 14; 26:11; 27:7) and in a variety of psalms.

41. For **keep it as a festival** see v. 39. The first part of this verse is absent in Gk.

For **statute. . . generations** see v. 21.

42. The word **booths** which gives the feast its name can signify a "thicket" (Job 38:40); in other texts, as here, it denotes a temporary shelter (Gen. 33:17; 2 Sam. 11:11; 1 Kgs 20:12, 16; Isa. 1:8), perhaps from the sun (Isa. 4:6; Jon. 4:5). For references to **the festival of booths** outside the Pentateuch see 2 Chr. 8:13; Ezra 3:4; Neh. 8:14–17; Zech. 14:16, 18, 19.

The word **citizens** is that used in 16:29; 17:15; 18:26; 19:34; 24:16, 22.

43. For **generations** see 3:17.

The phrase **that . . . may know** is not a prominent feature of the Holiness editing, but is one of the characteristics it shares with Deuteronomy (e.g. 4:35; 29:6), with Deuteronomistic editing (e.g. Josh. 3:7; Jdg. 3:2), and with parts of the priestly writing (e.g. Exod. 16:12; 29:46; 31:13).

For references to Egypt in the Holiness editing see 18:3; 19:36; 25:38, 42, 55; 26:45).

For the **appointed festivals** see v. 2.

The editors of the Holiness Code have evidently engaged in the process whereby the cultic practice of Israel is systematized and standardized. The process had begun with the monarchy, and taken a major step forward with the

Deuteronomic reformation under Josiah. This engagement in a sense served their interests, bringing them new power and privilege, but it also offered the community as a whole a new framework by which its identity could be structured and sustained. In the fragmented and alienating experience of exile this was a significant achievement.

7. THE SANCTUARY LIGHT AND THE BREAD (24:1–9)

This short section deals with two issues affecting the sanctuary. It divides easily into:

24:1–4 – the sanctuary lights
24:5–9 – the sanctuary bread.

There are no signs here of the Holiness editing, and much of the section has close affinities with material found elsewhere in the priestly writing. It is best to conclude that it was not part of the original Holiness Code.

The material is framed as a command by Yahweh to Moses (v. 1), which he in turn passes on to the people (v. 2), or acts upon on his own account (vv. 5–7). The basic form is ritual law; apart from the commands to Moses himself (vv. 5–7) it is framed in the third person.

Little is known about the sanctuary **lamp** and its use from texts outside the priestly writing. Within priestly texts commands about the making of the lampstand are found in Exod. 25:31–40, and details about its manufacture in Exod. 37:17–24. There is also a passage that deals with the oil for the lamps (Exod. 27:20–21), and which this passage here in vv. 2–4 effectively duplicates. There is no reason to doubt that the lighting of sanctuaries is ancient; with reference to Shiloh there is specific reference to the "lamp of God" (1 Sam. 3:3). Here, it would appear, the light was allowed to go out.

A similar situation pertains with respect to the bread. The "bread of the presence", a particular type of offering (B. W. Herrmann, "Götterspeise", 1960), is familiar in the priestly texts which deal with the construction of the tabernacle

(Exod. 25:30). There is also early witness to the use of "holy bread" at the sanctuary at Nob (1 Sam. 21:4 – "bread of the Presence" in v. 6). P. A. H. de Boer ("An Aspect of Sacrifice", 1972) suggests that there is no incompatibility in the idea that the bread is both offered to God, and is also, by its consumption, an agency of strength and salvation to his servants the priests. R. Gane ("Bread of the Presence", 1992) notes that "of the presence" stresses Yahweh's residence with Israel, and suggests that the context, embodying priestly beliefs about covenant, sabbath and creation, protects the procedures from excessively anthropomorphic perceptions about God.

It is only possible to guess as to the significance of the lights and the bread in earliest times. That they in some way honoured the deity, marking his presence and perhaps providing for him seems probable.

These verses indicate how the oil for the sanctuary lamp is to be made, and make it clear that the light must not be allowed to go out. The passage in effect duplicates material in Exod. 27:20–21, and probably belongs to the writers responsible for the priestly narrative.

2. The oil is to be made from **beaten olives** (v. 2; cf. Exod. 27:20; 30:24; Deut. 28:40; Mic. 6:15), and it is to be **pure** (cf. Exod. 27:20) – i.e. with no other substance in it. The same is required of the frankincense in v. 7; Exod. 30:34. For **beaten** cf. Exod. 27:20; 29:40; Num. 28:5; 1 Kgs 5:25.

The **lamp** is a word commonly used of sanctuary lights (e.g. Exod. 25:37; 1 Sam. 3:3; 1 Kgs 7:49), but is also appropriate for domestic work (Prov. 31:18), and can often be used figuratively (e.g. 2 Sam. 21:17; Ps .119:105). The light is to be there regularly (not "continually" – *RSV*) – i.e. through the night (v. 3).

3. The lamp's location is made clear. It is to be kept **outside the curtain** (see on 4:6), but inside **the tent of meeting** (see on 1:1), and Aaron is to be responsible for its maintenance. In Sam. and Gk this responsibility includes Aaron's sons.

The word **covenant** is not the usual word (i.e. that used in v. 8) ("testimony" – *REB, NIV*; "covenant box" – *GNB*). B. A.

Levine (*Leviticus*, 1989) prefers "the curtain of [the Ark of] the Pact".

The phrase **set it up** ("in order"– *RSV*) embodies a word found in other priestly contexts (e.g. 1:7, 8, 12; 6:5; cf. Exod. 27:21).

The phrase **from evening to morning** indicates that the lamp must be kept burning throughout the night as well as the day. It burns **regularly** ("continually").

For the phrase **it shall be a statute . . . generations** see 3:17.

Apart from minor variations in word order v. 3 duplicates Exod. 27:21.

4. Here the point is repeated (there is no parallel in Exod. 27:20–21). Aaron (and his sons – Gk) is responsible for the **lamps**, which must be **set up**, and kept burning **regularly** (Sam. and Gk have "until the morning" at the end of the verse).

The **lampstand**, with its seven branches, is described in detail in Exod. 25:31–40 (see also Num. 3:31; 8:2–4). The temple lampstands are mentioned in 1 Kgs 7:49 (cf. Zech. 4:2). Such items could also be found in private houses (2 Kgs 4:10).

The word **gold** is absent in Heb., but it is probably to be understood (Exod. 25:31). *REB* and *NJB* understand **pure** here to mean ritually clean and to describe the **lampstand**.

The following verses (vv. 5–9) give instructions about the bread, which, like the oil in vv. 1–4, is to be continually present in the sanctuary.

5. The bread is to be made of **choice flour** (see 2:1), and twelve **loaves** (see 2:4) are to be prepared from it. In Gk the verbs in vv. 5a, 6a, 7a, are second person plural.

For **bake** see 6:17; 7:9; 23:17 and for **two-tenths of an ephah** see 5:11; 6:20; 19:36; 23:17.

6. These **loaves** are then to be set in **two rows**. The word here is used only in this context, in texts which deal with the bread of the presence (1 Chr. 9:32; 23:29; 2 Chr. 13:11; 29:18; Neh. 10:34), though a closely related word signifies a battle line (e.g. 1 Sam. 4:2; 17:10, 22) or what is apparently a row of lamps (Exod. 39:37). It is constructed from the same root as **set it up** ("keep it in order" – *RSV*) (v. 3).

Assuming that **rows** is correct, there are to be two, with six **loaves** in each, and they are to be placed on **the table of pure gold** (Exod. 25:23–30; 37:10–16). **Gold** can be assumed, as in v. 4, though *REB* and *NJB* suggest that the point has to do with the purity of the table.

7. Each row is to be accompanied by a quantity (not specified) of **pure frankincense** (see 2:1, 2, 15, 16; 5:11; 6:15; Exod. 30:34). *REB* assumes that it is to be sprinkled on the rows. The frankincense functions, seemingly with the bread, as a **token offering** ("memorial portion" – *RSV*) (see 2:2). It is also apparently an **offering by fire** (see 1:9) to Yahweh.

The word **pure** here is that used in v. 2; Exod. 27:20; 30:34.

8. Heb. (most mss.) repeats the phrase **on the sabbath day**, hence **every sabbath day**. The repetition is not present in Gk. Heb. also lacks **Aaron**, though he is doubtless to be assumed.

For **regularly** see v. 2.

The responsibility of Aaron each sabbath is to replace the bread, and presumably the frankincense.

In v. 8b some explanation is offered to the effect that the action signifies a **commitment** by the people which constitutes **a covenant forever** (*RSV*, *NIV* read **commitment** as on Israel's "behalf"). *REB* takes it to be "a gift from the Israelites".

For **covenant** see 2:13. The word signifies a binding commitment, often with visible pledges or signs which function as guarantees. It defines the basic relationship between Yahweh and Israel's ancestors (cf. 26:9, 15, 25, 42, 44, 45; see also the priestly texts Gen. 9:9–17; 17:2–21; Exod. 2:24; 6:4, 5; n.b. also the **covenant** made with Phinehas – Num. 25:12, 13). *GNB* reads it here as Israel's "duty".

9. The bread is finally identified as a priestly due. It is described as **most holy** (see 2:3), and it is clear that Aaron and his sons must eat it in a **holy place** (see 6:16).

For **offerings by fire**, and for **perpetual due** see 3:17 ("statute"); 6:18.

8. BLASPHEMY AND VARIOUS PENALTIES
(24:10–23)

The main issue dealt with in this section is the question of blasphemy. It consists essentially of a story, and a collection of legal penalties, the latter apparently inserted, but now part of the story. The material divides as follows:

24:10–14, 23 – the story of the man who blasphemed the Name

24:15–22 – a collection of legal penalties.

The influence of the Holiness editor is evident at the end of the list of penalties – for I am Yahweh your God (v. 22). It is arguable therefore that the list originally had a place within the Holiness Code. The story, by contrast, has close affinities, in form and content, with that of a man who gathered sticks on the sabbath in Num. 15:32–36. A tendency to devise "midrashic" stories, interpreting legal principles and illustrating their practical operation, may well be one of the latest elements in the development of Pentateuchal tradition. A speculative attempt is made by H. Mittwoch ("The Story of the Blasphemer", 1965) to integrate the story into the wider Pentateuchal narrative. Other stories which resolve complex legal questions by means of a narrative and a divine oracle relate to Passover (Num. 9:6–14) and inheritance (Num. 27:1–11; 36:1–12).

The list of penalties is set in the context of a word of Yahweh to Moses (v. 13a) which he then passes on to the people (v. 15a). The essential form is casuistic with formulations such as **anyone who. . .** predominating and **when a man . . .** (*RSV*) (v. 19). The second person plural is found in the last statute about one law for all, and is probably traceable to the Holiness editor.

The basic issue raised in this section, blasphemy, is probably to be distinguished from the question raised in 19:12 ("swear . . . falsely"). It has to do with the Decalogue principle about taking Yahweh's name in vain (Exod. 20:7; Deut. 5:11) rather than with the failure to keep promises or an intent to deceive a neighbour. The Book of the Covenant declares that

"you shall not revile God. . ." (Exod. 22:28), which may represent the same kind of concern. Its close association with the "ruler", however, may suggest that the divine authority embodied in the ruler is the point at issue in such texts (see e.g. 1 Kgs 21:10).

The other penalties (vv. 17–21) deal with issues well represented in the Book of the Covenant. Murder (v. 17) is of course forbidden in the Decalogue (Exod. 20:13; Deut. 5:17), and the death penalty is prescribed in Exod. 21:12. To kill an animal (vv. 18, 21) requires compensation, another long-standing requirement found in the Book of the Covenant (Exod. 21:33–34; 22:1). For the priestly writers the shedding of any blood (that of human or beast) is so fundamental that the compensation required is traceable to the covenant with Noah (Gen 9:5, 6). Injuries to other people, and the **lex talionis** principle (vv. 19–20), are also dealt with in the Book of the Covenant (Exod. 21:22–25). It seems probable that this short list of penalties comes from comparable sources to those that help to make up the Book of the Covenant (e.g. Exod. 21:12–17; 22:18–20).

The short story (vv. 10–14, 23) tells of how Shelomith's son quarrelled with an Israelite and **blasphemed the Name.** In v. 10 it is clear that the son's father was an Egyptian, and one key function of the story is to illustrate the principle set out in v. 22, that there is one law for **alien** and **native** alike. Shelomith's son is not fully "native", but qualifies as an "alien".

10. The verb **fighting** ("quarrelled" – *RSV*) can easily be rendered "struggled" (BDB), and may well imply physical combat leading to injury (Exod. 2:13; 21:22; Deut. 25:11; 2 Sam. 14:6). *REB* has "involved in a brawl".

11. In the context of this struggle the son of Shelomith **blasphemed the Name**. *REB* reads it as "he uttered the holy name in blasphemy". *GNB* simply reads the whole expression as "cursed God". The verb means "to utter a curse against" (BDB), and it is relatively uncommon. It can be used of curses against people (Num. 23:8; Prov. 11:26; 24:24), days (Job 3:8), or dwellings (Job 5:3). This is the only instance

where it is used of God. J. Weingreen ("The Case of the Blasphemer", 1972) suggests that the use of the word here is neutral (i.e. "uttered"), and that **curse** identifies the behavioural fault. J. B. Gabel and C. B. Wheeler ("The Redactor's Hand", 1980) contest this view, maintaining that for the priestly redactor it is not how the divine name is pronounced, but that it is uttered at all (cf. also J. R. Porter, *Leviticus*, 1976).

The use of **Name** to signify God is frequent (see on 18:21; 19:12). The precise formulation here is unusual in biblical literature, however, and BDB suggests it is a scribal substitution for "Yahweh", the personal name, as in later Judaism, having become too sacred for human use. Alternatively the formulation could be witness to the lateness of the story as a whole; there is no reluctance to use the name Yahweh elsewhere in the story.

The word **curse** occurs more frequently, and comes from a root which would suggest that it means "to slight", "to trifle with", "to esteem lightly" or "to treat with contempt". This is the word used in Exod. 22:28 and 1 Sam. 3:13 (the sons of Eli) in relation to God.

The offence thus appears to entail a curse uttered against God, or perhaps more probably against his adversary, using God's name, and thereby exhibiting the man's contempt for the deity. D. H. Livingston ("The Crime of Lev. 24:11", 1986) suggests that the severity of the punishment stems from the fact that there are two aspects to the offence, pronouncing the name (as above), and cursing it; the son of Shelomith calls for the destruction of Yahweh in the name of Yahweh. It is probable, however, that the offence is one act (J. E. Hartley, *Leviticus*, 1992) – "he pronounced by cursing blasphemously" (B. A. Levine, *Leviticus*, 1989).

The mother is now identified (v. 11) as **Shelomith** who belonged to **the tribe of Dan** (cf. Num. 25:14–15 for another late identification of characters in a story). N. H. Snaith (*Leviticus and Numbers*, 1967) notes that Dan was the apostate tribe (Jdg. 18:30). The name Shelomith does occur elsewhere (1 Chr. 3:19; 2 Chr. 11:20), but the reasons for its use here are hard to identify. Shelomith means "pacifies", and suggestions have been made to the effect that by marrying an

Egyptian she blurred the enmity that there ought to be between Israelites and Egyptians – in short her "pacification" was inappropriate. This is speculative, and does not explain the origins of Dibri.

12. The offender is put . . . in custody (cf. Gen. 40:3, 7; 41:10; 42:17, 19, 30; Num. 15:34).

The root **made clear** ("declared" – *RSV*) means "to make distinct" (cf. Num. 15:34; Neh. 8:8; Ezek. 34:12), and it would appear that for some reason this is a difficult case. It seems likely that the difficulty, concerning which **the decision of Yahweh** must be known, lies in knowing whether to treat this man of mixed parentage in the same way as a native Israelite. Assuming that v. 16a was already part of the Holiness Code, it is hard to see that the penalty or the method of execution is the point at issue.

14. Yahweh's instructions to Moses require that the man be taken outside the camp (cf. the relocation of the man with **leprous disease** in 13:46; cf. also 1 Kgs 21:13). The camp would clearly be defiled if the execution were to take place within it.

The man's offence is that he **blasphemed** ("cursed" – *RSV*) (see v. 11).

All who heard the offence are to **lay their hands upon his head**. It could be the case that having heard they too are in some way defiled (J. R. Porter, *Leviticus*, 1976), and that the laying on of hands transmits their contamination to the offender. N. H. Snaith (*Leviticus and Numbers*, 1967) takes it to signify where the guilt lies. For the imposition of hands in general see 1:4.

The **whole congregation** is to perform the act of execution (cf. the role of the people of the land in 20:2). It is possible that stoning was thought not to involve the shedding of blood (N. H. Snaith, *Leviticus and Numbers*, 1967, p. 253), thus avoiding any cultic problems that might ensue. It is doubtful whether in practice blood-letting was always avoided.

23. The divine requirements were obeyed.

Verses 15–22 contain the list of penalties around which the story of the man who cursed is constructed. It deals with four

offences, the cursing of God (vv. 15–16), murder (vv. 17, 21), the killing of an animal (vv. 18, 21), and the inflicting of injuries (vv. 19–20). The principle that there is to be one law for citizen and alien alike is repeated (v. 22).

15. The first offence, cursing God, is the theme of the story in vv. 10–14, 23. The verb **curses** (v. 15) is that used at the end of v. 11.

For the idea **shall bear . . . sin** see 5:1; 20:20.

16. The phrase **blasphemes the name . . .** is that found in v. 11, though here the name "Yahweh" is included. The occurrence of these phrases (**curses** and **blasphemes**) in this order suggests that Weingreen's view (see v. 11) may not be correct. *REB* continues to take the offence in v. 16 as in v. 11 to be "whoever utters the name". These were originally separate, though similar, offences.

For the phrase **shall be put to death** see 20:2, and for the involvement of the **whole congregation** see v. 14. The primary interest of the whole section emerges again in v. 16b – i.e. one law for **citizen** and **alien** (see 16:29) alike.

17. The second penalty deals with murder; the consequence is death, though no indication is given about the method of execution.

18. The third penalty concerns **anyone who kills an animal**. Here the requirement is that he must **make restitution**. This verb comes from a root meaning to "be complete" or "sound" (BDB). It is used in Exod. 22:1 with the sense here of restitution or compensation (cf. also 5:16; Josh. 2:25; 2 Kgs 4:7; Ps. 37:21; Job 41:11; Prov. 22:27). The compensation principle is specified – **life for life**.

19. The fourth penalty, physical injury inflicted on another person, embodies the same compensation principle (**lex talionis**). Some think it unlikely that the law was applied literally (G. J. Wenham, *The Book of Leviticus*, 1979; J. E. Hartley, *Leviticus*, 1992); the purpose would be to establish the principle of appropriate compensation. B. A. Levine (*Leviticus*, 1989, pp. 268–270) thinks otherwise. In either event the aim seems to be to replace private revenge with criminal law, and to halt spirals of retribution and violence. The word **maims** is that previously used of a condition which

excludes a man from priestly service (21:17; cf. also its use in relation to animals in 22:20).

For **another** ("neighbour" – *RSV*) see 5:21; 18:20; 19:11, 15, 17; 25:14, 15, 17.

20. The phrase **fracture for fracture** (v. 20) embodies the root used of broken limbs in 21:19. The expressions **eye for eye** and **tooth for tooth** pick up phrases from the Book of the Covenant (Exod. 21:24).

The phrases **injury inflicted/injury suffered** embody the root for "maims" in v. 19.

21. The requirements of vv. 17, 18 are repeated (in Gk the reference to killing an animal (v. 21a) is absent).

22. The principle of one law for **citizen** and **alien** alike is reaffirmed. The word for **law** is "ordinance" in 18:4, 5.

Taking the section as a whole it would appear that a short list of penalties, comparable to those contained in the Book of the Covenant, and now part of vv. 15–22, has been supplemented by Holiness editing. This probably includes the repetitions of v. 21, and the principle of one law for all (v. 22a), together with Yahweh's self-identification (v. 22b). Priestly editors have added a story which illustrates the one law principle in practice (vv. 10–14, 23), and probably v. 16 which reiterates aspects of the story.

9. THE SABBATH YEAR AND THE JUBILEE YEAR (25:1–55)

This section deals primarily with land, property and questions of wealth and poverty. It divides as follows:

25:1–7 – the sabbatical year for the land
25:8–17 – the jubilee year
25:18–24 – supplements on the sabbatical year and the jubilee
25:25–34 – redemption
25:35–55 – the poor in Israel.

The work of the Holiness editor is easy to detect at a number

of points. Yahweh's familiar words about who he is are found in vv. 17, 38, 55 (cf. e.g. 18:2). His claim to have delivered Israel from Egypt is found in vv. 38, 42, 55 (cf. 19:36; 22:33; 23:43, and the idea that the land is his gift occurs in vv. 2, 38 (cf. 20:22; 23:10). The importance of keeping **statutes** and **ordinances** if the land is to be secured is stressed in v. 18 (cf. 18:4, 5, 26; 19:37), while the issue of holiness (cf. e.g. 19:2) (in this instance of the land) occurs in v. 12.

The whole section is presented as commands to Moses (v. 1) which he must pass on directly to the people (v. 2). The commands are conveyed for the most part as instruction in the second person singular. This is the case for most of the instructions about the sabbatical year (vv. 3–7), and also for the basic requirements about the jubilee year (vv. 8–9a, 14a, 15–16, 17b). The redemption laws are cast essentially as casuistic law (vv. 25b–34), but are introduced by a second person singular instruction (v. 25a). The poverty laws are essentially second person singular instruction (vv. 35–37, 39–44, 47–54), though vv. 48–54 are largely casuistic in form. Those parts of the text cast in the second person plural can again be very easily seen as an aspect of the Holiness editing (vv. 2, 9b–13, 14b, 17a, all of the supplementary material in vv. 18–24, and also vv. 38, 45–46, 55). J. A. Fager's (*Land Tenure*, 1993, pp. 123–125) analysis approaches the matter differently, though in a way which is not entirely incompatible, identifying a basic nucleus of laws regulating the redemption of property or persons sold because of debt, and a series of accretions. These, for Fager, elaborate on those who could serve as redeemers, exclude urban property in walled cities, provide theological interpretation, and finally expansions, warrants and adjustments by priestly editors. The chapter has always been difficult for analysts, but there is now a general acceptance that the sabbath year and jubilee law rest on traditional practice and custom of some kind.

The application of the sabbath principle to the land (vv. 1–7) was already a feature of the Book of the Covenant (Exod. 23:10–11). Whatever earlier religious beliefs may lie behind the practice there is no doubt that in Exod. 23:10–11 the primary motive is humanitarian. What grows of itself

during the fallow year is another form of provision for the poor, and beyond them animals of the wild. Here the principle is less obviously a targeted means of provision for the poor; the stress in v. 6 is on provision for the community at large, including the land owner. The emphasis rather is ecological; this is a **solemn rest** which the land itself enjoys. Apart from 26:34–35 there are no other biblical allusions to a sabbath of the land (but see 1 Macc. 6:49, 53). For further laws about how the land is to be treated and respected see 19:23–25.

The jubilee laws (vv. 8–17) are found only here. The seventh sabbatical year is obviously of particular importance, and so on the fiftieth year (which probably means the seventh sabbatical year), the year of jubilee, the land returns to its original owner. Earlier evidence is almost entirely lacking, but further references to the occasion occur in late priestly texts (27:18, 23–24; Num. 36:4), and in Ezek. 46:17 (the year of liberty). The word **jubilee** comes from a root meaning "ram's horn". The word occurs with that sense in Exod. 19:13; Josh. 6:5, and the probability is that the instrument was blown only on momentous sacred occasions. The jubilee law does, however, give further effect to known earlier laws about release from slavery (Exod. 21:1–11; Deut. 15:12–18), and in a number of respects transforms them. Release at the jubilee appears to be automatic (v. 10), and is now a community and not merely private responsibility. It should also be noted that the section does not in principle tolerate slavery for native Israelites (vv. 39–46), and that non-Israelite slave owners are now explicitly brought under the law. The return of land (fields and houses) does not appear to be envisaged in any form in earlier legislation.

The non-observance and impracticality of jubilee law is often asserted, and it is true that there are no overt references to it in the crisis outlined in Neh. 5:1–13 (but see B. A. Levine's (*Leviticus*, 1989, pp. 270–274) reconstruction). Nevertheless, it is unwise to dismiss the law as merely "utopian". Though the word is not used it would appear that Jer. 34:8–22 attests some kind of jubilee. Certainly the word **liberty** provides common ground (Jer. 34:8, Lev. 25:10).

There are suggestions in 26:34, 35; 2 Chr. 36:21 which can be taken as an indication that the sabbatical year has been neglected, and of course every seventh sabbatical year was in practice the jubilee. It is widely acknowledged now that land "releases" of this kind were a reality throughout the ancient near east, albeit on an occasional basis, to prevent or resolve major social and economic crises (R. Westbrook, "Jubilee Laws", 1991, pp. 38–52; R. B. Coote and D. R. Ord, *In the Beginning*, 1991, pp. 124–133; J. A. Fager, *Land Tenure*, 1993, pp. 24–36). What seems to be unique to Israel is the "jubilee" principle, which, as Fager suggests, can be understood as Israel's way, in the absence of a king, of ensuring that "releases" occur. He also suggests that, though in an objective way the law would have been hard to administer, it may have been an attempt to help returning exiles regain land, and to prompt a process whereby land, in the circumstances of the return, was distributed relatively equally (J. A. Fager, *Land Tenure*, 1993, pp. 98–111; cf. also B. A. Levine, *Leviticus*, 1989, pp. 270–274). The deeper meanings reflect a concern to prevent the accumulation of large estates for the exclusive use of the rich, and for such issues as familial solidarity and viability (J. A. Fager, *Land Tenure*, 1993, pp. 112–118). This approach tends to see the law more in terms of a manifesto, a claim about God's agenda, than the product of case law.

The background to the verses on redemption (vv. 25–34) is family law. The root used here denotes the next-of-kin whose obligation it is to repurchase, if at all possible, the person or property of someone who has incurred debts which he can pay only by the sale of himself, his family or his possessions. Examples of redemption in practice can be found in Ruth 4:4–6; Jer. 32:6–12. This function is so essential that the redeemer can be rendered "next-of-kin", and can be used in a variety of contexts – e.g. the role of the next-of-kin as avenger of blood (Num. 35:19). Earlier Israelite law is inclined to use a different word for other situations where the payment of a ransom or redemption price is required – e.g. an unwanted wife (Exod. 21:8), or to escape a death penalty in certain carefully specified situations (Exod.

21:30). Priestly laws use the same word for the redemption of the first born (Num. 18:15–16).

Laws about the needs of the poor have already been met in the Holiness Code (19:9–10, 13b), while both the Manual of Offerings and the Manual of Purity are alert to the difficulties the poor would face in meeting the requirements of the cult (e.g. 5:7–13; 14:21–32). A sensitivity to the problems of poverty is firmly rooted in the old laws of the Book of the Covenant, where Yahweh is clearly depicted as advocate and champion of the poor (Exod. 22:22–24, 25–27; 23:6). In Deuteronomy a varied range of measures intended to help the poor is proposed. This includes the tithe every three years (14:28–29), the cancellation of debts every seven years (15:1–2), and the prompt payment of wages (24:14–25), in addition to adaptations of the Exodus law about loans (24:10–13). The Holiness laws about harvesting and the gleanings (19:9–10; 23:22) are also found in Deuteronomy (24:19–22). If the Deuteronomic cancellation of debts every seven years includes the right to reclaim land, and not just the remission of outstanding loans, then clearly the jubilee law in Leviticus is less generous to the poor (R. B. Coote and D. R. Ord, *In the Beginning*, 1991, pp. 131–133). On the other hand, as B. A. Levine (*Leviticus*, 1989) observes, this is the only legal material that explicitly addresses the issue of land tenure. It may therefore embody traditions that are at least as old as those attested in Deuteronomic law. J. E. Hartley's (*Leviticus*, 1992, pp. 427–430) discussion favours earlier rather than later origins for both sabbatical year and jubilee. The point is that jubilee law represents a **strengthening** of the redemption principle; if land has not been kept within the family by the processes of re-purchase, it reverts automatically in the fiftieth year.

These verses (vv. 1–7) establish the principle that in every seventh year the land must lie fallow. Even what grows of its own accord (**aftergrowth** – *NRSV*) must be left unharvested (v. 5). This seventh year is described as **a sabbath of complete rest for the land** (v. 4). It would appear at first sight that vv. 6–7 concede that a daily gathering of whatever grows of its own accord is permissible.

1. The reminder that Yahweh is speaking to Moses on **Mount Sinai** is rare in Leviticus. The Manual of Offerings is apparently conveyed from **the tent of meeting** (see 1:1), while the Manual of Holiness, in its present form, gives no indication of the location from which God speaks (11:1). The conclusion to the Holiness Code (26:46) identifies Sinai as the place from which the preceding laws are given, but what precisely that refers to is unclear. The piling up of synonyms for the law in that verse suggests the work of the Holiness editor (cf. also 27:34).

2. The idea that the land should enjoy a sabbath rest is not unique to the Holiness Code. It is found in the Book of the Covenant (Exod. 23:10–11). For other references to **sabbath** in the Code see 19:3; 23:3, 11, 16, 32.

3. Here the text speaks of six years sowing in the fields, and six years in which **you shall prune your vineyard** (including olive groves – B. A. Levine, *Leviticus*, 1989). The pruning involves a distinct agricultural technique (cf. Isa. 5:6).

4. This sabbath, like that which Israelites enjoy, is **a sabbath of complete rest** (see on 23:3). There is to be no sowing in the field or pruning in the vineyards.

5. The phrase **aftergrowth** ("what grows of itself" – *RSV*; *NIV*; cf. *GNB*) is unusual, but the word does occur in 2 Kgs 19:29. *REB* takes it to mean that you must not harvest the crop that grows from "fallen grain". This may help ease the tension often felt between v. 5 and vv. 6–7, if we can in fact distinguish between what grows from fallen grain and what the land **yields during its sabbath** (v. 6). Whether such a distinction would or could have been made is another matter.

The phrase **of your harvest** ("in your harvest" – *RSV*) (cf. 19:9; 23:10, 22) presumably refers to anything that grows after the harvest of the sixth year has been gathered.

This produce must not be harvested (**you shall not reap**). The same principle applies to **the grapes of your unpruned vine**. The word **grapes** occurs elsewhere in the priestly writing in Num. 6:3, and on a wider basis in e.g. Gen. 40:10; Isa. 5:2; Jer. 8:13; Hos. 9:10; Amos 9:13. The **unpruned vine** comes from the root which provides the word "Nazirite"

(BDB – "one consecrated" or "devoted") (cf. e.g. Num. 6:2; Jdg. 13:5; 16:17; Amos 2:11). The usage here and in v. 11, in relation to a vine, is unique. "Untrimmed" or "undressed" is usually assumed to be the meaning by way of analogy with the Nazirite's uncut hair.

The word **gather** differs from that used in v. 3. It means "to cut off" (BDB) and obviously denotes the kind of harvesting process appropriate for grapes (cf. Deut. 24:21; Jdg. 9:27; Jer. 6:9; 49:9; Obad. 5). For **complete res**t see v. 4.

6. It has sometimes been supposed that vv. 6–7 relax the requirements of vv. 1–5. Here the sabbath of the land provides food for all the household (v. 6) and its animals (v. 7), the assumption being that this food is whatever grows of its own accord (the **aftergrowth**). It is important to look carefully at what is forbidden in vv. 4–5. There must be no sowing of field and no pruning of vineyard. There must be no reaping of what grows of its own accord in the fields, and no cutting off of the grapes from the unpruned vines. If we can assume that "reaping" and "cutting off" are organized harvesting activities, with their own technologies, rather than the random gathering of what appears from day to day of its own accord, then vv. 1–7 hold together. The land itself will provide the food required, so that there is no need for organized human activity (i.e. "work") (cf. the double provision of manna on the sixth day (Exod. 16:5)).

Members of the household include **male and female slaves**. Slaves are a familiar theme in earlier laws (Exod. 21:2, 7, 20, 21, 26, 27), and in the Decalogue (Exod. 20:10; Deut. 5:14). They are also widely attested in narrative tradition (e.g. Gen. 12:16; 30:3; 31:33; 32:6; 39:17, 19; 41:12; 50:2; Exod. 2:5; 2 Sam. 6:20, 22).

For the **hired servant** see also vv. 40, 50, 53; 19:13; 22:10 and cf. Exod. 12:45. Laws in Deuteronomy cite the **hired servant** in 15:18; 24:14, and for other allusions see Job 7:1, 2; 14:6; Isa. 16:14; Mal. 3:5. In Sam. the second person plural is used to denote possession of the hired servant and slaves. The word usually denotes one who works for wages (B. A. Levine, *Leviticus*, 1989).

For the **bound labourer** (*RSV's* "sojourner") see vv. 23, 40,

47; 22:10 (cf. Exod. 12:45; Num. 35:15). This suggests a foreign resident (B. A. Levine, *Leviticus*, 1989). The word might denote a more temporary dependent than the "alien" (BDB), perhaps a "guest" (*NJB*).

7. This provision during the sabbatical year is also for **your livestock**; the word here clearly indicates domestic animals. It is distinct from **the wild animals** (all living creatures) for which the same provision is available. The word **yield** is the same as that which *RSV* renders as "fruits" in v. 3.

In vv. 8–17 the basic requirements for the jubilee year are set out. It occurs every fifty years, which is probably intended to mean that every seventh sabbatical year (vv. 1–7) is a jubilee year (see v. 11). The blowing of a trumpet will **proclaim liberty** (i.e. from slavery and probably from various forms of debt) to all inhabitants (v. 10). The other feature of the year is the return of all property to its original owner (vv. 13–16).

8. The calculation is described (cf. the counting processes in 15:13, 28; 23:15). It is almost certainly intended to include the first and the last year, thus making the jubilee year one of the sabbatical years (v. 11).

9. The **trumpet** here (v. 9) ("ram's horn" – *REB*) is the word used in 23:24.

The word **loud** here renders the phrase trumpet blasts ("shout" or "alarm" (BDB) in 23:24).

The actual day of jubilee or release is identified as **the tenth day of the seventh mont**h – i.e. the day of atonement (16:1–34; 23:26–32; Num. 29:7–11).

10. Israel must **hallow** (make "holy" or "dedicate") (see 22:2, 3) this particular year.

It is characterized as a year in which **liberty** is proclaimed. This rare word also occurs in Exod. 30:23 in connection with myrrh, and where *NRSV* translates it as liquid. BDB renders it "a flowing" or "free run". Other texts where it is associated with "freedom" or "release" are Isa. 61:1 (of captives) and Jer. 34:8, 15, 17 (of slaves). It is used in Ezek. 46:17 as a title for the jubilee year – the year of liberty. The word is related to the "releases" that were often proclaimed when ancient near eastern kings came to the throne (B. A. Levine, *Leviticus*,

1989). The point is made very clearly that this "release" is applicable to all inhabitants of the land.

The word **jubilee** (cf. vv. 13, 28, 40, 50, 52, 54; 27:17, 18, 23, 24) comes from the word "ram" or "ram's horn" (BDB). It indicates what kind of "trumpet" (v. 9) was intended.

The word **property** ("holding" – *REB*; "ancestral property" – *NJB*) has already occurred in 14:34. It is frequent in this section (vv. 13, 24, 25, 27, 28, 32, 33, 41, 45, 46), and also elsewhere in the priestly writing (e.g. 27:16, 22, 24, 28; Gen. 36:43; 47:11; Num. 27:4; 35:8, 28).

The word **family** can be rendered "clan" (BDB; *NJB*) (see also vv. 41, 45, 47, 49; 20:5); it probably denotes the extended family, or perhaps a protective association of families (N. Gottwald, *The Tribes of Yahweh*, 1979/1980, pp. 245–292).

11. It seems likely that the jubilee is also a sabbatical year (see vv. 4–5). It has been suggested that the jubilee could have been a short "year" (hence **fiftieth** rather than "forty–ninth") (G. J. Wenham, *The Book of Leviticus*, 1979). Other possibilities, including overlapping from two different calendars, are considered by J. E. Hartley (*Leviticus*, 1992, pp. 434–436).

12. It is also a **holy** year. Provision comes not from "reaping" a harvest or "gathering" grapes, but from what the land **produces** on a day by day basis (see vv. 6–7). *REB* has "you are to eat the produce direct from the land" ("directly from the fields" – *NIV*).

13. The return to property is a key feature of the jubilee, and is stressed again (see v. 10). There follows some further detail about transactions in relation to the jubilee principle. In the first place an intrinsic integrity in such transactions is required.

14. The verb **make a sale** poses no problems, and is common in legal texts (Exod. 21:7, 8, 16, 35; 22:1; Deut. 14:21; 21:14; 24:7) and elsewhere. The Heb. also includes a noun from this root, the thing sold.

For **neighbour** see 6:2; 18:20; 19:11, 15, 17; 24:19.

For **buy** in legal texts see 27:24; Exod. 21:2.

The insistence on fair dealing – **you shall not cheat one another** (see also v. 17) – employs the verb "to oppress"

(BDB) (see 19:33). *REB* has "neither party must exploit the other" ("take advantage" – *NIV*; "deal unfairly" – *GNB*).

15. Some indication is given of what is in mind. The prices charged and paid in any transaction must be graded according to the number of years remaining before the next jubilee.

The word for **crops** comes from the same root as **yield** in vv. 7, 12. *NJB* reads "the price he fixes for you will depend on the number of productive years still to run".

16. The verse contains an idiomatic phrase derived from the root usually rendered "mouth", and which here expresses calculations (cf. 27:16; Gen. 47:12; Exod. 12:4; 16:16, 18; Num. 26:54; Josh. 18:4; 1 Kgs 17:1; Prov. 12:8; 27:21; Hos. 10:12) or carries the meaning "in proportion to" v. 52; (Exod. 16:21; Num. 6:21; 7:5; 35:8; Job 33:6). The greater the number of years that remain the higher the price, and the closer the jubilee the lower the price will be (see also Deut. 15:9–10 for a theoretical recognition that laws of this kind may create opportunities for exploitation).

17. The concluding words of self-identification by Yahweh are preceded by the insistence that Israel must **fear** her God (see also vv. 36, 43 and 19:14, 32). The phrase is common enough to suggest that it is part of the Holiness editing.

Verses 18–24 appear to be supplementary comment regarding the sabbatical year and the jubilee. They contain promises of security if Israel is obedient (vv. 18–19), and in particular a promise of abundance in the sixth year to cover all needs in the year itself, and in the two that follow (vv. 20–22). The requirement that land must not and cannot be sold in perpetuity is repeated (vv. 23–24).

These comments are framed entirely as statutes in the second person plural, and are probably the contribution of the Holiness editor.

18. For **statutes** see 18:3, 4, and for **ordinances** see 18:4. The insistence that obedience is the key to well-being and security is characteristic of Israel's laws (e.g. Exod. 20:12; 23:25–26; Deut. 5:16; 28:1–14).

For **securely** (cf. v. 19) see e.g. 26:5; Deut. 12:10; 33:12, 28;

Jdg. 8:11; 18:7; 1 Sam. 12:11; 1 Kgs 5:4.

19. The phrase **eat your fill** attests the abundance (cf. e.g. 26:5; Exod. 16:3; Deut. 23:25; Ruth 2:18; Ps. 78:25; Prov. 13:25).

20. In vv. 20–22 natural doubts about the sabbatical principle are dealt with (cf. also the story in Exod. 16:22–30).

If to **sow** and to **gather** is forbidden, will there be sufficient food to sustain the family and community? For the words **gather** and **crop** see the phrase "gather in their yield" in v. 3. In vv. 5, 11 a different word is translated "gather" in connection with vines.

21. The phrase **I will order my blessing for you** has affinities with Deut. 28:8; Job 38:12; Ps. 133:3; Amos 9:3, 4. The provision will be for **three years** – i.e. for the sixth year itself, for the sabbatical year, and for the year that follows, since the sowing in the eighth year will not be available as food until the ninth (v. 22).

22. For **old** see 26:10. **Produce** translates the same word as **fruit** in vv. 3, 21.

23. The word **perpetuity** has connections with the verb "to put an end to" or "to exterminate" (BDB). Its occurrence as a noun (only here and in v. 30) suggests some such meaning as "completion" or "finality" (BDB) – thus "beyond reclaim" (B. A. Levine, *Leviticus*, 1989). The ultimate owner of the land is God himself, the theological perception that shapes the chapter as a whole. It is worth noting that the concept of "stewardship" (delegated authority over the land) is not utilized here. Those who "own" land actually have nothing more than the status of **aliens** (see 16:29) and **tenants** (or "bound labourers") (see v. 6; 22:10; "guests" in *NJB* may be preferable), attached, as it were, to Yahweh's household.

24. It is in this context that the land as something **you hold** must be understood. For this root see v. 10; 14:34; 27:16.

The word **redemption** embodies the root which is important to the next textual unit (vv. 25–34). It is possible that v. 24, and even v. 23, should be read as part of that unit. In any event, thought about a return to ancestral property in the jubilee year, and the fact that land must not be sold in perpetuity, leads naturally enough to the conclusion that the

possibility of redemption (the buying back of land by the next of kin) must always be open. It would appear, in fact, that redemption is the expected norm; the jubilee is a measure of last resort, ensuring that land which has not been returned, or which cannot be returned for some reason, finally comes back to its rightful holder.

In vv. 25–34 the redemption process is discussed, that by which the next-of-kin should buy back property which has been sold because of poverty. Land is the property in mind. If the poor person's circumstances change he too may redeem the property (vv. 26–27); if there has been no redemption by the jubilee year then the property will be returned automatically without payment (v. 28). Further discussion of the redemption principle ensues, particularly as it affects houses and the property of Levites (vv. 29–34).

25. The phrase **falls into difficulty** ("becomes poor" – *RSV*) is uncommon. It also occurs in vv. 35, 39, 47; 27:8, and probably expresses the idea of being brought low by circumstance.

For **sells** see v. 14, and **property** see v. 10. The phrase **the next-of-kin** could be rendered "his redeemer". That this is a duty, and not merely an option, for the next-of-kin, is clear.

26. In situations where there is no redeemer the seller himself can take steps to recover his property, should his financial circumstances improve. The phrase **prospers** (see also vv. 47, 49) means literally "his hand has reached" (i.e. he "has enough" (BDB)). It has already been used in 5:11; 14:21 (see also 27:8; Num. 6:21; Ezek. 46:7).

For the phrase **finds sufficient means**, as much as required, see Deut. 25:2 (as much as is deserved); Neh. 5:8 (as much as we are able).

27. The amount of money required in such situations will be calculated according to the years the property has been in the hands of the other person. The **difference** ("overpayment" – *RSV*) (that which "remains over" or is "in excess" (BDB)) is rare, but used several times in the priestly writing (Exod. 16:18, 23; 26:12, 13; Num. 3:46, 49). This means presumably that he must pay back the money he received

when the land was sold, plus an amount appropriate for the years it has been in the hands of the person to whom he sold it. The overpayment is probably to be understood as relating to "the time still to run" (*NJB*) or to be "the balance up to the jubilee" (*REB*; cf. also *GNB*). It has to be acknowledged that there are many obscurities with respect to the pricing of land and the nature of the market in ancient Israel; the laws take much as self-evident (R. Westbrook, "Jubilee Laws", 1991, pp. 90–117).

For **property** see vv. 10, 25.

28. If he never finds himself with sufficient to repossess the property then it remains with the purchaser until the **year of jubilee**; then he regains possession of the property freely and without payment.

The phrase **sufficient means** is that used in v. 26.

For **the purchaser** see the root **buy** in v. 14, and for **jubilee** see v. 10.

The word **released** is the verb "go out"; the phrase could be translated "and he shall go out in the jubilee, and return to his property".

29. Here attention turns to houses, and particularly those in a **walled city**. As v. 31 makes clear the forthcoming stipulations would not apply to property in villages. If circumstances require it such a house may indeed be sold. In this case rights of redemption last for a whole year after the date of the sale. The verb speaks of the "completion" of the year (cf. Gen. 47:18; Jer. 1:3).

30. If, however, there is no redemption within the space of this first year, then the house belongs to the new owner in perpetuity; there is no restoration of such property in the year of jubilee. This exception may be ancient (R. Westbrook, "Jubilee Laws", 1971, p. 53), though the effect, as noted by R. B. Coote and D. R. Ord (*In the Beginning*, 1991, p. 129), is to exclude the urban properties of relatively wealthy people.

The phrase **before a full year has elapsed** includes the root "to fill"; it is used elsewhere in the priestly writing to denote the completion of a period of time (e.g. 8:33; 12:4, 6; Num. 6:5, 13) (n.b. also its use in this way in other texts – e.g. Gen.

25:24; 29:21; 50:3; 1 Sam. 18:26; 2 Sam. 7:12).

The phrase **shall pass** ("made sure" – *RSV*) comes from the root "to arise" or "to stand up" (BDB). Its use as here, with the sense "to confirm a right to", is rare; it is used in relation to purchases in 27:19; Gen. 23:17, 20, and to the kingdom in 1 Sam. 24:20.

For **perpetuity** see v. 23. For **the purchaser** see v. 14.

The Heb. text in v. 30, contrary to Sam. and the Versions, seems to suggest a city which is not walled. Given the text of v. 29, and the contrast drawn with houses in villages in v. 31, it is best to assume some corruption in Heb. in v. 30.

For **generations** see 3:17. For the use of the verb "go out" (**released**) to denote the jubilee requirements see v. 28.

31. A different arrangement affects houses in unwalled villages. The word **villages** can denote any settlement (e.g. Gen. 25:16), including those which are dependent on cities (e.g. Josh. 15:46), and others which are apparently not (Isa. 42:11). Houses in settlements of this kind are to be treated like the fields. They are redeemable at any time, and subject to the jubilee release.

The verb **classed as** ("reckoned" – *RSV*) is the same as that used in v. 27.

These stipulations in vv. 29–31 give some support for the supposition that urbanization began to break up the older rural ideas about what could become a marketable commodity. Relaxation of the jubilee principle in connection with town houses makes the process of accumulation (cf. Isa. 5:8–10) increasingly easy.

32. Attention turns to **the cities of the Levites**. Such cities are attested in relatively late priestly texts (Num. 35:1–8; Josh. 21:1–45; cf. 1 Chr. 6:54–81). Possessions of this kind seem to run counter to the Deuteronomic insistence that Levi has no portion or inheritance in Israel (10:9; 18:1). The principle of landed property held by priests is affirmed in Ezek. 45:1–5; 48:8–22; workers from all the tribes are supposed to till the land on behalf of the priests (Ezek. 48:19–20). That there should be such holdings appears to be an exilic proposal. This is the first reference to the Levites in Leviticus, and there is no obvious distinction here between them and the

priests, the sons of Aaron. The Holiness Code appears to share the view of Deuteronomy about priests and Levites.

The cities **belonging to them** ("of their possession" – *RSV*) embodies the same root as **property** in this chapter (see v. 10). The redemption of houses in such cities is permitted at all times.

33. The text here poses problems. Heb. appears initially to envisage a situation in which a Levite **does** exercise his right of redemption, in which case v. 33b, promising the property's release at the jubilee, is difficult to interpret. *RSV*, *REB* and *GNB* (with Vg) suppose the text to mean that if a Levite does **not** redeem his house, then it automatically comes back into his possession at the jubilee. *NJB* assumes that the Levite has bought property, and that the text requires that at the jubilee he leave it, and return to his own city (a Levitical city), where presumably he has property of his own. This reading does not follow easily from the present form of the Hebrew text. *NIV* suggests that Levitical property is redeemable, and also (if it has not been redeemed) that it returns at the jubilee.

Another possibility is that the text is concerned with property redeemed from the Levites (see *RV*n), and thus *NRSV* – **Such property as may be redeemed from the Levites . . . shall be released in the jubilee** (cf. also *JPS* and B. A. Levine, *Leviticus*, 1989; G. J. Wenham, *The Book of Leviticus*, 1979). This seems to presuppose a situation in which certain cities, where properties belong to a variety of owners, have been declared to be Levitical. When property is sold Levites are the only permitted purchasers. Redemption is permitted, but in the jubilee year redeemed property of this kind passes once and for all into the hands of the Levites. So too, in all probability, does all property not in Levitical hands. In this way the ideal of a truly Levitical city is realized at the first jubilee after the year in which the city is thus designated. This interpretation is based on a translation of the following kind:

"And if a man redeems (a house) from the Levites, then the sold house and the city to which it belongs ("of his possession") shall be released (to the Levites) in the jubilee; for the houses of the cities of the Levites are their possession among

the people of Israel".

34. The fields belonging to such cities may not be sold in any circumstances. They belong to the Levites at the outset, and continue to do so for all time. The word **open land** ("common land" – *RSV*) is frequent in literature from priestly sources (e.g. Num. 35:2, 3, 4, 5, 7; Josh. 14:4; 21:2; 1 Chr. 5:16; 2 Chr. 31:19; Ezek. 27:28; 45:2; 48:15, 17).

On **possession** see v. 10 and on **for all time** see 3:17.

The remaining verses of the chapter (vv. 35–55) address directly the question of poverty. Agreements to lend money to the poor which include interest payments are strictly forbidden (vv. 35–38). Making slaves of fellow Israelites is also ruled out (vv. 39–46). Redemption of fellow Israelites from wealthy **aliens** is the issue addressed in the concluding verses (vv. 47–55).

35. The word **kin** (see also v. 25) is used as in 19:17, 18, that is with a wide frame of reference which may include at the very least any fellow Israelite.

The phrase **fall into difficulty** ("becomes poor" – *RSV*) is also used in v. 25.

The words **and become dependent on you** are a rendering of an idiomatic phrase meaning literally "and his hand slips (or shakes) with you". This suggests that his economic situation has become so feeble that he can no longer support himself.

Correspondingly the insistence that **you shall support them** comes from the verb "to strengthen". This usage, with the sense of sustaining and supporting, is found in Isa. 42:6; 45:1 with respect to Yahweh and his servant/anointed.

The phrase **resident aliens** embodies the two words that ought to be distinguished (*RSV* – "stranger" and "sojourner"). On "stranger" see 16:29. The word "sojourner" ("guest" – *NJB*) is derived from the verb "to dwell" (see vv. 23, 40, 47; Gen. 23:4).

36. The willingness to lend without **interest** is an important principle of Israel's social law (cf. Exod. 22:25; Deut. 23:19, 20; cf. also Ps. 15:5; Prov. 28:8; Ezek. 18:8, 13).

The word **profit** also appears to mean interest, but does

not figure elsewhere in the laws (cf. Ezek. 18:8, 13, 17; 22:12; Prov. 28:8). *REB* understands the two words to denote a deduction in advance, and an additional charge on repayment. *NIV* and *GNB* take the two words together as "interest of any kind" (*NIV*) or "any interest" (*GNB*). S. E. Loewenstamm ("On Tarbit and Neshek", 1969) takes **interest** to be interest on a loan of money, and **profit** interest on a loan of victuals. R. P. Maloney ("Usury", 1974) conducts a wide-ranging study of ancient near eastern practice with respect to loans and the payment of interest.

The reference to the fear of God occurs elsewhere in the Holiness Code (vv. 17, 43; 19:14, 32); it is more probably a feature of some of the sources used in the Code than of the Holiness editors themselves.

38. This is an amalgam of phrases and ideas from the Holiness editors, with Yahweh's self-identification followed by a reference to the deliverance from Egypt (cf. vv. 42, 55; 19:36; 22:33; 23:43; 26:13, 45) and to Canaan as Yahweh's gift (cf. 18:3; 20:22; 23:10; 25:2).

39. In vv. 39–46 there is the recognition that the role of "dependent alien" or "guest" may not always be desired or be appropriate. The possibility that a poor person should work for a fellow Israelite is accepted. This is conceivably a third stage in the spiral downwards into destitution (the first two being those discussed in vv. 25–34, 35–38) (G. C. Chirichigno, *Debt Slavery*, 1993, pp. 302–343).

For **dependent** ("brother" – *RSV*) and **impoverished** ("becomes poor" – *RSV*) see v. 35, and for **sell** see v. 14.

What is not accepted is that the relationship should be that of master and slave. The phrase **make them serve as slaves** means literally "make them serve with hard service" (cf. Gen. 29:27; 30:26; Ezra 8:20; cf. the tabernacle service in Num. 4:26, 32); **as slaves** seems appropriate since v. 40 is going on to speak of other forms of status within the household.

40. The **hired . . . labourer** has already been cited in v. 6, 19:13; 22:10 (cf. also vv. 50, 53; Exod. 12:45; Deut. 15:18; 24:14).

For the **bound labourer** (or "guest") see vv. 23, 35. *RSV* reads "as a hired servant and as a sojourner". This would

appear to mean that despite the commercial relationship between the head of the house and the hired servant the latter still has the rights of the "guest" ("sojourner").

The contract will last **until the year of the jubilee**. This seems severe (slave release occurs after a mere six years in Exod. 21:1–6; Deut. 15:12–18). The situation of course is different; the man is not subject to the low status and humiliations of slavery (cf. e.g. Exod. 21:20–21). G. C. Chirichigno (*Debt Slavery*, 1993, pp. 302–343) makes a case for connecting the seventh-year legislation with less serious debts, requiring the temporary sale of dependents; a land sale indicated a more serious state of insolvency. In practice of course it would be usual to serve less than fifty years.

41. It seems to be expected that the **hired servant**, and his wife and children, will then be in a position to return to their **own family** (v. 41) (see v. 10). For **ancestral property** see v. 10.

42. This expectation is clearly inspired by the conviction that there is a profound incongruity about the relationship between head of house and a hired servant. All Israelites together have been delivered from slavery in Egypt, implying that all together are equal recipients of God's grace. Slavery itself must therefore be absolutely precluded; hired service is a reluctant and temporary concession to harsh economic realities. K. Baltzer ("Liberation", 1987) provides further comment on the language and issues of debt release in exilic and post-exilic times, with special stress on Deutero-Isaiah and Nehemiah.

43. There is the further insistence that **rule** (the power of the head of the house) must not be **with harshness**.

The word **rule** sometimes carries with it connotations of "control" or "domination" (see e.g. 26:17; 1 Kgs 4:24; 9:23; Isa. 14:2).

Harshness or "severity" confirms the direction of the thought. It is not very common (e.g. Exod. 1:13, 14; Ezek. 34:4).

The phrase continues to be used in vv. 46, 53. *REB* reads "you must not work him ruthlessly" (cf. *NIV*).

On the **fear** of God see v. 36.

44. The slavery theme raises questions about the purchase and ownership of slaves from other nations (vv. 44–46). In

this instance there is no prohibition, whether of **male** or **female** slaves (see v. 6).

Reference to the **nations** does occur in earlier Pentateuchal tradition (Exod. 9:34; 34:10; Num. 14:15; Deut. 15:6), and earlier in the Holiness Code in 18:24, 28; 20:23. It plays an important part in the thought of the next chapter (26:33, 38, 45).

45. This right to buy may also include the purchase of **aliens** (see 16:29).

Families is the word used in v. 10. It seems likely that a purchase from the **alien's** family is in mind. The requirement seems to be that they must have been born in Israel, a circumstance which apparently makes the sale acceptable.

The slave is thus the **property** (the word in v. 10) of the householder.

46. Furthermore there is no year of release for such slaves. The owner can **keep them as a possession** ("bequeath them" – *RSV*) for the next generation (cf. v. 10).

Gk lacks the phrase **you may treat as slaves**. The idea that other peoples might be enslaved as a response to the oppression Israel has experienced is reflected in texts such as Isa. 14:2; 61:5.

For **fellow Israelites** as "brethren" (*RSV*) see vv. 35, 39, where *NRSV* understands kin or dependents.

For **rule . . . with harshness** see v. 43.

47. The final part of the passage considers the possibility that **resident aliens** ("strangers" or "sojourners" – *RSV* (see v. 35)) could become rich, and that they might wish to buy and sell slaves (vv. 47–55). This verse makes it difficult to accept "sojourner" as "bound labourer" as *NRSV* sometimes wishes to do (e.g. vv. 6, 40); would such a person be in a position to make such a purchase?

The word **prosper** comes from the verb "to reach" or "to overtake" (BDB) (see 5:11; 14:21; 27:8), and the Heb. also incorporates the noun "hand" in the idiom. These texts tend to deal with those who lack resources; its use here, and in vv. 26, 49, in connection with those who become prosperous, is a special feature of this chapter.

For **kin** (possibly fellow Israelite) see vv. 25, 35, and for **fall**

into difficulty ("becomes poor" – *RSV*) see v. 25. For **sell** see v. 14.

The word **branch** ("member" – *RSV*) (not present in Gk) probably means "offshoot" (BDB), and this usage in connection with a stranger's family is unique.

48. The normal processes of redemption can operate in such a situation, as described in v. 25. The phrase **one of their brothers** in this context clearly has a close member of the family in mind.

49. Others who may act as redeemer are an **uncle** or an **uncle's son**.

The word **uncle** can apparently have a wider frame of reference, as for example the loved one in the Song of Songs (e.g. 1:13, 14, 16), but this specific usage to denote a father's brother is the norm in H and P (10:4; 20:20; Num. 36:11), as well as in other texts (e.g. 1 Sam. 10:14; 14:50).

The phrase **anyone of their own family who is of their own flesh** renders two different Hebrew words for "flesh". The first is common elsewhere in the Holiness Code (18:6, 12, 13; 20:19; 21:2; cf. also Num. 27:11) to denote closely related persons. The other, with the meaning blood relation, occurs in 18:6, and in a range of other texts (e.g. Gen. 2:23, 24; 29:14; Jdg. 9:2; 2 Sam. 5:1). For **family** see also v. 10.

If they **prosper** (as in v. 47) slaves may of course redeem themselves.

50. The following verses deal with the calculations by which the redemptions price is decided. The period between the year of purchase and the next jubilee year must be worked out, and this determines the number of years for which payment must be made; the cost can then be determined in terms of the annual rate paid to a hired servant. The verb **compute** (cf. vv. 27, 52; 27:18, 23) comes from a root meaning "to think" or "to account" (BDB).

For the year of **jubilee** (cf. vv. 51, 52) see v. 11.

On **hired labourer** see v. 40.

51. It would appear that vv. 51–52 address the issue in more detail, though some lack of clarity remains. It would appear that if there are still many years until the jubilee the purchase price must also be paid as part of the redemption costs (v. 51)

– i.e. in addition to the sum required in v. 50. How many years is not made clear, and this might perhaps be by mutual agreement.

52. For the phrase **according to the years** see v. 16 (the root rendered "mouth"). If the years remaining until the jubilee are **few** (how few?) the calculation is based only on the rate applicable to those years, in accordance with the principle articulated in v. 50.

The *REB* reading appears to understand the point to be that if there are "many" years an appropriate proportion of the purchase price must be repaid (v. 51), and if there are "few" that too must be reckoned accordingly. On this view vv. 51–52 appear to do no more than reiterate the requirement made in v. 50 (cf. also *NIV, GNB*).

53. The point is made that this relationship (between a prosperous alien and a poor Israelite) must be in all essentials the relationship between a head of house and a hired servant (see v. 40).

For the expression **rule with harshness** see vv. 43, 46.

54. Moreover, in the last resort, if there is no redemption by any of the means indicated, then such a person, along with his family, must **go free** (or be released – see v. 28) in the year of jubilee. The principle whereby an alien might become a slave for life (vv. 45–46) does not apply in reverse.

55. The concluding comment seeks to justify these legal requirements in terms of Israel's status as **servants** ("slaves" – *REB, GNB*) of Yahweh. This is a different word from the technical term **hired labourer** in vv. 40, 50. It was used in v. 42, and occurs again in 26:13. It has a wide frame of reference, in relation to all kinds of slavery and service; it is common in a wide range of literature as a term for those who serve or worship Yahweh (e.g. Gen. 26:24; Josh. 1:1; 1 Kgs 8:31; Ps. 105:26; 119:125; Mal. 3:22). The basic point is enforced by the fact that the exodus was a deliverance from service/slavery. There is therefore a recognition that there is something intrinsically incongruous about institutions such as slavery, and even hired service, as far as Israel is concerned.

The laws formulated in this section constitute a concession to harsh economic realities. That concession does not, however, carry with it the assumption that such realities are acceptable or inevitable, still less desirable. The overall interests of Israel as a community demand that the effects of those realities be mitigated and the spirals of poverty be broken, and by force of law wherever that can be achieved.

10. DISCOURSE: PROMISES AND WARNINGS
(26:1–46)

This concluding section in the Holiness Code consists of an extended discourse, containing promises and warnings about Israel's attitude to the laws which have just been set out. It is natural to suppose that it comes from the editors themselves. It can be divided as follows:

26:1–2 – introductory stipulations based on the Decalogue tradition

26:3–13 – promises of prosperity

26:14–39 – warnings of disaster

26:40–46 – possibilities of restoration.

The chapter as a whole has many of the marks of the Holiness editors, and there is no reason to doubt that the whole is an original composition from such sources. Yahweh's insistence on identifying himself as Israel's god is well represented (vv. 1, 2, 13, 44, 45; cf. e.g. 18:2). To **walk** in Yahweh's **statutes** (vv. 3, 15, 21, 23, 43, 46; cf. 18:4, 5, 26; 19:19, 37; 20:8, 22; 25:18) and to **observe** his **commandments** (vv. 3, 14, 15; cf. 18:4, 26; 30; 19:19, 37; 20:8, 22; 22:31; 25:18) are familiar words in a variety of combinations. Yahweh's **ordinances** also feature in the chapter (vv. 15, 43; cf. 18:4, 5, 26; 19:37; 25:18). The special bond that unites Yahweh and Israel is attested in vv. 12 (cf. 19:36; 20:24, 26; 21:6, 8, 15, 23; 22:9, 16, 32; 23:22; 24:22; 25:17, 38, 55) and for the first time is identified as a **covenant** (vv. 9, 15, 25, 42, 44, 45). The exodus is identified as the foundation of this relationship (vv. 13, 45; cf. 19:36; 22:33; 23:43; 25:38, 42, 55).

The summarizing statement in v. 46, which marks the end of the Holiness Code, identifies all that the Code contains as **statutes**, **ordinances** and **laws**, transmitted by Moses, and given on Mount Sinai. This appears to contrast with the Manual of Offerings (1:1–2), which is transmitted from the tent of meeting. It is probably unwise to theorize about editorial processes on the basis of this text. The tent of meeting is an appropriate place from which to deliver directions about offerings; Sinai is appropriate for the wider range and scope of the material from which the Holiness Code is constructed.

The fact that several collections of laws conclude with a discourse of this kind has often been noted. Characteristic is the juxtaposition of promises and warnings. The Book of the Covenant concludes with the discourse in Exod. 23:20–33. It is dominated by promises of guidance and protection (vv. 20, 22–23, 27–30), prosperity and health (vv. 25–26), and a spacious land (v. 31). The warnings are primarily in the form of commands to pay heed and obey (vv. 21, 24, 32–33), particularly with respect to alien influences; the only specific threat speaks of the angel's unwillingness to pardon transgression (v. 21). In Deuteronomy there is a major discourse at the conclusion of the main body of law (28:1–68). It describes in detail the blessings that accompany obedience to Deuteronomic law (vv. 3–14), and at much greater length the corresponding curses that follow failures of commitment (vv. 15–68). The whole appears to be constructed around six blessings (vv. 3–6) and six corresponding curses (vv. 16–19). In content they deal with the well-being of (1) the city, (2) the fields, (3) fertility in the community, (4) the fertility of the land, (5) fertility among herds and flocks, (6) safe and successful journeys. The rest is an extensive commentary which takes into account all aspects of Israel's experience as a nation, and not least the possibility of deportation and exile (vv. 64–68).

The discourse here in the Holiness Code has more affinities with that in Deuteronomy than with the conclusion to the Book of the Covenant. This concerns, not only its length, but also the greater weight it gives to warnings of disaster (vv. 14–39) over promises of blessing (vv. 3–13). In content these

promises and warnings have a good deal in common with the elements of commentary in Deut. 28:1–68, with a major focus on political and economic security. The realities of exile are given particular prominence (vv. 27–39), albeit in a distinctive fashion, and the possibility of restoration, if attitudes are right, provides the final focus (vv. 40–45). B. A. Levine (*Leviticus*, 1989, pp. 275–281) appropriately sees in this epilogue a grappling with the question of Israel's destiny, in the wake of the disasters associated with the destruction of Jerusalem and the exile.

It is reasonable to conjecture that the blessings of Deut. 28:3–6 contain traditional words of peace and goodwill, and it is likely that they, along with corresponding curses in Deut. 28:16–19, became enshrined in some kind of cultic observance (Deut. 27:11–13). That this observance had some connection with the promulgation of community law is suggested by the link between cult, curse and legal requirement in Deut. 27:14–26. Theories about a covenant festival in Israel are less attractive and less popular than once they were, but the basic evidence in Deut. 27:11–26, some of which is arguably old, and suggesting interconnections between cult, community law and blessing/curse, continues to be persuasive with respect to a cultic background for these concluding discourses.

The brief introduction to the concluding discourse (vv. 1–2) contains basic Decalogue stipulations about graven images (v. 1) and sabbath observance (v. 2). These particular stipulations were considered appropriate perhaps because they were thought by the Holiness editors to constitute foundations for the kind of loyalty that was essential for the well-being or otherwise of the community, as described in the rest of the chapter. Some commentators prefer to read them with 25:1–55 (M. Noth, *Leviticus*, 1962/1965; B. A. Levine, *Leviticus*, 1989), or to treat them separately (J. R. Porter, *Leviticus*, 1976; J. E. Hartley, *Leviticus*, 1992).

The practice of introducing new material with a short section of legal principles drawn from the Decalogue is evident elsewhere in the Holiness Code (e.g. 19:3–4; 19:11–12).

1. The second Decalogue commandment, forbidding pictorial representations of deity, is given more detailed attention here than in 19:4. **Idols** are prohibited (as in 19:4), and so too are **carved images**, the first occurrence of this word in Leviticus. It does occur in the Decalogue (Exod. 20:4; Deut. 5:8; cf. also Deut. 4:16, 23, 25), and the root ("to hew") suggests the emphasis is on the process of carving or sculpting images of deity. It would appear that the image can be of wood or stone (cf. e.g. Hab. 2:18, 29), or also of metal (cf. e.g. Jdg. 17:3, 4; Isa. 40:19; 44:10).

Among other prohibited representations of deity are the **pillars**, also cited here for the first time in Leviticus. These are some kind of standing stone, which do not always have negative associations in biblical texts. The pillar could be a personal monument, as suggested in 2 Sam. 18:18, or might mark a grave (Gen. 35:20) or a place where agreements have been reached (Gen. 31:45, 51, 52). In a number of texts, sometimes identified as the Elohistic source, it can signify a place of authentic divine revelation (e.g. Gen. 28:18, 22; 31:13; 33:20; 35:14; Exod. 24:4). Nor is it necessarily alien in texts such as Isa. 19:19; Hos. 3:4; 10:1, 2. Its association with Canaanite religion (Exod. 23:24; 34:14) probably encouraged the generally iconoclastic attitude to the pillar, as found here and in Deuteronomistic literature (e.g. Deut. 7:12; 12:3; 16:22; 1 Kgs 14:23; 2 Kgs 17:10; 18:4; 23:14; cf. also Mic. 5:13).

The **figured stones** are another forbidden cultic object, and may signify a carving in rock. The word is relatively infrequent, but occurs again with the same meaning in Num. 33:52. In Ezek. 8:12 **figured** is rendered "pictures" by *RSV*, and "images" by *NRSV*. In Proverbs it signifies the "imagination" (18:11 *RSVn*; cf. also Ps. 73:7) or a "setting of silver" (25:11).

The word **worship** comes from the Decalogue (Exod. 20:5; Deut. 5:9), and is widely used elsewhere to denote the service of other gods (e.g. Exod. 23:24; Num.25:2; Deut. 8:19; 11:16; Josh. 23:7; 1 Kgs 16:31).

2. The other Decalogue principle concerns observance of the sabbath (see 19:3, 30 for the turn of phrase used here and for the general background).

To this is appended the requirement that Israel **reverence** Yahweh's **sanctuary** (see 19:30 for the idea and turn of phrase). The verb here often signifies "to fear". With the sense of "respect" or "reverence" it is used in 19:3 in relation to parents, and it is also applicable to the worship of deities (e.g. Jdg. 6:10; 2 Kgs 17:7).

These verses (vv. 3–13) contain the blessings that will accompany a steadfast obedience to Yahweh's **statutes** and **commandments** (v. 3). In brief, they promise a fruitful land (vv. 4–5), peace and national security (vv. 6–8), an expanding population (v. 9), and Yahweh's continuing presence (vv. 11–13).

3. The introductory conditions embody the basic beliefs of the Holiness editors.

4. The **rains** is a general term not often used in the Holiness Code or in priestly texts (cf. the Yahwistic texts Gen. 7:12; 8:2 and prophetic texts such as Isa. 44:14; Jer. 5:24; Ezek. 1:28; Hos. 6:3; Amos 4:7).

The phrase **in their season** is used elsewhere in relation to rain (e.g. Deut. 11:14; Jer. 5:24; for other contexts see Pss. 1:3; 104:27; 145:15; Prov. 15:23). As B. A. Levine (*Leviticus*, 1989) observes, it was extremely important that sufficient rain fell at the appropriate time.

The word **produce** is customarily used of all that comes from the soil (v. 20; Deut. 11:17; 32:22; Jdg. 6:4; Ps. 78:46); in Hab. 3:17 it is used specifically of the vine.

5. Here various phases in the agricultural year are identified. The **threshing** denotes the harvesting period, of barley and wheat in April–May. Specifically it comes from the verb "to tread", indicating the process whereby grain is separated from chaff.

The vintage (cf. Jdg. 8:2; Isa. 32:10; Jer. 48:32) marks the harvesting of grapes (in July or August), and probably also the dates, figs and olives (September).

The **sowing** (cf. Gen. 8:22) denotes the late autumn when the rains return, and cereals and beans are sown. The point is evidently that the harvests will be so abundant that there will be no time of idleness or unemployment from spring to late autumn.

The phrase **to the full** is that used in 25:19, denoting "abundance".

For **securely** see 25:18, 19.

6. In addition to economic security Yahweh promises **peace in the land** (v. 6). This word has many nuances speaking of wholeness, completeness and well-being; in this context freedom from war and civil disturbance seem to be to the fore (cf. Josh. 9:15; Jdg. 4:17; 1 Sam. 7:14; 1 Kgs 5:26).

The verb **lie down**, as is often the case, means "to sleep" (cf. e.g. Gen. 19:4; 28:11; Deut. 7:7; 1 Sam. 3:5; Prov. 6:22). To do so without being **afraid** (from the verb "to tremble" or "be terrified") is obviously a crucial element in the concept of **peace**. Insecurity may also be fostered by **dangerous animals**, the predators that threaten life and livelihood; these too are to be removed as a threat. The phrase **and no sword shall go through your land** might belong at the end of v. 5 (see Gk).

7. Such **enemies** as there may be Israel will **chase** and defeat. The idea that with Yahweh's support the few will always defeat the many is familiar in a number of biblical texts (e.g. Jdg. 7:2; 2 Chr. 16:8), along with the conviction that no trust is to be put in mere military power (Isa. 31:1).

8. Here **five** will be sufficient to defeat a **hundred**, and a **hundred** sufficient for **ten thousand**.

9. The phrase **I will look with favour upon you** comes from the verb "to turn"; for other texts with this sense "to regard graciously" see e.g. Num. 16:15; 2 Sam. 9:8; 1 Kgs 8:28; 2 Kgs 13:23; Pss. 25:16; 40:5; 69:16; 86:17; 102:17; 119:32; Mal. 2:13.

For **fruitful** with reference to population expansion see Gen. 17:6, 20; 28:3; 48:4; Ps. 105:24.

References to the **covenant**, the binding commitments that unite Yahweh with Israel, are frequent in this chapter (vv. 15, 25, 42, 44, 45), but rare elsewhere in Leviticus (see 2:13). The idea is often thought to have its origins in Deuteronomistic circles (cf. e.g. Deut. 4:13; Josh. 7:11; Jdg. 2:1; 2 Kgs 17:15). Here in the Holiness Code the covenant in mind is that made with the nation's ancestors (v. 42; cf. Gen. 17:2). An earlier covenant with Noah has an important place in the priestly writing (cf. e.g. Gen. 9:9). The verb **will maintain** (from the root "to stand") is used elsewhere of the

carrying out of agreements or commitments of various kinds
(e.g. Gen. 26:3; Deut. 8:18; 1 Sam. 1:23; 15:11; 1 Kgs 6:12; Jer.
23:20).

10. The phrases **old grain** and **long stored** come from the
adjective "old" (n.b. its use in 25:22). The general sense of the
verse seems to be that the harvests will produce an excess of
food; there will always be plenty of old produce to eat, and some
of it will have to be cleared away to make room for the new.

11. The phrase **I will make my dwelling place in your midst**
is constructed from the verb "to give" or "to put" and the
noun customarily rendered "tabernacle" in the priestly
writing. In Gk "my covenant" occurs instead of **my dwelling**
place. This theology of divine presence is clear in the priestly
text Exod. 29:45.

The assurance that Yahweh will not **abhor** ("spurn" – *REB*)
Israel is connected to the promise. The language of abhor-
rence has a significant place in this chapter (cf. vv. 15, 30, 43,
44). In vv. 30, 44 the possibility is, as here, that Yahweh will
spurn Israel; in vv. 15, 43 the fear is that Israel will spurn
Yahweh's laws (cf. also Jer. 14:19; Ezek. 16:45).

12. The divine presence is not thought of in static terms.
Yahweh **will walk** among his people; this is a dynamic pres-
ence embodying communication and companionship. The
commitments of the covenant are evident in mutuality and
belonging; Yahweh belongs to Israel, and Israel to Yahweh.

13. Here the exodus is presented as primarily a liberation
from slavery; this interpretation of that event underlies the
whole legislative programme in H.

The verb **broken** could be rendered "shattered" or
"broken in pieces".

The **bars** can be used of the poles by which the ark is
carried (1 Chr. 15:15), but usually, as here, it denotes the
cross bar of a yoke, and symbolizes some kind of oppression
(Isa. 58:6, 9; Jer. 27:2; 28:10; Ezek. 30:18; 34:27).

The word **yoke** also often has this figurative sense (e.g.
Deut. 28:48; 1 Kgs 12:4; Jer. 20:20).

The word **erect** ("uprightness" – BDB) has affinities with
the verb "to arise"; its occurrence here as an adverb is unique.
NJB reads "made you walk with head held high."

These verses (vv. 14–39) contain a catalogue of the disasters that will overtake Israel if Yahweh's commandments are not taken seriously. These entail initially sickness (v. 16), lost harvests (v. 16) and loss of freedom (v. 17). The rest of the unit builds progressively on these disasters, indicating the further consequences of continuing disobedience:
– drought and failed harvests (vv. 19–20)
– destructive predators (vv. 21–22)
– pestilence, defeat, widespread hunger (vv. 23–26)
– cannibalism, devastation of the land, dispersion (vv. 27–33)
– disorientation and defencelessness in alien lands, which only some will survive, while the land enjoys its sabbath rest (vv. 34–39).

14–15. The introductory comments reflect in all respects the ideas and attitudes of the Holiness editors. Familiar terminology (**commandments** (absent in Gk), **statutes**, **ordinances**) identify the basic principles of the Code's law which must be obeyed. Failure to do so means a breaking of the **covenant** (see v. 9).

The verb **spurn** (reject – BDB) is used in various contexts to indicate a rejection of Yahweh (cf. e.g. v. 43; Isa. 30:12; Jer. 6:19; 8:9; Ezek. 5:6; 20:13, 16).

For **break** with **covenant** cf. Gen. 17:14; Deut. 31:16, 20; Isa. 24:5; Jer. 11:10; 31:32; 33:20; Ezek. 16:59; 44:7.

16. The phrase **I will bring terror on you** is unusual. It embodies the verb "appoint" (*RSV*) meaning "to set over" or "make responsible for" (cf. Num.1:50; Jer. 40:5), and its figurative use here is unusual. The word translated **terror** ("sudden terror") is uncommon (Ps. 78:33; Isa. 65:23; Jer. 15:8); the *NRSV* text of Isa. 65:23 renders it **calamity**. This would be a reasonable rendering here in v. 16 as an overall description of the disasters which are to be listed more specifically in the phrases that follow. In Sam. "sickness" occurs instead, a very similar word in Heb.

The word **consumption** (or "wasting disease" – *REB*, *NIV*; "incurable diseases" – *GNB*) occurs also in the similar passage in Deut. 28:22, but not elsewhere, and is difficult to identify with certainty.

The word **fever** (cf. also Deut. 28:22) has connections with

the verb "to kindle", and it is easier to be confident about its meaning. The **fever** in question, along with the **consumption**, are described as conditions that **waste** the eyes. The verb here means "finished" or "spent", and the probability is that the diseases destroy or damage eyesight. They are also clearly life-threatening – **and cause life to pine away** (*REB* – "cause the appetite to fail"). This verb is another rare word (cf. 1 Sam. 2:33).

The second half of v. 16 turns to another calamity, the futility of sowing that which only enemies shall eat. For **in vain** see v. 20; Job 39:16; Isa. 49:4; 65:23.

17. In v. 17 calamity at the hands of enemies is elaborated. Yahweh will be Israel's opponent – **I will set my face against you** – and defeat at the hands of enemies will ensue.

The word **struck down** is common in such contexts (cf. e.g. Num. 14:42; Deut. 1:42; Jdg. 20:32; 1 Sam. 4:2; 7:10; 2 Sam. 10:15, 19; 18:7; 1 Kgs 8:33; 2 Kgs 14:12).

Israel will be ruled over by **enemies** (those who "hate" her – *RSV*). For **rule** see 25:43, 46, 53.

The habit of fear will be such that Israel will be dislocated and disorientated by it even in times of relative peace and security – **and you shall flee though no one pursues you**. This brings to an end the first set of calamities that Yahweh threatens, should Israel's loyalty prove fragile.

18. The possibility that such events will not be effective in consolidating that loyalty is confronted in vv. 18–20, and a second set of calamities is introduced.

The phrase **I will continue to punish you** (cf. v. 28) contains a verb widely used for acts of correction; with reference to God's disciplinary intervention it is sometimes found in the psalms (Pss. 6:1; 38:1; 39:11) and other poetic texts (Jer. 10:24; 30:11; 31:18).

Sevenfold visitations are typical of the chapter (cf. vv. 21, 24, 28). The point is to stress the severity of the discipline (cf. Gen. 4:15) rather than its precise quantity.

19. Yahweh expresses his determination to **break** their pride – for the same verb see v. 13 and the broken yoke. The word **pride** can be rendered "exaltation" (BDB), and is often used positively and approvingly (e.g. Isa. 4:2). It is a

characteristic of God himself (e.g. Exod. 15:7; Isa. 24:14; Mic. 5:3), and for this reason perhaps it can denote a false pride and arrogance when related to human achievement.

The phrase **your proud glory** ("pride of your power" – *RSV*) also occurs in Ezek. 24:21 in connection with the sanctuary. For "glory" or "power" cf. also Ezek. 30:6, 18; 33:28; Amos 3:11 (**defence** – *NRSV*).

The reference to sky **like iron** is unusual, and probably denotes the unrelenting persistence of drought. The earth, not surprisingly, is like **copper** ("brass" – *RSV*; "bronze" – *REB, NJB, NIV*; "iron" – *GNB*), unyielding in its failure to produce. In Deuteronomy's parallel passage the similes are reversed with the earth described as iron, and the heavens as bronze (Deut. 28:23). B. A. Levine (*Leviticus*, 1989) notes the presence of this simile in seventh-century BCE treaties.

20. The **strength** of those who work the land will be **spent to no purpose** (see v. 16). The verb **spent** comes from the root meaning "to be complete" or "finished" (BDB); the point is clearly that efforts to till the land will lead to exhaustion and failure.

For **produce** see v. 4.

The fruit trees will be similarly unproductive. There is strong textual support for **trees of the field**, as in v. 4 (e.g. Sam., Gk).

21. The third set of calamities is introduced in vv. 21–22.

The use of the verb **continue** ("walk" – *RSV*) in connection with obedience is characteristic of Deuteronomy and the Holiness Code (see 18:4).

The word **hostile** "opposition" or "contrariness" occurs only in this chapter (see also vv. 23, 24, 27, 28, 40, 41).

The phrase **will not obey** includes the verb "to be willing" as well as the verb "to listen". There is clearly a concern to stress that this will now be an attitude of stubborn and wilful refusal.

To **plague** could just as well be rendered "blows" or "wounds" (BDB), or simply "calamities". There are certainly some texts where disease is implied (e.g. 1 Sam. 4:8; Deut. 28:59); here there is no further indication that such disasters are specifically in mind.

For **sevenfold** see v. 18.

22. The specific "blow" which will fall is the devastation wrought by predatorial animals. The **wild animals** (literally "creatures of the field") will cause disruption and loss of life. For "the field" as the home of wild animals see e.g. Exod. 23:11, 29; Deut. 7:22; Hos. 2:14, 20; 4:3; 13:8; 1 Sam. 17:44; 2 Sam. 2:18; Job 5:23.

The phrase **bereave you of your children** is found in other texts (e.g. Gen. 42:36; 1 Sam. 15:33; Ezek. 5:17; 14:15).

For **livestock** see 1:2. The word **destroy** is from the verb "to cut off"; other texts which use it of the destruction of animal life are Exod. 8:9; Mic. 5:10; Zech. 9:10.

For **make you few in number** cf. Jer. 10:24; Ezek. 29:15. The reference to **roads** that become **deserted** suggests a country with diminished population, and nothing by way of trade or commerce.

23. A fourth set of calamities follows in vv. 23–26. The Heb. in v. 23 reads simply "and if by these. . ." (there is no explicit reference to **punishments**). The word **turned** does carry a strongly disciplinary tone (cf. Jer. 6:8; 31:18).

For **continue hostile to me** see v. 21.

24. Yahweh will respond in kind – **I too will continue hostile to you**.

The verb **strike** as an act of judgement is attested in such texts as 1 Kgs 14:15; Isa. 5:25; 9:12; 27:7; Jer. 2:30; 5:3; Ezek. 32:15.

For **sevenfold for your sins** see v. 18.

25. The calamities are further described as a **sword against you**; this is probably still a general figurative reference to disaster.

The phrase **executing vengeance for the covenant** is unique. Since the concept of "covenant" carries legal overtones the phrase has the sense of taking action against a breach of faith and loyalty.

In v. 25b it begins to become clear what the "striking" and "sword" entail, and even if Israelites seek to escape to the cities (from the wild animals of v. 22?) they will not be safe. First there will be **pestilence** (cf. Exod. 5:3; 9:15; Num. 14:12; Deut. 28:21); this will be followed by surrender **into enemy hands**.

26. The phrase **staff of bread** (v. 26) occurs elsewhere as a reference to food supplies (e.g. Ps. 105:16; Ezek. 4:16; 5:16; 14:13); these will be cut off.

For **bake** see 24:5. For **oven** see 2:4; 7:9; 11:35; it would appear to be both portable and breakable. The point seems to be that there will be so little bread that ten women (households?) will be able to use one oven.

The phrase **and they shall dole out your bread by weight** is puzzling (for **weight** cf. 19:35 and for its association with bread cf. Ezek. 4:16). The effect is that the people will **eat**, but **not be satisfied**.

27. The fifth and final set of calamities follows in vv. 27–33.

For **disobey** and for the phrase **continue hostile to me** see v. 21.

28. Yahweh will himself **continue hostile to you** (see v. 24). In this instance it will be **in fury**. Yahweh's rage will collide with their stubbornness and intransigence.

For **sevenfold for your sins** see v. 18.

The verb **punish** was used in v. 18, and signifies the severest discipline.

29. The calamities specified reach a new level of horror. In the first instance the deprivation and starvation will be such that parents will be driven to eat their children (cf. the story of the siege of Samaria in 2 Kgs 6:24–31).

30. The point seems to be that for corpses to lie unburied in an unclean place and in contact with the detestable pollution of idols is a disaster of major proportions.

The verb **destroy** often means "to exterminate"; it is also used of buildings (Isa. 23:11; Mic. 5:13), and in Num. 33:52 of **high places** ("shrines" – *REB*) as here. Such locations were often holy places, and in earlier literature appear to be acceptable (e.g. 1 Sam. 9:12–25; 10:5, 13). The Deuteronomic historians took the view that kings should eliminate them (e.g. 2 Kgs 12:4; 14:4; 15:4, 35; 21:3; 23:5, 8, 9; cf. also Ps. 78:58). The view of **high places** here in the Holiness Code is negative; sacrifices are, after all, to be brought to the tent of meeting (17:3–4).

The phrase **incense altars** translates a relatively rare word found elsewhere in Isa. 17:8; 27:9; Ezek. 6:4, 6; 2 Chr. 14:5;

34:7. It is familiar in Ugaritic, and there is the possibility that it embodies the name of a deity Baal-Hammon (B. A. Levine, *Leviticus*, 1989). A cult associated with the sun god is a possibility (J. E. Hartley, *Leviticus*, 1992). The fact that these objects can be **cut down** raises questions about their nature, but something wooden is not necessarily implied. The root verb can mean "cut off", with the sense "bring to an end", hence "demolish" (*REB*), "smash" (*NJB*), "tear down" (*GNB*).

The word **idols** is extensively used, particularly in Deuteronomistic literature and in Ezekiel, to denote lifeless images (e.g. 1 Kgs 15:12; 2 Kgs 17:12; 21:21; Ezek. 6:5, 13; 14:4, 5; 18:6, 15). It is their lifelessness which makes it appropriate to speak of them as **carcases**. The defilement and disgrace attaching to corpses in this predicament engendered a particular feeling of abhorrence among the Holiness editors (see D. P. Wright's comments on **dead bodies** (*The Disposal of Impurity*, 1987, pp. 122–125).

For **abhor** see vv. 11, 15; Yahweh responds in kind as in v. 24.

31. A third disaster in this fifth set of calamities is the devastation of the country (vv. 31–32). Cities will become **waste**, a word used of the ruins of Jerusalem in Isa. 52:9, and **sanctuaries** will become **desolate**. As with the high places (see v. 30) it is to be assumed that the Holiness editors considered the **sanctuaries** inauthentic. Some mss. and Sam. read the singular **sanctuary**. **Desolate** is used in the same way in the parallel passage in the Book of the Covenant (Exod. 23:29; cf. Isa. 1:7).

For **smell your pleasing odours** see 1:9.

32. Here **devastate** and **appalled** come from the same verbal root (BDB). Yahweh threatens to cause desolation to the extent that all who witness it will be appalled. For use of the word to mean **devastate** see e.g. 1 Sam. 5:6; Ezek. 20:26; 30:12, 14; Hos. 2:14, and with the sense to be **appalled** see e.g. Jer. 2:12; Ezek. 26:16; 27:35; 28:19; Isa. 52:14. The devastation will be such that all protection will disappear and **enemies** will readily settle in the land.

33. The ultimate calamity is described – you **I will scatter among the nations**. Deportation and emigration will destroy

the community. The verb **scatter** is often used in agricultural contexts of the winnowing process (e.g. Ruth 3:2; Isa. 30:24; 41:16); of the dispersal of peoples it occurs in e.g. 1 Kgs 14:15; Pss. 44:11; 106:27; Jer. 31:10; Ezek. 5:10, 12; 12:14, 15; 20:23; 22:15; Zech. 2:2, 4.

The threat to **unsheathe** the sword uses the verb "to empty out"(BDB). It occurs in a number of texts in relation to the drawing out of swords (e.g. Exod. 15:9; Ezek. 5:2, 12; 12:14; 28:7; 30:11). The dispersals will arise out of the privations of war. *REB* reads "I will pursue you with the drawn sword" (cf. *NIV*).

For the land as **desolation** see vv. 31, 32, and for cities as a **waste** see v. 31.

34. The last part of this long list of calamities deals with the experience of dispersion (vv. 34–39). The verb **enjoy** (v. 34, cf. v. 43) comes from a root meaning "be pleased with" or "accept favourably" (BDB). The *NRSVn* **make up for** is based on the fact that later in the chapter it can be rendered **make amends for** (v. 41). If this interpretation is adopted the land makes amends for all the broken sabbaths that have preceded the dispersion. The meaning "to be pleased with" or "to take pleasure in" is perfectly acceptable however (cf. e.g. Gen. 33:10; Pss. 44:3; 147:11; Isa. 42:1). In this case the land, as is suggested later in v. 34, enjoys its sabbath rest. The land is released from the labour of sustaining a stubborn and rebellious people.

For **desolate** see vv. 31, 32, 33, and for **rest** see 23:32; 25:2.

35. The suspicion that the land is not in any real way "making amends for", but rather resting from its labour, is confirmed here; it was always subject to the labour of supporting Israel. Now in its **desolate** state it can enjoy the sabbaths it deserves.

36. Some will of course survive in the lands of their enemies, but they will be weak and defenceless.

The form of the word **faintness** is found only here, but it is connected to a root meaning "tender", "weak", or "soft" (BDB). The idea of a **driven leaf** is also found in Job 13:25. The sentiment of v. 17 is repeated here in v. 36. Their fear and lack of confidence will be such that they **fall though no one pursues**.

37. This theme is sustained. The dispersed people will flee even when there is no sign of danger.

The verb **stumble** also occurs in Lam. 5:13 in connection with those who stagger under loads of wood. Here the point seems to be the trampling and confusion generated by a crowd in a state of panic. There will therefore be no capacity to resist an enemy.

The verb **to stand** renders an unusual form of the verb (cf. Ps. 139:21 where it is rendered by NRSV as "rise up against").

38. The threat that the people will **perish** occurs in the parallel passage in Deuteronomy (28:20, 22; cf. also 8:19, 20; 30:18; Jer. 27:10, 15); they will be devoured by the land itself, suggesting no access to its resources and subsequent destitution.

39. Those who do survive will **languish**. This word can be used of festering wounds (Ps. 38:6) or of decay in general (e.g. Isa. 34:4; Zech. 14:12). Its association with **iniquities** (cf. vv. 41, 43 and see 5:1, 17; 7:18; 10:17; 19:8; 20:17, 19; 22:16) is another feature the Holiness Code shares with Ezekiel (Ezek. 4:17; 24:23; 33:10).

The meaning of v. 39b is not entirely clear. In Gk the phrase **because of the iniquities of their ancestors** is absent. Its overall rendering is attractive, but is probably an attempt to resolve some of the difficulty: "And those of you who are left shall perish because of your sins, in the land of their enemies they shall pine away". The Heb. can be taken to mean that the dispersed people suffer for the sins of earlier generations, and this is widely assumed by modern translations. The phrase might mean rather that they share in those **iniquities**. They will therefore fester and decay as a generation, just as their fathers did.

The concluding verses in the Holiness Code offer some hope for a return from exile, providing in the process some of the best indications of its likely historical setting. Yahweh is still ready to abide by his covenantal commitments (vv. 42, 44–45) provided the people will confess and humble themselves. There is the clear consciousness that exile in Babylon has not spelt the end of the community's life, and that a commitment

to Yahweh and his will is still an option. The passage does not foresee an imminent return, and is probably best dated at a central point within the exilic period.

40. The verb **confess** is that used in 5:5; 15:21 (cf. also Num. 5:7; Ezra 10:1; Neh. 1:6; 9:2, 3; Dan. 9:4, 20). *NJB* translates "then they shall admit their guilt", seemingly confident that indeed they will (cf. *GNB*). *REB* reads "though they confess. . .", implying that, until they reach the lands of their enemies, Yahweh will not listen and forgive.

For **iniquity** see 16:21.

The word **treachery** was used in 6:2 of a "trespass" (cf. also Num. 5:31; 31:16; 22:16, 31). Its relative lateness as a way of describing Israel's apostasy is confirmed by such texts as 1 Chr. 10:13; 2 Chr. 28:19; Ezek. 17:20; 20:27; 39:26; Dan. 9:7.

For the phrase **continued hostile to me** see vv. 21, 23, 27.

41. The dispersion is seen as **hostile** in a reciprocal way (see vv. 24, 28). Gk appears to read **brought them into** as "destroyed them in".

The reflexive use of the verb **humbled** is characteristic of late texts (e.g. 2 Chr. 7:14; 12:6, 7, 12; 30:11; 32:26; 33:19, 23).

The adjective **uncircumcised** has already occurred in a figurative sense in 19:23 (cf. its use in relation to lips (Exod. 6:12, 30) and ears (Jer. 6:10)). Its use for a flawed character, as here, is also attested in Jer. 9:25; Ezek. 44:7, 9. It suggests an unreceptive and incapacitated condition when used of the heart.

The verb **make amends for** is that translated **enjoy** in vv. 34, 43, and in their contexts both translations seem acceptable; there is perhaps some deliberate play on the ambiguity (n.b. the juxtaposition in v. 43).

42. Given this humbled and repentant disposition Yahweh is ready to **remember** his **covenant** with the ancestors (cf. v. 45). This formulation occurs elsewhere in the priestly writing (e.g. Gen. 9:15, 16; Exod. 2:24; 6:25; cf. also Ps. 105:8; Jer. 14:21; Ezek. 16:60). The ancestors also figure prominently in Deuteronomy as those to whom promises and commitments were made (e.g. Deut. 1:8; 6:10; 9:5, 27; 29:13; 30:20; 34:4).

Yahweh will also **remember the land**, a basic element in the promises made to the ancestors.

43. The land will, however, be **deserted by them** (cf. Isa.

7:16). In this condition it will be free to **enjoy its sabbaths** (see vv. 34, 41).

For **desolate** see vv. 31, 33, 34, 35, and for **make amends for their iniquity** see v. 41.

The verbs **spurn** and **abhorred** both occur in v. 15 in association with Yahweh's laws, as do the familiar descriptions of them as **ordinances** and **statutes**.

44. The idea that Yahweh will respond in kind has already been expressed more than once (vv. 23–24, 27–28); here, however, Yahweh's will to **spurn** and **abhor** his people is revealed to be less than absolute. The context implies of course the repentant attitude of vv. 40–41, but the basic disposition of God seems to preclude total destruction and abandonment of the covenant.

The verb **destroy them utterly** is from the root meaning "to make a complete end" (cf. the usage elsewhere in the priestly writing – Num. 16:21, 45; 25:11).

The verb **break** in connection with the Israel's infringement of the **covenant** is found in v. 15; its use, as here, of Yahweh's breaking the covenant is attested also in Jdg. 2:1; Jer. 14:21; Zech. 11:10.

45. It is on their account – **in their favour** – that Yahweh will **remember** the **covenant**.

The word **ancestors** from the word meaning "former" or "first" (BDB) (cf. Deut. 19:14).

The idea that Yahweh delivered Israel from Egypt **in the sight of the nations**, and with his reputation at stake, is prominent in the intercessions of Moses (e.g. Exod. 32:11–14; 33:12–16; Num. 14:13–19). The aim, that Yahweh should be **their God**, is a familiar sentiment of the Holiness editors (e.g. vv. 1, 12; 18:30; 19:2, 3, 10, 25, 31, 34, 36; 20:7, 24, 26; 23:22, 43; 24:22; 25:17, 36, 38, 42, 55).

46. This marks the end of the Holiness Code, and arguably also the end of a larger collection of law deemed to have been given on Sinai. In addition to the familiar **statutes** and **ordinances** there are also **laws** (singular in Gk), a feature of the Manuals of Offerings and Purity (see 6:9, 14, 25; 7:1, 11, 37; 11:46; 13:59; 14:32, 54, 57; 15:32) and not previously cited in the Holiness Code.

The verse may be fulfilling a similar function to 7:37–38. Just as those verses tie the Manual Offerings into the corpus of Sinaitic legislation, so v. 46 incorporates into that same body of law the Manual of Purity and the Holiness Code.

THE APPENDIX
(27:1–34)

The final chapter in Leviticus seems to be supplementary. It has its own conclusion (v. 34), identifying it as a body of commandments given to Moses on Sinai, and it has more to add on the question of redemption as raised in the Holiness Code (25:25-34). The main focus is on redemption as it relates to vows, a topic that also receives some attention in Num. 30:1-16. The jubilee year, first mentioned in 25:11, has an important place in some of the calculations and valuations (vv. 17, 18, 21, 23, 24). The text does not, however, reveal any of the most characteristic marks of the Holiness editing. The style is very much of a piece with legislation elsewhere in Leviticus. The phrase **Yahweh said to Moses, "Say to the people of Israel. . ."** (vv. 1, 2) has obvious parallels in 17:1–2; 18:1–2; 19:1–2; 20:1–2; 23:1–2; 25:1–2, but it is also a feature of the priestly editing in general (cf. e.g. 1:1–2; 4:1–2; 7:22–23; 11:1–2; 12:1–2; 15:1–2).

It may be that this material was added after the completion of the second Temple (see General Introduction: Sources and Redaction).

REDEMPTION AND VOWS
(27:1–34)

Within this block of supplementary material the following units can be identified:

27:1–8 – persons dedicated to Yahweh
27:9–13 – animals dedicated to Yahweh
27:14–15 – buildings dedicated to Yahweh
27:16–25 – land dedicated to Yahweh
27:26–27 – firstlings

27:28–29 – "devoted" things
27:30–33 – tithes.

The form of the laws in this chapter is primarily casuistic –
e.g. **when a person . . . then . . .** (vv. 2–3, 14) or **if . . .** (perva-
sively). There are not statutes in the second person plural;
forms of address are invariably in the singular (vv. 2–8, 15, 23,
25, 27). Impersonal third person singular forms are very
prevalent (vv. 9–33).

While it is certainly the case that the redemption motif
provides connections with 25:25–34 the essential back-
ground to these texts is the practice by which persons and
property are dedicated to Yahweh. The old stories about
Hannah and Samuel reflect the practice by which a son could
be dedicated in this way (1 Sam. 1:11, 22–28). In this instance
the child functions at the sanctuary in some kind of priestly
ministry (1 Sam. 2:18; 3:1, 3). There is an element in this
story which connects it with the vows made by Nazirites,
namely the refusal to cut hair (1 Sam. 1:11; cf. Jdg. 13:5;
Amos 2:11–12). Priestly detail about Nazirite vows is
contained in Num. 6:1–21. There is the clear implication
here that such vows need not be for life (vv. 4, 5, 8, 13);
indeed the termination of the vow is a major point of interest
(vv. 13–20). The main concerns in Num. 30:1–16 relate to the
vows made by women, and the possibility of their being nulli-
fied by men. For a reference in Leviticus to votive offerings
(those made in fulfilment of vows) see 7:16–17; 22:18–25
(cf. also Num. 15:1–10).

It is possible, with G. Henton Davies (*IDB*:IV, pp.792–793),
to identify different kinds of vows. There are those which in
effect are bargains – e.g. that made by Jacob at Bethel (Gen.
28:20–22), and that by Jephthah with regard to his daughter
(Jdg. 11:30–31), those which express devotion – e.g. David's
plan for the ark (Ps. 132:2–5), and finally there are vows of
abstinence – e.g. from taking spoil (Num. 21:1–3) or from
eating (1 Sam. 14:24). A major study of the subject, in biblical
and ancient near eastern sources generally, has recently been
undertaken by T. W. Cartledge (*Vows in the Hebrew Bible*, 1992).
His findings indicate that vows made to deities were very

frequently related to physical illness; other concerns which might prompt a vow were war, travel, and family matters such as the need for children.

The recognition here in Leviticus, and in other later texts (e.g. Num. 6:1–21; 30:1–16), that vows are redeemable or of limited duration, suggests a certain pragmatism in priestly circles. As well as providing relief from commitments made rashly, or without due consideration, the financial substitutes obviously provided an additional source of priestly revenue. The old idea, present in the story of Samuel, that children might be dedicated as sanctuary personnel, had long since ceased to be necessary or desirable, given the formalization of priestly structures and hierarchies in the house of Aaron. There was scope of course for Nazirite vows (Num. 6:1–21). The essential seriousness of votive commitments is preserved in the ensuing legal provisions.

In vv. 1–8 it is clear that persons who have been in some way dedicated to Yahweh can be released from the commitments by a monetary payment. In the context of a well established priestly hierarchy it seems likely that the most probable situation in mind would be the Nazirite vow (Num. 6:1–21).

B. A. Levine (*Leviticus*, 1989) sees the main function as being to secure funds for the needs of the sanctuary, and draws attention to 2 Kgs 12:4–5 where there is explicit reference to money raised from an assessment of persons.

1. The laws are to be transmitted directly by Moses to the people (v. 2).

2. The phrase **makes an explicit vow . . . for a human being** is not completely straightforward. It includes the verb "to be surpassing" or "extraordinary", and BDB suggests in this instance it means "to do a hard or difficult thing" – i.e. to "make a hard vow" (cf. Num. 6:2). For **vow** see 7:16; 22:18, 21, 23; 23:38.

The root word in **equivalent** ("at your valuation" – *RSV*), a prominent feature of this chapter (cf. vv. 3, 4 – see **assessed value** in vv. 15, 19 (cf. v. 23)), is used in the Manual of Offerings in relation to the priest's valuation of a guilt offering (5:15, 18, 25). The overall point seems to be that

such vows would be extraordinary, and that some kind of valuation should be proposed when the vows are made.

3. The following verses indicate how such valuations should be made. G. J. Wenham ("Leviticus 27:2–8 and the Price of Slaves," 1978) suggests that the prices indicated are those which slaves would have cost. A male between twenty and sixty years old is to be assessed at **fifty shekels of silver**. For **male** see 6:18, and for the **shekels . . . by the sanctuary shekel** see 5:15.

4. Female vows are assessed at **thirty shekels**. For **female** see 12:5, 7; 15:33. This reduced value for females corresponds with the lower social status attributed to women in such societies (cf. 12:2, 5). Male control over female vows, and therefore over their freedom, is made very clear in Num. 30:1–16. B. A. Levine (*Leviticus*, 1989) thinks that the differentiation may reflect assumptions about the greater earning power of men. Such assumptions about relative productivity are not necessarily appropriate or accurate (J. R. Wegner, "Leviticus", 1992, p. 43).

5. For younger people, between the ages of five and twenty, the valuation is less. For a male it is **twenty shekels** and for a female **ten**. These figures probably reflect not so much the social status of the persons concerned, as their perceived capacity to contribute to the well-being of the community. The valuation of mature females at a higher rate than young males does suggest some sense of their intrinsic worth.

6. For very young children the valuations are correspondingly lower, for a male **five shekels** and for a female **three**.

7. Older people beyond the age of sixty are assessed at the rate of **fifteen shekels** for men and **ten** for women. In Gk it is specified that they are **silver**. This again suggests that strength and energy are key factors in the valuation; in terms of social respect the elderly were generally appreciated for their experience and maturity.

8. The recognition in v. 8 that someone may not be able to **afford** payments of this kind recalls the provision made in such texts as 5:7, 11; 14:21. The root used here, however, comes from the rare verb "to be low", which also occurs on several occasions in the Holiness Code (25:25, 35, 39). There

it denotes the process by which fortunes deteriorate and people become impoverished. In such cases the person concerned is to be brought before the priest ("made to stand"), and valued by the priest in terms of the poor person's capacity to pay.

The verb in v. 8b expressing what the person can afford is used on a number of occasions elsewhere in Leviticus (e.g. 5:11; 14:21, 22, 30, 31, 32; 25:26, 47, 49; cf. also Num. 6:21; Ezek. 46:7). It constitutes a figurative use of the verb "to reach".

In vv. 9–13 it becomes clear that vows made with regard to clean animals, those which can be offered to Yahweh, cannot be redeemed. The usual situation would probably be one in which a votive offering had been promised, though v. 11 does indicate that unclean animals, namely those unsuitable for offerings, could also be the subject of vows.

9. The word **animal** is a general term covering all quadrupeds, and rendered "creatures" in 11:2.

For **offering** see 1:2. Such creatures, once given to Yahweh in the form of a vow, are **holy** (see 10:10).

10. Any attempt to **substitute** or **exchange** the animal is prohibited. The verb **exchanged** comes from a root meaning "to pass on" or "through", and its use with the sense "to change", as here, is uncommon (cf. e.g. Gen. 31:7, 41; 35:2; Ps. 102:26; for the sense "renew" cf. Isa. 40:31; 41:1). The root **substituted** is found elsewhere in, for example, Ps. 106:20; Jer. 2:11; Ezek. 48:14; Hos. 4:7).

The basic principle is so firmly insisted on that even the exchange of bad for good is forbidden.

It seems unlikely that v. 10b intends any relaxation of the principle; the point is rather that if any such exchange were made both animals would now be deemed "vowed" and therefore **holy**.

11. One can only speculate as to the circumstances in which an **unclean animal** might be the subject of a vow. It seems most likely that animals given for priestly use are in mind, perhaps, for example, the camel, as cited in 11:4, or other forms of animal transport such as an ass. If the original owner wishes to reclaim it the animal is set before the priest,

just as a person is in v. 8.

12. The priest for his part makes an assessment as to whether it is **good** or **bad**, and values it accordingly. This can be read as "high or low" (B. A. Levine, *Leviticus*, 1989) – in short, the assessment stands whatever the market value. There seems to be a direct address to the priest here – "as you the priest" (*RSV*).

13. This valuation provides for the redemption sum; with animals of this kind release from the vow is permitted. The root behind the verb **redeemed** is familiar in the Holiness Code (25:24, 25, 29–33, 48–49, 51–52, 54).

There is the further requirement that **a fifth** be added to the valuation determined by the priest. This additional payment is a feature of the recompense made in connection with guilt offerings (5:16; 6:5).

In vv. 14–15 it is shown that buildings dedicated by vow to Yahweh can be redeemed. The price depends once again upon the valuation made by the priest.

14. The word **consecrates** comes from the root meaning "to make holy" (see 10:10). The situation in mind would presumably be one in which property has been handed over for priestly use.

Once again the priest's initial assessment is whether the house is **good or bad** (cf. v. 12).

Whatever he determines as its value **so it shall stand** (cf. also v. 17). The verb here is "to arise" or "to stand up" (BDB), a root with a wide range of applications. Its use here to denote a decisive price is rare, but it does occur in relation to vows in Num. 30:5, 10.

15. A vowed object is holy, but in this instance redemption is possible.

For **redeem** see v. 13.

As in the case of unclean animals **a fifth** must be added to the priest's valuation (cf. v. 13). This compensation is paid to the priests for their loss of the use of the house. Then and only then does the property return to the original owner.

The following verses (vv. 16–25) address the more complicated question of land which has been dedicated to Yahweh

as a vow. The land is certainly redeemable, but the valuation is affected in particular by the proximity of the year of jubilee. Under some circumstances (vv. 20–21) it may pass permanently into priestly hands.

16. The verb **consecrates** means "make holy" (see v. 14), while the phrase **inherited landholding** renders the noun "possession" ("ancestral land" – *REB*; "family land" – *NIV*). It has already been used in 14:34 and 25:10 ("property"), and in numerous other verses in the latter chapter. It is frequent also here in chapter 27 (cf. vv. 21, 22, 24, 28). It is a particularly favoured word to denote houses or landed property in the priestly writing and other late texts (see 25:10).

Here too an **assessment** (see v. 2) is necessary.

For the phrase **in accordance with** see 25:16, 51.

The basis of the valuation is not entirely clear. It may be that **its seed requirements** ("the seed for it" – *RSV*) means the amount of grain the land will normally yield, so that a field capable of producing **a homer of barley** would be valued at **fifty shekels of silver**. As J. Milgrom ("The Book of Leviticus", 1971, p. 84) points out a homer of seed would sow a very large area, and make the land improbably cheap. *NJB* reads "in terms of its yield", while *REB* prefers "according to the amount of seed-corn it can carry". This probably means "according to the amount of seed it takes to sow it" (*GNB*, cf. *NIV*). B. A. Levine (*Leviticus*, 1989) notes this method of describing plots of land in other ancient near eastern sources, and it is the view best adopted.

The **homer** (cf. e.g. Isa. 5:10; Ezek. 45:13; Hos. 3:2) is usually estimated to be about six and a half bushels.

17. Since **the year of jubilee** (see 25:10) is a decisive factor, and in this exceptional instance marks a point at which the ownership of land is transferred (see v. 21), the valuation will vary according to the proximity of the year. If the vow is made with a full fifty-year period outstanding then the redemption price is to be fixed at the full valuation.

18. If the vow is made with fewer than the fifty years remaining then a deduction is made from the valuation; this deduction is in proportion to the number of years that remain.

The verb **compute** occurs again in v. 23, and plays an important part in the calculations in 25:27, 50, 52.

The word **reduced** comes from the verb "to diminish" (BDB); its use here of a sum of money is unusual (cf. Num. 27:4; 36:3, 4 for its use elsewhere in the priestly writing in connection with a family and its inheritance).

19. The principle entailing the addition of **a fifth** of the value, at the point when redemption is desired, obtains here in relation to land (cf. also vv. 13, 15).

For the use of the verb **redeem** in these contexts see v. 13.

The phrase **it shall revert to the original owner** ("remain his" – *RSV*) comes from the root "to stand" (BDB); for its use with this sense "to confirm the ownership of" see 25:30; Gen. 23:17, 20.

20. Here it becomes clear that, at the jubilee year, fields which are the subject of a vow, and which have not been redeemed, become the permanent possession of the priests. The circumstances under which this would occur would be the owner's failure to initiate the redemption process (there is no reference to his "wish" (*RSV*) in Heb.), or if he has sold it to another person. This latter eventuality is problematic. It seems to suggest that though a vow makes the property over to the priests, the legal rights still remain with the person who has made the vow. B. A. Levine (*Leviticus*, 1989) suggests that it envisages a situation in which the priests sell the land, knowing that the donor does not intend to redeem it. J. E. Hartley (*Leviticus*, 1992) refers to other possibilities – deception on the part of the donor who hides the fact of the vow to a buyer (cf. also M. Noth, *Leviticus*, 1962/1965; J. R. Porter, *Leviticus*, 1976), or a "sale" which leaves someone else with the responsibility for working the land.

21. The verb **released** comes from the root "to go out", and is clearly conventional jubilee terminology (see 25:30).

At this point the land becomes **holy to Yahweh**, his own particular possession. The description of it as a field that has been **devoted** ("vowed unconditionally" – *NJB*) embodies the root used in the context of holy war to describe the spoils that must be made over to Yahweh (cf. e.g. Deut. 13:17; Josh. 6:17, 18; 7:1, 11, 15; 1 Sam. 15:21). It recurs in vv. 28, 29 (cf. also

Num. 18:14; Ezek. 44:29). The consequences of neglect of or indifference to this requirement are very serious, as many of these texts suggest. The use of the word here makes it clear that after the jubilee there can be no further debate or negotiation; the land is finally and decisively **devoted**, and becomes a priestly possession.

22. The final situation considered is that of a field which is vowed subsequent to its purchase.

For **consecrates** see vv. 14, 16.

The phrase **inherited landholding** is the word employed in 14:34, and extensively in chapter 25 (see vv. 10, 13, 25, etc.); the text here makes it clear that the word means the property that belongs to the person and his family in perpetuity.

23. It is reasonable to suppose that the person wishes to redeem the land, and that the priest's calculations are made in the same way and for the same reasons as those in vv. 18–19; the addition of the fifth, as in v. 19, is probably to be assumed. A distinctive word is used for the process of valuation here (**proportionate assessment**); it is rare, but found elsewhere in the priestly writing for calculations of various kinds (Exod. 12:4; Num. 31:28).

It seems probable that **as of that day** is correct, referring to the day of redemption rather than the jubilee year (*NJB* understands it to be the same day as the valuation – cf. *REB*, *NIV*, *GNB*). This redemption price is holy to Yahweh (**a sacred donation**).

24. The principle of possession by inheritance is fundamental, and it clearly overrides a potential priestly interest in land of this kind; at the jubilee it passes into the hands, not of the priests (as in v. 21), but of the original owner.

25. The final note indicates that all valuations are to be made according to **the sanctuary shekel** (see v. 3) ("the sacred standard" – *REB*; "the official standard" – *GNB*); the additional information is that **twenty gerahs** make a shekel (cf. Exod. 30:13; Num. 3:47; 18:16; Ezek. 45:12). Both shekel and gerah were originally measures of weight before becoming a coinage and measure of monetary value.

In vv. 26–27 the question of vows and the firstborn of flocks

and herds is addressed. The basic point is that, since these already belong to Yahweh, they cannot be the subject of a vow (v. 26). The situation of an unclean animal is different (v. 27). Taking Num. 18:15 into account it would appear that the firstborn of unclean animals must be redeemed. It is hard to see the circumstances under which such an animal would at this point be the subject of a vow, if indeed it must be redeemed at the outset. If it was vowed subsequently then the laws set out in vv. 11–13 would apply.

26. Laws affirming that the **firstling** of flock, herd and human beings belongs to Yahweh first occur in Exod. 13:2. The principle is affirmed elsewhere in the priestly writing (Num. 3:13; 8:17–18; 18:15). It is, however, very old, as both the Book of the Covenant (Exod. 22:29b–30) and the Ritual Decalogue make clear (Exod. 34:19–20). The latter text indicates that an unclean animal, an ass, must be substituted by a clean animal, a lamb. An alternative is simply to mark the ass as Yahweh's by breaking its neck. Any thought that the **firstling** be dedicated to Yahweh is precluded; it is already his.

For the word **ox** see 4:10, and for **sheep** see 5:6, 7.

27. The firstling of an **unclean animal** (perhaps a camel or ass) must be redeemed at once. The verb **ransomed** (cf. also v. 29) occurs in a quite different context in the Holiness Code (19:20) – that of a woman who is a slave.

The phrase **at its assessment** ("at your valuation" – *RSV*) clearly implies the priest's valuation – as in vv. 14, 23. The usual addition of **one-fifth** is required (see vv. 13, 15).

The final phrase means presumably that the priest is entitled to sell the firstling as priestly property, should the original owner be unwilling to redeem it; indeed he must do so because it is **unclean** and not the subject of a vow.

In vv. 28–29 there is a return to the question of people or things which are **devoted**. Land which has been vowed, and has not been redeemed by the year of jubilee, has already been identified as **devoted** in v. 21; it is the exclusive and permanent property of Yahweh. Everything which has this status, and persons may be included (v. 29), is beyond the scope of redemption.

28. It would appear that **devoted** (see v. 21) can be a kind of vow, and if so it is absolutely irredeemable (see further D. P. Wright, *The Disposal of Impurity*, 1987, p. 284 n.13). It might include a **human** (perhaps a slave or a child), in which case the person would probably fulfil some kind of function within priestly households. It could include an **animal**, in this instance a domestic animal from flock or herd, whether for sacrifice or for priestly use.

The word **inherited** comes from the same root as **possession by inheritance** (vv. 22, 24); clearly a patrimony could be the subject of a **devoted** vow. All such commitments make the person or object offered **most holy** (see 2:3).

29. Here attention turns to the **devoted** things which must die. It is most likely that the situation in mind is that described in Num 31:7, 13–17, where prisoners of war and captives constitute those who should be **devoted**. It would also include the murderer (Num. 35:31–34). **They shall be put to death** constitutes the solemn formula familiar in law codes (cf. e.g. Exod. 21:12, 15, 16, 17) – "dying he shall die" or "he shall surely die". At the time when this material was finally compiled certain aspects had become symbolic (e.g. prisoners of war). J. R. Porter (*Leviticus*, 1976), citing Ezra 10:7–8, suspects that excommunication was the customary penalty for practical matters.

In the concluding verses (vv. 30–34) the possibility is considered that tithes might be redeemed. It would appear that the produce of the land can be redeemed, albeit at a cost (vv. 30–31), while the tenth animal from flocks and herds cannot be recovered (vv. 32–33).

The tithe, literally a "tenth part", is referred to in Leviticus for the first time here. The old story of Abram and Melchizedek helps to establish the principle (Gen. 14:20), and its explicit absence from the older laws is surprising. The requirement that you must not appear at the pilgrim feasts "empty-handed" (Exod. 23:15; 34:20) may refer only to such gifts as the first fruits. The tithe is firmly attested in Deuteronomic law. It relates to agricultural produce and must be brought to the central sanctuary (Deut. 12:17;

14:23), where it is consumed by the offerers. Every third year, however, it provides social security for the needy (Deut. 14:28; 26:12). In the priestly writing the tithe is clearly payment to the subordinate clergy, the Levites (Num. 18:21–24), and they in turn must pay a tithe from the tithes to the priests, the sons of Aaron (Num. 18:25–32; cf. Neh. 10:38–39; 13:5, 12; 2 Chr. 31:5–6, 12). Failure to stock the house of God with tithes is part of Malachi's charge against the people (Mal. 3:8–10). In Amos 4:4 tithe-giving every three days (!) symbolizes an excessive and distorted regard for the cult.

30. It is clear that here too the **tithes** are a gift from the produce of the land. They are **holy**, and therefore belong to Yahweh.

31. The main concern here, however, is to indicate the cost of redeeming it (for redemption see v. 13). That this was conceivable is perhaps surprising, and it is not easy to envisage the circumstances under which anyone would wish to do so; the additional costs of redemption would scarcely be helpful to the poor. The price of redemption is the cost of the produce plus the usual **one-fifth** (cf. vv. 13, 15, 27).

32. The tithing principle is explicitly applied to **herd** and **flock** (cf. 2 Chr. 31:6). On the face of it this is a development of the practice attested in Deuteronomy.

The reference to animals which pass **under the shepherd's staff** (v. 32) ("counting rod" – *REB*) indicates the customary method of counting them (cf. Jer. 33:13). For other references to such implements in the hands of shepherds see Ps. 23:4; Ezek. 20:37; Mic. 7:14. The method of counting provides the means by which the tithed animal is determined; as such it is **holy to Yahweh**.

33. This procedure is intended to provide an objective means of selection, which would avert disputes between priests and people. Whether the tenth animal is deemed **good or bad** is immaterial. Gk reads "you shall not make an exchange of good for bad". It seems likely nevertheless that seriously blemished animals would not have been permitted as part of the counting process. Leviticus has persistently insisted, from 1:3 onwards (cf. also 22:17–25), that blemished

animals are not acceptable to Yahweh (cf. also Mal. 1:8).

The tenth animal is **holy** to Yahweh, and no **substitution** can be countenanced (cf. v. 10). The situation envisaged in v. 33b is probably one in which an exchange has been attempted but detected. The penalty for such a ploy is that both animals will be deemed **holy** and therefore lost to the owner, with the further penalty that no redemption is permitted – it **cannot be redeemed**. Other tithed animals are presumably subject to the redemption stipulations set out in v. 31.

34. The concluding verse, which probably relates to the preceding laws in 27:1–33, identifies them as given to Moses by Yahweh on Mount Sinai (cf. 7:37–38; 26:46).

INDEX OF AUTHORS

INDEX OF SUBJECTS